The
GHOST

A

~

CULTURAL

~

HISTORY

First published 2017 by order of the Tate Trustees
by Tate Publishing, a division of
Tate Enterprises Ltd,
Millbank, London SW1P 4RG
www.tate.org.uk/publishing
Reprinted in paperback 2019,2021
© Tate Enterprises Ltd 2019

A catalogue record for this book is available from the British Library
ISBN 978-1-84976-646-3
Designed by Avni Patel
Colour reproduction by DL Imaging Ltd, London
Printed in China by C&C Offset Printing Co., Ltd.

The
GHOST

A
CULTURAL
HISTORY

SUSAN OWENS

TATE PUBLISHING

CONTENTS

INVENTING GHOSTS

*But whether reconcileable to the understanding
or not they are most interesting to the imagination*
WALTER SCOTT

It is late on Christmas Eve in Charles Dickens's *A Christmas Carol*, and Scrooge is sitting alone by his meagre fire when, with a great clanking of chains, the ghost of his old business partner Jacob Marley bursts into his room. Even faced with this dreadful apparition, however, Scrooge stubbornly fights against the evidence of his eyes and ears – and his suspicions are not lost on Marley.

> 'You don't believe in me,' observed the Ghost.
> 'I don't,' said Scrooge.
> 'What evidence would you have of my reality, beyond that of your senses?'
> 'I don't know,' said Scrooge.
> 'Why do you doubt your senses?'
> 'Because,' said Scrooge, 'a little thing affects them. A slight disorder of the stomach makes them cheats. You may be an undigested bit of beef, a blot of mustard, a crumb of cheese, a fragment of an underdone potato. There's more of gravy than of grave about you, whatever you are!'[1]

Scrooge's brave attempt at a joke cannot suppress his rising terror, and he is soon forced to change his mind. But his initial doubts about the ghost strike a chord with many of us. Can the dead really return to haunt the living? No one knows for sure. But for all our ambivalence, the idea that they just *might* appears to be hard-wired into the British frame of mind. Ghosts are woven into the fabric of our lives: every village, town and great house has at least one spectral resident, sometimes a whole host of them. It has, it seems, always been that way. Back in 1529 Thomas More raised his eyebrows at their sheer numbers, and noted that there was no country in Christendom in which one heard more news of 'apparycyons'.[2] Today, anyone who lives in a very old house finds themselves asked frequently, and quite matter-of-factly, if it is haunted. Surprisingly often, the answer is yes; and it is perhaps a reflection of the phlegmatic British character that, by and large, we quietly cohabit with our resident ghosts – whether we wholeheartedly believe in them or not.

The question of whether or not ghosts can be said to 'exist' I leave to others to debate. Like many people, I am fascinated by ghosts while not being quite sure what they are, and I confess to maintaining a precarious balance of scepticism and credulity that would probably not stand up to rigorous scrutiny. Ghosts remain one of the most profound enigmas of human life. 'It is wonderful', observed Samuel Johnson,

> that five thousand years have now elapsed since the creation of the world, and still it is undecided whether or not there has ever been an instance of the spirit of any person appearing after death. All argument is against it; but all belief is for it.[3]

Despite our current passion for ghost-hunting with infrared thermography and motion censors, used in reality television programmes such as *Most Haunted*, we have still not succeeded in pinning them down. They remain as elusive as ever, and we still have no more idea now of what they are than Dr Johnson had in his day.

What captivates me are the ghosts that we create in our imaginations. My fascination with ghosts began when I was a student, under the spell cast by the stories of Dickens and Henry James. But what has since astonished me is the sheer range of artists and writers to whom the subject has appealed: over centuries, ghosts have inspired countless stories and pictures, every writer and artist inventing them afresh. John Donne, writing in the early seventeenth century, threatened to become a ghost to exact revenge upon his faithless mistress: 'Then shall my ghost come to thy bed,' he warns, chillingly.[4] For Percy Bysshe Shelley two centuries later, they were natural phenomena – like clouds, or leaves caught up in the wind – taking their parts in a great, airy, cosmic theatre. In the 1850s Dante Gabriel Rossetti imagined an intense, psychologically charged encounter with doppelgängers in the centre of a dark forest, while in the 1940s Paul Nash drew the strange, ancient 'ghost-personages' that he found embedded in the British landscape. Ghosts have been painted as walking corpses, as unruly demons and as see-through wraiths. They emerge from bubbling clouds or appear draped in white sheets. And they have been used to entertain us and make us laugh just as often as to frighten or admonish us. In this book I tell their story as it has been written and painted into the cultural life of the land.

Our relationship with ghosts is deep-rooted – when I began to research this book I found written accounts of human spirits appearing after death as far back as the eighth century. It seems likely that our dealings with them stretch back much further still, far beyond the written record. Given their long-term residency in our imaginations, I was curious to discover what happened when the scope of those imaginations altered. I wanted to know if, and how, ghosts were affected by the great changes that, over time, have made us see the world in new ways: the decisive rearrangements of our mental furniture brought about by the Reformation, the Enlightenment, new technologies. How would More's 'apparycyons' compare with those that feature in the worldly mini-dramas concocted by Daniel Defoe in the early eighteenth century; or the awe-inspiring figures painted by William Blake at the beginning of the nineteenth; or the see-through ghosts captured on camera in the Victorian era? How much do they have in common with the ghosts created in the minds of the artists and writers of today?

When I began asking these questions, I quickly discovered that ghosts are mirrors of the times. They reflect our preoccupations, moving with the tide of cultural trends and matching the mood of each age. They were, most definitely, not always the insubstantial presences we tend to think of today. While a modern ghost might materialise, drift gently towards a door and disperse, in the medieval period it was more likely to break the door down and beat you to death with the broken planks. While writers associated with the 'graveyard school' in the mid-eighteenth century invited us down into the crypt and conjured up macabre spectres to remind us of our mortality, the Romantics saw the world differently: for them, ghosts could tell us about the most secret corners of our souls. And from the 1890s until the Second World War, artists and writers took ghosts out of the historic mansions and urban homes they had so vigorously haunted for most of the Victorian era and re-located them in the heart of the country, down leafy lanes, deep within ancient barrows and along the routes of old pilgrim-paths.

Perhaps what surprised me the most was the range of emotions ghosts inspire. Those we invent do not always set out to frighten us – although some do, very effectively: in 1669 Samuel Pepys admitted to his diary to being 'almost afeared to lie alone' after an evening spent telling ghost stories with his friends.[5] Other ghosts console us, bolster our spirits in the dark days of occupation or war, or, satisfyingly, dole out justice to wrongdoers. Most of us have

a sincere desire to see a ghost, even though we know it would frighten us. How would such a sighting make us feel? Exhilarated, privileged; in close touch with the past. The artists and writers who find new and inventive forms for them in their pictures and stories appeal to our emotions as much now as their predecessors did.

Is the British weather particularly conducive to the idea of ghosts? Do the mists, fogs and rains of our climate play on our imaginations, suggesting uncanny presences out there in the murky darkness? We have, it seems, always told ghost stories to one another. In medieval and early modern Britain, in what were primarily agricultural communities, most work was done in the hours of daylight, and in the autumn and winter evenings people closed the door against the darkening afternoon and sat by the light of the fire, whiling away the time in telling tales. Ghost stories are, and always have been, tales of the people, treasured, told and elaborated from one generation to the next. 'Nothing is commoner in *Country Places*,' noted one observer in 1725, 'than for a whole Family in a *Winter's Evening* to sit round the Fire, and tell Stories of Apparitions and Ghosts.'[6] 'Thus dames the winter night regales / Wi wonders never ceasing tales' was how the Northamptonshire poet John Clare described a 'cottage evening' in January in his *Shepherd's Calendar* of 1827.[7] And while he took a largely sensible, rational view concerning the existence of ghosts, Defoe was careful to advise caution, acknowledging that there was a baby in the bathwater:

> if we give up all the Stories of Ghosts and Apparitions, and Spirits walking, to discover Money that is hid, we shall lose to the Age half the good old Tales, which serve to make up Winter Evening Conversation...[8]

These days we are more likely to buy collections of ghost stories than to repeat old family tales – although some of us continue to do that, too. Many of these published stories are organised by region, local ghosts naturally having more flavour than far-flung ones, and are made to be read aloud and enjoyed by a little group gathered around the fire on a winter's evening, curtains drawn against the dark. The stories might evolve over time, but the impulse remains constant.

I heard my first ghost story when I was ten years old, one morning in school assembly, all of us sitting cross-legged on the floor. Our headmaster told us how, cycling into school through our Derbyshire village, he had seen his father and instinctively waved a greeting. But then he remembered: his father was dead. This has the hallmark of the classic ghost experience – the mundane normality of the encounter, and the absurdity of that second before the mind catches up with the eye. His tale took root in my mind that day – perhaps it did in the minds of all the children sitting in that hall – and ever since I have known the power of a ghost story not only to create a frisson, but also to make us look at the world in a different way.

I have never met anyone – or perhaps I should say any British person – who didn't have a ghost story of some kind to tell. Even the sceptical cannot resist recounting a tale of the strange and uncanny, even when the telling is hedged about by disclaimers: 'I don't believe in ghosts, but...' In the course of researching this book people have told me countless stories, a whole spectrum ranging from small but unaccountable phenomena to genuinely frightening experiences. This is why I wanted to write this book. Ghosts are something we share; they are perhaps even an intrinsic part of what it is to be human.

I have also been struck by the degree to which our architectural heritage is bound up with ghosts. As Noël Coward observed in 1938, 'The Stately Homes of England / Though rather in the lurch / Provide a lot of chances / For Psychical Research'.[9] These days it is hard to find a National Trust house that is not equipped with a haunted room. Ham House, just to the west of London, harbours one of the most high-profile, aristocratic ghosts, being said to be haunted by the formidable Duchess of Lauderdale; politically astute, wealthy and influential in life, she would indeed be a ghost to be reckoned with. The Trust offers special ghost-tours of Ham, during which visitors are instructed to listen for her footsteps on the stairs and to be on the alert for the smell of her rose-scented perfume. In fact, the commercial potential of ghosts has long been realised. Joseph Addison's play *The Drummer, or the Haunted House* (1716) begins with lines spoken by the enterprising butler:

There came another coach to town last night, that brought a Gentleman to enquire about this strange noise, we hear in the house.

This spirit will bring a power of custom to the *George* – If so be he continues his pranks, I design to sell a pot of ale, and set up the sign of the Drum.[10]

As Addison realised back in the early eighteenth century, a resident ghost is gold dust for any pub, hotel or stately home, adding a lucrative dimension of the supernatural. These days pubs and restaurants advertise their haunted status. The Golden Fleece in York (the city's 'Most Haunted Pub', according to their website), and Rye's Mermaid Inn, are neck-and-neck at the top of the league, each boasting no fewer than five resident spirits. The last time I went into the Morpeth Arms near Tate Britain, the site of the old Millbank Prison, the management were screening live footage in grainy black and white from their basement, the vaults of which were once used as a temporary prison for convicts. If a ghost did put in an appearance that evening, however, it went unnoticed by the cheerful groups of after-work drinkers. These resident ghosts are generally of the non-malicious sort – not the kind likely to spill our drinks or to throw pots and pans at us during our tour of the kitchens, but picturesque apparitions that we would be thrilled to glimpse. Ghosts – if they cannot exactly be described as living history – certainly personify our shared past by replaying it. They are so valuable to us because they are externalised memories, reminding us of the layers of history beneath our feet, of the old stories that refuse to be erased.

In the chapters that follow I have usually employed the word 'ghost' because it is now the most generally accepted name, but occasionally substituted 'spirit', 'apparition' or 'spectre' where it made the point more effectively or prevented repetition. Some of the writers I discuss here, however, have preferred to use particular terms and to avoid others. The word 'apparition', for example, was usually favoured by 'serious' authors of the Restoration and Enlightenment periods – as opposed to writers of entertaining ballads and pamphlets – because, to contemporary ears, 'ghost' had a ring of rusticity, if not of downright vulgarity. These are telling uses of language – what ghosts were called at different periods can tell us a great deal about how people understood

them. Ultimately, however, writers were describing similar phenomena, whatever words they used. In most cases, the word 'ghost' now does the job very well.

The rich variety of ways in which artists and writers have interpreted and invented ghosts is an important part of the story I unfold here. While on the whole I have based my choice of material on the traditional view that a ghost is the spirit of a person who was once alive and which returns and makes its presence felt in some way, I also admit a range of other ideas, and even within my own basic terms I offer a lateral interpretation. Saints who return to perform miracles, or who are otherwise spurred into posthumous action, are included. The ambulant skeletons painted onto the walls of churches in the fourteenth century – the 'Three Dead' – are treated as a variety of ghost because they tell the 'Three Living' so plainly that they, too, were once living men.[11] That is their point. They are not coolly allegorical like the capering figure of Death in the *danse macabre*: he was never alive. As spirits of men who have died and come back to tell the tale, the Three Dead possess the essential component of humanity. Folkloric characters such as elves and fairies, however, and nature-spirits like white ladies, are excluded on the grounds that they are separate categories of supernatural being without the vital human element that ghosts possess. It is precisely this ingredient – that ghosts are people of sorts, humanity's shadows, but at the same time utterly remote – that accounts for the enduring fascination they exert.

In writing this book I have kept this human element in mind. And while the chapters that follow introduce many ghosts (of the past as well as the present), they also take us into the worlds of successive artists and writers who have wondered about, described, depicted and invented them.

I

The

LIVING

and the

DEAD

In maner of a dyaloge it wente

ANON., 'A DISPUTATION BETWEEN
THE BODY AND THE WORMS'

I. SAINTS, BEASTS AND SILVER SPOONS

3 February in the year 1014. At Gainsborough in Lincolnshire, the
Danish conqueror Sweyn Forkbeard saw a sight that astonished him:
the former East Anglian king, St Edmund, armed and advancing towards
him. The terrified Sweyn, mounted on a stallion, shouted to his troops
who were stationed around him, crying: 'Help, fellow-warriors, help!
St Edmund is coming to kill me!'[1] But none of his warriors could see
Edmund, who was able to approach the king and to attack him fiercely with a
spear. Sweyn, in great pain, fell from his horse and died that day at twilight.
St Edmund, who had been murdered in 869 by Danish invaders, had appar-
ently returned from the dead with a regicidal mission. Few acts of revenge
can have been left to cool for as long as this.

This account was written in the first half of the twelfth century by
an English monk, John of Worcester, and was one of many re-tellings
and embroiderings of the posthumous miracles of St Edmund, the earli-
est collection of which was written around 1095 by Hermann, an East
Anglian archdeacon.[2] According to him, St Edmund's intervention at that
particular time was the direct result of an appeal to the saint made by all
the people of East Anglia, distressed by Sweyn's outrageous demands for
an enormous tribute from Bury St Edmunds, where the saint's body lay.[3]

Among the earliest illustrated biographies of the saint is *The Life and
Miracles of St Edmund*, which dates from around 1130 and is now among the
treasures held in the Morgan Library in New York (*fig. 1*). One of the minia-
ture paintings in this gorgeously illustrated volume depicts the moment of
supernatural spectacle. The artist shows Sweyn not on a horse but, as he is
described in variant accounts of his death, tucked up in bed. He lies under
a colourful bedspread (though still wearing his crown), while St Edmund,
vivid against a blue background, springs light-footedly into his chamber,
thrusting his lance into the king's chest. The composition is evenly
balanced, the principal part divided into two arched fields. The deep blue
of St Edmund's left-hand section suggests distance or eternity, while Sweyn's

green right-hand section represents the domestic sphere, a bed-chamber hung with white curtains, from behind which three frightened-looking men peer, evidently unwilling to risk attracting St Edmund's attention. Each king moves into the other's space: just as Sweyn's lower legs and feet project into the blue section, implying his imminent entry into eternity, so the tip of Edmund's spear and his left hand, holding a moneybag, protrude into the domestic chamber as the supernatural encroaches into the everyday. Edmund's slender lance not only pierces both the king's half of the composition and his body; at its other end it extends out beyond the decorative frame and border where it strays into the undecorated margin, as though this uncanny object does not quite know where it belongs.

The timing of the earliest accounts of St Edmund's miracles is significant, written as they were so soon after the trauma of the Norman Conquest in 1066. Many Saxons in late eleventh-century England must devoutly have wished for protection by their old saints from their new oppressors. Sometimes this was expressed indirectly. One tale popular at that time, later written down by the twelfth-century historian William of Malmesbury, concerned Saint Edith of Wilton (*fig. 2*), who had died around 984 but was roused to posthumous action by an insult. In 1020, during a visit to her resting place at Wilton Abbey, Cnut, the son of Sweyn Forkbeard, began to make disparaging comments about Edith's status as a saint on the grounds that her father, King Edgar, was a 'vicious man, an especial slave to lust, and more tyrant than king'. Continuing to make 'taunts like this with the uncouthness characteristic of a barbarian', he demanded that Edith's tomb be opened so that it could be seen whether her body remained uncorrupted – a sure sign of purity and sainthood. He got more than he bargained for: as he was peering into her grave, she sat up and struck him.[4]

Another story, concerning St Æthelthryth (also known as Etheldreda) dealt directly with the more recent invaders. This seventh-century Anglo-Saxon saint had been Abbess of Ely, which, following the Norman Conquest, had harboured anti-Norman dissidents. During the English revolt against the Normans in 1070–1, the rebels swore an oath of loyalty on St Æthelthryth's relics and regarded her as their special patron.[5] When at this time a Norman, Gervase, was thought by the monks of Ely to be oppressing the monastery and hostile to the religious community, 'everyone who was for whatever reason oppressed by him, confronted him

with the name of the lady saint'. Evoking St Æthelthryth's name, however, did not at first appear to be effective and, undaunted, Gervase 'would put one in fetters, pronounce condemnation on another, keep calling another to court', and so on. But when the Abbott himself was summoned to appear in court before Gervase, matters came to a head. That night:

> St Æthelthryth appeared in the form of an abbess with a pastoral staff, along with her two sisters, and stood before [Gervase], just like an angry woman, and reviled him in a terrifying manner as follows: 'Are you the man who has been so often harassing my people – the people whose patroness I am – holding me in contempt? And have you not yet desisted from disturbing the peace of my church? What you shall have, then, as your reward is this: that others shall learn through you not to harass the household of Christ.' And she lifted the staff which she was carrying and implanted its point heavily in the region of his heart, as if to pierce him through.

Gervase disturbed his household with his 'terrible groaning and horrible screaming' and his cries of 'Lady, have mercy! Lady, have mercy!'[6] And, with that, he died. St Æthelthryth had finally had enough – and for a long time afterwards, the story of her post-mortem return was enough to protect Ely's religious community.

But what about the other side of the coin? Not all those who returned from the grave came to fight on the side of the oppressed. In the twelfth century, remarkable accounts began to be written that described 'revenants' – a name derived from the French word *revenir*, to return. They too were tangible, corporeal presences; but this species of return was definitely not regarded as miraculous. These dead refused to stay in their tombs and insisted on climbing out and stalking back to their towns and villages, night after night, to attack the living. But what was the background to these stories? Had generations of people looked out fearfully towards the wild, lonely places – the marshes, the moors and the misty hills – and shuddered at what their imaginations conjured up, glad to close their doors and to reach the safety of the hearth?

The idea of something not quite human lurking malevolently out there in the darkness is buried deep within our collective imagination and has a long history. It is at the centre of the greatest surviving Old English poem, *Beowulf*, the text of which is preserved in a single medieval manuscript now in the British Library. *Beowulf* tells a story that was, to the late tenth- or early eleventh-century scribe, already as old as the hills. It was probably composed in the eighth century, but it tells of a Scandinavian prince of some two centuries earlier who had crossed the sea to Denmark with a band of warriors to fight Grendel, a man-eating monster who was tormenting the Danes. Grendel cannot strictly be described as a ghost, because he has not returned from the dead, but he has some decidedly ghostly features, and descriptions of him share common elements with later accounts of revenants.

At the beginning of the poem we are taken to Heorot, a magnificent mead-hall. This venue – 'hart's hall' – represents fellowship and harmony, a special place where men gather together to eat and drink, to tell and to hear stories. Accompanied by a harp, a minstrel sings of God's creation, of how He 'set up in triumph the radiance of sun and moon as light for those dwelling on land, and adorned the corners of the earth with branches and leaves'.[7] The scene is set – the gathering by firelight inside, doors shut against the cold and darkness outside. The Beowulf poet then describes Grendel as one who lives in darkness in his lair of marsh and fen, a far cry from the decorative, radiant landscape celebrated in the minstrel's song.[8] Grendel makes his first devastating attack when he is angered by the music he hears from Heorot, its intrinsic order and harmony at odds with the darkness and disorder he represents.

But what kind of creature is Grendel? He is certainly a monster: he wields an overwhelming muscular force, and is eventually dispatched in a very physical way, when Beowulf tears off his huge arm. The Beowulf poet uses epithets that suggest a more complex being, however. He introduces Grendel as a '*grimma gæst*', when *gæst* in Old English meant spirit, and was a word that could be used in the context of the Holy Spirit or an individual soul. It could also mean an angel, or a demon; but, equally, it could signal the concept of a supernatural being more like a ghost. Grendel is further described as a '*deorc deathscua*', a dark death-shadow, which suggests not a solid figure but a shifting and insubstantial fog. His manner of approaching Heorot is also odd. We might expect the land to shake under a giant's

heavy tread, but Grendel is described as a *'scrithan sceadugenga'*, and while *'sceadugenga'* means walker in darkness, the word *scrithan* denotes a gliding movement. There is the suggestion that in his own territory he has the ability to be as vaporous as the *'mistige moras'*, the misty marshes in which he dwells. For all Grendel's fabled physical strength and his violent nature, for all his monstrousness, he possesses an additional dimension of the uncanny; he is a dreadful, half-glimpsed being we would not be surprised to encounter in the pages of M.R. James or Robert Aickman. In all essential aspects – his appearance in darkness, his shadowy form, his gliding motion and his penchant for disrupting human affairs – Grendel can be seen as a proto-ghost.[9] Considering how central the ghostly figure would be to the British imagination as the centuries unfolded, his place in such an important early literary work is fitting.

When in the final years of the twelfth century the Yorkshire canon William of Newburgh sat down to write his great work, the *Historia rerum Anglicarum* or history of English affairs, he did not think it amiss to record *'prodigiosa'* – unnatural marvels – alongside political events of the previous hundred years or so. William was only interested in reliable sources; and although it seemed odd to him that the dead were said to walk, it was because there were so many believable accounts that they deserved a place in his chronicle:

> That the corpses of the dead, moved by some kind of spirit, leave their graves and wander around as the cause of danger and terror to the living before going back to tombs which open up to receive them, is not something which would be easily believed, were it not for the fact that there have been clear examples in our own time, with abundant accounts of such events.[10]

As a chronicler, William naturally wanted to put these accounts into some sort of historical context. Had corpses always got up out of their graves and gone on the rampage, menacing their family and erstwhile neighbours, he wondered? He thought not. He describes how he had searched for earlier stories of the dead returning to menace the living, but without success: 'Nothing of the sort is reported in books of former times', he wrote. And surely, he continued, 'since these ancient books recorded the everyday

and matter-of-fact events of former times, they would not have been able to suppress accounts of stupefying and horrible events if indeed they had occurred'. William concludes that it must be a recent phenomenon. Indeed, it was something of an epidemic: contemporary accounts were so abundant, he complains, that 'it would be extremely tedious for me to have to write down all those things I have heard of which happened in our own times'.[11]

Could it have been, however, that in the past the clergy had suppressed accounts of these 'stupefying and horrible events'? They were, after all, the scribes; it was they who controlled what was included in histories, and what was left out. And ghosts were not entirely absent from earlier writings: the Venerable Bede, of whose work William approved, occasionally referred to supernatural visitors in his *Historia ecclesiastica gentis Anglorum*, or *Ecclesiastical History of the English People* (completed in 731), but his ghosts were special envoys sent from heaven – a much more respectable class of revenant.

On the face of it, William's life was a highly circumscribed one, spent within the community of the Augustinian priory of Newburgh in the lonely hills of North Yorkshire. And yet he spoke with men and women in different parts of the country when he made visits to other regions, and it was from them, it seems, that he got to hear about supernatural goings-on. One story concerned a ghost that appeared in Buckinghamshire – he remarked that he 'was first told about it by the people of the neighbourhood, and afterwards more fully by Stephen, a venerable archdeacon of that district'. A man died, and was buried 'with full customary rights'. However:

> the very next night he entered the bedchamber of his sleeping wife. She woke, greatly afraid, as he attempted to lie upon her in the marital bed. The same thing happened the next night, and on the third night the terrified woman struggled with her dead husband yet again before arranging for some of her family and neighbours to stay awake on watch with her throughout the night. When the dead man came back, he was greeted by the alarmed shouts of the watchmen, and, unable to cause any more mischief, went away.[12]

How was one to tackle such a problem? There were, it was generally agreed, two methods, one secular and one religious; and both could be effective. In the case of the Buckinghamshire ghost, the church offered a solution when the man's family consulted an archdeacon and his assembly,

who took the story to the Bishop of Lincoln. The bishop was 'just as amazed as everybody else', but his advisors shrugged their shoulders and informed him – with impressive nonchalance – that 'such things had often happened in England', and vouchsafed that 'the usual remedy (which gave comfort and reassurance to a frightened community) was to dig up the body of whichever miserable person was causing the nuisance and cremate it'.[13] The bishop, however, looked upon this with some distaste, finding it 'both unseemly and sacrilegious'. He came up with a solution that was just as ritualistic – and presumably reassuring to the public – but that replaced the savage gesture of pagan tradition with the lighter touch of Christian doctrine:

> he prepared a scroll of absolution and gave it to the archdeacon with the instructions that the dead man's grave should be opened, and the scroll placed on his chest, and the grave closed up again.

The deed was done, and it worked; the revenant 'never wandered again, and was kept from molesting and terrorising anyone else'. Another story William relates occurred in Berwick, where a wealthy man, who 'had been given over to sinful behaviour' died, but repeatedly rose from his tomb and wandered through the town, accompanied by the sound of barking dogs. People worried that he might attack them if they ran into him, and also that, as a walking corpse, he would contaminate the air and bring sickness to the town. They took matters into their own hands, assembling ten strong young men 'who dug up the offending corpse, dismembered it and burnt the pieces in a fire'.[14] The ghost was seen no more; but according to William they had been sadly right about the risk of contagion, which affected the town badly and killed a great many.

We begin to hear people's voices here, speaking through William's own. Their stories reflect a community's fear of attack by violent outsiders and their anxiety about the rapid spread of disease as well as a deep-seated superstition that the dead can return. It was a problem that at least had an obvious solution: the scapegoat-revenant could be dealt with one way or another, the trouble dispelled and the proper order of things re-established. But how did these stories come about, and how much did they owe to traditional tales? There are echoes of Grendel, of course, in the implacably violent intentions of revenants as well as in the

insistent nature of their attacks; but perhaps a closer association is with the *draugr*, or undead corpse, of Icelandic Sagas. *Grettis Saga*, for instance, tells of a shepherd called Glam who was widely disliked, and who met a violent end. After his death and burial under a cairn of stones, however, he went on a murderous rampage, damaging property and terrifying people. The hero Grettir eventually severed his head from his body and laid it between his thighs, before he was burned and his ashes buried far away from man and beast.[15] *Eyrbyggja Saga* also has a *draugr*, Thorolf Halt-Foot, who died of rage and who wandered around with other revenants; and *Laxdaela Saga* has the unregenerate Hrapp: 'Difficult as he had been to deal with during his life, he was now very much worse after death, for his corpse would not rest in its grave'.[16] Had this concept, so highly developed in these sagas, travelled to England and given particular shape to an existing set of fears? Or was the idea that corpses might leave their graves and come back to attack the living a universal one? We cannot know for sure. But to the men and women of Buckinghamshire, Berwick and all the other places these things were said to have happened, the stories that feverishly circulated of recently buried individuals getting up out of their graves must have been hard to dismiss as they bolted the doors of their houses at nightfall.

What such stories recorded by William of Newburgh and others had in common was the conviction that the revenants described had died 'bad' deaths: one of them had lived a 'sinful' life, while another was guilty of 'poor conduct'; with the implication that they had died unrepentant.[17] Their moral failings separated them from their communities, leaving a door open through which they could embark on a violent post-mortem career. Two centuries later, the ghosts of men and women still appeared to the living; but developments in Christian thought that had, in the intervening years, re-drawn the map of the afterlife, changed both their reason for doing so and the manner in which it was done. What necessitated a re-think was the concept of purgatory, which had been relatively new in the late twelfth century but was by around 1400 firmly established.

How purgatory worked is vividly illustrated by a teaching aid created in the fifteenth century for the instruction of novitiates in a monastery. In the right-hand margin of a poem, under the heading 'Of ye relefyng of saules in purgatory', the artist has drawn a fiery pit at the bottom of the

page (*fig. 3*). Bright flames rise up around the poor naked souls who raise their hands and open their mouths in anguish. But what distinguishes it from hell – apart from the helpful label 'purgatory', written just below – is that here, there is hope: just above the suffering souls, close enough to be licked by the tallest flames, some of their contingent, squashed together in a wooden barrel, are being winched up to heaven. There, at the top, is the heavenly city represented by a crenellated tower, with God the Father in the centre making the sign of peace. Hoisting the purged souls upwards via a pulley set into heaven's wall is a priest at the altar, celebrating Holy Communion. Below him, holding on to the end of the rope, a monk gives alms to two raggedly dressed men. And to make the point abundantly clear, on the right is an inscription noting that these souls are being released from purgatory by dint of prayer and alms-giving.

It is this framework of belief that shaped some of the strangest medieval ghost stories to have survived – those which were told by ordinary men and women and perhaps even written in their own words. Around 1400, a Cistercian monk at Byland Abbey in Yorkshire had to hand a manuscript volume dating from the late twelfth century that combined tracts by the Roman author Cicero with various theological texts. There were some blank pages both in the body of the book and at the end, which he decided to fill with tales that local people had told him of supernatural encounters.[18] Astonishingly, the book survived the abbey's dissolution, was acquired by a seventeenth-century antiquary, and later found its way to a London bookseller before being bought by Charles II; it eventually arrived in the British Museum along with the contents of the Old Royal Library, presented in 1757 by George II. As far as we know, what the monk had written in the interstices of the text was more or less ignored until 1922, when – in an episode worthy of one of his own plots – the manuscripts scholar and author of ghost stories M.R. James noticed a brief description of the tales in a scholarly catalogue that 'may well', he noted, 'have excited the curiosity of others besides myself'.[19] He transcribed the monk's Latin and published it in an academic journal as 'Twelve Medieval Ghost Stories'.[20]

Most of the stories are, in James's phrase, 'unduly compressed' and somewhat gnomic as a result, but in his opinion they 'evidently represent the words of the narrators with some approach to fidelity'.[21] Most are set in the environs of Byland Abbey itself, the remains of which lie a few miles north of Newburgh Priory in North Yorkshire, and recount strange

experiences people had as they went about their business. The first tale tells of a man riding home with a pannier of beans. His horse stumbled and fractured its leg, whereupon the man shouldered his sack of beans and continued on his way. But he was stopped in his tracks by a sight that terrified him: what seemed to be the 'phantom shape of a horse rearing up on its hind legs and striking into the air with its front hoofs'.[22] The man invoked the name of Jesus Christ and forbade the phantom to harm him, at which point the horse began to follow him. A little further on, the ghost tried another tactic to get the man's attention – it appeared in the form of 'a whirling heap of hay, with a light shining in the middle of it'. Again the man addressed it, saying: 'Begone, whatever or whoever you are that wishes me ill!' The ghost finally appeared in human form, which gave it the power of speech; it 'addressed him with a solemn oath, giving its name and the reasons for its distress'. Anxious to be given some helpful task to perform, the ghost then said: 'Permit me to carry your load of beans and help you in some way', and carried the sack as far as the river. The sack was then by some means – though the man admitted he was not sure how – replaced on his own back. Later, the man 'made sure arrangements were made for masses to be sung so that the spirit which had appeared to him might be helped and absolved'.

One of the simplest and seemingly most didactic tales tells of a man walking through the fields with his head ploughman when he was suddenly accosted by the spirit of a clergyman who attacked him, tearing at his clothes. When the man overcame the spirit and persuaded it to reveal who it was (presumably by the tried-and-tested technique of invoking the name of Christ), the spirit admitted that it was a certain Canon of Newburgh who had been excommunicated for stealing some silver spoons. The spirit begged the man to go to Newburgh, report the matter to the prior and ask him for absolution. The spoons were found, absolution was granted and 'the spirit rested in peace thereafter'.[23]

The most highly developed of the Byland monk's stories describes the uncanny experiences of a tailor called Snowball. One evening, as Snowball was riding home on the road from Gilling to Ampleforth, he heard a strange sound, rather like the splashing of ducks in a river, and, looking up, saw what seemed to be a crow whirling overhead. As he watched, it tumbled to earth and lay on the ground trembling. When he got closer he saw that sparks were flying out from its sides.

Realising that it was some sort of spirit, Snowball crossed himself, saying, 'I forbid you, in the name of God, to do me any harm.'[24] At this, the crow-shape shot off with a terrible shriek and came to rest about a stone's throw away. Snowball decided to continue on his way, but the crow came forward and attacked him, knocking him to the ground. At this point Snowball drew his sword and fought with the creature, and again when he invoked the name of God, the crow wailed and hurled itself a greater distance away. Approaching it again, this time holding the hilt of his sword against his chest to form the sign of the cross, Snowball saw that his adversary had transformed itself into a chained dog. This time he commanded it to speak in the name of the Trinity and the blood of the five wounds of Jesus Christ. Thus compelled, the spirit spoke, explaining that in life it had committed crimes and was suffering in purgatory, and asked Snowball to find a priest in order to obtain absolution for it. The story at this point goes into detail about the spirit's requirements in the form of masses and prayers. When the tailor had obtained a written absolution, he buried the scroll containing it in the man's grave. He then kept an appointment he had made with the ghost, armed not only with the gospels and other sacred texts but also, for good measure, with reliquaries that he placed in the form of a cross. The spirit then appeared to him again, first in the form of a goat, and then as the decomposing corpse of a man, and said, 'God be praised ... You may know that next Monday I and thirty others will enter upon eternal joy'.[25]

One of the most intriguing aspects of these stories is the variety of guises in which ghosts were said to appear – as a horse, a whirling heap of hay, a crow, a dog. In another story one makes itself known with a terrible shrieking sound (perhaps this is the source for James's screaming ghost in 'A Neighbour's Landmark', 1924). It later turns into a square piece of canvas that rolls around. These shape-shifting spirits seem intent on getting a purchase on the physical world in any way they can in order to attract attention before, in most cases though not all, gaining access to human form so that they are able to communicate their predicament – that they are souls suffering in purgatory needing to ask the living to take action by organising prayers, masses and absolution for them in order to secure a speedy transfer up to heaven.

These tales still resound with the emotions of astonishment and fear felt by the hapless people to whom uncanny things happened. But why did the anonymous monk record these tales? Was it because he was genuinely

fascinated by the details of these intrusions of the dead into the natural world? He was evidently a trusted ear in the local community outside the abbey's walls. Did he record the tales more or less as they were told to him? Or did he re-work local superstitions and folk tales until they functioned as *exempla*, stories designed to instruct and to point a moral? Whether the religious framework common to the tales written down by this monk was intrinsic to the stories actually recounted to him, or whether he elaborated nuggets of folklore into exemplary stories warning against the dangers of a sinful life and providing evidence of the horrors of purgatory, we cannot be sure. But the idea that spirits were able to take on the physical forms of certain animals and inanimate objects has the ring of real folk belief, and indeed the phenomenon of spirits appearing in animal form long outlived the medieval period; in 1725 the antiquary Henry Bourne recorded that herdsmen would often speak of having seen '*Spirits* in the Shapes of *Cows* and *Dogs* and *Horses*' (although as a man of the Enlightenment he dismissed it as 'either *Hearsay*' or as evidence of 'a *strong Imagination*').[26] Whether the monk put a doctrinal spin on the stories or not, they give us a rare insight into the way people at the end of the fourteenth century living outside the cloister looked at the world – and the place of ghosts within it.

2. 'SUCH SHALL YOU BE'

Push open the door of St Andrew's Church in the remote hamlet of Wickhampton on the edge of Halvergate Marshes in Norfolk. Your eye is caught by paintings on the wall opposite: right there in your line of vision are three grinning skeletons, each taller than the height of a man (*fig. 4*). Turn to step inside, and there, in front of you, are three further figures, again more than life-size: a party of young noblemen out for a day's hunting. One wears a gauntlet and carries a hawk on his wrist; they are all elegantly dressed, wearing close-fitting doublets and stockings that display their shapely legs and fashionably pointed shoes. A smaller attendant, now faded and indistinct, accompanies them, while, to the left, a hound starts after a hare that has just broken cover. Is it this sudden movement that causes two of the three noblemen to turn and look back? At this moment they catch sight of the ghastly vision. Each of the grisly apparitions turns his skull towards the noblemen, and two raise bony arms to greet them.

Painted in the second half of the fourteenth century, this mural depicts a subject that came to be known as The Three Living and The Three Dead.[27] The contrast between these two opposing groups at Wickhampton could, on the face of it, hardly be greater. The skeletons stand stiffly, planting their large bony feet wide apart and holding their arms out awkwardly from their sides, a clumsy stance that throws the noblemen's elegant poses into sharp relief. But despite the confrontation between the grotesque and the graceful that makes the painting so arresting, the skeletons are, in a profound way, the noblemen's doubles. They are meant to be understood as truth-telling mirrors: on this side lies life, beauty and pleasure, while on the other side – the dividing line provided here by the central blasted tree – lies death, that no one can escape, and that strips every man and woman of clothes, flesh and all earthly concerns. The Latin words once inscribed on the scrolls hovering above the heads of the skeletons are now illegible, but, back in the fourteenth century, whether you were a prosperous merchant or an illiterate peasant, the message broadcast to you would have been resoundingly clear: death comes to us all, so you had better prepare yourself.

Although they are still undeniably striking, today the paintings at Wickhampton are shadows of what they once were. At some point in their history, they, alongside other medieval paintings in the church, were painted over. They were uncovered in 1851, and a detailed drawing was made as a record, only for the paintings to fall victim some years later to Victorian sensibilities: for the second time they were covered with a discreet veil of paint. When the lime-wash was removed in the early twentieth century, much detail was lost with it.[28] Even so, this painting has fared better than some of its contemporaries. Taste for the macabre began to wane after the end of the seventeenth century, and it is perhaps unsurprising that – in the case of those that survive at all – while the halves of the paintings representing the living have been left intact, the painted dead have often been obliterated by later accretions or by architectural remodelling. At St Peter and St Paul in Heydon, Norfolk, an elaborate commemorative tablet has been fixed over the section of the wall featuring the three dead, leaving only two grotesque corpse-heads peering incongruously over the top, while the sinuous tail of a snake, presumably originally lodged in an eye-socket, is nearly all that is left of the third. Head back eastwards and you reach Seething, where a similar painting was

also sited opposite the church door; in the nineteenth century a window was cut into the wall, obliterating two of the dead. The one surviving corpse is now blurred and indistinct, but it is still just possible to make out a withered arm raised in greeting. As at Wickhampton, the gesture is directed towards the three living in the painting; but, surely, it applies equally to you and me as we enter the church. To a person walking into the building in the second half of the fourteenth century, when the paint was fresh, these walking corpses and skeletons must have been terrifyingly vivid presences, always waiting there, ready to impart their grim message.

The Three Living and The Three Dead were not only emblazoned on church walls; they also lurked among the leaves of illuminated books. They are there in a richly decorated psalter now in the British Library (*fig. 5*), created around 1310 and given by the Bedfordshire baron Robert de Lisle to his daughter Audere, a nun.[29] But while the Wickhampton artist chose to represent the three dead as skeletons because the contours of their bones and toothy skulls made bold, graphic images that could be read from a distance and in dim light, the artist who created this image knew that it would be studied at close quarters, and he took the opportunity offered by the intimate scale to make greater play of the three dead's decomposing bodies. He painted each of the three in a different stage of corruption. The corpse on the left has fragments of a tattered shroud clinging to its bones, but it has mostly rotted away, and worms writhe in its belly. The middle corpse is draped in a ragged shroud that covers its head, and is the most animated of the three; it places a bony hand on its companion's shoulder, and bows its head as though in grief. The third is in the most advanced state of decay; it has no shroud and is reduced to a skeletal figure, with a gaping cavity from pelvis to sternum, standing squarely facing us as though candidly exhibiting the full extent of its wretchedness, its expression fixed in a grin. The three living men are kings, each wearing a crown picked out in gold. Their expressions are exquisitely drawn as each responds to the encounter, and in a touching gesture the right-hand king reaches back to clutch his friend's hand, while transfixed by what he sees. The hawk perching on his other hand looks quizzically over its shoulder at the corpses. Each of the six figures speaks, not in Latin but in the vernacular: 'I am afraid', says the first king. 'Lo, what I see!', exclaims the second. 'Methinks these be devils three', declares the third. The dead reply: 'I was well fair', says the first;

'Such shall you be', warns the second, while the third exhorts the kings, 'For God's love, beware by me'.[30]

The brutally gruesome imagery of the three dead seems at odds with the precious vellum volume and its fine illuminations. Unlike the wall paintings, the rich colours of this drawing have been protected from the light so that the pigments sing out, as bright and fresh now as when they were first applied. Would Audere have found it shocking to turn the pages of this luxury codex, with its images illustrating the life of Christ and elegant theological diagrams, and to come upon walking corpses? Or was the medieval frame of mind, especially that of a nun, accustomed to the contemplation of mortality? The shocking encounter depicted was certainly designed to provoke soul searching.

Memento mori, reminders that we all must die, were part of the cultural fabric of the fourteenth century. And after the overwhelming catastrophe of the Black Death, which between 1348 and 1349 killed roughly a third of the population of the British Isles, the Three Living and The Three Dead became increasingly popular as a subject for church wall-paintings as, to a greater extent than before, people were urged to live with one eye on their own mortality.[31] The Three Living and The Three Dead was perhaps a precursor of the *danse macabre*, those series of prints in which Death, in the form of a skeleton, capers about among people of all walks of life. But in comparison with most representations of clean-boned Death, the three ghostly dead are physically repulsive. They were meant to be: their job was to shock people out of their sinful ways.

The meaning of The Three Living and The Three Dead, wherever it was encountered, was plain: no matter how wealthy you are, and how richly you dress – and the three living are always nobles, princes or kings, decked out in their finery – one day you will die. It was a moral lesson, designed to remind the viewer, or the reader, of the emptiness of worldly pleasures, the dangers of pride, the transitory nature of beauty and – above all – the pressing need to prepare for death and judgement. For the congregations of Wickhampton, Heydon, Seething and all the other churches where the three grotesque ghosts looked down at them from the walls, and for Audere de Lisle browsing through her decorated psalter, their presence was inescapable.

The church placed great weight on teaching through images. It was a position that had been given the *imprimatur* of Gregory the Great, who had remarked in a letter of 599 to the Bishop of Marseilles that 'a picture is provided in churches for the reason that those who are illiterate may at least read by looking at the walls what they cannot read in books'.[32] And of course most medieval people would have encountered relatively few images outside the context of the church – so, when they did, the visual impact of these pictures would have been all the greater, and more likely to influence their thoughts. In his poem *The Regiment of Princes*, the early fifteenth-century poet Thomas Hoccleve remarked on the power and efficacy of such paintings:

> The ymages that in the chirches been
> Maken folk thynke on God and on his seintes
> Whan they the ymages they beholde and seen,
> Where ofte unsighte [lack of seeing] of hem causith restreyntes [hindrance]
> Of thoghtes goode. Whan a thyng depeynte [painted] is
> Or entaillid [carved], if men take of it heede,
> Thoght of the liknesse it wole in hem breede [nurture].[33]

But how did people really feel about these 'ymages'? To a hard-working peasant or anyone of the middling sort sitting on a bench waiting for the service to begin, less pious thoughts must occasionally have broken in upon meditations on the Almighty and His entourage. Did they, perhaps, reflect that these walking corpses seemed always to single out the grandest folk as they went about their aristocratic amusements, beautifully dressed and obediently attended – and not ordinary working people like them? Could these observers have quietly felt a grim satisfaction at the dramatic comeuppance of their betters?

An intriguing painting dating from the late fifteenth century can be found at the village of Sparham in Norfolk (*fig. 6*). St Mary's parish church contains a highly unusual representation of animate corpses painted on a wooden panel that originally formed the dado, or lower section, of a rood screen that separated the nave from the chancel. Rather than

an admonitory corpse shockingly confronting a living person, here the artist has depicted a couple. Male and female corpse-ghosts stand side by side in a flowery meadow, turning towards each other. They interact: he extends a bony hand towards her, perhaps having just given her the posy of flowers she holds in her right hand. They are dressed finely: the male corpse sports a floor-length fur cloak, a gold chain and a white hat with a jaunty feather stuck in the brim, while the female has on a low-cut dress, tightly cinched in at the waist and trimmed with ermine. With her left hand she lifts her skirt, displaying more of the rich fabric. A delicate, translucent silk mantle covers her chest, and she wears a gold pendant. They speak to each other, their words unfolding in elegant banners above their heads: '*Natus homo [de] muliere brevi de tempore parvo*', he says – [the life of] a man born of a woman [is] brief, of little span. '*Nunc est nunc non est quasi flos qui crescit in arvo*', she replies – now it is, now it is not, like a flower that blooms in a field.[34]

These are not terrifying corpses glowering ominously down from the wall like the three dead in other churches; far from it. Although particularly richly dressed, they would have resembled the kinds of figures to be found among a fifteenth-century congregation. Their position, on the dado of the rood screen – normally the location for more decorative images of angels and saints – also placed them right in amongst the throng.[35] These animate corpses are ambiguous – they are, of course, macabre, their lipless mouths open in wide toothy grins, the 'eyes' with which they look at each other really hollow sockets (and gouged at a later stage by iconoclastic vandals, making the effect even more gruesome).[36] Their hands are skeletal, and what we can see of their bodies shows them to be decayed corpses, skin stretched tautly over bones. Nonetheless, they are touching in their tender gestures towards each other – and even in death, they retain their individuality and humanity. Are these ghosts really meant solely to be moralising images, truth-telling mirrors reminding us of the skull beneath the skin? Or do they also convey a subtly different idea? Although this would, of course, run counter to the church's teaching, this couple could be interpreted as making a different sort of exhortation, sneaking it in under the cover of feigned piety: life is short, they seem to say; make the most of it!

When John Golafre died in 1442 at Fyfield in Oxfordshire, his passing was observed with one of the earliest examples of what would become known as a 'cadaver' or *transi* tomb. This double-decker affair featured dual effigies: at the top, the figure of Golafre arrayed in armour, the very picture of stony propriety; but beneath it, in an openwork tomb chest, he is represented again – this time as a semi-mummified corpse. His eyes have sunk into their sockets, the skin is stretched over his cheeks and neck, and his ribs stick out prominently. The grotesque spectacle, contrasting Golafre as a man of consequence arrayed in the trappings of power and authority with a poor everyman humbled and transformed by death, served – and still serves – to remind anyone standing in front of his tomb of his or her own mortality. It was a stark visual warning against pride and too great an investment in worldly matters at the expense of spiritual ones.

Golafre's message hardly needed a verbal accompaniment; his withered stone corpse told its own sobering tale. But for one poet writing in the fifteenth century, a *transi* tomb set off a train of thought that led him to imagine what a ghostly corpse and the worms that devour it would say to each other if they could speak. His poem 'A Disputation between the Body and the Worms' is included in a manuscript collection of verse, put together in the second half of the fifteenth century, that is decorated with lively illustrations (*fig. 7*).[37] The poet describes how, in a season of 'huge mortalitie' because of 'sondry disseses' including the plague, he enters a church and, having said his prayers, sees a new monument that he describes as a magnificent newly made tomb decorated with coats of arms. At the head of the poem an artist has represented the colourful monument, topped with the effigy of 'a fresche fygure fyne of a woman', as the poet describes it, dressed in the latest fashion. Below the structure, however, he has drawn the woman's decomposing body barely covered by its shroud, worms and toads busily nibbling whatever flesh remains on her bones. Directly below this gruesome image, the tomb's epitaph is inscribed:

Take hede unto my fygure here abowne [above]
And se how sumtyme I was fressche & gay
Now turned to wormes mete [meat] & corrupcone [corruption]
Bot fowle erth and stynkyng slyme and clay.[38]

Having contemplated this fine tomb with its gorgeous effigy of a well-dressed, attractive woman and read her epitaph, the poet then falls asleep. So absorbed is his mind with what he has seen that he has a dream in which the woman addresses the worms in a kind of extended, dramatised epitaph: 'In maner of a dyaloge it wente', he says. The woman begins by complaining indignantly:

'Wormes, Wormes,' this body sayd,
'Why do the thus, what causes thou me thus to ete?
By thou my flesche is horribilly arayed [disfigured],
Whilk [which] was a fygure whylom [once] freshe & feete [pretty],
Right amyabyll [amiable] & odorus & swete.'

On another page of the manuscript, the woman, in skeletal form but wearing an elaborate head-dress (*fig. 8*) – evidently loath to relinquish quite all of her beautiful clothes – is depicted standing on a little grassy platform. She gestures animatedly with her bony hands as she disputes, while four well-fed worms below balance on the tips of their tails and peer up at her as they listen intently to her argument.

The worms then have their say. 'Nay, nay,' they protest, 'we will not yet depart thee fro / While that one of thy bones with other wil hange'; in any case, it is only because they have no sense of smell or taste, they add, that they can bear to eat her 'orrybyll flesche'. They go on to explain that, in the end, they take possession of all flesh regardless of the person's former status: 'Be thou lord, lady, or hye [high] sovereign, / To powder & dust in tyme to come thou shall'. The woman eventually accepts the worms' argument and comes to regret indulging in the sin of pride to which her 'abowndant bewte [beauty]' had made her susceptible. Eventually she resigns herself to her situation in the grave: 'Lat us be frendes', she proposes; 'Let us kys & dwell to-gedyr evermore'.

Ghosts of the dead were familiar figures in medieval culture, their task to remind the living of another life to come. It was the vestigial humanity of these painted, sculpted and poetic spirits, their insistence on telling their earthly counterparts that they too were once living men and women, that made their messages all the more pertinent. The question was how you accepted the moral they conveyed – either with alarm ('I am afraid') or with acceptance: 'Let us kys'.

II

QUESTIONABLE

SHAPES

3. 'ARE THEY ALL GONE INTO *ITALIE*?'

The English Reformation had serious implications for ghosts. When religious reformers did away with the notion of purgatory and replaced it with the idea that after the death of the body the soul proceeded directly to heaven or hell, they struck a heavy blow at common ideas and expectations. Gone were purgatory's permeable borders, which occasionally allowed souls to slip through and find ways of communicating with the living. Henceforth, after the body's death the soul made a journey along a one-way street, whether it were up – or down. With their rearrangement of the afterlife, the reformers had, quite simply, tidied ghosts away as part and parcel of the unwanted old paraphernalia of Catholicism; if reformist rhetoric were to be believed, they simply vanished from the scene. As one clergyman, Robert Wisdom, put it in 1543, 'sowles departed do not come again and play boo peape with us'.[1]

Initially, the absence of ghosts was used as proof that the reformed, Protestant church, freed from mysticism and superstition, was a clean, modern machine, functioning well on its own doctrinal fuel. Members of the clergy expressed a certainty about the matter that bordered on bravado: 'Thankes to god,' exclaimed Wisdom, 'ever since the word of god cam in thei be nether herd nor senne.'[2] The Elizabethan Archbishop Edwin Sandys was just as sure, confidently asserting that 'the gospel hath chased away walking spirits'.[3]

But had it? Inconveniently for the reformers and contrary to their polemical rhetoric, ghosts continued to be seen in England, apparently unaware that they had been declared doctrinal impossibilities. But if ghosts were not the suffering souls of the dead, returning to beg early release from purgatory, then what were they? They became subject to a new degree of scrutiny – or, to put it another way, because ghosts did not officially exist, they had to be invented.

One of the most important literary attempts to account for ghosts' surprising persistence, *De spectris, lemuribus et magnis atque insolitis fragoribus*, was written by a Swiss reformed theologian, Ludwig Lavater, and published

in the Netherlands in 1569. Its English translation, with the more homely title *Of Ghostes and Spirites Walking by Nyght* (1572, *fig. 9*), was the first major treatise on the subject to be published in post-Reformation England. Although Lavater is careful to stress that in the new religious climate ghosts appeared less frequently than before ('Those rumblings of spirits in the night, are now muche more seldome heard than they have bene in times past'), he does acknowledge that, although it might not have worked in theory, it did in practice: 'Daily experience teaches us,' he writes, 'that spirits do appeare to men'.[4]

The man who translated Lavater's book into English, Robert Harrison, sums up the main points of the work in his pithy introduction: that many 'ghosts' were, in fact, optical illusions or products of overwrought minds; and that apparitions often interpreted as ghosts were actually good or evil spirits. The work will, he promises, be of benefit to credulous readers, who 'are most ignorant in this question, some thinking every small motion & noyse to be Spirites', and suggests that many experiences were in fact the result of 'franticke imaginations'.[5] However, he also explains that the book is addressed just as much to sceptics who are 'so fondly perswaded that there are no Spirits'. There was a lot at stake. The reformers were battling against entrenched habits of belief, and ghosts were puppets used on both sides of the argument. Lavater's book naturally carried a strongly anti-Catholic message, and Harrison did not scruple to resort to propaganda, asserting that the book would be 'disprofitable unto none, except perchance unto popish Monks and Priests, who are likely hereby to lose a great part of their gaines, which sometimes they gathered together in great abundaunce, by their deceitfull doctrine of the appearing of dead mens soules'.[6]

This charge was not left unchallenged, and a lengthy Catholic counter-blast to Lavater's book was published in 1588. The author, the French Capuchin Noël Taillepied, wrote in his treatise *Psichologie, ou traité de l'apparition des esprits* of the pressing nature of the subject. Matters concerning the 'Apparition of Ghosts and Disembodied Spirits' were not sterile doctrinal debate, he argued; on the contrary, the questions arising 'are daily debated not only among learned men and great scholars, but also by rustic and simple Folk in the common walk of life'.[7] And rather than being thin on the ground, as the reformers claimed, Taillepied insisted that ghosts appeared to men 'not unseldom', anywhere and at any time: 'by day as well as by night, on the high seas as well as on dry land, in the open country

and in houses', where they made 'horrid cracks and a vast hurly-burly'. In suggesting their ubiquity, Taillepied aimed to place them right at the centre of debate. They were everywhere: in the Bible; in classical literature; in authoritative historical sources; on the lips of men and women of all positions in society. You couldn't afford to ignore them.

Another complication was that ghosts were intimately connected in many people's minds with witchcraft, and had come to be understood as part of a spiritual hierarchy that included witches, angels, Satan and God Himself.[8] While many later writers quite naturally bracketed witches with ghosts, one particularly hardline Elizabethan commentator elected to discredit the whole notion. He was Reginald Scott, surveyor of the flood defences on Romney Marsh – and just as determined to hold back a rising tide of superstition. Scott was a practical man. His first book, *A Perfite Platform of a Hoppe Garden* (1574), the first English treatise on the cultivation of hops, was based on the author's knowledge of agricultural procedures in the Low Countries. And when he brought his empirical mind to bear on the question of the supernatural in his 'Discourse on devils and spirits', an appendix to his book of 1584, *The Discoverie of Witchcraft* ('discoverie' in the sense of exposure), he concluded that there were no witches in England – in fact, that witchcraft itself had no foundation in reality. And although he thought it 'ungoldly' to deny the existence of devils and spirits he looked with scorn upon the 'vaine & absurde opinions' of a raft of authorities who, as he put it, 'write so ridiculouslie in these matters, as if they were babes fraied with bugges [babies afraid of spooks]'.[9] Scott thought spirits incapable of assuming material form: therefore, applying this logic, he concluded that there could be no ghosts. Scott trusted the evidence of his own eyes and was interested only in rational conclusions based on lived experience. As the historian A.L. Rowse put it, Scott's 'scepticism was simple and straightforward: he recognised nonsense when he saw it'.[10]

Scott, however, accepted that people thought they saw ghosts – and he offered a series of rational explanations for their delusions. He thought that sometimes a person's depressive temperament led them to imagine what was not there: 'Manie through melancholie doo imagine, that they see or heare visions, spirits, ghosts, strange noises, &c'.[11] Others, he proposed, were unfortunate enough to be afflicted with 'a cowardlie nature' or had been adversely affected by 'an effeminate and fond bringing up',

which caused them to be naturally 'timerous and afraid of spirits, and bugs, &c'. On a dark night, he sneered, a 'sheepe is a perillous beast, and manie times is taken for our fathers soule, speciallie in a churchyard'. For the rest, it was a physiological matter: 'Some through imperfection of sight also are afraid of their owne shadowes.' In other words, they just needed their eyes tested.

Scott fired off a salvo of rhetorical questions: 'Where are the soules that swarmed in times past?' he demanded. 'Where are the spirits? Who heareth their noises? Who seeth their visions? Where are the soules that made such mone [moan] for trentals [requiem masses], whereby to be eased of the paines in purgatorie? Are they all gone into *Italie*,' he concluded with triumphant derision, 'bicause masses are growne deere here in *England*?'[12] Scott even went so far as to pour scorn on the biblical story of the Witch of Endor, which was usually produced, even by the most sceptical authors, as incontrovertible truth that spirits of the dead could return. According to the Old Testament, at King Saul's request the Witch of Endor raised up the spirit of the prophet Samuel (*fig. 15*). Saul asked her, 'What form is he of?' and she replied, 'An old man cometh up; and he is covered with a mantle.'[13] Ever the practical thinker, Scott took particular issue with the witch's description of Samuel's attire:

> she describeth his personage, and the apparell which he did usuallie weare when he lived: which if they were both buried together, were consumed and rotten, or devoured with wormes before that time. Belike he had a new mantell made him in heaven: and yet they saie Tailors are skantie there, for that their consciences are so large here.[14]

But despite their differences of opinion on the frequency with which ghosts appeared, when it came to what they actually were, Protestants and Catholics shared much common ground; both camps agreed that many apparitions were diabolic illusions designed to trick people. It was a compelling idea, and one that, to most people's minds, added a fearful new dimension to a ghostly appearance. The involvement of Satan himself in what was already regarded as an uncanny encounter was a downright terrifying prospect.

One writer, a Northamptonshire physician and author of a book on witchcraft, John Cotta, put an intriguing spin on this notion by his conception of the Devil as a creative artist. If mirrors, reasoned Cotta in

a work of 1616, could create 'outward shapes, and figures of creatures and substances', and painters were able to 'represent perfectly the true and lively shape of men, and other creatures, even when they are not onely absent, and removed in farre distant places, but when oft-times they have many yeares beene swallowed of the grave', then 'why should it be thought impossible unto the Divell (who certainely is more then exquisite *Apelles* excellent) to offer and present unto the eye likewise any true shape whatsover?'[15] Why indeed? If Lucifer's skill exceeded that of Apelles – the most skilled artist of antiquity – there was every reason to suppose that he was able to fashion a deceptively convincing replica of an individual.

Debate on the nature of ghosts was led at this time by polemicists with vested interests in proving one point or another. Robert Burton adopted a different role: he was more of a ringmaster. When he addressed the nature of spirits in *The Anatomy of Melancholy* (first published in 1621 but regularly expanded in later editions), his task, as he saw it, was to marshal and summarise all that had been thought and written on the subject, weighing up the merits of each idea as it was trotted past. As Librarian of Christ Church in Oxford, a post he held from 1624 until his death, and a man described by the antiquary Anthony Wood as a 'devourer of authors', Burton naturally turned to the works of authorities both ancient and modern as he attempted to establish a typology of these mysterious beings.[16] Reading his 'Digression of the Nature of Spirits, bad Angels or Divels, and how they cause Melancholy', we seem to follow him as he prowls around the library shelves, stopping first at this book and then that, remembering quotations, enumerating authorities, and pausing every now and then to catch our eye and remark on the state of the argument.

Burton freely acknowledges how complex and ultimately unknowable this area of study was – although, characteristically, he evokes an authority even on this point: 'the question be very obscure, according to *Postellus, full of controversie and ambiguity*: beyond the reach of humane capacitie', he worries. 'I confesse I am not able to understand it', he adds disarmingly before concluding *'finitum de infinito non potest statuere'* (the finite cannot pronounce upon the infinite).[17] But it was not a case of insufficient intelligence: as Burton saw it, it was more that the human

mind was not equipped with the right set of tools; 'all our quickest wits, as an Owles eyes at the sunnes light, waxe dull, and are not sufficient to apprehend them'.[18] Even so, he continues resolutely, 'as in the rest, I will adventure to say something to this point'.

Burton's principal concern was with establishing a sort of natural history of demons and spirits, tracing them through the writings of philosophers and theologians. He treats them as beings largely independent of humans, so when he does mention ghosts, in the sense of human souls appearing after death, it is almost in passing and perhaps, as a result, all the more revealing. In his first mention of them, under the heading '*Nature of Devils*', he does nothing to hide his disapproval:

> There is a foolish opinion which some hold, that they are the soules of
> men departed, good and more noble were deified, the baser groveled
> on the ground, or in the lower parts, and were divells, the which with
> Tertullian, Porphirius the Philosopher, M. Tyrius [...] maintaines.
> These spirits, he saith, which wee call Angells and Divells, are nought
> but soules of men departed, which either through love and pitty of
> their friends yet living, help and assist them, or else persecute their
> enimies, whom they hated, as Dido threatened to persecute Æneas.[19]

A volley of references and quotations ensues, following which Burton remarks again on what an 'absurd Tenent [tenet]' it is. Rather than drawing on recent theological developments to bolster his judgement, however, he prefers to reach back for a much earlier source, and notes that the fifth-century Neoplatonist philosopher Proclus 'confutes [it] at large'.

But the idea that some spirits are human souls keeps cropping up. Much of what follows in Burton's 'Digression' hinges on whether or not spirits have bodies and can assume physical form. If they did, what would they look like? One curious answer was advanced by the sixteenth-century French philosopher Jean Bodin, who (as Burton notes with barely disguised exasperation) would have these 'Spirits, Angels, Devils, and so likewise soules of men departed, if Corporeall (which he most eagerly contends) to be of some shape, and that absolutely round, like Sun and Moone, because that is the most perfect forme'.[20] No wonder Burton was sceptical.

Like the majority of his contemporaries, Burton considered 'ghosts' to be, in all probability, illusions conjured up by the devil. His ultimate concern in the lengthy and, indeed, digressive 'Digression of the Nature of Spirits, bad Angels or Divels' is with their effect on the human mind, and 'how they cause Melancholy'; and being tricked by an evil spirit was, Burton thought, undoubtedly perilous to our mental stability. There was plenty of evidence that there were devils that 'many times appeare to men, and affright them out of their wits, sometimes walking at noone day some-times at nights, counterfeiting dead mens Ghosts'.[21] But on the other hand, you might be generating the problem yourself by your own gloomy cast of mind: 'of all other, melancholy persons are most subject to diabolicall temptations, and illusions, and most apt to entertaine them, and the Divell best able to worke upon them.'[22] While before the Reformation anyone was liable to see a ghost, by the seventeenth century it had become, at least in part, a matter of temperament.

4. NEWS OUT OF PURGATORY

While in some quarters ghosts were the subject of earnest and often heated scholarly debate, elsewhere they were being given starring roles in the most rambunctious and scurrilous of stories. Pamphlets were short, cheaply produced printed books, usually of quarto size (10 × 8 inches, about 25 × 20 cm), that offered news, opinion and enter-tainment, and covered everything from political events to prodigious wonders of nature. Often anonymous or signed only with initials, the pamphlet was not an elevated literary form; indeed, in many cases it could barely be called a respectable one. But it was one of the age's most characteristic forms of expression, often combining eloquence and wit with frank impropriety, and it flourished in the fast-paced milieu of late sixteenth-century literary London in which debate, no matter how irreverent and satirical, thrived.[23] Pamphlets were improvisatory, a form of cheap and ephemeral literature supported by authors who were not above writing for commercial ends, stationers who in those days both published and sold books, and a public keen to buy lively, amusing and often sensational writing. They offered freedom of speech unhampered by the constraints and conventions of more formal literature.

The rise of the pamphlet towards the end of the sixteenth century coincided with two other decisive factors: a sceptical attitude to pre-Reformation religious doctrine and a growing cult of personality. A new literary genre was born: 'News out of Purgatory'. These stories described the travels of charismatic individuals in the afterlife, parodying canonical literary prototypes from medieval dream-visions to the excursions into the underworld described in classical and Renaissance literature. In content, they ranged from direct attacks on the Catholic concept of the afterlife to picaresque post-mortem adventures.

If any one character in this period could be imagined to possess sufficient legerdemain to turn the tables on death itself and return to earth to tell the tale, it was the Elizabethan actor and clown Richard Tarlton (*fig. 10*), who died in 1588. And sure enough, an anonymous pamphlet, *Tarltons newes out of Purgatorie*, was published two years later, making it one of the earliest of its kind. Tarlton, a man of fabled charisma and, according to the anonymous pamphleteer, a 'mad merry companion, desired and loved of all', was a legend both in and beyond his own lifetime, inspiring many stories of his skill in outwitting opponents and ingenuity in extracting himself from difficulties.[24] *Tarltons newes out of Purgatorie* sprang from the cult of personality that had grown up around the actor (and his name in the title was no doubt also calculated to increase pamphlet sales). This pamphlet described just one of many prodigious feats attributed to Tarlton, tales of which continued to circulate after his death – although it was presumably the most extreme. The story begins with a parody of medieval dream-visions in which, as dictated by convention, the narrator lies down in a meadow to sleep, and in his dream is visited by an authoritative and saintly guide-figure who reveals details of the afterlife. In this case, however, the dreamer's visitant is a far more earthy companion, 'no other but the very ghost of Richard Tarlton, which pale and wan sat him down by me on the grass'.[25]

The dreamer is at first afraid, but Tarlton's ghost reassures him by suggesting that he should be regarded as friendly, if mischievous: 'although thou see me here in the likeness of a spirit, yet think me to be one of those familiares lares [sprites or hobgoblins] that were rather pleasantly disposed than endued with any hurtful influence, as Hob Thrust, Robin Goodfellow, and such like spirits, as they term them, of the buttery'. Unconvinced, and drawing on the doctrinal consensus

of the late sixteenth century, the dreamer cries: '*In nomine Jesu*, avoid Sathan, for ghost thou art none, but a very divell.' He goes on to explain his theological position to the ghost with comical pedantry: 'for the soules of them which are departed, if the sacred principles of theologie be true, never returne into the world againe till the generall resurrection, for either are they plast [placed] in heaven, from whence they come not to intangle themselves with other cares, but sit continuallye before the seat of the Lambe, singing Alleluia to the highest; or else they are in hell.'[26] To which Tarlton's ghost responds with trenchancy, betraying the short temper for which he was known in life: 'why you whorson dunce, think you to set Dick Tarlton *non plus* with your aphorisms?'

The ghost then goes on to argue – from a position of first-hand experience – that there is a third place in addition to heaven and hell, 'that all our great-grandmothers have talked of, that Dante hath so learnedly writ of, and that is Purgatory', and agrees to tell the dreamer all about it.[27] The tale he unfolds pokes fun at church corruption by detailing the punishments meted out to monks and priests for their particular offences, and he describes individual punishments he witnessed as he wandered through the various rooms of purgatory – a friar covered in honey and tormented with wasps, a pair of lovers being whipped with nettles, and a cook forced to sit with a crane's leg in his mouth. Each gives rise to an entertaining tale explaining how the particular penance was incurred, until finally Tarlton explains to the dreamer that:

> my time was come that I must to the judge to be censured, what punishment I should have myself for all the mad wanton tricks that I did when I was alive. Faith, at last, because they knew I was a boon companion, they appointed that I should sit and play jigs all day on my tabor to the ghosts without ceasing...[28]

He evidently does not consider this to be a very harsh punishment. Quite the reverse. All the practice has, he boasts, 'brought me into such use that I now play far better than when I was alive, for proof thou shalt hear a hornpipe'. But at the first note the dreamer awakes and, after a sustaining supper, takes up his pen to record Tarlton's extraordinary account – although, he admits ruefully, 'not half so pleasantly as he spoke it'.[29]

A leading figure in this new genre was one of the most charismatic figures to inhabit the proto-bohemian world of late sixteenth-century literary London: the prolific and versatile author Robert Greene. Greene had acquired a certain notoriety: 'who in London', asked the scholar Gabriel Harvey, 'hath not heard of his dissolute, and licentious living'? Cataloguing Greene's misdemeanours, Harvey goes on:

> his fonde disguisinge of a Master of Arte with ruffianly haire, unseemely apparell, and more unseemelye Company ... hys villainous cogging [deceit], and foisting [cheating]; his monstrous swearinge ... his riotous and outragious surfeitinge...?[30]

But perhaps one of Greene's chief offences was his 'impudent pamphletting'. '[I]n a night & a day', wrote his friend Thomas Nashe, 'would he have yarkt up a Pamphlet as well as in seaven yeare, and glad was that Printer that might bee so blest to pay him deare for the very dregs of his wit.'[31] His prodigious output of pamphlets was certainly something that Greene himself affected to regret late in life. '[I]n seeking to salve private wants,' he complained, he had made himself 'a public laughing-stock. He that cometh in Print', he continued, 'setteth himself up as a common mark for everyone to shoot at.'[32] Greene's sincerity was only compromised by the place in which he chose to publish this lament: another pamphlet.

Greene's association with pamphlets did not stop with his death; his 'ghost' was to cut a surprisingly active figure in the publishing world. Its first appearance was in *Kind-Hart's Dreame*, a pamphlet possibly written by Henry Chettle, which was entered in the Stationers' Register just two months after Greene's death in September 1592. Here Greene's ghost is found alongside those of four other Elizabethan entertainers, who entreat Kind-Hart to publish their papers which, being dead, they are sadly unable to arrange for themselves.

Following this was another pamphlet, *Greene's News Both from Heaven and Hell*, in which his ghost adopts a more active role. Here, Greene begins by explaining himself to his readers:

> Be not dismayed, my good friends, that a dead man should acquaint you with news, for it is I, I per se I, Robert Greene *in Artibus Magister* [Master of Arts], he that was wont to solicit your minds with many

pleasant conceits, & to fit your fancies at the least every quarter of the year with strange & quaint devises best beseeming the season and most answerable to your pleasures. Having therefore so many times taken the true measure of your appetites, & finding the very height of your dispositions inclined to novelties, that you might the rather see how willing I am to satisfy your humours, I have sent you here the whole discourse of my adventures, what hath betide me since I left the terrestrial world, with a very true report of my infernal travels.[33]

Greene's News was purportedly commended to the press by 'B.R.', who explains in a prologue that he had been confronted in the street by Greene, in the form of 'a most grisly ghost wrapped up in a sheet, his face only discovered [revealed], with a pen under his ear and holding a scroll of written paper in his hand', as he made his way from Pancras Church to Pie [Pye] Corner after dark.[34] Greene's ghost entreats B.R. to commit the narrative to the press, and, 'popping the papers into my hand', promptly vanishes.

In the story, Greene's ghost relates his unsuccessful attempts to get into heaven. 'O, quoth St Peter, I have heard of you. You have been a busy fellow with your pen.'[35] St Peter decides, however, that Greene is not welcome on the grounds of having written pamphlets on the subject of 'cony-catchers' or swindlers (a 'cony' being a victim), such as *A Notable Discovery of Cozenage* and *The Second Part of Cony-Catching*, in which he purported to expose the methods of confidence tricksters. It was not the subject that the saint minded, but rather Greene's resolute focus on the lowest of petty criminals. Ironically, Greene is banished from hell by the same coin: because, with his pamphleteering, he has 'been an enemy to the art of cony-catching'.[36] Taken aback by the furious clamour of hell's vast retinue of criminals, all swearing to punish Greene 'for marring their market and hindering them of their taking', Lucifer throws him out.

Refused access to both places, Greene is charged by Lucifer to remain 'a restless spirit wandering through the world'. As a parting shot in the pamphlet, Greene warns his friends about the type of ghost he intends to be: 'the maddest goblin that ever used to walk in the moonshine'. He describes how, as a spirit at large in the world, he means to create mayhem, not only with simple strategies of getting men drunk and scaring young women, but with a more thoroughgoing intention to infiltrate 'all trades, all sciences and all occupations' in order to disrupt proceedings and,

in particular, to thwart justice. The ghost, for this particular pamphleteer, was a mischievous spirit with the power to transform himself into 'divers shapes' – and with a licence to turn the world upside-down.[37]

There is one further twist to the tale. In style and vocabulary, the account of his adventures in the afterlife is so consistent with Greene's own manner of writing that it has been proposed that the character of B.R. is fictitious, and the text really *was* written by Greene – before his death, one assumes.[38]

In 1598 Greene was resurrected again to relate a story of domestic virtue in John Dickenson's *Greene in Conceipt*. The pamphlet is adorned with a title-page portrait of the putative author, 'suted in deaths livery' with his shroud tied at the top of his head, sitting in a comfortable chair drawn up to a desk at which he earnestly writes, with ink-well, book and paper-knife conveniently to hand (*fig. 11*). Still active in 1602, 'Greenes Ghost' is named as the author of yet another 'cony-catching' pamphlet. Putting a famous author's name on a pamphlet, even in 'ghost' form, would no doubt have increased sales, and the idea of publishing or dictating from beyond the grave was evidently also an ongoing joke among pamphleteers – perhaps one that had even been set in motion by Greene himself.

5. 'REVENGE, REVENGE!'

'Come we for this from depth of underground,' asks Don Andrea's ghost incredulously, 'To see him feast that gave me my death's wound?'[39] The poor ghost in Thomas Kyd's *Spanish Tragedy* (c.1587) finds himself in an agonisingly difficult position. Forced to stand by helplessly as his enemies apparently flourish, his presence undetected by the living characters, all he can do is argue with his companion, the allegorical figure of Revenge – who, the ghost feels, is being altogether too laid-back. How had it come to this? His medieval predecessors had always found ways of making their presence felt.

Having lost their traditional role at the Reformation, ghosts were ripe for re-invention. They were still imagined as refugees from the afterlife – but rather than being preoccupied with effecting a swift passage to heaven, their attention was now directed to more earthly affairs. They became obsessed with seeing justice done. Ghosts found a natural home in revenge drama:

apart from Kyd, many playwrights including John Webster (*The White Devil*) and Cyril Tourneur (*The Atheist's Tragedy*) seized upon the supernatural to bring an extra dimension their plots.

For his *Spanish Tragedy*, which proved an outstandingly popular play, Kyd, like other dramatists of the era, found inspiration for this new ghost-type in a classical source: plays by the first-century Roman dramatist Seneca, which had been translated into English in the second half of the sixteenth century, and which frequently featured ghosts and magic. Drawing on a classical formula, Don Andrea's ghost and the figure of Revenge do something new in English drama: they act as a chorus, framing the drama and providing a commentary on proceedings. The medieval circus of bellicose clerics, spectral horses and blazing bundles of straw had been replaced by a more dignified forum in which commentary is delivered from the confines of a ring-side seat. The world had changed, and ghosts had changed with it.

The *Spanish Tragedy* begins with Don Andrea, who was killed in battle, telling us of his experiences in the classical underworld. In his posthumous prologue he describes how, waiting to be assigned a place either in 'fields of love' or 'martial fields', his 'wand'ring ghost' was issued with a passport down to Pluto's court (the underworld is not, we are to understand, free from bureaucracy). Proserpine selects his fate, choosing for him to be conveyed back to earth by the figure of Revenge. Don Andrea's ghost is then led from the stately tower set in the Elysian green 'through the gates of horn, / where bad dreams have passage in the silent night', arriving back on earth 'I wot not how – in twinkling of an eye'.[40]

But the ghost of Andrea is not doomed to play a wholly passive part as an anguished and disenfranchised observer. Although he suffers much from having no capacity to influence events as he watches them unfold from his position on the side-lines, with the deaths of his enemies at the end of the play he is finally granted the power to 'work just and sharp revenge' on his foes in the afterlife. 'Then, sweet Revenge, do this at my request', he asks: 'Let me be judge, and doom them to unrest'.[41] As a ghost who must for the course of the play confine himself to commentary, he is a feeble presence – but in the underworld the tables will be turned. 'For here though death hath end their misery,' promises Revenge in the play's final lines, 'I'll there begin their endless tragedy.'[42] The earthly drama might have played itself out, says Kyd, but it is never over for ghosts. Andrea will have his justice in the end.

In the hands of many dramatists writing at this time, however, the vengeance-seeking ghost became something of a stock figure. For a sense of how ubiquitous and in some cases downright tawdry it had become, consider a throwaway line in a work of 1596 by Thomas Lodge, *Wits Miserie and the Worlds Madnesse: Discovering the Devils Incarnat of this Age*, which refers to the performance of a play about Hamlet that pre-dated Shakespeare's tragedy: Lodge compares the pale face of a devil to 'the Visard of ye ghost which cried so miserally at ye Theator like an oister wife, *Hamlet, revenge*'.[43] In a similar vein, an anonymous play of around 1599, *A Warning for Fair Women*, contains a description of a tired tragic convention: 'a filthy whining ghost' that:

> Lapped in some foul sheet or a leather pilch,
> Comes screaming like a pig half-sticked,
> And cries, '*Vindicta!* Revenge, Revenge!'

Such unpromising entrances were, we are told, accompanied by a distinctly unimpressive use of 'a little rosin [resin]' that 'flasheth forth, / Like smoke out of a tobacco-pipe or boy's squib'.[44] Shabby costumes and shoddy stage-effects only served to underline the ghost-figure's lack of real substance in much of the era's drama. But two plays in this period that had ghosts at their core engaged more closely with ideas of their own time, reflecting different aspects of the complex climate of debate. One was *Doctor Faustus* and the other was *Hamlet*.

Christopher Marlowe based *The Tragical History of the Life and Death of Doctor Faustus* (*fig. 12*), the earliest known performance of which was held in 1594, on a story he found in a pamphlet, which in turn had its source in a medieval legend. Using the simple architecture of the existing plot, Marlow wrote one of the most dazzling tragedies of the era. The story was as simple as it was terrifying: the inexorable downfall of the brilliant scholar Doctor Faustus, who turns to magic and sells his soul to the Devil in exchange for twenty-four years of power on earth.

Where other dramatists used spirits as agents to commentate or to press for revenge, Marlowe peopled the drama with them. Faustus's wish to raise up and command spirits to 'Perform what desperate enterprise I will' is at the heart of his ambition.[45] The spirit Mephistopheles becomes his servant, who in turn conjures various devils; and good and evil angels

counsel Faustus. Faustus himself bargains with Mephistopheles for the ability to 'be a spirit in form and substance'.[46] In the airless world Marlowe creates in the play, the only significant relationships Faustus conducts are with spirits – with Mephistopheles and, towards the end, with the ghost of Helen of Troy. She is, of course, not Helen herself but a spirit in her guise – Faustus has previously admitted that his conjuring up of Alexander the Great and his 'Paramour' is an illusion, because 'it is not in my ability to present before your eyes the true substantial bodies of those two deceased princes, which long since are consumed to dust'. Faustus offers instead 'such spirits as can lively resemble Alexander and his paramour … in that manner that they both lived in, in their most flourishing estate'.[47]

In the midst of this environment in which it is a given that spirits are able to adopt human form and pose as individuals, Marlowe mocks both Catholic ghost-belief and the clergy's apparent blindness to a wider spiritual realm. When Faustus, made invisible by Mephistopheles, torments the Pope by snatching his dish away, the Cardinal of Lorrain solemnly pronounces the traditional doctrinal explanation for supernatural encounters: 'My lord, it may be some ghost, newly crept out of Purgatory, come to beg a pardon of your Holiness.' To which the Pope replies, 'It may be so. – Friars, prepare a dirge to lay the fury of this ghost'.[48]

What Marlowe shows us in Doctor Faustus is a man who, for a time at least, is able not only to control spirits and make them resemble ghosts, but also to bargain for a passport between the human and the supernatural world that extends to becoming, at will, a spirit himself during his twenty-four years of power. But perhaps Marlowe's most audacious touch of all, occurring shortly before Faustus is dragged to hell, is the inclusion of a scene leading to the doctor's sexual liaison with the pre-eminently desirable spirit-Helen ('And none but thou shall be my paramour!').[49] The dramatic possibilities of the ghost really were being pushed to the limit.

The greatest play in the English language has a ghost at its heart. Where Marlowe's drama conformed to the latest state of post-Reformation opinion (that 'ghosts' were actually spirits and not the souls of the dead), Shakespeare's reflects a more contradictory range of beliefs. The more sophisticated members of the audience watching the play at the Globe Theatre, mindful of the new directions of Protestant thought, would have been likely to conclude

that the ghost was a spirit that had assumed the form of Old Hamlet. Others, perhaps the majority, probably held muddled, uncertain views – was it an evil spirit? Or the soul of Hamlet's father, which was suffering in purgatory? Old habits of mind die hard, and it is not difficult to imagine entrenched folk belief continuing to exist alongside new intellectual theories.

Shakespeare created an arena in which all the possible contemporary explanations were voiced. Firstly, the idea that a 'ghost' is a figment of an overwrought or 'franticke' imagination: 'Horatio says 'tis but our fantasy,' remarks the sentry Marcellus.[50] Having encountered the ghost himself, Horatio, good scholar that he is, explains that he has been persuaded by empirical evidence, rather than the second-hand accounts he had previously received: 'I might not this believe / Without the sensible and true avouch / Of mine own eyes.'[51] He retains, however, a slight sceptical distance, revealed when he commands the ghost to: 'Stay, illusion' (is it, after all, a trick, a demonic spirit?); and shortly afterwards, on being told that 'Some say' that at Christmas time 'no spirit can walk abroad', Horatio makes it clear that he reserves the right to be selective about believing what people say: 'So have I heard, and do in part believe it.'[52]

As a scholar of Wittenberg, Hamlet is also abreast of the most sophisticated new thought on the matter, and therefore, on first seeing the ghost, raises the most topical question, namely whether it is a good or a bad spirit: 'Be thou a spirit of health or goblin damned, / Bring with thee airs from heaven or blasts from hell, / Be thy intents wicked or charitable'.[53] His next, punning lines express his intention to sift the ghost, to attempt to find out from first-hand experience what it is: 'Thou com'st in such a questionable shape / That I will speak to thee.'[54] He then appears temporarily to accept the ghost's apparent identity: 'I'll call thee Hamlet, / King, father, royal Dane.'[55] But in the next few lines his mind turns to other possibilities:

> ... What may this mean,
> That thou, dead corpse, again in complete steel,
> Revisit'st thus the glimpses of the moon,
> Making night hideous, and we fools of nature.[56]

A 'dead corpse' that gets out of its grave and stalks about at night dressed for a fight? This harks back to a much older tradition, but one that perhaps still lingered on in folk belief – that of the terrifying revenant.

The ghost itself gives an explanation straight from orthodox Catholic doctrine: that he is, indeed, Old Hamlet's soul in purgatory (although, adding to the mystery, he does not actually name his place of suffering):

I am thy father's spirit,
Doomed for a certain term to walk the night,
And for the day confined to fast in fires
Till the foul crimes done in my days of nature
Are burnt and purged away.[57]

But can it be believed? Isn't that just what an evil spirit *would* say?

In *Hamlet* Shakespeare re-fashions the dramatic ghost, taking the classical Senecan model as a basis but moulding it to match the turbulent ideology of the times. The ghost of Old Hamlet elicits the widest possible range of responses – expressions of religious belief of various kinds, intellectual positions and remembered snatches of folklore, as well as degrees of scepticism. It is this, alongside Hamlet's own questioning attitude towards it, that makes it the most representative ghost of its era – as well as one that still defies conclusive interpretation.

'I Long to talke with some old lovers ghost', wrote John Donne in his poem 'Loves Deitie'.[58] While other writers might have thought of experiencing an apparition from the point of view of an awed observer, wondering what it meant and afraid that it might be a devilish trick, for Donne it represented an opportunity to be seized for a frank conversation, man to man. What could this visitor from the distant past, this relic of a long-dead individual, tell him about love?

The question was rhetorical, of course, and Donne knew the answer: no one from those far-off days could have loved as hopelessly as he did. But the corporeal terms with which he frames the thought are encountered elsewhere in his poetry. 'The Funerall' reveals Donne's preoccupation with death, relics and the continuing life of the corpse in the tomb. In it he writes of dying and being buried wearing a wreath of his lover's hair tied around his arm, which he imagines as his 'outward Soule', an active ingredient in the grave, working to 'keepe these limbes, her Provinces, from dissolution'.[59] The suggestion of a corpse retaining physical integrity

for its erstwhile lover, with and through a relic of her body, is disturbingly sexual, and even slightly threatening. Will he stay in his grave and wait – or will he use those uncorrupted limbs to get out and pay her a visit?

With 'The Apparition' Donne upped the ante. What could the poet say to his sometime mistress that would appal her and fill her with mortal dread? He threatens to return from the grave and haunt her when she is in bed with a new lover.

> When by thy scorne, O murdresse, I am dead,
> And that thou thinkst thee free
> From all solicitation from mee,
> Then shall my ghost come to thy bed

He imagines her fearful reaction, and how it would cause her body to mirror his own pale, waxy appearance: 'Bath'd in a cold quicksilver sweat', she would appear to be a 'veryer ghost' than he.[60] Does he mean to climb into bed next to her? Despite the horror of the threat, however, there is something darkly comic, almost farcical, about the prospect of this grotesque encounter between erstwhile lovers.

Just as Shakespeare had done, Donne wrenches the idea of the ghost away from its conventional form and gives it a new and compelling shape. But if Shakespeare's great innovation had been to make the ghost reflect every possible shade of interpretation that might be put to it, Donne's was to inject it with a dark, supple energy, to transform it into a physical, passionate being. Forget sophisticated contemporary ideas about spirits and demons masquerading as human souls; for Donne the poet, the ghost was most definitely a being of flesh and blood, capable of loving, of threatening, and retaining all the passions of the living.

Donne believed he had seen an apparition himself. His biographer, Izaak Walton, relates how Sir Robert Drury, with whom Donne and his wife were living at the time, wished Donne to accompany him on a visit to the French court at Paris. Although reluctant to leave his pregnant wife, Donne was eventually persuaded. A few days later, having left Donne alone in the room where they had dined, Sir Robert returned to find him 'in such an Extasie, and so alter'd as to his looks' that he was amazed. When asked what had happened, 'after a long and perplext pause' Donne replied: 'I have seen a dreadful Vision since I saw you: I have seen my dear wife pass twice by me

through this room, with her hair hanging about her shoulders, and a dead child in her arms.' Sir Robert immediately sent a servant back home, who returned with news that Donne's wife had 'after a long and dangerous labour [...] been deliver'd of a dead child. And, upon examination, the abortion prov'd to be the same day, and about the very hour that Mr. *Donne* affirm'd he saw her pass by him in his Chamber.'[61]

In commenting on this strange tale, Walton performs a curious dance of self-positioning that is revealing of how people thought about ghosts, apparitions and other strange phenomena in the first half of the seventeenth century. 'This is a relation that will beget some wonder', he begins, 'and, it well may; for most of our world are at present possest with an opinion that *Visions* and *Miracles* are ceas'd.' He first suggests a psychic explanation for Donne's experience, setting out the poetic idea of a *'sympathy of souls'*, which he illustrates with an image of a pair of lutes strung and tuned to an equal pitch – when one is played, the other, placed at a distance on a table, will 'warble a faint audible harmony'. Then, as if conscious of an audible scoffing from his readers, he touchily justifies himself to 'the unbelieving' who 'will not allow the believing Reader of this story, a liberty to believe that it may be true', by reciting a list of respectably canonical spectres. The ghost of Julius Caesar, he points out, appeared to Brutus; St Austin and his mother Monica, moreover, both experienced visions. And if the 'incredible Reader' is still inclined to smirk, how about the Biblical story in which Samuel appeared to Saul? Walton then somewhat stagily distances himself from the argument: 'More observations of this nature, and inferences from them, might be made to gain the relation of a firmer belief: but I forbear, lest I that intended to be but a Relator, may be thought to be an ingag'd person for the proving what was related to me.' He brings his digression to a close, however, with an admission: the tale, he confesses, was not told him by Donne himself, but by 'a Person of Honour, and of such intimacy with him, that he knew more of the secrets of his soul, than any person then living: and I think', he concludes somewhat lamely, 'they told me the truth.'[62]

Towards the beginning of 1631, when Donne was dying, he sent for a wooden pedestal in the form of an urn and, asking for his room to be warmed with a fire, undressed and put on a winding sheet. This was tied up at his head and feet, leaving only his face exposed. He then balanced on the

pedestal, while an artist made drawings of him which served as preparatory sketches for a full-size marble monument to be placed in the choir of St Paul's Cathedral, of which Donne had been Dean since 1621. Subsequently carved by the Baroque sculptor Nicholas Stone, this monument was of Donne's own devising. In his biography, Walton relates how: 'Upon this *Urn* he thus stood with his eyes shut, and with so much of the sheet turned aside as might shew his lean, pale, and death-like face, which was purposely turned toward the East, from whence he expected the second coming of his and our Saviour Jesus.'[63] Donne kept one of these drawings by his bedside, and meditated on this curious, ghostly image of himself as the moment of his death drew near.

Stone's extraordinary sculpture, poised between the macabre and the beatific, speaks of Donne's Christian faith in the resurrection of the dead: he chose to have himself portrayed as though emerging from his tomb at the Last Judgement. The sheer oddity of the sculpture is striking today. Standing south of the choir in Wren's new St Paul's, the portrayal of Donne's corpse-chrysalis, in the act of rising from an urn as though newly regenerated from ashes and poised at the moment of resurrection – just before those closed eyelids are due to re-open – is strange and unsettling. Although the monument represents Donne in death, he is charged with the potential of life.

The drawing also served as the model for a portrait engraving by Martin Droeshout (*fig. 13*) that was used as the frontispiece to *Deaths Duell, or, A Consolation to the Soule, against the dying Life, and living Death of the Body*, the name Donne's final sermon was given when it was published the following year. It was, fittingly, about death and resurrection. Dr Donne has preached his own funeral sermon, the congregation said to each other.

There is one final peculiarity in the history of Donne's monument. After the disastrous fire that destroyed the medieval cathedral in 1666, it was one of very few monumental figures in St Paul's to have survived with relatively little damage. It was later discovered in the crypt where it had mysteriously found sanctuary. How it got to this place of safety from its position in the choir, however, nobody was able to say.

6. COLLECTING GHOSTS

A brisker wind began to blow in the middle of the seventeenth century, bringing with it a new spirit of scientific enquiry. Observations were

recorded, experiments conducted, data gathered and discoveries made. When the Royal Society was founded in 1660 its motto, *Nullius in verba* – take nobody's word for it – summed up the new attitude. What members valued most highly of all was direct experience.

One can get a sense of the revolution in intellectual attitudes that shaped the seventeenth century by comparing two writers, one belonging to the first half of the century, the other to the second. Robert Burton remained a student at Christ Church in Oxford until his death in 1640, ruefully describing himself as 'left behind, as a Dolphin on shore, confined to my Colledge, as *Diogenes* to his tubb'.[64] Nevertheless, he pursued knowledge and the latest thinking exhaustively through the pages of books in the libraries that surrounded him, sifting and comparing ideas put forward by different authorities. For the antiquary John Aubrey, who compiled notes from the 1650s until the 1690s, ruminating over what other writers had said was less important than seeking information at first hand. He went on field-trips, foraging for information and for fragmentary remains of buildings and artefacts and – above all – making drawings and notes: 'even travelling', he says, '(which from 1649 till 1670 was never off horse-back) did gleane some observations, of which I have a collection in folio of 2 quiers [quires, i.e. about fifty sheets] of paper plus a dust basket, some wherof', he noted modestly, 'are to be valued'.[65]

This value that Aubrey placed on his own empirical research had its foundations in a new way of understanding the world that had been set out in the early years of the century by the philosopher Francis Bacon. Rather than relying on literary authorities, wrote Bacon, it was vitally important to make your own observations, to get out of the library and look at the world around you. In a strikingly dramatic image in his *Advancement of Learning* (1605), Bacon compared time to a 'shipwreck' from which material 'remnants of history' – antiquities – may be salvaged.[66]

It was a metaphor that, by the middle of the century, had become all too apt. The acts of iconoclasm that had been perpetrated during the years of the English Civil War – which began in 1642, the year Aubrey went up to Oxford – had destroyed a great deal of the material culture connected with the country's Catholic past that had survived the depredations of the Reformation in the previous century. For Aubrey, these recent acts of destruction made the rescue of surviving antiquities all the more pressing. And these did not necessarily need to be material objects: according to

Bacon, 'proverbs, traditions, archives' and 'fragments of histories' could also be regarded as precious debris floating on the waves, waiting to be scooped up in the antiquarian's net.[67]

Among Aubrey's many interests was the folklore that he believed to be under threat at this time, not only through the ruptures of the Civil War but also through cultural changes, both material and social:

> Before Printing, Old-wives Tales were ingeniose: and since Printing came in fashion, till a little before the Civil-warres, the ordinary sort of People were not taught to read: now-a-dayes Bookes are common, and most of the poor people understand letters: and the many good Bookes, and variety of Turnes of Affaires, have put all the old Fables out of dores: and the divine art of Printing and Gunpowder have frighted away Robin-good-fellow and the Fayries.[68]

As a result, Aubrey saw it as his mission to collect and compile vulnerable evidence of oral traditions before it faded away. And whether the stories were credible or not was, as far as he was concerned, beside the point. They were specimens. 'I know that some will nauseate these old Fables', he wrote, 'but I doe profess to regard them as the most considerable pieces of Antiquity I collect'.[69] Aubrey was among the first scholars to recognise the value in these old wives' tales – the old ghost stories, beliefs and customs that he feared were already being pushed aside by the onward march of progress.

For Aubrey, who had been elected to the Royal Society in 1663, all phenomena were of interest and worthy of study. What was then known as 'Natural Philosophy' – the study of the natural world and the precursor to modern science – had, he said, been 'exceedingly advanced' during the course of the seventeenth century, but he noted that a whole other area had been neglected: 'Hermetick Philosophy', or what we might now call the occult. To Aubrey, this was an unaccountable omission: 'methinks, 'tis strange that Hermetick Philosophy hath lain so long untoucht. It is a Subject worthy of serious Consideration.' In response to this lack, for the only book that was published in his lifetime, *Miscellanies* (1696), he gathered together accounts of 'Apparitions' along with a wealth of other supernatural and psychic phenomena: day-fatality, local-fatality, 'ostenta' (portents), omens, dreams, voices, impulses, knockings, invisible blows, prophecies, marvels, magic, transportation by an invisible power, visions in

a crystal, converse with angels and spirits, corpse-candles in Wales, oracles, 'extasie', glances of love and malice, and, finally, second-sighted persons. The section titles in themselves are a dizzying compendium of wonders.

Some of Aubrey's 'apparition' stories derive from recent or contemporary literary sources, for example Walton's 1640 life of Donne (where he finds the account of Donne's vision of his dead child), his friend Anthony Wood's *Historia et antiquitates Univ. Oxon.* (1674), or Joseph Glanvill's *Saducismus Triumphatus*, first published in 1681. Other sources range from the *Athenian Mercury*, a twice-weekly periodical published in London in the 1690s, in which he finds a report of a ghostly lady 'of Quality', to Pliny's *Natural History* which notes the existence of human-like fairies in 'the Deserts of Africk' who, having appeared, 'vanish quite away like phantastical Delusions'.[70] The majority of Aubrey's tales, however, seem to have been told to him by acquaintances – he cites a story told at the Royal Society by John Evelyn, and another he quotes from a letter addressed to him from a member of Trinity College, Oxford – and most concern aristocratic or professional figures. Others were brought out from the shelves of his well-stocked mind. 'This put me in mind of a Story...', he begins one account, while another 'puts me in mind of a Dream'.[71]

A number of Aubrey's stories in *Miscellanies* recount pacts made by friends, in which each promises to appear to the other in the event of being the first to die. One such tale concerns Lord Middleton and the Laird Bocconi, who, because of their 'great Friendship' made an Agreement:

That the first of them that Died, should appear to the other in extremity. The Lord Middleton was taken Prisoner at Worcester Fight, and was Prisoner in the Tower of London under Three Locks. Lying in his Bed pensive, Bocconi appeared to him; my Lord Middleton asked him if he were dead or alive: he said, Dead, and that he was a Ghost; and told him, that within Three Days he should escape, and he did so, in his Wives Cloaths. When he had done his Message, he gave a Frisk, and said:

Givenni givanni 'tis very strange,
In the World to see so sudden a Change.

And then gathered up and vanished.[72]

Other stories concern prophetic ghosts:

> A Minister, who lived by Sir John Warre in Somersetshire about 1665, walking over the Park to give Sir John a Visit, was rencountred by a Venerable Old Man, who said to him, 'Prepare your self for such a Day (which was about three Days after) You shall die.' The Minister told Sir John Warre and my Lady this Story, who heeded it not: On the Morning fore-warn'd Sir John calls upon the Parson early to Ride a Hunting, and to Laugh at his prediction: His Maid went up to call him and found him stark Dead.[73]

But not all of Aubrey's tales concern purposeful ghosts. One of the most intriguing tells of the following mysterious encounter:

> Anno 1670, not far from Cyrencester, was an Apparition: Being demanded, whether a good Spirit, or a bad? returned no answer, but disappeared with a curious Perfume and most melodious Twang.[74]

As well as the main themes of the stories in *Miscellanies* – prophetic apparitions, 'pact' ghosts, or those appearing to geographically distant family members at the moment of death – Aubrey is evidently just as interested in recording the eccentric details that distinguish and animate individual cases: Bocconi's curious caper and accompanying rhyme, or the scent and sound of the Cirencester ghost. Remarkably, he makes virtually no comment on these stories, apart from mentioning where he heard the account, and scrupulously noting any discrepancies where one version differs in some detail from another. Aubrey rarely ventures an opinion of his own; on the above apparition, for example, he merely notes that 'Mr W. Lilly believes it was a Fairie'. Instead, his interest is in documentation: he assembles all the information, laying the raw materials out for the reader, as though each tale is a specimen in a cabinet of curiosities, to be individually examined, admired, discussed and compared with its fellows.

Although Aubrey believed that apparitions were occasionally encountered, he was not credulous: 'where one is true', he remarked, 'a hundred are figments'.[75] Nor did he have any interest in using ghosts to bolster an intellectual position. He studied 'Hermetick Philosophy' as a scientist and antiquarian, and his pursuit of a subject that fell outside the scope of

contemporary scientific enquiries can be seen, perhaps, as further proof of the independence of mind that led him to propose a much earlier origin for Stonehenge than was supposed at the time, as well as to be the first to realise that the date of a medieval building could be established from the shape of its windows.[76] Collecting ghost stories and anecdotes of supernatural phenomena was, for him, a way of rescuing important, if ephemeral scraps from the wreckage of history before they were submerged. What could these ghosts, wondered Aubrey, tell us about ourselves and our past?

While Aubrey was riding from county to county and collecting examples of folklore, other writers were gathering ghost stories – and getting into print before him. Not a great deal had been written on the subject of ghosts in England since the aftermath of the Reformation when the phenomenon was re-thought from a Protestant perspective. The second half of the seventeenth century, however, saw a new wave of books about them – but rather than setting out the Anglican position as a rational, sceptical one, which had been the task of earlier writers, the authors of these books had a different battle to fight. They were backed into a position of arguing for the reality of ghosts in the face of radical mid-seventeenth-century currents of thought. As a result, their stories differed from Aubrey's antiquities and curiosities: they had a job to do.

New concepts of how the physical world was structured were challenging time-honoured suppositions. The ideas developed by the French philosopher and mathematician René Descartes, although not as influential in England as on the continent, certainly shaped English thought. Materialism proposed that the universe was composed entirely from physical matter and was governed by mechanical forces – a view that denied the presence of unseen spirits, whether beneficent or evil, which most of Robert Burton's authorities took for granted. In *Leviathan* (1651), the English philosopher Thomas Hobbes was particularly scathing on the subject of the ghost, or 'Phantasme of the Imagination' as he preferred to put it.[77] The very word ghost, he snorted, 'signifieth nothing, neither in heaven, nor earth, but the Imaginary inhabitants of mans brain'.[78] But mindful of the tricky position in which his views placed him apropos Christianity, Hobbes was careful to distinguish what he called 'reall, and substantiall' apparitions – such as angels, formed by God to execute His will, which, he writes,

are 'Substances, endued with dimensions' that 'take up roome, and can be moved from place to place' – from other more dubious beings.[79] The problem with ghosts, thought Hobbes, was their lack of substance. If it was all a question of matter, then that was a quality that ghosts signally lacked. Are they not 'incorporeall', he asked? From his point of view, this invalidated any claim they might make to existence. 'Ghosts', he explained, 'that are in no place; that is to say, that are no where; that is to say, that seeming to be somewhat, are nothing.'[80]

One of the strongest rebuttals to Hobbes' materialist way of thinking came from a clergyman and member of the Royal Society, Joseph Glanvill. Glanvill's first book on the subject of spirits and witchcraft, A Philosophical Endeavour towards the Defense of the being of Witches and Apparitions, was published in 1666, but his most famous work, and one which went through several editions, was Saducismus Triumphatus: Or, full and plain Evidence concerning Witches and Apparitions. First published posthumously in 1681, it was edited by Henry More, a philosopher and theologian regarded as the founder of the tolerant broad-church movement known as latitudinarianism, and himself the author of The Immortality of the Soul (1659), which argued that the existence of spirits was connected to the existence of God. More took the opportunity of adding further stories and corroborative statements to Glanvill's text. The book's title refers to the Jewish sect of the Sadducees at the time of Christ, who did not believe in the resurrection of the dead and denied the existence of spirits. Glanvill saw the denial of ghosts' existence as the thin end of a wedge, and his book was a riposte to modern-day Sadducees. Writing of those who 'are sure there are no Witches nor Apparitions', he proposes that 'they are prepared for the denial of Spirits, a Life to come, and all the other Principles of Religion'.[81] This opinion, he says in his preface, exposes the holder to the charge of crypto-atheism:

> And those that dare not bluntly say, There is NO GOD, content themselves (for a fair step and Introduction) to deny there are SPIRITS or WITCHES.[82]

Glanvill saw it as his mission to defend the idea that ghosts – and by extension the whole spiritual hierarchy – existed, against attacks from writers such as Scott and Hobbes, whom he names in his preface. The most convincing way of doing that, he decided, was by telling stories.

But was there beginning to be something less than dignified about telling ghost stories at this time? Edward Fowler, Bishop of Gloucester,

also collected anecdotes of supernatural phenomena as evidence of the spiritual world, a number of which were published in *Saducismus Triumphatus* – and he was ridiculed by the Earl of Shaftesbury as a 'zealous Defender of Ghosts', whose faith was stretched 'to comprehend in it not only all scriptural and traditional miracles, but a solid system of old wives' stories'.[83] Glanvill seems also to have worried about appearing to endorse and disseminate such tales, because he rather stiffly points out in his preface that he has 'no humour nor delight in telling Stories, and [does] not publish these for the gratification of those that have', and goes on to explain that he records them 'as *Arguments* for the *confirmation* of a Truth which hath indeed been attested by multitudes of the like Evidences in all places and times'.[84]

Realising that he needed to manoeuvre himself into a strong position, Glanvill upended the obvious charge that his evidence looked like flimsy hearsay next to the intellectual heft of materialism. He defends his method by characterising his intellectual opponents as those who 'enjoy the *Opinion* of their own Superlative *Judgements*, and enter me in the first rank of *Fools* for crediting my *Senses*, and those of all the World, before their *sworn* Dictates'. This is not only the clergyman but the Fellow of the Royal Society speaking, who values empirical evidence above theory. By rhetorical sleight of hand, Glanvill presents ghosts as solid and indisputable evidence that can be perceived by the senses, as opposed to the mere 'Opinions' propounded by Scott, Hobbes and their ilk.

The most celebrated story to appear in *Saducismus Triumphatus* – which Glanvill had, in fact, first published in 1667 in *A Blow at Modern Sadducism* – was that of the drummer of Tedworth. This was a spectacular case of haunting. It went on for over two years, and the disturbance manifested itself in a wide variety of ways, from loud noises and knocks to flying shoes and strange smells. It all began in 1661 when Mr Mompesson of Zouche Manor near Tidworth (Tedworth, in an older spelling) in Wiltshire visited the neighbouring town of Ludgershall. While he was there he became aware of the sound of drumming, and asked his friend, the town bailiff, what it meant. Glanvill explained the events that unfolded, and that lay at the heart of all that followed:

> The Bailiff told him, that they had for some days been troubled with an idle Drummer, who demanded Money of the Constable by vertue of a pretended Pass, which he thought was counterfeit. Upon this

Mr. *Mompesson* sent for the Fellow, and askt him by what Authority he went up and down the Country in that manner with his Drum. The Drummer answered, he had good Authority, and produc'd his Pass, with a Warrant under the Hands of Sir *William Cawley*, and Colonel *Ayliff* of *Gretenham*. Mr. *Mompesson* knowing these Gentlemens Hands, discovered that the Pass and Warrant were counterfeit, and thereupon command[ed] the Vagrant to put off his Drum, and charged the Constable to carry him before the next Justice of the Peace, to be farther Examined and Punisht. The Fellow then confessed the Cheat, and begg'd earnestly to have his Drum. Mr. *Mompesson* told him, that if he understood from Colonel *Ayliff*, whose Drummer he said he was, that he had been an honest Man, he should have it again, but in the mean time he would secure it, so he left the Drum with the Bailiff, and the Drummer in the Constable's Hands, who it seems was prevailed on by the Fellows intreaties to let him go.[85]

The following month, just as Mr Mompesson was preparing for a visit to London, the Bailiff had the drum sent to him for safekeeping until matters were resolved. He returned home to worrying news. His wife told him that while he had been away 'they had been much affrighted in the Night by Thieves, and that the House had like to have been broken up'.[86] They might have thought that was the end of the matter; but Mr Mompesson had not been at home for many days before it happened again. One night he was disturbed by 'a very great knocking at his Doors, and the outsides of his House'. Arming himself with a brace of pistols, he searched the house, but found nothing – only, an indication that the disturbance had a supernatural dimension: 'he still heard a strange Noise and hollow Sound. When he was got back to Bed, the Noise was a Thumping and Drumming on the top of his House, which continued a good space, and then by degrees went off into the Air.' It was this uncanny detail that inspired one of the frontispiece illustrations to *Saducismus Triumphatus* – with the addition of a little artistic licence *(fig. 14)*.

This noise continued to disturb the family, usually beginning after they went to bed and going on for nearly two hours. Eventually it began to emanate from the room where the drum itself was kept. It would beat recognisable military drum calls, such as '*Round-heads* and *Cuckolds*, the *Tat-too*, and several other *Points of War*, as well as any Drummer'.[87] But the problem extended beyond noise. The phantom diversified its attacks, persecuting

6. COLLECTING GHOSTS

Mr and Mrs Mompesson's children by making scratching noises under their beds, violently beating their bed-steads, and lifting them right up into the air. It behaved in a troublesome manner with a member of household staff, making a board levitate while he tried to take hold of it, but continually snatching it out of reach – a game that went on for some time, until Mr Mompesson 'forbid his Servant such Familiarities'. It made chairs walk about the room by themselves, hurled shoes and created a sulphurous smell 'which was very offensive'. It even lobbed a bedstaff at the vicar.

Some pages into the account, Glanvill enters the story himself, explaining that in 1663 he 'went to the House, on purpose to enquire the Truth of those Passages, of which there was so loud a report'. Hearing scratching noises in one of the bedrooms, he conducted a thorough search, but could find no 'Trick' or 'Contrivance' that was causing the disturbance. At that point he allowed himself to be 'verily persuaded ... that the Noise was made by some *Daemon* or *Spirit*'.[88]

The drummer himself, while temporarily detained at Gloucester Gaol for theft, admitted that he had '*plagued*' Mr Mompesson, adding '*he shall never be quiet, till he hath made me satisfaction for taking away my Drum*'.[89] As a result of this confession he was tried as a witch, with all the circumstances of the Tedworth case used as evidence against him. He was sentenced to transportation, but managed to return to England. It was noted that, during his absence, the disturbance had temporarily ceased.[90]

The Mompesson case became a *cause célèbre*. Charles II himself sent two members of his court to the house to investigate – although during their stay nothing out of the ordinary occurred.[91] In his unpublished notes for a natural history of Wiltshire, Aubrey describes how Christopher Wren also visited in an attempt to witness the phenomena. Despite staying the night, Wren saw 'no strange things, but sometimes he should heare a drumming, as one may drum with one's hand upon wainscot; but', he added sceptically, 'he observed that this drumming was only when a certain maid-servant was in the next room'. And all observers noticed that 'the Devill kept no very unseasonable houres: it seldome knock't after 12 at night, or before 6 in the morning'.[92] In 1663 Samuel Pepys recorded a conversation with the unconvinced Lord Sandwich on the subject: 'my Lord observes that though he doth answer to any tune that you will play to him on another drum, yet one tune he tried to play and could not; which makes him suspect the whole, and I think it is a good argument.'[93]

Whatever the true nature of the events related by Glanvill, what is most striking about the story of the Tedworth drummer is how expressive it is of the political tenor of the times. The events are recorded to have begun in 1661, just a year after the restoration of the monarchy, when the turbulence of the interregnum, and the rise of radical political groups such as the Levellers, were at the forefront of people's minds; it is surely significant that the owner of the drum had been a soldier in Oliver Cromwell's New Model Army.[94] Look, says Glanvill, to those he called the 'small pretenders to *Philosophy* and *Wit*', who were, in his view, unwise enough to deride belief in witches and apparitions: Charles II may be on the throne, and order restored to the land, but you had better believe that chaos and attendant supernatural evil still pose a threat to the proper order of things. Was Glanvill playing on post-Civil War fears to give additional weight to his evidence for witches and apparitions, hoping to consolidate his religious position? At the least, we can say that the drummer, with his Cromwellian background and apparent ability to stage this kind of sustained attack on a 'discreet, sagacious and manly' English gentleman, sharply reflects the anxieties of the age.[95]

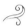

Its sensational content caused *Saducismus Triumphatus* to enjoy huge popularity, and it went through several different editions in the first quarter of the eighteenth century. Other books quickly followed: the Somerset gentleman Richard Bovet's *Pandæmonium, or, the Devil's Cloyster* in 1684 and the natural philosopher George Sinclair's *Satan's Invisible World Discovered* in 1685. Like Glanvill's, the stories in these books largely concerned apparitions that interacted with the living, and that seemed to be purposeful – even if the precise nature of that purpose remained unclear. One of the most intriguing of these late seventeenth-century compendia was *The Certainty of the Worlds of Spirits* (1691), a book by Richard Baxter, a Puritan clergyman, prolific theological writer and old friend of Glanvill. The book was expressly written, Baxter declares on the title page, for the benefit of 'Sadduces [sic] and Infidels'.

Baxter was a forceful evangelical. He had no truck with divines who played with words, but presented himself as a 'plain and pressing downright Preacher' who sought to address his flock with gravity and sincerity.[96] Such was his popularity as a speaker that at a church in

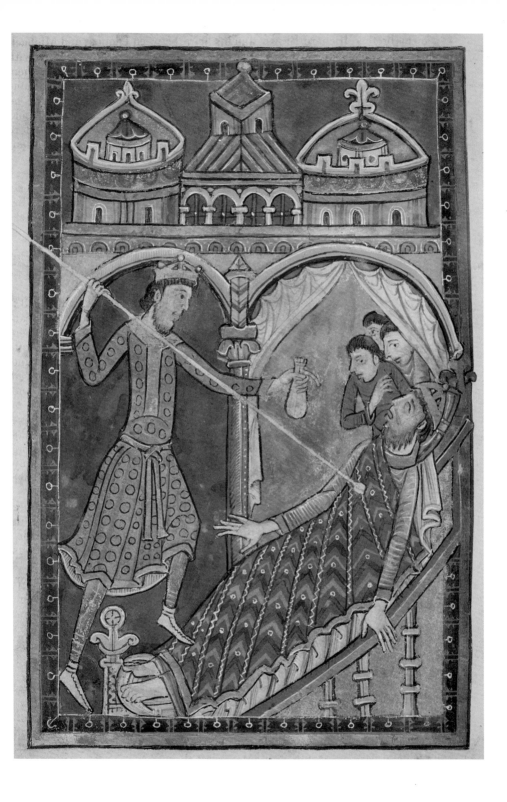

Fig. 1 (previous page)
The Alexis Master
(attrib.; active 1119–35)
Miniature of the ghost
of King Edmund killing
Sweyn Forkbeard in *The
Life and Miracles of St Edmund*,
Bury St Edmunds *c*.1130
27.4 × 18.7 (page size)
The Morgan Library
& Museum, New York

Fig. 2 Portrait of
St Edith from the
*Genealogical chronicle of the
kings of England*,

probably East Anglia
c.1300–7 (detail)
475 × 27.5
British Library, London

Fig. 3 'Of ye relefyng
of saules in purgatory',
manuscript illustration
in *A Carthusian Miscellany
of Poems, Chronicles and
Treatises in Northern English
including an epitome or
summary of Mandeville's travels*,
Yorkshire or Lincolnshire
c.1460–1500
British Library, London

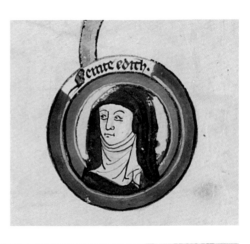

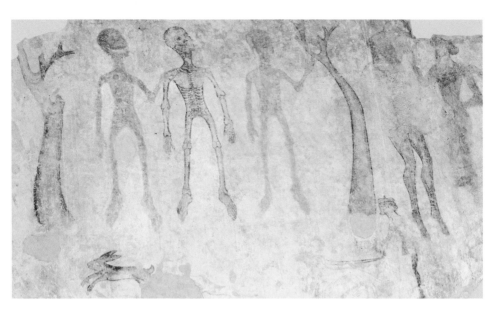

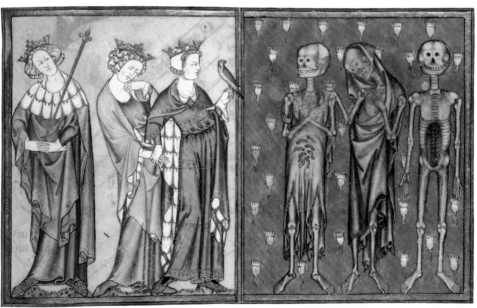

Fig. 4 The Three Living
and The Three Dead,
wall painting in
St Andrew's Church,
Wickhampton, Norfolk
c.1350–1400 (detail)

Fig. 5 The Madonna
Master (attrib.)
*The Three Living and the
Three Dead*, miniature in
the *De Lisle Psalter*, South
East England c.1310
British Library, London

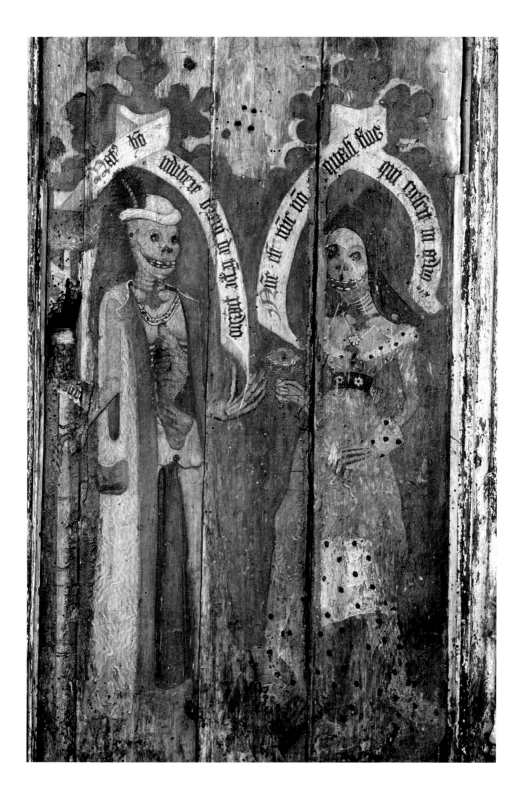

THE GHOST ~ A CULTURAL HISTORY

Fig. 6 (opposite)
Corpse-couple depicted
on rood-screen panel,
St Mary's, Sparham,
Norfolk, c.1480–90

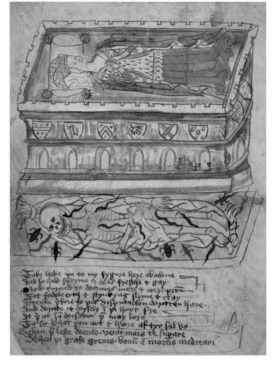

Figs 7 & 8 A tomb chest
with a decomposing
corpse beneath; and
a skeleton and worms
debating, manuscript
illustrations to 'A
Disputation between the
Body and the Worms',
in *A Carthusian Miscellany
of Poems, Chronicles and
Treatises in Northern English
including an epitome or
summary of Mandeville's travels*,
Yorkshire or Lincolnshire
c.1460–1500
British Library, London

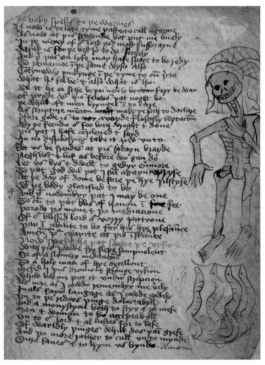

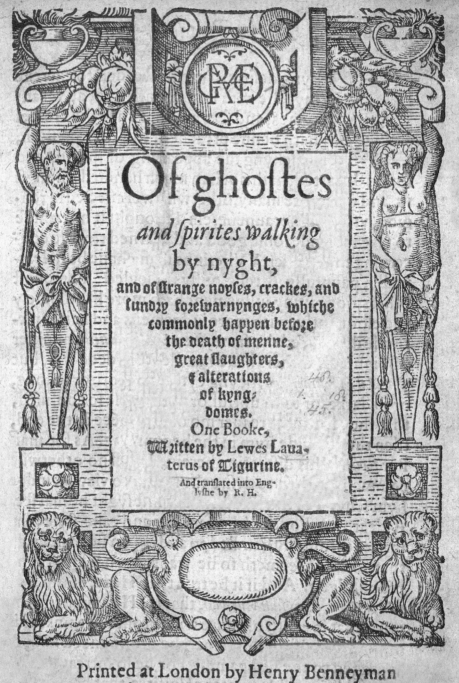

Of ghostes

and spirites walking

by nyght,

and of ſtrange noyſes, crackes, and
ſundꝛy foꝛewarnynges, whiche
commonly happen befoꝛe
the death of menne,
great ſlaughters,
& alterations
of kyng=
domes.
One Booke,
Written by Lewes Laua-
terus of Tigurine.

And tranſlated into Eng-
lyſhe by R. H.

Printed at London by Henry Benneyman
for Richard VVatkyns. 1572.

Fig. 9 (opposite) Title
page, Ludwig Lavater,
*Of Ghostes and Spirites
Walking by Nyght,* and of
*strange noyses, crackes, and
sundry forewarnynges, which
commonly happen before the
death of menne, great slaughters
& alterations of kyngdomes,*
London 1572
British Library, London

Fig. 10 John Scottowe
(d.1607) 'Mr Tharlton',
calligraphic initial 'T'
representing Richard
Tarlton playing a fife
and drum in manuscript
alphabet book, Norwich
*c.*1575–1600
British Library, London

Fig. 11 The ghost
of Robert Greene,
illustration in John
Dickenson, *Greene in
Conceipt new raised from his
grave to write the tragique
historie of faire Valeria of
London,* London 1598

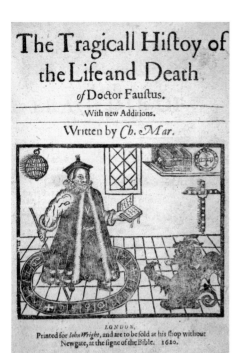

Fig. 12 (above left)
Title page, Christopher
Marlowe, *The Tragical History
of the Life and Death of Doctor
Faustus*, London 1620,
British Library, London

Fig. 13 (above right)
Martin Droeshout
(1601–after 1639)
*Portrait of John Donne, used
as the frontispiece to Donne's
posthumously published sermon*
Deaths Duell, *c*.1632
Engraving 15.4 × 10.4
Private collection

Fig. 14 William Faithorne
(*c*.1620–91)
The Drummer of Tedworth,
frontispiece to part II of
Joseph Glanvill, *Saducismus
Triumphatus*, London 1681
(detail)
Engraving 16 × 9.8
British Library, London

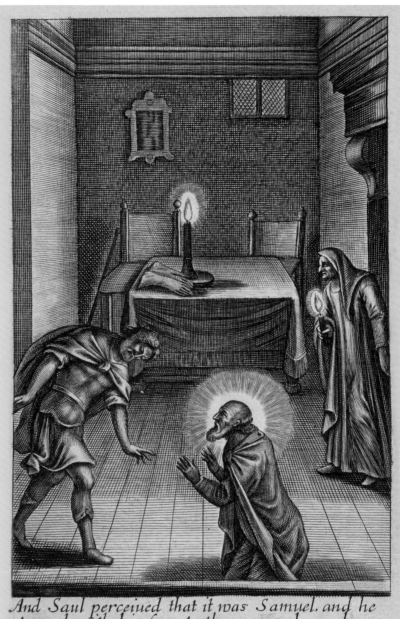

And Saul perceiued that it was Samuel, and he stouped with his face to the ground, and bowed himself. 1ˢᵗ Samuel. Chap: 28: v:14.

W. Faithorne. fecit.

Fig. 15 William Faithorne (c.1620–91) *Saul and the Witch of Endor*, frontispiece to part I of Joseph Glanvill, *Saducismus Triumphatus*, London 1681 Engraving 16 × 9.8 British Library, London

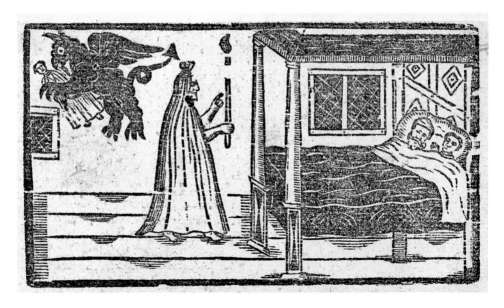

The Midwives Ghost:

Who appeared to several People in the House where she formerly lived in *Rotten-Row* in *Holbourn, London*, who were all afraid to speak unto her; but the growing very *Impetuous*, on the 16th. of this Iustant *March*, 1680, declared her mind to the Maid of the said House, who with an Unanimous *Spirit* adhered to her, and afterwards told it to her Mistris, how that if they took up two Tiles by the Fire-side, they should find the Bones of Bastard-Children that the said Midwife had 15 years ago Murthered, and that she desired that her Kinswoman *Mary* should see them decently Buried; which accordingly they did, and found it as the Maid had said. The Bones are to be seen at the *Cheshire-Cheese* in the said place at this very time, for the satisfaction of those that believes not this Relation.

To the Tune of, *When Troy Town*, &c.

London, Printed for *T. Vere*, at the Sign of the *Angel* in *Guilspur-Street*. 1680.

Fig. 16 (above) *A Godly
Warning for all Maidens*,
London 1686–8
Woodcut
Magdalene College,
Cambridge, Pepys
Collection (detail)

Fig. 17 *A New Ballad
of The Midwives Ghost*,
London 1680
Woodcut and letterpress
Magdalene College,
Cambridge, Pepys
Collection

 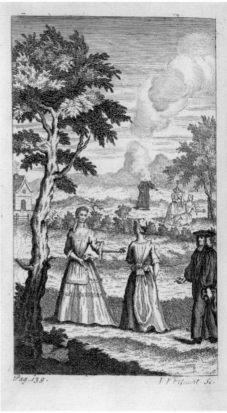

Figs 18 & 19
Jan van der Gucht
(1697–1776)
Courtroom scene (left)
and a meeting with
the minister (right)
illustrations to Andrew
Moreton (pseudonym
for Daniel Defoe), *An Essay
on the History and Reality of
Apparitions*, London 1727
British Library, London

Fig. 20 Anon.
English Credulity, or the Invisible Ghost in Cock Lane 1762
Etching 16.9 × 23.3
British Museum, London

Fig. 21 Johan Joseph Zoffany (1733–1810)
David Garrick in The Farmer's Return *c.*1762
Oil on canvas 101.6 × 127
Yale Center for British Art, Newhaven, CT

Fig. 22 (opposite)
William Hogarth (1697–1764)
Credulity, Superstition and Fanaticism: A Medley 1762
Etching and engraving 43.6 × 32.9
The Lewis Walpole Library, Yale University, CT

CREDULITY, SUPERSTITION, and FANATICISM.
A MEDLEY.

Believe not every Spirit, but try the Spirits whether they are of God, because many false Prophets are gone out into the World.
1 John. Ch.4.V.1.

Design'd and Engrav'd by W.m Hogarth. Publish'd as the Act directs March y.e 15.th 1762.

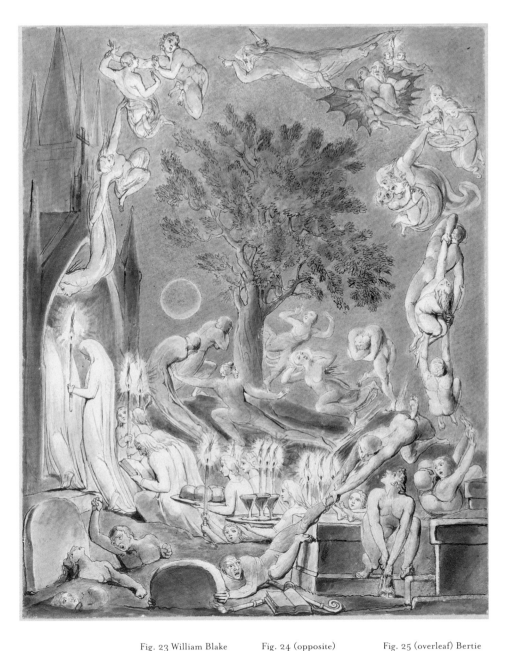

Fig. 23 William Blake
(1757–1827)
*The Gambols of Ghosts According
with Their Affections Previous
to the Final Judgement* 1805
Pen, ink and watercolour
27.4 × 21.7
Private collection

Fig. 24 (opposite)
Susanna Duncombe (née
Highmore; 1725–1812)
The Ghost Scene from The
Castle of Otranto,
*c.*1764–83
Graphite, ink and
watercolour 18.7 × 11
Tate

Fig. 25 (overleaf) Bertie
Greatheed (1781–1804)
*Alfonso Appeared in the Centre
of the Ruins*, illustration
to *The Castle of Otranto*, 1796
Pen, ink and watercolour
25.5 × 17
The Lewis Walpole Library,
Yale University, CT

37 Castle of Otranto

Kidderminster five extra galleries had to be installed to accommodate the congregation when he preached there; and during a visit to London in 1654–5 the crush was so great that there was no place in the church even for the grandest folk; the only perch the vicar himself could find was in the pulpit, squashed in behind Baxter, who had, in a rather undignified way, to preach standing between the vicar's legs.

Reading Baxter's commanding rhetoric today we can get a sense of what it was like to sit in his congregation. He begins softly and in reasonable tones, remarking that there were already 'sufficient Proofs of invisible Powers or Spirits, and their Actions towards Men, which many in full Treatises have already given the World'.[97] That being the case, what reason could there be to publish another, you might wonder? Here's why: 'how convincing soever those Discourses be,' he continues, getting into his stride, 'Multitudes, bred up in Idleness and Sensuality, and thereby drowned in Sadduceism and Bestiality, never see those Books.' 'Nor will they read them, if they have them', he adds for good measure. That being so, was not going into print with another set of stories to be regarded as a futile course of action? Baxter had a solution, and a simple one: to combat apathy and underline relevance, the stories he chose to include were mostly 'near to them, both for Time and Place'.[98] His table of contents offers an enticing cornucopia of recent, local hauntings – 'An instance now in London'; 'Another as strange'; 'One from Cambridge'; 'One at Hunniton' – pepped up with exciting accounts 'Of Lightnings tearing Churches' and 'Of Whirlwinds and Hurricanes'.

That ghost stories provided incontrovertible proof of the existence of a spiritual realm was, by this time, a given. But Baxter went one further than this, and used them as moral exemplars.[99] He told the story of Richard White, a Staffordshire smith, a tale he had been told in his youth by 'most credible and religious persons' (like Glanvill, Baxter is keen to establish the veracity of his accounts). White 'was a prophane Atheistical Man' who denied the existence of devils, but 'in his Cups would wish he could once see the Devil, if there were such a thing'. Sure enough, on 'a clear Moon-shine Night, the Devil in the shape of a great ugly Man, stood by his Bed side'. This terrifying apparition opened the bed-curtains and looked him in the face, smiling horribly. When eventually it vanished, the experience left the smith a changed man – a 'professor of zeal, and strictness in Religion'.[100]

Another story also relates a night-time encounter by a man who 'doth oft fall into the Sin of Drunkenness', but this time his invisible visitor is a concerned spirit that 'knocks at his Bed's head, as if one knock'd on a Wainscot' whenever he went to bed the worse for drink. In this instance, however, supernatural intervention does not bring about the required transformation. Baxter is incredulous, and when he met the man he asked him 'how he dare so sin again, after such a Warning'. The drunkard, however, could offer 'no Excuse'.[101] Baxter adds two afterthoughts to this story – the first is a moral:

> What a powerful thing Temptation and Fleshly Concupiscence is, and what a hardned Heart Sin brings Men to. If one rose from the Dead to warn such Sinners, it would not of itself persuade them.[102]

In the second, Baxter mulls over the nature of this friendly ghost:

> It poseth me to think what kind of Spirit this is, that hath such a Care of this Man's Soul... Do good Spirits dwell so near us? Or are they sent on such Messages? Or is it his Guardian Angel? Or is it the Soul of some dead Friend that suffereth, and yet, retaining Love to him ... would have him saved?

Only God knows, he concludes – yet He 'keepeth such things from us, in the dark'.[103] No matter: Baxter's task, as he saw it, was not to provide an explanation, but to unfold a series of dreadful warnings like a series of sermons, with the intention of making the reader mend his or her ways. The stories 'should warn all', he writes, 'to take heed, that they be not helpers and servants to Devils', because, 'O!', he exclaims, 'what an Army hath Satan, for his work of destroying Souls'.[104] To read about apparitions in Baxter's forceful telling is the next best thing to being visited by one – in this moral framework, the story itself has become a proxy for a haunting.

III

GHOSTS
for a
NEW
AGE

All argument is against it; but all belief is for it

DR JOHNSON

7. 'STRANGE AND WONDERFUL NEWS'

While Joseph Glanvill, Richard Baxter and other men of the cloth were earnestly relating accounts of apparitions in order to prove, once and for all, the existence of a spiritual world and to exhort their readers to lead more godly lives, others were simply gathering around the fire to enjoy telling, and listening to, ghost stories.

On 8 April 1661, Samuel Pepys enjoyed a convivial evening with friends at the home of Sir William Batten, Surveyor of the Navy, at his official residence, Hill House in Chatham: 'supped very merry,' he recorded in his diary, 'and late to bed'.[1] During the course of the evening Sir William had told Pepys that his predecessor as Surveyor, Kendrick Edisbury, had died in the room in which he was to sleep that night, and was said to haunt it. The thought 'did make me somewhat afeared,' Pepys admitted to his diary – 'but not so much as for mirth sake I did seem', he added. Initially all was well:

> till 3 in the morning, and then waking; and by the light of the moon I saw my pillow (which overnight I flung from me) stand upright, but not bethinking myself what it might be, I was a little afeared. But sleep overcame all, and so lay till high morning ...

An account like this, relating a particular instance of the mind playing tricks, is something with which most of us can identify, whether or not we would care to admit it; but Pepys's diaries also give a vivid sense of how the idea of ghosts was woven into the fabric of his life and that of his friends and acquaintances. He records a number of evenings spent talking about them. Sometimes it was in a spirit of analysis, as in June of 1663 when both 'at and after dinner' with colleagues there were 'great discourses of the nature and power of Spirits and whether they can animate dead bodies' – Lord Sandwich was 'very scepticall', and Pepys was inclined to agree.[2] At other times he seems simply to have enjoyed entertaining his friends, as when in September of the same year he told three stories of 'Spiritts' 'to their good liking'.[3] On another occasion, in March 1669, after

supper he and his friends 'fell to talk of spirits and apparitions', frightening each other so much with the 'pretty perticular stories' they told that Pepys admitted to being 'almost afeared to lie alone' that night.[4]

Pepys was curious about ghosts, was genuinely interested in what they were, and loved telling and hearing stories about them. They were part of his mental furniture, and his accounts of evenings spent telling stories suggest that many such were in circulation in middle-class, professional and aristocratic circles alike: Pepys and his friends evidently enjoyed the frisson of fear that a good ghost story produced. It is tempting to suppose that the published accounts of ghosts so earnestly offered by divines as proofs of the existence of a spiritual world were, in the last decades of the seventeenth century, co-opted as entertainment.

Pepys's fondness for ghost stories and his passion for music dovetailed in his enthusiasm for ballads, which he began to collect in earnest in the 1680s, buying them in bulk from specialist printers.[5] They came in the form of 'broadsides', sheets of paper measuring about 10 × 12 inches (25 × 30 cm), printed horizontally with text on one side only.[6] Broadsides were the tabloids of their day, bringing not only songs but also information, frequently of a sensational nature, to a large audience. For just a penny or two, one could buy all sorts of 'strange and wonderful news', as it was often termed: accounts of epic sea-battles, fantastic rains of wheat, duels between noblemen, terrible earthquakes, giants and other prodigies of nature, exploits of highwaymen, executions, dreadful storms, and tales of other remarkable signs and wonders.

Broadsides, alongside chapbooks (small, popular booklets), almanacs, pamphlets and other cheap printed sheets, were extraordinarily popular in the second half of the seventeenth century, and huge numbers were produced.[7] 'What Age ever brought forth more, or bought more Printed Waste Paper?' complained one pamphleteer in 1681.[8] Only a tiny proportion of these sheets, however, has survived in comparison to more valuable caricatures and political satires – the survival rate for prints tending to be in inverse proportion to the numbers originally produced. An ephemeral news-sheet or a ballad printed on poor-quality paper, which would be passed from hand to hand as it was read and sung from, and then perhaps pinned up on the wall (indeed, one broadside illustrates ballads decorating a privy), had little chance of survival beyond a few months or years. A detailed, hand-coloured caricature print, on the other hand, of which

far fewer impressions would have been made, was more likely to be valued and preserved, protected by a frame or by the covers of a portfolio.

The dramatist Thomas Holcroft recalled that during his childhood in the mid-eighteenth century:

> Even the walls of cottages and little alehouses … had old English ballads, such as Death and the Lady, and Margaret's Ghost, with lamentable tragedies, or King Charles' golden rules, occasionally pasted on them. These were at that time the learning, and, often, no doubt, the delight of the vulgar.[9]

Ballads were a particularly ubiquitous variety of broadside, their popularity partly due to the scope they enjoyed: they covered topics from politics to love, and ghosts were much in demand. And unlike the clergymen who were compiling stories of the supernatural at the same moment, balladwriters knew exactly what apparitions were; they were, without doubt, the restless souls of the dead.

The ten principal headings under which Pepys arranged his ballad collection give an overview of the subjects with which they were preoccupied: '1 – Devotion & Morality; 2 – History – True & Fabulous; 3 – Tragedy – vizt. Murdrs. Executns. Judmts. Of God. &c.; 4 – State & Times; 5 – Love – Pleasant; 6 – Lo[ve] … Unfortunate; 7 – Marriage, Cuckoldry &c.; 8 – Sea – Love, Gallantry, & Actions; 9 – Drinking & Good Fellowshipp; 10 – Humour, Frollicks &c mixt'.[10] Ghosts were wont to feature in at least half of these categories, their association with the strongest emotions and most meaningful events of life – love, courtship, betrayal, death and justice – making them irresistible to ballad-writers.

Love of the 'Unfortunate' kind naturally provided the most common habitat for ghosts. A ballad in Pepys' collection, *Two Unfortunate Lovers, Or, A true Relation of the lamentable end of John True and Susan Mease*, printed in the mid-1680s, relates a dramatic story of love and death. It tells of a shoemaker from Coventry, John True, who fell in love with a local maid. Wary of his professions of love, Susan initially treated him coolly, until he convinced her of the depth of his feeling; at last she agreed to give him 'my hand, my heart & love', assuring him that her love was 'constant firm and true'. Having won Susan's trust, however, John cruelly betrayed her: he 'went and wooed another Maid, / which griev'd her heart full sore'. As a result of his faithlessness, poor Susan

died of grief, or was 'kill'd with loving him', as the balladeer melodramatically put it. When he heard the news, John was overcome with grief and remorse: 'When as her lover understood, / for truth that she was dead, / He rag'd, and ready was to tare / the hair from off his head.' He lay down on her grave and confessed his love for her, whereupon Susan's ghost spoke to him:

> ... as he lay upon the ground,
> he heard a voice to say,
> *John True, if e're thou lov'dst me dear,*
> *make hast and come away.*
> Then started he up from the grave,
> and stood like one struck dumb,
> And when he had regain'd his speech,
> he said, *I come, I come.*

The grief John then felt mirrored hers: 'And thus with sorrow and grief of heart / he lay a whole fortnight'; and, like Susan, he died of it: 'when he had confest his fault, / he yielded up his spirit.' The balladeer completes the song with the following advice: 'You youngmen all that have true loves, / be sure unto your friend, / And if you love, be sure your love, / be true unto the end'.[11]

Another ballad in Pepys' collection, *A Godly Warning for all Maidens* (1686–8), tells a somewhat similar tale (although told from the perspective of the opposite sex), but with a darker denouement. It concerns a young man called Bateman who intended to marry a beautiful woman from Clifton in Nottinghamshire, and they made solemn vows to love each other truly. She proved, however, to be fickle. After a mere two months had passed she broke off the engagement in order to marry a German widower – 'Because he was of greater wealth, / and better in degree'. Heartbroken, on the day of the wedding Bateman 'hang'd himself in desperate sort, / before the Brides own door'. So sorrowful and troubled did this make her that 'wheresoever she did go, / her fancy did surmise, / Young *Batemans* pale and ghastly Ghost / appear'd before her eyes'. Things only got worse. Even while lying in her husband's arms in bed – or perhaps especially then – she was wont to hear 'Great cries & grievous groans', and a voice that threatened to keep her to the promise she had broken, that cried: 'O thou art she that I must have; / and will not be denay'd.' For some time she was 'Preserved from the spirits power' because she was expecting a baby, but as soon as she had given birth

the danger became immediate. So afraid was she that she asked friends to stay with her, because, she predicted:

> Out of the bed, quoth she this night,
> I shall be born away.
> Here comes the spirit of my love,
> with pale and g[h]astly face,
> Who till he bear me hence away,
> will not depart this place:

But even in the throes of terror, the woman acknowledged the awful justice of the situation, exclaiming: 'Alive or dead I am his right'. Her friends tried to help by sitting up in her chamber, but sleep overcame them, and 'that woful night' the woman 'from thence was born away'. As with the *Two Unfortunate Lovers*, the ballad concludes with a moral:

> You Maidens that desire to love,
> and would good Husbands chuse,
> To him that you have vow'd to love
> by no means do refuse.[12]

By framing the issue in heightened, supernatural terms, creating a world in which lovers' vows are eternally binding and falsity has dire consequences for all concerned, the balladeers bring dramatic shape and excitement to otherwise commonplace stories. They are also able to tie it all up neatly by pointing a moral that had universal relevance: 'Here is a lesson to be learn'd', warns the author of *A Godly Warning for all Maidens*.

What is remarkable is the ways in which the ghosts' roles are imagined. Susan and young Bateman are each transformed by their deaths: from being the helpless victims of unscrupulous lovers they were in life, they become powerful agencies. Death confers authority upon them, enabling them to turn the tables on their betrayers with a siren call – which they either exercise gently, as with Susan Mease, whose ghost seems to speak lovingly to John True, or vengefully, as with young Bateman. These ghosts have been forged by death into agents of emotional justice. Their misfortune has given them the power to tackle the sort of wrongdoing that, being of no interest to worldly authorities, would otherwise go unpunished.

A Godly Warning for all Maidens has an additional religious dimension. In the final lines, God Himself is evoked: 'For God that hears all secret oaths, / Will dreadful vengeance take, / On such that of a woeful vow, / Do slender reckoning make.' God – encountered here in decidedly Old Testament mood – is imagined as supplying a further and absolute layer of moral justice that condones the ghost's actions. This concept of the spiritual dimension which ghosts inhabit is given visual expression by an illustrative woodcut. Bateman, dressed in a shroud tied up at the top of his head and carrying a lighted taper, approaches the marital bed in which his erstwhile lover lies with her husband. As though in a comic strip, in another part of the image a terrible, if somewhat ungainly, devil with horns, wings and a great goggle-eye flies away with the woman clutched in his claws like a stiff doll (*fig. 16*).

The ballad-ghost's role as an agent of justice also extended to uncovering murder and punishing those responsible; Pepys' category number three ('Tragedy – vizt. Murdrs. Executns. Judmts. Of God. &c.') was also richly populated with apparitions. One of the most popular and lurid murder-ballads was *A New Ballad of The Midwives Ghost*, published in 1680 (*fig. 17*). The ballad itself is preceded by a summary of the story that seeks to establish its credentials. We learn that the ghost of the midwife:

> appeared to several People in the House where she formerly lived in Rotten-Row in Holbourn, London, who were all afraid to speak unto her; but she growing very Impetuous, on the 16th of this Instant March, 1680, declarred her mind to the Maid of the said House, who with an Unanimous Spirit adhered to her, and afterwards told it to her Mistris, how that if they took up two Tiles by the Fire-side, they should find the Bones of Bastard-Children that the said Midwife had 15 years ago Murthered, and that she desires that her Kinswoman Mary should see them decently Buried; which accordingly they did, and found it as the Maid had said. The Bones are to be seen at the Cheshire-Cheese in the said place at this very time, for the satisfaction of those that believes not this Relation.[13]

This confession by the conscience-stricken ghost, backed up by the sensational discovery of bones, and all expressed as a true experience, gives a vivid new dimension to the ballad-story. No doubt the grisly display at

Ye Olde Cheshire Cheese helped to sell copies – the fact that this public house was on Fleet Street, the centre of London's printing and publishing industry, was surely no coincidence.

Another ghost with a guilty conscience features in *Strange and Wonderful News from Northampton-shire, OR, The discontented Spirit*, a ballad printed in a chap-book of 1675. Despite having died 267 years previously, the ghost was still so beset by the pangs of guilt for having stolen a sum of money that it appeared to a farmer and instructed him to help set things right: 'Prepare and go thy ways (said he) / to Southwark Ile be thy guide; / To such a house to set things strait, / which I so long ago did hide.' The ghost explained to the farmer that if he looked in a particular cellar he would find 'Some money and some writings too', and instructed him to give these things to the 'right owner', reassuring him that 'Ile be with thee the place to shew'. The ghost watched the farmer dig in the cellar, ensuring that he did not make off with the loot. The handover to the rightful owner's descend-ants having been effected, 'the spirit vanished away / Unto the place from whence it came', and was seen no more, its conscience assuaged. In time-honoured fashion, the balladeer points a moral:

> Thus friends and neighbours you do see,
> that wilful murther will come out,
> Thou it be done nir [ne'er] so long ago,
> yet time and years will bring it about.

Ghosts, being out of time, are part of an absolute system of justice that is not affected by the incremental passage of years that dulls human memory and conceals the evidence of crimes. This is, of course, intended as a warning, and the ballad ends with the following message:

> Therefore lets fear the Lord on high,
> that we may be of the flock which Christ hath blest,
> And then we need not fear to dye,
> our souls no doubt will be at rest.[14]

But despite this somewhat superficial Christian gloss, the story essen-tially presents a secularised idea of crime and punishment. Although there are parallels here with some medieval ghosts, like the poor Canon

of Newburgh troubled with the theft of silver spoons, the ballad makes no mention of hell and damnation being contingent on bad deeds, but suggests that a troubled conscience will prevent a person's spirit from resting. The ghost in this ballad, who has been tormented with anxiety for so many years, is held up as a warning: you don't want to end up like him.

As they are represented in ballad form, ghosts, far from being disruptive, as in Glanvill's book, were quite the opposite: their role was to put things in order that had been thrown into disarray. As the souls of the dead who had either been wronged or had transgressed, they represented a spiritual authority that was evidently felt to coexist comfortably with Christian doctrine, and to reflect divine order. And, satisfyingly, ghostly authority was seen to trump that of earthly power. Ghosts signally looked after children, the poor, the good-hearted, the marginalised – all those who were particularly vulnerable to wrongdoers in life.

Should we think of ballad-ghosts as broadly following most people's beliefs in the late seventeenth century? Perhaps not entirely – the ballad was, after all, a highly conventional literary form with its own rules, and one that had to appeal to the taste and fulfil the expectations of a wide audience in order to sell copies, much like tabloid newspapers today. Ghosts were re-invented as puppets, stock figures who played out conventional scenarios over and again. It might, in fact, be better to think of it the other way around. Accounts that people gave of 'real' encounters with ghosts often hinged on the self-same issues that were so often found in ballads – ghosts making appearances in order to reveal terrible crimes, or to prevent miscarriages of justice. In 1660, for example, the ghost of one Robert Parkin was reported to have appeared in the parish church at Appleby, crying out: 'I am murdered I am murdered I am murdered' – which was enough for the Justice of the Peace to launch an investigation into his death.[15] And when the second wife of Sir Walter Long tried to have his son by his previous marriage disinherited, his dead first wife was said to have placed her disembodied 'fine White-hand' repeatedly between the parchment and the candle as the clerk tried to draft the legal document. He soon gave up the attempt.[16] Sometimes the ghosts of the recently deceased appeared simply to mention to a member of the family that there was some money concealed in a jar on the top shelf. Had the sorts of ghosts that people reported having seen habitually indulged in any of this sort of helpful activity, whether of a legal or simply of an administrative nature, before balladeers invented it as

a role and published it in ubiquitous broadsheets? Or was it an instance of life imitating art?

Broadsides were often decorated with appealing wood-cuts. Although some were produced especially for a particular narrative, many were not descriptive in the way we expect illustrations in books to be; often printed from wood-blocks made for an earlier story and re-used, they were frequently tangential or even frankly inappropriate. A telling example is a bawdy ballad of the late seventeenth century, *Love in a Mist*, illustrated with images which include a fifteenth-century devotional picture of the Visitation, showing the Virgin Mary and St Elizabeth, the mother of John the Baptist, decorously hugging each other, giving thanks that they are both soon to give birth.[17] It was, presumably, enough that the print represented an embracing couple. There was an unsentimental practicality about broadside production; wood-cuts announcing executions generally had a cut-out section underneath the gallows that allowed them to be re-used: small blocks ready engraved with the appropriate number of hanging figures – cut-and-paste corpses – could simply be slotted into position as required.

Broadside ballads with a ghost theme, such as *A Godly Warning for all Maidens* and *The Midwives Ghost*, use similarly stock iconography: they depict ghosts full-length, shown from the side, and wearing voluminous shrouds tied up in a bunch at the top of the head but loose at the feet to facilitate movement, and with schematically represented faces visible in profile. Almost invariably they carry a burning torch with one hand and gesture or point with the other. As was usual in broadside production, this ghost-image was used whether or not it illustrated the details of a particular ballad. In the case of *The Midwives Ghost* it patently did not, as the ballad emphasises the extraordinary diversity of the midwife's appearance, ranging from how she looked in life (presumably wearing her ordinary clothes) to a vision of hell. The apparitions described in the story are 'very strange / The like whereof hath not been seen: / Sometimes resembling of her shape, / At other times Hells mouth to gape'.[18] Nevertheless, the stock image of the ghost was pressed into service.

This emblem was convenient visual shorthand: the ghost's simple costume and prop made its identity clear and unmistakeable, and as a result it was copied from one print to another. This way of representing

a ghost developed partly because of the particular printing technique used for broadsides. These prints were mostly made by cutting an image into the plank-side of a block of wood, leaving the area to print black standing in relief and chiselling away the areas not to be printed. The relative softness of the plank (unlike the harder end-grain) made it difficult to engrave in detail, so, unless in very skilled hands, it tended to lead to relatively crude images. The heavy, vertical folds of the ghost's pronounced drapery, its schematic form and stick-like arms were all ideally suited to this printing method, and perhaps even arose in part as a result of its particular constraints. A more amorphous form of spectre – a transparent one, for instance – would have presented the wood-cutter with serious technical problems. This simple, practical convention adopted by illustrators and publishers formed a shorthand for what ghosts looked like – one that prevailed until the late eighteenth century.

8. TRUE RELATIONS AND DIVERTING HISTORIES

Anyone walking down a busy city street in the early years of the eighteenth century would have been assailed by a profusion of printed ephemera. If that person were browsing through a box of such material on a late summer's day in 1706, he or she might have picked up a slender pamphlet with the title *A True Relation of the Apparition of one Mrs. Veal, the next Day after Her Death: to one Mrs. Bargrave at Canterbury, the 8th of September 1705* that had recently been printed by B. Bragg at the sign of the black raven in Paternoster Row. It was anonymous, as most such pamphlets were, and there was nothing remarkable about its appearance. Even so, it was a landmark in the history of the ghost story – and it became hugely successful, going into numerous editions. The tale within was almost certainly written by Daniel Defoe, one of the most versatile and innovative of English writers (he was also, at various times, a hosiery merchant, a keeper of civet cats, the owner of a brickworks, a journalist, a literary editor and a spy). By the time of his death, Defoe had written some 560 books, pamphlets and journals on subjects ranging from politics and religion to sexual adventuresses and shipwrecks – and he has a good claim to having invented the novel. It was really only a matter of time before he tackled the topic of ghosts.

From the outset, Defoe makes it clear that he is doing something new with *A True Relation* – he is addressing not the sensation-hungry, ballad-consuming masses but a sophisticated and educated readership. 'This thing is so rare in all its Circumstances,' he begins, 'and on so good Authority, that my Reading and Conversation has not given me any thing like it; it is fit to gratifie the most Ingenious and Serious Inquirer.' He then goes on to claim Mrs Bargrave, one of the protagonists, as his 'Intimate Friend' and to assure the reader that he, personally, is able to vouch for her reputation.[19]

As told by Defoe, the story of Mrs Veal's apparition was a far more sober affair than those that fuelled ballads and sensation-sheets. It told the tale of Mrs Bargrave, who was sitting sewing at her home in Canterbury one day when, at noon, there was a knock at her door. To her great surprise, her visitor was a childhood friend, Mrs Veal ('a very Pious Woman'), whom she had not seen for a long time.[20] When Mrs Bargrave rose to greet Mrs Veal, the latter would not kiss her, explaining that she was unwell, and drew her hand across her eyes. Nevertheless, they sat and talked for nearly two hours in their old friendly way, although Mrs Veal frequently repeated her gesture of raising her hand to her face, and even asked Mrs Bargrave if she thought her appearance had been affected by the 'fits' to which she was prone. Her friend replied 'No ... I think you look as well as ever I knew you.'[21] They spoke in particular of the comfort they both derived from a devotional book, *The Christian's Defence Against the Fears of Death* by Charles Drelincourt, Mrs Veal remarking to her friend that the author 'had the clearest Notions of Death, and of the future State, of any who had handled that Subject'.[22] Mrs Veal then asked Mrs Bargrave if she would write to her brother and ask him to disburse some rings, a 'Purse of Gold' and 'Two Broad Pieces' (gold coins each worth twenty shillings) in her possession, which after some hesitation her friend promised to do.[23] Eventually Mrs Veal got up to leave, and 'walk'd from Mrs *Bargrave* in her view, till a turning interrupted the sight of her'.[24] It was only later that Mrs Bargrave discovered that Mrs Veal had died of a sudden fit at noon the previous day, and that her visitor had not, in fact, been her old friend – but her ghost.

What is most striking about the tale is what is absent. In contrast with the stories gathered by Restoration divines and the dramatic accounts found in broadsides and chapbooks, here Defoe draws no moral. If anything, his tale resembles one of John Aubrey's narratives in that it is essentially

mysterious, appealing more to a reader's sense of wonder than their love of sensation. Defoe simply ends the tale by remarking on how affected he, personally, has been by it, and asking, somewhat defensively, 'why we should dispute Matter of Fact, because we cannot solve things of which we can have no certain or demonstrative Notions'.[25] This is Enlightenment reasoning: it is, he says, illogical to dismiss things simply because we do not know about them.

Defoe was a master of narrative, and *A True Relation* captures the reader's attention at the outset with an intriguing back-story of how both women had suffered parental neglect or unkindness as children, when they had offered comfort to each other. This gives an emotional dimension to their meeting: as readers, we want to know what these women will say to each other, and their conversation when they first meet has a psychological plausibility new to the genre. Above all, *A True Relation* is perhaps the most dignified of supernatural stories. Defoe's plain tale of two pious, respectable women earnestly discussing the merits of religious texts makes the histrionics of much contemporary popular literature appear absurd by comparison.

The strange story of Mrs Veal's ghost had been in circulation since the beginning of 1706, an account of it having first been published in the *Loyal Post* on Christmas Eve 1705 (an early instance of the ghost story served up as Christmas fare); Defoe evidently saw its potential as a saleable narrative and seized upon it.[26] There was a particular reason for his alacrity. In 1706, when he wrote the tale, he was in desperate need of funds, owing over £2,000 and fearing that he would, not for the first time, be imprisoned for debt.[27] At such a time, Defoe must have been particularly alert to commercial opportunities. Moreover, Mrs Veal's vigorous promotion of Drelincourt's *The Christian's Defence Against the Fears of Death*, a book first published in France in 1651 but going in translation through numerous editions in England over ensuing decades, appears to be a pioneering instance of what we would now call product placement. Its prominent inclusion seems to have been the result of a deal made by Defoe with its English publishers in advance of a new edition of Drelincourt, brought out in that same year, 1706, and indeed some later editions of *A True Relation of the Apparition of One Mrs. Veal* are even subtitled '*Which apparition recommends the perusal of Drelincourt's book of consolations...*'. In the context of Defoe's purportedly true story, the ghostly Mrs Veal's sincere endorsement of the book's representation of the afterlife – it 'was the best she said on that Subject, was ever Wrote' – was gold dust for its publisher.[28]

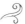

Twenty-one years after the publication of *A True Relation*, Defoe returned to the subject with *An Essay on the History and Reality of Apparitions*, published under the pseudonym Andrew Moreton.[29] This book re-shaped the subject for a new age. At first glance, however, it seems almost old-fashioned – did it not sound like the kind of tract that had been published some forty or fifty years earlier? But, as Defoe points out in his preface, it is precisely because of the particular intellectual tenor of the times that such a book was necessary:

> Between our Ancestors laying too much stress upon [apparitions], and the present Age endeavouring wholly to explode and despise them, the World seems hardly ever to have come at a right Understanding about them.[30]

It was a question of balance. Defoe perceived a similar lack of equilibrium in people's attitudes; they seemed either to be at one extreme or the other. Nowadays, he remarks, men and women either 'despise [apparitions] in such an extraordinary manner ... as if nothing but seeing the *Devil* could satisfie them there was such a Person' (here he indulges in a brief but evidently satisfying digression upon what it would be like if the devil did appear, 'in full Grimace', to frighten these bold unbelievers); or, on the other hand, they are 'so horribly frighted at the very mention of an Apparition, that they cannot go two Steps in the dark'. The question, therefore, was 'How to bring the World to a right Temper between these Extreams'? Defoe promises to allow the light of reason to flood in upon the question: 'if setting things in a true light, between Imagination and solid Foundation, will assist towards it, we hope this Work may have some Success', he says. Restoration polemic was old hat: Defoe tells us that he will not even attempt to 'argue for the Reality of Apparition. Let Mr. Glanville and his Antagonists, the Hobbists and Sadducees of those Times, be your Disputants upon that Subject'.[31] He presents his authorial position as one of balance, enquiry and rational scepticism – framed by religious doctrine, but not driven by it.

An Essay's tone is direct, conversational and urbane – ''tis too grave for the Times', Defoe remarks at one point, having raised the question of Angelic appearances, 'and as we are not writing Divinity, I shall not

load you with serious Points'.[32] He pitches the book squarely at a sceptical, educated readership and is careful to emphasise how much nonsense is spoken on the subject of apparitions, remarking that 'our Hypochondriack People see more *Devils* at noon-day than Galilaeus did Stars'. 'But', he continues, 'this no ways Impeaches the main Proposition, viz. That there are really and truly Apparitions of various kinds...'[33]

One kind Defoe was less keen to credit are those that were 'vulgarly called Ghosts, that is to say, departed Souls returning again and appearing visibly on Earth'. He firmly dismisses the ghost of the popular imagination, so familiar from ballads, and pours cold water over the 'Doctrine of disquiet Souls returning hither, to do or obtain Justice, to make or demand Restitution, and that they could not be at rest 'till such and such things were settled, Wills perform'd, dispossed'd Heirs righted, conceal'd Treasons discover'd, conceal'd Treasures found out'. This kind of thing, he went on, 'were it true, would make the World uninhabitable: Ghosts and Apparitions would walk the Streets at Noon-Day; and the living might go on one side of the Street, and the dead on the other; the latter would be infinitely more numerous'. It would be administrative chaos. 'Nothing', he concludes, 'can be more preposterous than such a Notion'.[34] He subscribes instead to a more intellectually respectable idea of spirits that can 'take up the Shape of the Dead as well as of the Living', up to and including 'the very Cloaths, Countenances, and even Voices of dead Persons'.[35]

For the author of a book about the reality of apparitions, Defoe spends a great deal of time pointing out that most sightings are imaginary. They are mostly conjured up, he argues, by the workings of our consciences:

> CONSCIENCE, indeed, is a frightful Apparition itself, and I make no Question but it oftentimes haunts an oppressing Criminal into Restitution, and is a Ghost to him sleeping or waking ... Conscience makes Ghosts walk, and departed Souls appear, when the Souls themselves know nothing of it.[36]

Defoe, of course, is not merely concerned with making statements. In order to illustrate and dramatise his points, he tells stories – lots of them; and rather than corralling them into separate sections, he weaves them into the fabric of the book. 'I Have heard a Story which I believe to be true', he continues at this point. This particular story concerns a man

who was taken to court on suspicion of murder. A number of witnesses came forward and testified, but although he was guilty, nothing other than circumstantial evidence emerged against him. The trial was drawing to a close, and there were no further witnesses to examine. In a few moments, the defendant would be acquitted; but suddenly:

> he gives a Start at the Bar, as if he was frighted; but recovering his Courage a little, he stretches out his Arm towards the Place where the Witnesses usually stood to give Evidence upon Tryals, and pointing with his Hand, My Lord, says he, (aloud) that is not fair, 'tis not according to Law, he's not a legal Witness.

What the defendant had seen, of course, was the ghost of the murdered man at the witness's stand. No-one else was aware of it, but the judge, instantly divining what the defendant thought he saw, calmly spoke as though the apparition were indeed present, and as though it were about to give evidence. The defendant replied to the judge by saying: 'Nay, if you will allow him to be a good Witness, then I am a dead Man.' Because he looked as though he was about to collapse, he was brought a chair, and 'as he sat down he was observed to be in a great Consternation, and lifted up his Hands several times, repeating the Words, *a dead Man, a dead Man*, several times over'. Seizing his moment, the judge then exhorted him to confess and even read him a text from the Bible, upon which 'the self-condemn'd Murtherer burst out into Tears and sad Lamentations for his own miserable Condition, and made a full Confession of his Crime', explaining that he saw the man he had murdered standing right there in the court, ready to speak out and 'staring full upon him with a frightfull Countenance', which confounded him – 'as well it might', adds Defoe. 'And yet', he continues, 'there was no real Apparition, no Spectre, no Ghost or Appearance, it was all figur'd out to him by the Power of his own Guilt, and the Agitations of his Soul, fir'd and surprised by the Influence of Conscience'. The man was, he concludes, 'tortur'd with the Terrors of his own Thoughts, haunted with the Ghosts of his own Imagination'.[37]

Defoe's manner of telling the tale is strikingly dramatic: he uses dialogue to bring it alive and includes details, such as the bringing of a chair for the defendant, to build up a plausible situation. An illustration by the London engraver Jan van der Gucht, a friend of William Hogarth,

accompanies the story, showing the 'ghost' appearing in the courtroom (*fig. 18*). He trails extravagant billows of smoke, from which only his bare head emerges, and despite this extraordinary manner of appearing he is apparently undetected by everyone but the defendant. The apparition scowls fiercely over his cloud at the man in the dock, who responds in terror, throwing his hands in the air and stepping back in consternation (as far as his shackles will allow), while everyone else stands around unconcernedly chatting to each other.

One of the lengthiest stories in the book – which Defoe enticingly announces as a 'very diverting History' – is of a different nature, about the apparition of a good angel who appeared in order to prevent a sexual liaison from taking place. It concerns a young gentlewoman who had made an arrangement to meet her wealthy suitor alone in an out-of-the-way house (*fig. 19*). As she makes her way across the fields on her way to the tryst (having sent her maid back on some pretext), she meets the minister of the town who tells her frankly that he knows where she is going:

> Come, come, young Lady, *says he*, you can't conceal your wicked Purposes; you have made Mr. ------- an Appointment; he prevail'd on you last Night, and you have now deck'd yourself up with your Ornaments to meet him, and prostitute your Virtue, and your Honour, and your Conscience, all to his corrupt vicious Appetite ...

Mortified, she is forced to turn back; and assuming that her suitor has boasted publicly about their planned liaison she sends him a letter 'full of Reproaches for his vile Usage of her'. On receiving it, the young man is astonished, and tries to discover what had happened. The woman eventually explains that she had been stopped by the minister, who seemed to know exactly what they had intended – an account that the young man, who had been entirely discreet, cannot, of course, believe. Defoe has fun with the drama of their mutual misunderstanding, expressed in witty, punning exchanges of dialogue ('you ought to have scorn'd, if you had been a Gentleman,' she rebuked, 'to give *the Lie* to a Woman'). Defoe – always on the look-out for a saleable tale – even regrets not having the space to tell the story at greater length: 'If I could give you the Entertainment of all the Letters that pass'd between them ... it would make two Acts of a good Comedy'.

Resolving to put the matter to the test, the young man questions the clergyman, who consults his pocket-book and finds that he had been away in London on that particular day. The couple continue to quarrel over the mystery, until eventually the young woman concludes that she must have encountered 'some heavenly Appearance in the Doctor's Cloaths, for I knew not his Face and Voice only, but his very Gown; and if it was a good Angel, I have the more reason to be thankful that he hindred me from running into the Arms of the *Devil*'. Defoe, in turn, concludes: 'This must be certainly one of those Angelick Guards which the God of Nature, in Mercy to Mankind, has placed as a detach'd Body of Spirits to counter-act the Devil, prevent the Arch-enemy seducing his Creatures, and over-whelming the World with Crime'.[38]

Defoe is a hard writer to pin down. In *An Essay* his tone veers from the comic to the serious and back again, and if he begins the book with a plea for balance, he finishes it by poking fun at readers with overactive imaginations:

But above all I would beg my reading merry Friends of the *thoughtless kind* not to be so much surpriz'd at the Apparitions of their own Brain; not to start and be frighted when they first make *Devils* by Day-light, and then see them in the dark; and as they may be assur'd they will hardly ever see any thing worse than themselves, so let them resolve not to be scar'd at Shadows, or amus'd with Vapours; mistaking the *Devil* for an Ass, and tell us of the Saucer Eyes of a Pink-eyed Bear; not fancy they see a Hearse with headless Horses, and take the Night Cart for a fiery Chariot, which one would think they might distinguish by their Noses, unless they will own that their Fear gave them a worse Smell than that of the *Devil*.[39]

In a more serious mood, Defoe argues for the value of stories as evidence of the actual existence of supernatural beings: 'The Possibility however of Apparitions, and the Certainty of a World of Spirits, as I can by no means doubt, so I shall take up none of your own time to answer the Objections and Cavils of other People about it; because I think the Evidence will amount to a Demonstration of the Facts, and Demonstration puts an end to Argument'.[40] But does he expect to be taken seriously here? Perhaps not entirely. At the end of the story of the lovers and the clergyman, he makes the telling remark: 'Be it a Parable or a History, the Moral is the same'.[41] Whatever ghosts are,

he implies, the most important thing about them is what they can tell us about ourselves. The importance of imaginative literature is that it allows the reader to inhabit another person's mind, and to experience their moral dilemmas. Whether a story is factually true is not particularly important – what really does matter is its psychological insights.

In the end, for Defoe it is the telling of stories that counts – and the longer the story, and the fuller it is of suspense, sharp dialogue and incidental detail, the better. While accounts of supernatural occurrences in works by writers such as Aubrey, Glanvill and Baxter are treated like scientific specimens to be placed one by one before the reader, Defoe's tales live and breathe. They grasp the reader by the hand as they tramp along country footpaths, run headlong down city streets or dash upstairs to fetch a book. They weave the supernatural into the ordinary fabric of life – into family arguments, business arrangements, journeys and lovers' trysts. And they sparkle with emotional vignettes: a man in the dock musters all his presence of mind in the face of disaster; a young woman blushes in shame and confusion; a couple energetically quarrel, carried away by the momentum of their own eloquence.

If Defoe had gambled on the popularity of *An Essay on the History and Reality of Apparitions* he was proved right – before he died in 1731 it had gone through three editions, and it was reprinted several more times throughout the century.[42] The age of Enlightenment had evidently not diminished the market for supernatural tales. In the guise of the mercurial Moreton, Defoe's innovation was to re-cast the subject of apparitions to make it palatable to a range of readership that encompassed the credulous and the sceptical alike, while leavening the whole with 'A great Variety of Surprizing and Diverting Examples, never Publish'd before'. In doing so, he invented the ghost story as we know it.

9. CREDULITY AND COMMON SENSE

'Ghosts and Witches, at present, rarely make their Appearance. A better Natural Philosophy has laid these Spirits, and quieted our Church-Yards; where the Ghosts of the Deceased used to frolic and gambol, like Rats in a Cellar'.[43] Or so it seemed in the mid-eighteenth century to a sophisticated and increasingly urban population. The clear light of reason promised to

dispel the shadows of ghosts' natural habitats, and belief in them no longer spoke of piety, as it had in the seventeenth century: it began to have the less desirable connotations of being rustic and poorly educated. Even one of the new era's most popular and widely read books on the subject, Defoe's *Essay* (1727) subjected ghosts to rigorous scrutiny and suggested that most were figments of the imagination

The very architecture of the age seemed calculated to leave no corners in which ghosts could lurk. The new Palladian style for great mansions and country houses and the elegant planning of the neo-classical town-houses of Georgian England looked to the grandeur of Ancient Rome and the rational ideals of the Renaissance. Banishing the quirky, accretive qualities of old houses with their low ceilings, twisting stairs and dark corridors, architects sought instead to create handsome, beautifully proportioned, orderly interiors, brightly lit by big windows. Could ghosts get a toe-hold behind the neatly regular doors of Royal Crescent in Bath, or in the spick and span streets of London's fashionable West End?

Apparitions were not, however, entirely squeezed out by the new fashions sweeping the realm, whether intellectual or architectural. In fact, by the eighteenth century the British had acquired a reputation for a deep-seated belief in ghosts that even the strongest dose of reason would have been hard put to purge. Adopting the literary disguise of 'Ali Mohammed Hagdi', physician to 'his Excellency Cossem Hojah, late Envoy from the Government of Tripoli, in South-Barbary', in 1730 the writer Anthony Hilliar observed that:

> Nothing weakens the Minds, and turns the Brains of the *English* People more than the delusive Horrors which the common Stories of *Daemons* and *Goblins* bring along with them ... If you tell them that a Spirit carry'd away the Side of a House, or play'd at Foot-ball with half a dozen Chairs, and as many Pewter Dishes, you win their Hearts and Assent ... Many of the antientest and finest Seats in the Kingdom are gone to ruin, having been totally neglected and uninhabited for some Ages, on account of their being *haunted*; nay, Whole Towns and Villages have e'er now been depopulated, upon a *white Horse*'s being seen within half a Mile of them, and near a Church-yard in the Night time.[44]

Ghosts certainly maintained a strong presence in the imaginations of even the staunchest advocates of the Enlightenment. In July 1711, in the pages of

his recently founded *Spectator*, Joseph Addison described the site of a ruined abbey near to the house of a friend, which had acquired the reputation of being haunted. His friend's butler had solemnly warned him to avoid walking there after dusk on the grounds that the footman had been 'frightened out of his wits' by a spirit that, he reported, had appeared to him there in the form of a headless horse, and, moreover, a maid had recently been startled into dropping her milk pail by a mysterious rustling in the bushes. Addison sensibly ignored the warning, but was nonetheless susceptible enough to remark that he 'could not but fancy it one of the most proper Scenes in the World for a Ghost to appear in', and even casts himself as a connoisseur of the melancholy atmosphere:

> The Ruins of the Abby are scattered up and down on every Side, and half covered with Ivy and Elder-Bushes, the Harbours of several solitary Birds which seldom make their Appearance till the Dusk of the Evening. The Place was formerly a Churchyard, and has still several Marks in it of Graves and Burying-Places. There is such an Eccho among the old Ruins and Vaults, that if you stamp but a little louder than ordinary, you hear the Sound repeated. These Objects naturally raise Seriousness and Attention ...[45]

But as though catching himself wallowing too enjoyably in his own gloomy thoughts, he briskly concludes: 'and when Night heightens the Awfulness of the Place, and pours out her supernumerary Horrors upon every thing in it, I do not at all wonder that weak Minds fill it with Spectres and Apparitions.' Although understandable, this reaction was, of course, illogical – as, Addison reminds us, we will recall from John Locke's chapter on the association of ideas in *An Essay Concerning Human Understanding*. 'The Ideas of Goblins and Sprights have really no more to do with Darkness than Light', he continues. 'Yet let but a foolish Maid inculcate these often on the Mind of a Child, and raise them there together, possibly he shall never be able to separate them again so long as he lives'.[46]

Earlier that year, and also in the *Spectator*, Addison had opined on the popularity of ghosts on the stage: 'there is nothing which delights and terrifies our English Theatre so much as a Ghost, especially when he appears in a bloody Shirt. A Spectre', he continued, 'has very often saved a Play, though he has done nothing but stalked across the Stage, or rose through

a Cleft of it, and sunk again without speaking one Word.'[47] He might have ruefully cast his mind back to those words when, five years later, his own comedy *The Drummer; or, the Haunted House* – in which a 'ghost' had a very much more active role to play – met with a distinctly muted reception at the box office.[48] Not many heeded the author's cordial invitation:

> Then every evening come in flocks, undaunted,
> We never think this house is too much haunted.[49]

Addison was in a bind. The ghost, of course, had longstanding dramatic credentials and could, if handled sensitively, introduce a powerful – and potentially lucrative – note of awe and solemnity. But could a contemporary play offered to a sophisticated Drury Lane audience still field the kind of ghost that had stalked the stage in late Elizabethan and Jacobean revenge tragedy? Were such ghosts still valid cultural currency in the eighteenth century? Or, to a contemporary audience in a sceptical era, had their histrionics not become rather embarrassing?

Addison's solution was to have it both ways. For his comedy he re-packaged the ghost in a way he hoped would appeal to his audience. The 'ghost', as he revealed in the play's prologue, was not actually a ghost at all:

> Though with a ghost our comedy be heighten'd,
> Ladies, upon my word, you shan't be frighten'd;
> O, 'tis a ghost that scorns to be uncivil;
> A well-spread, lusty, jointure-hunting devil;
> An am'rous ghost, that's faithful, fond and true,
> Made of flesh and blood – as much as you.[50]

The audience was thus invited to enjoy the dramatic spectacle while being in on the joke.

Addison gives the play a veneer of classical respectability by loosely basing the scenario on the plot of the final books of Homer's *Odyssey*. It concerns a soldier, Sir George Truman, who was thought to have been killed in battle but who had, in fact, survived. Many months later he returns home, in disguise, to find his wife surrounded by suitors. One, the London dandy Fantome, has been pretending to be Sir George's drum-beating ghost in order to drive away another, the foppish Tinsel.

Helped by a loyal servant in his confidence, Sir George disguises himself as a conjurer so as covertly to observe his wife's behaviour. Witnessing her virtuous conduct and convinced she still loves him, ultimately the real Sir George makes himself known. He plays the part of his own ghost by beating a drum and thus seeing off the terrified Fantome; and he and Lady Truman are finally reunited.

Nearer at hand, Addison's other source was, of course, the tale of the drummer of Tedworth (see p. 61). The cultural significance of this story was evidently still considerable, even though Glanvill's account of it had first been published in 1667, nearly fifty years earlier, and the events themselves (whatever their nature) had occurred some years before that. The Tedworth story, however, was clearly still so embedded in popular mythology that it was an instantly recognisable reference, and one, Addison evidently felt, worth evoking for its overtones of farce and trickery.

Part of the play's comedy derives from the rustic characters' terrified reactions to the 'ghost', and Addison makes the most of hair-trigger responses that cause people to ascribe a supernatural cause to any minor mishap. In the opening scene, the coachman admits to the butler and the gardener that the disturbance in the house 'makes one almost afraid of one's own shadow. As I was walking from the stable t'other night without my lanthorn,' he continues, 'I fell a-cross a beam, that lay in my way, and faith my heart was in my mouth – I thought I had stumbled over a spirit.' Not to be outdone, the butler responds with a tale of his own, yet more feeble than the coachman's: 'As I sat in the pantry last night counting my spoons, the candle methought burnt blue, and the spay'd bitch look'd as if she saw something.'[51]

Such suffering at the hands of 'ghosts' was not, however, without a remedy. As the foppish Tinsel advises Lady Truman, a spell of London society normally did the trick:

Oh! I have known many a country Lady come to *London* with frightful stories of the hall-house being haunted, of fairies, spirits, and witches; that by the time she had seen a comedy, play'd at an assembly, and ambled in a ball or two, has been so little afraid of bugbears, that she has ventur'd home in a chair at all hours of the night ... 'Tis the solitude of the country that creates these whimsies; there was never such a thing as a ghost heard of at *London*, except in the play-house ...[52]

Away from the play-house, Addison's way of thinking chimed with the tenor of the times: a sceptical attitude to ghosts had become a litmus test for membership of intelligent, urban society. An essayist writing on the subject in the *Gentleman's Magazine* in October 1732 began his article with the remark that 'The Learned and the Vulgar are much divided in their Opinions concerning the Existence or real Appearance of *Ghosts, Daemons,* and *Spectres*' and attributed such belief, in part, to 'a motley Mixture of the low and vulgar Education'.[53] Partly to blame, he thought, was cheap reading matter, which filled its readers' heads with '*Suburbian Ghosts*, rais'd by petty *Printers*, and *Pamphleteers*, and the Apparitions consequent to their *Half-penny* bloody Murders'. But the divide between the educated and the uneducated was not as clear-cut as it might seem; anyone could be the victim of a clever confidence trick. 'The Story of Madam *Veal*', the writer hints darkly, 'has been of singular use to the Editors of *Drelincourt* on Death.' And ghosts were apt to find their way even into respectable books:

> If our Reason sets us above these low and vulgar Appearances, yet when we read of the Ghost of Sir George Villers, of the Piper of Hammell, the Daemon of Moscow, or the German Colonel, mentioned by Ponti, and see the Names of Clarendon, Boyle &c. to these Accounts, we find Reasons for our Credulity, 'till at last we are convinc'd by a whole Conclave of Ghosts met in the works of Glanvil and Moreton.[54]

Sir George Villiers was said to have returned from the grave in 1628, shortly before the murder of his son, the Duke of Buckingham, to issue a warning – did his aristocratic *imprimatur* put a different complexion on matters? The essayist concludes, however, with the reassuringly withering story of Mr Justice Powell, who teased his friend the Bishop of Gloucester for being a 'zealous Defender of *Ghosts*'. Mr Powell told the Bishop that he was lying in bed at about midnight when he was woken by the sound of 'something coming up Stairs, and stalking directly towards my Room. I drew the Curtain, and saw a faint glimmering Light enter my Chamber'. Here the Bishop interjected: 'of a *blue* Colour, no doubt'; 'of a *pale Blue*', confirmed Mr Powell. He then described how 'the Light was follow'd by a tall, meagre, and stern Personage, who seem'd about 70, in a long dangling *Rugg Gown* [one made of coarse woollen cloth], bound round with a broad Leathern *Girdle*; his Beard thick and grizly; a large *Furr*

Cap on his Head, and a long Staff in his Hand; his Face wrinkled and of a dark sable *Hue*'. The bishop interrupted again: 'And did not you speak to it ... There was *Money* hid, or *Murder* committed, to be sure.' 'My Lord, I did speak to it', Mr Powell continued; 'the Answer was ... That *He* was the *Watchman of the Night*, and came to give me Notice, that he had found the *Street-Door* open.'[55]

This deluge of chilly common sense had already begun to affect the demeanour of purportedly real ghosts. In December 1706, Robert Withers, the vicar of the small parish of Gateley in Norfolk, had made the following curious entry in the register of the nearby church at Brisley:

Mr Grove went to see Mr Shaw on the 2nd of August last. As they sat talking in the evening, says Mr Shaw, 'On the 21st of the last month, as I was smoking my pipe and reading in my study between eleven and twelve at night, in comes Mr Naylor (formerly Fellow of St John's College, but had been dead full four years). When I saw him I was not much affrighted, and I asked him to sit down, which accordingly he did for about two hours, and we talked together. I asked him how it fared with him. He said, "Very well." "Were any of our old acquaintances with him?" "No" (at which I was much concerned), "but Mr Orchard will be with me soon, and yourself not long after." As he was going away I asked him if he would not stay a little longer, but he refused. I asked him if he would call again. "No; he had but three days' leave of absence, and he had other business."[56]

The administrative structure of the afterlife suggested by the ghost's phrases 'leave of absence' and 'other business', deriving from the formal culture of institutional life, appeared to have been tightened up even since Don Andrea's experiences of posthumous bureaucracy in *The Spanish Tragedy*. Respectable ghosts no longer, it seemed, appeared like pink-eyed bears or headless horses. Moving as ever with the times, to meet a newly rational age some of them evidently elected to adopt a soberly professional demeanour, and to face the mysteries of the afterlife with a remarkably stoic taciturnity.

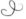

The supernatural *cause célèbre* of the eighteenth century was the Cock Lane ghost. The story began in 1759 when a man called William Kent, along

with Fanny Lynes, the sister of his dead wife, took lodgings with Richard Parsons, who was the clerk of St Sepulchre's Church in the City of London. The house was in Cock Lane, a narrow street near the church. It did not, however, turn out to be a successful arrangement; Kent sued Parsons over an outstanding debt, and the couple moved out, finding new lodgings in Clerkenwell, where Fanny later died of smallpox. Then, in January of 1762, strange sounds started to be heard in the Cock Lane house – knockings and scratchings, which were particularly concentrated in the bedroom of the Parsons' eldest daughter Elizabeth, then aged eleven. Through a system of communication devised by Parsons and the assistant preacher of St Sepulchre's, the 'ghost' spoke through knocks, and identified herself as none other than Fanny Lynes. She claimed, sensationally, that Kent had poisoned her.

The story's effect on London society was electrifying. If 'the Quality' had failed to flock to Drury Lane to see Addison's play, they made up for it at Cock Lane. '[T]he whole town of London think of nothing else', exclaimed Horace Walpole. He described his own visit in a letter to a friend:

> I went to hear it – for it is not an *apparition*, but an *audition* – we set out from the opera, changed our clothes at Northumberland House, the Duke of York, Lady Northumberland, Lady Mary Coke, Lord Hertford and I, all in one hackney-coach and drove to the spot; it rained torrents; yet the lane was full of mob, and the house so full we could not get in – at last they discovered it was the Duke of York, and the company squeezed themselves into one another's pockets to make room for us. The house, which is borrowed, and to which the ghost has adjourned, is wretchedly small and miserable; when we opened the chamber, in which were fifty people, with no light but one tallow candle at the end, we tumbled over the bed of the child to whom the ghost comes, and whom they are murdering there by inches in such insufferable heat and stench.[57]

A small committee was convened to investigate the disturbance, which included Samuel Johnson, who was open-minded on the ghost question, remarking on another occasion that: 'It is wonderful that five thousand years have now elapsed since the creation of the world, and still it is unde- cided whether or not there has ever been an instance of the spirit of any

person appearing after death. All argument is against it; but all belief is for it.'[58] After solemn deliberations at Cock Lane, however, Johnson, writing in the *Gentleman's Magazine*, concluded 'that the child has some art of making or counterfeiting particular noise, and that there is no agency of any higher cause'.[59] Shortly afterwards, the 'ghost' was discovered to be a hoax perpetrated by the young girl at the behest of her father.

Cock Lane crystallised mid-eighteenth-century attitudes. The disdain the fashionable urban elite had for ghost-belief evidently did nothing to diminish their enthusiasm when one was detected. The Cock Lane ghost became the object of fascination and amusement. People treated it, in fact, as though it were a play. The episode triggered an extraordinarily rich creative response, uncovering a surprisingly keen cultural appetite for the supernatural. What was less surprising was the satirical nature of these responses. One of the most direct attacks was made by the anonymous creator of an etching with the title *English Credulity, or the Invisible Ghost in Cock Lane*, dated February 1762 (*fig. 20*). Set in the girl's bedroom at Cock Lane, the composition represents a disparate and voluble crowd, speech-bubbles rising above their heads. Two figures are identified: at the left, the blind magistrate Sir John Fielding exclaims sarcastically, 'I should be glad to see this Spirit', while the actor and playwright Samuel Foote remarks to a nearby clergyman that if it had happened sooner he would have put the ghost into his recent play *The Lyar* – a comment for which he is reprimanded: 'Now thou Infidel dost thou not believe.' A coachman cheerfully predicts that the ghost will be better for business than the recent coronation (referring to that of George III, which had taken place the previous autumn). 'How they Swallow the Hum[bug]', smiles his friend. Meanwhile, one clergyman holds up a pocket-watch and addresses the ghost, 'If a Gold Watch knock 3 times'; while another entreats him not to disturb it, and a third grovels on the floor to peer under the bed by the light of a candle. On the far side of the bed a group of women pray and lament, while the little girl in bed gleefully holds up both hands to demonstrate that she has not been causing the noise herself, beneath a spectral image of the ghost. Whoever the artist was, he or she evidently felt that the events had provoked a good deal of unedifying behaviour.

Writers were equally quick to attack the credulity and trickery exposed by the events at Cock Lane. Oliver Goldsmith published a pamphlet, *The Mystery Revealed*, and Charles Churchill wrote a long poem, *The Ghost*, in which

9. CREDULITY AND COMMON SENSE

he attacked Johnson for his role in the investigation as 'Pomposo, insolent and loud, / Vain idol of a *scribbling* crowd'.[60] Covent Garden revived Addison's *The Drummer* and in March 1762, over at Drury Lane, David Garrick staged *The Farmer's Return*, a play that inverted the traditional idea of superstitious country dwellers by casting the farmer, amused by the credulity of London folk, entertaining his family with a humorous account of his talk with 'Fanny' during a visit to the city. The Royal Academician Johan Joseph Zoffany painted a scene from the play featuring Garrick as the farmer, seated back at home in his parlour and regaling his wife and children, who look suitably astonished (*fig. 21*). A print representing Zoffany's painting was published, circulating the image among a wider public. The cultural ripples set in motion by Cock Lane spread widely.

But by far the most vehement response was one that slotted the Cock Lane 'ghost' into a wider context of so-called supernatural phenomena, and thrust it belligerently back in the public's face as a prime example of their absurd, hysterical folly. The artist was William Hogarth, and his print *Credulity, Superstition and Fanaticism: A Medley* (*fig. 22*), published on 15 March 1762, was an excoriating attack on religious extremism.

Just as in the later sixteenth century Catholicism had, for many English Protestants, become synonymous with superstitious beliefs, so in the 1740s Methodism fostered what its opponents felt to be a worrying degree of interest in ghosts. Its founder, John Wesley, was a rousing and inspiring orator, whose preaching attracted huge audiences, particularly among the working classes. It was all thoroughly alarming to orthodox Anglicans. For Wesley, apparitions and other supernatural phenomena served as evidence of the spiritual realm. Moreover, he claimed to have reason on his side; when asked if he had ever seen a ghost, he responded with unimpeachable rationality. 'No', he replied, 'nor did I ever see a murder. Yet I believe here is such a thing; yea, and that in one place or another, murder is committed every day. Therefore I cannot as a reasonable man deny the fact; although I never saw it, and perhaps never may. The testimony of unexceptionable witnesses fully convinces me both of one and the other.'[61]

In *Credulity, Superstition and Fanaticism* Hogarth represents a non-conformist minister preaching a hell-fire sermon to his congregation from a high pulpit in a Methodist meeting house.[62] Leaning forward, he bellows with such passion that his wig flies off, revealing his tonsured head, a sign that he is a closet Jesuit – the implication being that Methodism was dangerously

close to Roman Catholicism. To his side is a 'scale of vociferation', which ascends from 'nat[ura]l tone' to 'bull roar'; his pitch is described in the words appearing in the gaping mouth depicted at the top, which screams 'Blood blood blood blood'. In each hand the preacher dangles a puppet: in his left a devil and in his right a witch on a broomstick. His pulpit is decorated with models of famous ghosts: the fabled Mrs Veal, Julius Caesar seeing his own apparition in the mirror as he dies, and Sir George Villiers. These representatives of the spiritual realm, of a kind promoted by late seventeenth-century divines, now looked to mainstream Anglicans like a rag-bag of superstitious nonsense.

At the bottom right is another scale, one that rises from a model representing a religious extremist's brain. This thermometer records the brain's excitable states of mind, rising from the lowest, 'suicide', through 'madness' and 'despair', reaching a narrow mid-point with the unpromising designation: *'Luke Warm'*. Above this the excesses soar immediately from 'Love Heat' and 'LUST' to 'EXTACY', thence from 'Convulsion Fits' to 'Madness'. Enshrined in a little cloud, announced by a pair of trumpeting cherubs, is the pinnacle of the religious maniac's passions: 'RAVING'. Perched on top of this contraption are representations of two things at the uppermost of the extremist's mind: the Cock Lane ghost, in the form of a shrouded figure wielding two mallets, next to a bed occupied by a child (that the Parsons family were Methodists played into Hogarth's hands); while surmounting the whole is a model of the drummer of Tedworth, still evidently a by-word for superstition and credulity more than a hundred years after the events themselves had supposedly taken place. Underneath the brain are two books supporting the whole structure, their carefully depicted lettering indicating who is to be blamed for all this. They are 'Glanvil on Witches' and 'Wesley's Sermons'.

Immediately below the pulpit a young couple stand embracing, their erotic transports mimicking the throes of religious ecstasy; he fondles her neck with one hand, and, in a visual pun on 'Cock Lane', slips a phallic model of the ghost down the front of her bodice with the other. To the left are two figures of popular folklore: Mary Tofts, who had supposedly given birth to a litter of rabbits; and the Boy of Bilson, who, in the grip of a feigned demonic possession, spewed iron nails and pins. Behind them, grotesque members of the congregation howl, grimace and gesticulate hysterically as they indulge in fits of religious rapture, while a globe

advertising itself as a 'new and correct' topography of hell – including 'Eternal Damnation Gulf', 'Bottomless Pit' and (in place of Torrid Zone) 'Horrid Zone' – and painted with a goggle-eyed face gaping in fierce despair, is suspended over their heads.

Even by the standards of Hogarth's characteristic trenchancy, *Credulity, Superstition and Fanaticism* is a furious visual rant, one that piles reference upon reference until the detail is all but overwhelming: 'a Medley', indeed. On its publication, the print met with an understandably mixed reception. Alexander Pope's great friend Bishop Warburton, despite being himself a staunch opponent of Methodism, described it as 'a horrid composition of lewd Obscenity & blasphemous prophaneness'. All he could say in its favour was that 'the worst parts of it have a good chance of not being understood by the people'.[63] On the other hand, Walpole admired it, considering Hogarth to have 'exerted his last stroke of genius on the occasion', and praising its 'mixture of humorous and sublime satire, that not only surpassed all his other performances, but which would alone immortalise his unequalled talents'.[64]

Much later, a deeply emotional response to Hogarth's print signalled just how significantly the intellectual tide was to turn over the following decades. John Keats saw it when he was ill and, horrified and distressed by the extremes of human misery and delusion it so mercilessly delineated, called it a 'damned melancholy picture' and claimed that it gave him 'a psalm-singing nightmare'. It even came to represent a yardstick marking the course of his recovery. 'I know I am better,' he admitted, 'for I can bear the Picture.'[65]

IV

TERROR
and
WONDER

10. COME DOWN INTO THE VAULTS

The clear light of reason did not penetrate into every corner of the eighteenth century. There were dark, eerie places where owls shrieked, doors creaked and, if there was a moon, it was usually threatened by dismal clouds. It was an age of melancholy as much as it was one of enlightenment.

The churchyard began to exert an irresistible magnetism for poets. Existing in a space apart from the noisy business of the world, both geographically and spiritually, quiet graves invited solemn reflections on the brief span of human life – on such themes as potential unfulfilled, passions quieted and grandeur overthrown. In literary terms, however, the very peacefulness of the place could hinder as much as it helped. It was all very well to sigh philosophically over the eternal mysteries of mortality and the hereafter – but when it came to orchestrating ideas, was the silent presence of the dead beneath the turf and in the crypt quite enough? With the greatest respect, were corpses not somewhat deficient in dramatic potential?

The poet and clergyman Thomas Parnell came up with a solution in his *Night-Piece on Death*, first published (posthumously, appropriately enough) in 1721. It is night when his protagonist walks through the dark graveyard, thinking of all the 'venerable dead' buried there. 'Time was', he muses sadly, 'like thee they Life possest, / And Time shall be, that thou shalt Rest.' The moon disappears behind a cloud, when suddenly the ground erupts and the dead that occupied his thoughts begin to appear in front of him:

All slow, and wan, and wrap'd with Shrouds,
They rise in visionary Crouds

But these ghosts do not intend to frighten him – rather, they seem eager to chorus his own thoughts: 'And all with sober Accent cry, / Think, Mortal, what it is to dye.' Then another, more authoritative Voice begins to speak,

emanating from the region of 'yon black and fun'ral Yew / That bathes the Charnel House with Dew'; the speaker identifies himself as the 'King of Fears' – Death himself. The Voice delivers a stern admonishment:

Fools! if you less provok'd your Fears,
No more my Spectre-Form appears.
Death's but a Path that must be trod,
If Man wou'd ever pass to God:

Ghosts would not appear to us at all, the Voice suggests, if only we had faith that, parted from the body, the soul would joyfully 'Spring forth to greet the glitt'ring Sun'.[1]

Parnell's supernatural characters vividly dramatise what would otherwise be solitary reflections on mortality and redemption through faith; each of the ghostly voices responds to an aspect of the protagonist's thoughts, whether echoing his fearfulness or interrupting in order to give him a bracing pep talk. But even if Parnell's ghosts turned out only to be symbolic literary devices, the poem's morbid atmosphere was a powerful influence on what would become known as the 'graveyard school' of poetry.

It was more than twenty years after the publication of A Night-Piece on Death that the cultural climate warmed up enough to allow the seeds it had sown to sprout. But when shoots emerged, they took a slightly different form, as though their long duration underground had corrupted them, producing less wholesome organisms. The expression of Christian faith that drove A Night-Piece on Death remained an important element – but as rational argument gave way to the evocation of atmosphere, it was the macabre that came to the fore.

Robert Blair, the minister of Haddington presbytery at Athelstaneford in East Lothian, worked slowly on his long poem The Grave. He had begun it while living in Edinburgh, and when he was ordained in 1731 its prolonged gestation continued. As a minister, Blair was in a difficult position: Scotland's prevailing climate of Calvinism meant that poetry was treated with suspicion, and it was not until the evangelical revival of the 1740s that the fervent expression of emotion became acceptable. Even then, Blair only got The Grave published with difficulty; but when it appeared in 1743, it became an instant bestseller.[2]

10. COME DOWN INTO THE VAULTS

If Parnell's churchyard had been a stage-set for a dialogue between Fear and Faith, with the odd ancient yew and croaking raven wheeled on for effect, Blair's was sticky with mud and musty with decay. He insists that we, the readers, experience visceral sensations of horror, and leads us by the light of a 'sickly taper' through 'low-brow'd misty vaults, / (Furr'd round with mouldy damps, and ropy slime)' from which we instinctively shrink back. And outside there is a gale blowing:

> The wind is up: hark! how it howls! Methinks
> Till now I never heard a sound so dreary:
> Doors creak, and windows clap, and night's foul bird,
> Rook'd in the spire, screams loud ...

This is a place not only of a kind of creeping horror that reaches out to needle the senses, but also a scene of supernatural drama, peopled with 'grisly spectres' that 'rise, / Grin horrible, and obstinately sullen / Pass and repass'. And people tell dreadful stories, of the 'Strange things' that 'have happen'd here':

> Wild shrieks have issued from the hollow tombs;
> Dead men have come again, and walk'd about;
> And the great bell has toll'd, unrung, untouch'd![3]

But however physical they are, Blair's ghosts are not given individual identities; instead, they are puppets in a revolving carousel of horrors, forever going on their mysterious rounds, or else they are the subjects of vague, spine-chilling rumours. If previously ghosts had been imagined as single figures to be reckoned with, in 'graveyard' poetry they multiply promiscuously, joining together to create a richly Gothic atmosphere.

The Grave went through an extraordinary forty-seven editions before 1798. Then in 1805 it was given yet another lease of life when the publisher Robert Cromek approached the visionary poet-painter William Blake and asked him to provide illustrations for a new, deluxe edition of the poem. It is thought that Blake produced twenty large watercolours, of which only twelve were included in the book when it was published in 1808.[4] One of the unused illustrations, The Gambols of Ghosts According with Their Affections Previous to the Final Judgement (fig. 23), illustrates the lines:

Well do I know thee by thy trusty yew,
Cheerless, unsocial plant! That loves to dwell
'Midst sculls and coffins, epitaphs and worms:
Where light-heel'd ghosts, and visionary shades,
Beneath the wan cold moon (as fame reports)
Embodied thick, perform their mystic rounds:[5]

Blake takes Blair's vaporous image and transforms it into a cosmic drama,
fleshing out the 'light-heel'd ghosts' into distinct individuals and dividing
them into two contrasting groups, the saved and the damned. The saved
walk close together in an orderly procession through the churchyard and
into the church porch, heads bowed, wearing spotless white robes. They
carry tall, lighted candles and trays of bread and wine, and one old man
studies a Bible as he walks. But two young spirits look up, startled by the
antics of the damned ghosts, staring in wide-eyed astonishment at the
naked, blue and grey bodies that whirl acrobatically around them, high
over their heads in a great arc. The figures of the damned twist, stretch and
contort themselves, clutching and snatching at each other as they struggle
through their chaotic aerial dance. In the foreground an airborne ghost
tugs insistently at the leg of one who clutches desperately at a tombstone,
reluctant to join the revels, while below them one ghost violently pulls
another up out of a grave by her hair. Created many years after *The Grave*
was first published, Blake's teeming crowds of physically unruly spectres
re-fashion Blair's vision for a new, expressive age.

Ghosts were not confined to poetry; the rise of Evangelicalism also
affected prose, and 'churchyard' thoughts began to colour essays as much
as poems. Travelling in Cornwall in the mid-1740s, the clergyman James
Hervey found himself with time on his hands and decided to stroll down
to the village church. Happily finding the doors unlocked, 'In a Situation
so *retired* and *awful*,' he recalled, 'I could not avoid falling into a Sett of
Meditations, *serious* and *mournfully pleasing*.'[6] Writing it up later in his essay
'Meditations Among the Tombs', he dramatised his visit for his readers,
imagining himself back on the spot. Having looked around the church,
pondering the memorial tablets, he turns his attention to the crypt:

Yonder Entrance leads, I suppose to the *Vault*. Let me turn aside, and
take one View of the Habitation, and its Tenants. – The sullen *Door* grates

upon its Hinges: Not used to receive many Visitants, it admits me with Reluctance and Murmurs. – What meaneth this *sudden Trepidation*; while I descend the Steps, and am visiting the pale Nations of the Dead? – Be composed, my Spirits; there is nothing to fear in these quiet Chambers: 'Here, even the Wicked cease from troubling.'[7]

Having found 'no Phantoms, but such as Fear raises' in the crypt, curiosity prompts him to linger for 'a more *intimate Survey*'.[8] His thoughts then dive into the coffins themselves:

And could we draw back the Covering of the Tomb; could we see, What Those are now, who Once were Mortals – Oh! how would it surprise, and grieve us! *Surprise* us, to behold the prodigious Transformation, that has taken place on every Individual; *grieve* us, to observe the Dishonour done to our Nature in general, within these subterraneous Lodgments!

Here, the sweet and winning *Aspect*, that wore perpetually an attractive Smile; grins horribly a naked, ghastly Skull. – The *Eye*, that outshone the Diamond's Lustre, and glanced her lovely Lightning into the most guarded Heart: Alas! Where is it? Where shall we find the rolling Sparkler? How are all those radiant Glories totally, totally eclipsed![9]

His imagination having roved so intimately over dead faces and bodies, lingering with ghoulish relish on corruption and decay ('the Reptile riots in his Flesh; "the Worm feeds sweetly on Him"'), he now pictures the horror he would feel if a corpse began to move:

Should one of these *ghastly Figures*, burst from his Confinement; and start up, in frightful Deformity, before me: – should the *haggard Skeleton*, lift a clattering Hand; and point it full in my View: – should it open the stiffened Jaws; and, with a hoarse tremendous Murmur, break this profound Silence: – should it accost *me*, as *Samuel*'s Apparition addressed the trembling King ... The *solemn Warning*, delivered in so striking a Manner, must strongly impress my Imagination ...[10]

Hervey's vision of an animated corpse is conspicuously medieval, from its pronounced bodily decay, and its habit of waylaying the unsuspecting

passer-by, to its uncompromising didacticism. This 'haggard Skeleton' is a three-dimensional descendant of the walking corpses of medieval church-wall paintings. But it also has a more contemporary aspect: Hervey imagines it as a species of full-scale mechanical automaton of the kind that was being introduced to English audiences at this moment. A group of such self-moving figures, which included a flute-player and a drummer, had been exhibited to great acclaim as recently as 1742 at the Opera House in London's Haymarket.[11] Its modern descendants – in the shape of grotesque models that jerkily sit up to point a skeletal finger at us as our cars rattle past – populate fairground ghost trains up and down the land.

Like Blair's *Grave*, Hervey's *Meditations and Contemplations* (1746–7), which included 'Meditations Among the Tombs', was phenomenally successful; by 1800 it had been published in twenty-six editions, each of which usually numbered a huge five or six thousand copies.[12] As long as a respectable framework of Christian doctrine was maintained, it seemed that the mid-eighteenth century's appetite for macabre fare, in which ghosts were nearly always on the menu, was a keen one.

Blair and Hervey offered their readers vicarious sensations of visiting musty crypts and dark graveyards. But it was not long before people began to put down their books and to seek thrilling and awe-inspiring experiences in the world around them.

By the light of flaming torches and a full moon, visitors gaze in awe at the soaring Gothic arches of Tintern Abbey. Taking his smartly dressed companion by the hand, a man in the foreground gestures eloquently towards the scene; she leans back to admire it. The torches light the walls fitfully, although the corners remain in deep shadow. The moon casts a silvery light over the ruins, silhouetting the picturesque foliage. On a ledge high above, the tiny figures of a brave couple with their torch-bearing attendant marvel at the view. In the shadow of a column at the left, unseen by the visitors, a pale figure leans. Is it a monument, displaced by the gradual crumbling of its proper setting? Or a ghost?

When Peter van Lerberghe painted this watercolour around 1802, the sensibility displayed by Tintern's visitors was not exactly new; by this time British people had long appreciated the atmosphere of melancholy ruins – and associated these ruins with ghosts. In John Webster's

The Duchess of Malfi (1612–13), Delio tells Antonio:

> Yond's the cardinals window. This fortification
> Grew from the ruins of an ancient abbey;
> And to yond side o' th' river lies a wall,
> Piece of a cloister, which in my opinion
> Gives the best echo that you ever heard
> So hollow and so dismal, and withal
> So plain in the distinction of our words,
> That many have suppos'd it is a spirit
> That answers.

Antonio replies: 'I do love these ancient ruins. / We never tread upon them but we set / Our foot upon some reverend history ...'[13] Later in the seventeenth century John Aubrey examined his response to ruins and put his finger on the particular sensations they inspired: 'the Eie and Mind is no lesse affected with these stately Ruines, then they would have been when standing and entire', he mused. 'They breed in generous Minds a Kind of Pittie: and sett the Thoughts a-worke...'[14] The 'pittie' Aubrey felt was surely an emotional response not only to the ruins but also to their long-dead inhabitants, who could be conjured up in the mind to animate an historical site.

Over the course of the eighteenth century it became fashionable to appreciate ruins. The remains of medieval abbeys that punctuated the British landscape – ruins that had, of course, been created at the time of the Reformation – had a particular appeal for the Georgians. Ideas of sublimity in the landscape began to be discussed in earnest, and the sensation of 'delightful Horror' that one might experience while travelling through wild and lonely landscapes was identified and mulled over. The most influential writer on this subject was Edmund Burke, who in his *Philosophical Enquiry into the Origin of Our Ideas of the Sublime and Beautiful* (1757) acknowledged the range of our emotional responses to the environment. Burke noticed in particular how powerfully the imagination was stimulated by ruins and ancient monuments. Writing of Stonehenge, he observed how:

> those huge rude masses of stone, set on end, and piled on each other,
> turn the mind on the immense force necessary for such a work.

Nay, the rudeness of the work increases this cause of grandeur, as it excludes the idea of art, and contrivance.[15]

It was his experience of the mysterious, the unknown and the awe-inspiring that led Burke to observe that 'dark, confused, uncertain images have a greater power on the fancy to form grander passions than those which are more clear and determinate'.[16] This new understanding of the psychological effects generated by certain landscapes and weather conditions – and the implied presence of the dead at ancient sites – became, in a sense, a self-fulfilling prophecy, affecting how people looked at the world. They began to seek out places that would excite these previously latent sensations.

The evening visitors to Tintern are evidently fashionable tourists in search of sublimity, more interested in enjoying their sensations of awed reverence than in studying architectural detail. Otherwise they would have visited by day. They are responding to what in 1782, in his *Essay on Landscape Painting*, Joseph Holden Pott, the future archdeacon of St Albans, had called 'an awful romantic wildness in the Gothic remains, that moves the mind very powerfully'.[17] If van Lerberghe's watercolour records the events of a particular evening, then someone, mindful of the growing taste for ruins, had cleverly capitalised on the popularity of sublime architecture in general, and the emotional value of Tintern in particular. Neo-classical buildings, based on foreign exemplars, represented reason and order and were very fine, no doubt; but these ruins were British history made visible as well as powerful expressions of spirituality. Like stony ghosts of its own pre-Reformation past, Gothic ruins haunted the land. In the popular imagination, the sublimity of such scenes naturally encouraged notions of long-departed monks and other ghostly figures, the settings and their supposed inhabitants mingling to create an enjoyable frisson.

On 9 March 1765, Horace Walpole wrote to his friend the Rev. William Cole to tell him how his novel *The Castle of Otranto* had taken shape in his imagination:

I waked one morning in the beginning of last June from a dream, of which all I could recover was, that I had thought myself in an ancient castle (a very natural dream for a head filled like mine with Gothic

story) and that on the uppermost bannister of a great staircase I saw a gigantic hand in armour.

That very evening, he recalled, he 'sat down and began to write, without knowing in the least what I intended to say or relate'.[18] The extraordinary 'romance' that rapidly arose from these dreamy foundations, published on Christmas Eve of 1764, is often called the first 'Gothic' novel. As well as a dream of an 'ancient castle', the story was also, as Walpole admitted later, inspired by his own fantastic interiors at Strawberry Hill, the 'little Gothick castle' he had created in Twickenham, complete with turrets and battlements, and with a dim, rarefied atmosphere for which he coined the word 'gloomth'.

The Castle of Otranto is a story about the distant past violently erupting into the present. Walpole, in fact, initially wove an elaborate fiction about the text itself, claiming that it was of remote antiquity and had only recently surfaced in an old library. In his preface to the first edition – and in the guise of the fictitious translator of the 'Original Italian', William Marshal – Walpole describes how the book had been 'printed at Naples, in the black letter [i.e. in Gothic type], in the year 1529' but that it recorded much earlier events, and that: 'If the story was written near the time when it is supposed to have happened, it must have been between 1095, the era of the first crusade, and 1243, the date of the last, or not long afterwards.' That the fictitious library was supposed to belong to 'an ancient catholic family in the north of England' served to add another layer of antiquity by implying adherence to the old ways in a place protected from the desecrations of the Reformation by its remoteness.[19]

The novel begins with a shocking supernatural event: the imminent wedding of the young Isabella to the son of Manfred, Prince of Otranto, is tragically prevented when the bridegroom, Conrad, is found 'dashed to pieces, and almost buried under an enormous helmet' that had mysteriously hurtled into the castle's courtyard. Only momentarily disconcerted, the evil Manfred, fearing the extinction of his line, decides to marry Isabella himself and, to her horror, sets off in pursuit of her. Over the course of the ensuing story, supernatural presences reveal themselves in various forms: a giant is rumoured to stalk the castle; Ricardo, Manfred's long-dead grandfather, heaves a 'deep sigh', steps out of his painted portrait 'with a grave and melancholy air' and trudges off down a gallery (fig. 24); and a cowled figure

slowly turns to reveal its face to be 'the fleshless jaws and empty sockets of a skeleton'. The vaults of the ancient castle of Otranto itself, where Isabella seeks sanctuary, seem to stir and breathe:

> The lower part of the castle was hollowed into several intricate cloisters … An awful silence reigned throughout those subterranean regions, except now and then some blasts of wind that shook the doors she had passed, and which grating on the rusty hinges were re-echoed through that long labyrinth of darkness.[20]

Just as the story itself was inspired by architecture, whether the 'ancient castle' of Walpole's dream or his own elaborate medievalist confection at Strawberry Hill, so in *Otranto* the interior spaces contribute to the novel's uncanny and menacing atmosphere. In Walpole's hands, the building itself induces psychological horror.[21] Drawing on a newly identified emotional response to ruins and ancient buildings, Walpole developed the concept of the haunted house.

Before the end of the novel, the haunted castle itself becomes a ruin at the hands of a giant ghost. The spirit of Alfonso, the ancient ruler of Otranto, is provoked into violent action by the outrages that threaten to divert the castle's ownership away from its true heir: 'the walls of the castle behind Manfred were thrown down with a mighty force, and the form of Alfonso, dilated to an immense magnitude, appeared in the centre of the ruins' (*fig. 25*).[22] Until Walpole wrote *Otranto*, ghosts had generally been regarded as symbolic figures (such as the Three Dead, or the numerous shades imagined by the 'graveyard' poets), or – if not the devil playing tricks on us – as the souls of the recently deceased. Walpole revived the medieval idea, expressed in saints' biographies, that ghosts could be visitors from the distant past, stirred into violent retributive action by injustice. In binding together ancient history, old buildings, ruins and ghosts with the glue of psychological horror, Walpole invented a new, highly charged way of looking at the world – one that has had consequences for the way in which ghosts have been thought about ever since.

'[B]ut are they all horrid, are you sure they are all horrid?' Catherine Morland's anxious question is put to the friend who has compiled a list

of recommended reading matter for her in Jane Austen's ironic parody of Gothic novels, *Northanger Abbey*.[23] Writers of later Gothic novels traded on their sensationalist subject matter, vying to outdo each other with tales of the grim, the ghastly and the gruesome. Armoured ghosts, cowled skeletons, murderous tyrants, rotting corpses and bleeding spectral nuns jostled for the reader's attention, offering strong doses of the horrific and the sensational. The reading public demanded it. The 'pleasing kind of horror in the mind of the reader' raised by ghost stories that Joseph Addison had noticed at the beginning of the eighteenth century had by the end of it gripped the popular imagination.[24]

Gothic novelists differed in their treatment of ghosts. Ann Radcliffe frequently used apparently supernatural presences to emphasize a haunted atmosphere, such as when Emily, the heroine of *The Mysteries of Udolpho* (1794), retires to bed in the castle leaving a lamp burning, 'but its gloomy light, instead of dispelling her fears, assisted it; for, by its uncertain rays, she almost fancied she saw shapes flit past her curtains and glide into the remote obscurity of her chamber'.[25] But although Radcliffe repeatedly suggests supernatural causes for events, she nearly always provides a rational explanation for them that is rooted firmly in the material world. Matthew Gregory Lewis, on the other hand, did not believe in explaining things away. He positively revelled in the supernatural – and the more gruesome, the better. His novel *The Monk* (1796), written when he was just nineteen, put ghosts into a new context of sensational horror, in a dizzying plot involving incest, violence, rape, murder and sorcery. Attacking the book early in 1797 in the *Critical Review*, Samuel Taylor Coleridge suggested that it was a novel 'which if a parent saw in the hands of a son or daughter he might reasonably turn pale'.[26]

But it was Lewis who caught the mood of the times. He insisted on the physicality of ghosts – with the spectre of a bleeding nun, for instance – and manoeuvered animated corpses and skeletons into grimly dramatic encounters with the living. 'Alonzo the Brave and Fair Imogine' was a ballad that appeared in *The Monk* but was also published in Lewis's collection *Tales of Wonder* (1801). It concerns a rejected lover who returns on the day of his beloved's wedding:

The lady is silent: the stranger complies,
His visor he slowly unclosed;

Oh! then what a sight met Fair Imogine's eyes!
What words can express her dismay and surprise,
When a skeleton's head was exposed![27]

Lewis's note of grotesquery that borders on the farcical was hugely influential. An anonymous collection of ballads, *Tales of Terror*, that was rushed out later in 1801 to cash in on the success of Lewis's *Tales of Wonder*, includes the morbid song: 'Grim, King of the Ghosts; Or, the Dance of Death. A Churchyard Tale':

No flesh had the spectre, his skeleton skull
Was loosely wrapp'd round with a brown shrivell'd skin;
His bones, 'stead of marrow, of maggots were full,
And the worms they crawl'd out, and the worms they crawl'd in.

His shoes they were coffins, his dim eye reveal'd
The gleam of a grave-lamp with vapours oppress'd;
And a dark crimson necklace of blood-drops congeal'd,
Reflected each bone that jagg'd out of his breast.[28]

Here the poet borrows the grimmer elements from the poems and essays of the 1740s and from Lewis's peculiarly corporeal ghosts of the late 1790s, and turns the volume up to the maximum – with the addition of a certain graveyard humour.

Indeed, the lavish frontispiece that folds out from the pages of *Tales of Terror* might seem parodic if it weren't so excessive in its grotesquery (*fig. 26*). Grinning skeletons energetically (if paradoxically) feast on a corpse, while others haul a body from a grave, accompanied by strange ghoulish birds, a distinctly minatory centipede and a fat toad that sucks on a frayed limb. But this time, there was no overarching Christian message. Gothic horror had found its own momentum, and by the end of the century it reached a pitch of bloodthirsty violence not to be encountered again until the arrival of horror films in the latter part of the twentieth century.

But the greatest change of all that these popular books reveal was the attitude to ghosts. In the second half of the eighteenth century, the idea of the sublime introduced the concepts of terror and wonder as emotions to be pursued, whether as direct or vicarious experience. Ghosts were

the kings and queens of these dark, indistinct regions – and they were poised to take on a new role in spectacular entertainment.

11. SUBLIME SPECTACLE

If you had been strolling through Covent Garden in the autumn sunshine of the first days of October 1801, a newly pasted playbill outside the Lyceum Theatre in Wellington Street might well have caught your eye. It would probably have made you look twice, because even taking into account the exaggerated claims habitually made by such advertisements, it offered an unusual spectacle (*fig. 27*). Opening on 5 October, this show promised to

> introduce the PHANTOMS or APPARITIONS of the DEAD or ABSENT, in a way more completely illusive than has ever been offered to the Eye in a public Theatre, as the Objects freely originate in the Air, and unfold themselves under various Forms and Sizes, such as imagination alone has hitherto painted them ...[29]

This was the first exhibition in England of a show that was called a 'phantasmagoria' – a newly coined term that possibly meant 'assembly of ghosts', although it has been suggested that the inventor was simply casting around for a word that sounded intriguing, and added the catchy ending 'agoria' to 'phantasm' just for effect.[30] This was, after all, the era of the competitive visual spectacle, when London offered numerous optical attractions, all vying for the attention of a sophisticated urban audience in search of novelty.[31]

This spectacular entertainment had arrived in London from the Continent, where its director, the impresario Paul de Philipsthal (who sometimes went by the assumed name Philidor), had been travelling with various ghost shows since 1789.[32] The phantasmagoria was, essentially, a more advanced version of the magic lantern shows that had been popular entertainments in England and Europe since the seventeenth century, in which pictures painted in transparent colours on glass slides were projected onto a screen or simply a white wall in a darkened room. When Samuel Pepys was shown a magic lantern in August 1666, he described in his diary the 'pictures in glass' he had seen which made 'strange things

appear on a wall, very pretty'.[33] If, however, you had returned to the Lyceum on the evening of 5 October and bought a ticket for the show, you would have experienced something that made magic lantern shows look very homely indeed. A vivid eye-witness account is provided by the mathematician and chemist William Nicholson, who attended one of the early performances in the spirit of scientific research and in the company of a group of young students, and wrote his experiences up for the *Journal of Natural Philosophy*. After he had found his seat in the large auditorium, most lamps were extinguished, leaving only a 'gloomy and wavering light' by which Nicholson witnessed the first part of the show: as the curtain was raised, a cave was revealed, painted with 'skeletons, and other figures of terror'. Then the sole light was put out, leaving the audience in total darkness, when suddenly there was a deafening noise, and what Philipsthal described as a 'tremendous Thunder Storm, accompanied with vivid Lightning, Hail, Wind, etc.'. Images of ghosts and skeletons then began to appear, hovering in mid air. They seemed to drift towards the audience, increasing in size, then mysteriously to recede back into the darkness. Some of them transformed themselves before Nicholson's eyes: a man's head, for example, was alarmingly 'converted into a skull', and eyes and mouths were seen to move. After a while the spectres and skeletons changed tack and stopped diminishing in size but appeared instead suddenly to advance upon the audience, growing larger and larger until they dramatically disappeared by sinking into the ground. 'This part of the exhibition', Nicholson noted, 'by the agitation of the spectators appeared to be the most impressive' – although he added, in a dignified aside, that it 'had less effect with me'.[34]

How did it work? As with the magic lantern, the figures created for the phantasmagoria were painted onto glass slides, with the surrounding area made opaque. Light directed through the painted slide projected the image onto a surface, where it appeared much larger, and one slide could be superimposed over another and manipulated to give the effect of movement. But the mechanism of the phantasmagoria differed from the magic lantern show in one important way. The image was projected not onto a wall, but onto the back of a translucent screen made of waxed gauze or muslin which was only let down after the lights had gone out (any noise made by the mechanism was presumably disguised by the rumbles and crashes generated by the thunder-machine), giving the impression to

an unwitting audience that the luminous apparitions were hovering in mid-air. Enhancing the effect that they were floating, the images could be made to look as though they were advancing or receding by wheeling the lantern itself forwards or backwards. None of these effects could have been achieved without the Argand lamp, patented in England in 1783–4, which created a light far brighter than the candles of a magic lantern, and one sufficiently powerful to illuminate these images for a large audience.

From the spectator's point of view, the biggest difference introduced by the phantasmagoria was its scale and theatricality. Sitting in a dark room, the audience must have found the experience – at least at first – thrillingly unpredictable enough to produce a pleasurable frisson of terror. To a public well-versed in Gothic fiction, the phantasmagoria show offered face-to-face encounters with the terrifying ghosts and skeletons from the pages of *The Monk* and other sensational novels. But its claims went further than that: in professing to produce images of ghosts 'such as imagination alone has hitherto painted them', it was announcing an ability to represent shifting and indistinct horrors that no other medium could even approach.

Before his arrival in England, Philipsthal might, at various points, have attempted to give the impression that he was actually raising the spirits of the dead. But now he was candid about the fictional nature of the show, even broadcasting that it was his intention 'to expose the Practices of artful Imposters and pretended Exorcists, and to open the Eyes of those who still foster an absurd belief in GHOSTS or DISEMBODIED SPIRITS'.[35] The power of fiction to grip the imagination and to produce terrifying visions had been proved over and again in the 1790s by Gothic novelists – it was obvious that the phantasmagoria show no longer needed the safety-net of pretended reality. It was a form of entertainment that grew out of the cult of the sublime, and which thrillingly promised to probe into the darkest corners of the mind. With its new optical technology, the phantasmagoria was ideally equipped to create an enclosed world in which imagination and fantasy could be nurtured. The show's appeal was to the spectator's vision, hearing and even the anticipation of touch, as the spectres seemed to rush forward into the audience – and, as such, it was a natural progression from the ambitions of poets such as Robert Blair, who was intent on making the flesh creep with his virtual assault on the senses back in the 1740s.

These theatrical entertainments opened up new possibilities in the hitherto rather sedate arena of British oil painting. The two worlds had collided back in 1781, when the artist and designer for Drury Lane Theatre, Philippe Jacques de Loutherbourg, created what he called the Eidophusikon (*fig. 28*). New coinages were all the rage at this time: this one, from the Greek meaning 'image of nature', signalled his ambition to achieve a greater degree of verisimilitude than had previously been possible in painting. De Loutherbourg wanted to bring the techniques of stage design to the world of fine art, and the Eidophusikon was a theatre in miniature – just 6½ feet (2m) wide, 3¼ feet (1m) tall and 9¾ feet (3m) deep – in which painting itself played all the roles.

De Loutherbourg set the Eidophusikon up in a large room of his house on London's Lisle Street, and charged a hefty five-shilling entry fee. Fashionable London crowded in to see this new show, and over a hundred spectators at a time witnessed 'those captivating scenes which inexhaustible Nature presents to our view at different periods and in different parts of the globe', as de Loutherbourg put it in his prospectus, all displayed 'in the most lively manner'.[36] Against a painted backdrop representing a distant vista, cut-out figures and ships and even three-dimensional models were manoeuvred back and forth by a system of rods and pulleys, moving at different speeds to give the illusion of their relative distances – as in a toy theatre. De Loutherbourg even created changing weather conditions, painting clouds on strips of linen, which, moved by a windlass, appeared to drift slowly past, and using smoke to emulate foggy conditions. Perhaps most spectacularly of all, he projected a variety of lights onto the scene, using differently coloured glass filters to reflect the atmosphere and time of day. Before the introduction of the Argand lamp, these lights must have cast only a dim glow over the scene – but perhaps this was conducive to creating the desired sense of magic that harsh lighting would have dispelled.

Like the phantasmagoria show, de Loutherbourg's Eidophusikon appealed not just to the eyes but also to the ears. Drawing upon his experience as a theatre designer, he created the effect of thunder by shaking a thin copper sheet, and the sound of waves, rain and hail by agitating small stones, beads or shells in a cylinder. So impressive were his sound effects that when, one evening, a real storm passed overhead members of the audience rushed out on to the balcony to compare the two; on balance they decided that de Loutherbourg's was better.[37]

11. SUBLIME SPECTACLE

For the first year de Loutherbourg's subjects included a view of London from Greenwich at dawn, the port of Tangier at noon and a view near Naples at sunset. The most dramatic was the final one, 'a Storm at Sea, and Shipwreck'. But when he came to choose subjects for the Eidophusikon's second season, which began in December 1781, there was a noticeable increase in the degree of drama on offer – among these subjects were the 'Cataract of Niagra, in North America' and 'The Rising of the Moon, with a Water Spout, exhibiting the Effect of three different Lights, with a View of a Rocky Shore on the Coast of Japan'. It was with the concluding scene that de Loutherbourg made his first foray into the supernatural: 'Satan arraying his Troops on the Banks of the Fiery Lake, with the Raising of Pandemonium, from Milton'; it was described by a witness as 'one of the most sublime spectacles ever produced by the hand of science'.[38] The scene was a fiery lake, from which the Devil's henchmen Beelzebub and Moloch emerge:

> Legions of Demons are then seen to rise at the summons of the chief, and the whole brightens into a scene of magnificent horror. Eruptions mingled with thunder and lightning issue from a volcano which supplies the Lake with a torrent of liquid fire. The lightning exhibits all the vivid and varied flashes of that natural phenomenon, and the thunder includes every vibration of air and shock of element which so often in its prototype strike terror and admiration on the mind.[39]

The technique of rubbing the surface of a drum, which de Loutherbourg had previously employed to suggest the sounds of wind and thunder, was now used for the demons' voices.

It was the Eidophusikon's capacity to evoke an atmosphere suggestive of the supernatural that prompted the wealthy young aesthete William Beckford to commission de Loutherbourg to stage the Christmas revels at his vast Gothic folly, Fonthill Abbey, that same year. At Fonthill, the Eidophusikon created more than just ghostly images – it seemed to weave a strange supernatural world. De Loutherbourg promised an experience beyond the scope even of the imagination, 'a mysterious something – a something that eye has not yet seen or heart of man conceived', and it was wildly successful.[40] Beckford later recalled:

that strange, necromantic light which Loutherbourg had thrown over what absolutely appeared a realm of Fairy, or rather, perhaps, a Demon Temple deep beneath the earth set apart for tremendous mysteries... The glorious haze investing every object, the mystic look, the vastness, the intricacy of the vaulted labyrinth occasioned so bewildering an effect that it became impossible for anyone to define at the moment, where he stood, where he had been, or to whether he was wandering.[41]

The experience was more like being inside a picture than looking at one. Light shows had long been associated with the projection of ghosts: a dictionary of 1696 described the 'Magic Lanthorn' as a 'small Optical Macheen that shews by a gloomy Light upon a white Wall, Spectres and Monsters so hideous, that he who knows not the Secret, believes it to be perform'd by Magick Art', and another of 1707 described the 'Phantoms and terrible Apparitions' that it conjured up.[42] But de Loutherbourg's inventive and theatrical manipulation of light and colour cast a more powerful spell, one that stimulated the imagination with its fleeting and half-glimpsed figures. The magical results of that Christmas's entertainment prompted Beckford to write his extravagant Orientalist fantasy, *Vathek*, as soon as he returned to London in 1782.

Over the following decades, many artists creating conventional easel paintings might have thought themselves above all this razzmatazz. Writing to a friend in 1829, John Constable sarcastically quoted an acquaintance who had, perhaps unwisely, seen fit to inform this most scrupulously observant of nature-painters that the object of fine art was to '*unite imagination with nature*'. Art, Constable added crossly, 'is now filled with *Phantasmagoria*'.[43] But whether they liked it or not, they were competing with the spectacular optical effects that were entertaining audiences all around them, ranging from the intensely dramatic scenes conjured up by de Loutherbourg's Eidophusikon, or in the enclosed space of the phantasmagoria show, to the vast panoramas of the kind displayed in the purpose-built, drum-like building in Leicester Square from 1794, which were painted with such skill that they could create the illusion that one was surveying a foreign cityscape. At the same time, Romanticism, with its focus on the expression of intense emotional states and subjective, individual experience, was transforming the arts. Artists began to bring a new dimension to their drawings and paintings, consulting their

imaginations as much as the world around them and inventing a bold visual vocabulary to express the ghosts and other supernatural figures they found there. Nevertheless, they needed their paintings to rise above the level of entertainment and, like de Loutherbourg with his Miltonic scene of demons at a fiery lake, they mined literary texts to give authority and gravitas to their compositions.

12. 'HOPES OF HIGH TALK WITH THE DEPARTED DEAD'

'It beats all the ghost-scenes I ever read.'[44] Lord Byron was speaking of the Biblical story in which the Witch of Endor summoned the ghost of the prophet Samuel back from the dead at the request of King Saul (see p.38). It was the most famous ghost story in the Western world, and, given its copper-bottomed source, it was also the least controversial. Ever since the Reformation it had been a touchstone for Catholic and Protestant authors alike, and was repeatedly cited as proof that, under certain circumstances, ghosts could and did appear. But it was not until the Romantic period that the story's dramatic potential was fully realised. The subject offered a strong dose of the 'magnificent horror' that had been so admired in de Loutherbourg's Eidophusikon: the setting, a dark cavern; the characters a witch, King Saul (overcome with emotion) and, best of all, the fearsome figure of the prophet himself, rising from the dead.

There had been plenty of visual ghosts around before, but they had mostly confined their appearances to ephemeral and popular arenas, such as pamphlets and broadsides. The prophet Samuel, however, who was occasionally depicted in book illustrations, was a far more serious matter. The Regency essayist Charles Lamb, who was, as a child, 'dreadfully alive to nervous terrors', recalled one particular image 'which', he remarked plaintively, 'I wish that I had never seen': an illustration to a Bible history representing the Witch of Endor raising the spirit of Samuel, accompanying the verse: 'An old man cometh up; and he is covered with a mantle.'[45] This picture haunted Lamb's imagination – 'O that old man covered with a mantle!' – as it was to haunt the minds of others.[46] In the Romantic age, when ghosts began to take centre stage in visual art, the prophet became an irresistible subject. His terrible authority was a powerful magnet for the visionary imagination.

William Blake was drawn to intense psychological states, whether joy or despair, and in his interpretations of Biblical scenes he stripped away extraneous detail, leaving pared-down compositions in which every contour serves to heighten the drama of his vision. When in around 1800 he came to the subject of Saul, Samuel and the Witch of Endor (*fig. 29*) as part of a series of watercolours he had been commissioned to paint illustrating scenes from the Bible, he focused intently on the moment of Saul's encounter with the long-dead prophet. Blake depicts Samuel in the act of rising up from the ground, but although he is only seen from the ankles up he towers over Saul and the witch, who crouch down on either side of him. He turns to glare furiously down at Saul, who starts back, his features contorted in horror and dismay, holding his hands out defensively in front of him. Blake's ghost is muscular and physically imposing, even threatening – but the medium of watercolour also allows him to be insubstantial. Light seems to pass through him, or to emanate from him. This is a quality that watercolour was ideally suited to suggest: unlike oil paint, its translucent pigment allows light to bounce back off the white paper beneath, creating a luminous effect. Like the images projected by lantern slides and the new phantasmagoria shows, the watercolour medium allowed the ghost to glow, signalling its supernatural status.

We cannot know exactly what we would have seen from a seat in a phantasmagoria show of the early nineteenth century, but perhaps paintings by the Zurich-born artist Henry Fuseli (born Johann Heinrich Füssli) offer some sense of the mysterious power of their imagery. Fuseli's darkly potent imagination transformed literary scenes into intense, emotionally charged encounters. His figures glow with a pale supernatural light against a dark, mysterious background and express extreme emotion through their balletic postures. Many of Fuseli's paintings pre-date the advent of phantasmagoria shows, but they anticipate the visual impact of the glowing figure emerging from the dark that became these entertainments' chief stock-in-trade.

Fuseli had tackled the subject of Saul, Samuel and the Witch of Endor himself back in 1777 in a drawing of heavily scored lines and deep, inky washes which shows the king fainting into the arms of a soldier when confronted with the physically imposing prophet.[47] He also sought dramatic subjects in English literature, and frequently delved into Shakespeare's plays. One painting, now known only from a print (*fig. 30*), represented

the ghost of Hamlet's father appearing to Hamlet, Horatio and Marcellus. The print shows a scene of high-pitched emotional drama as Hamlet wrestles against Horatio's restraining hold, sinews stretched to their limits as he fights to follow the ghost. To the right of the composition, the ghost, in full armour, stands with his feet planted firmly apart, pointing away from the castle with his sword in an imperious summons and glaring commandingly at his son. Like Blake, Fuseli uses light to signal his supernatural status – Old Hamlet is back-lit by the moon, which appears like a halo behind his head, and ghostly streaks of light glimmer around the contours of his armour.

Blake's watercolour was made for a private patron, Thomas Butts. But Fuseli's composition was intended for a much wider public. The print reproduces a painting that Fuseli was commissioned to make for the 'Shakespeare Gallery', a high-profile and ambitious venture by the engraver and printseller John Boydell. The last quarter of the eighteenth century saw a boom in visual culture: where previously the market in prints had been dominated by mezzotint portraits which reproduced paintings of the fashionable and the worthy, the situation was transformed when newly established commercial galleries and public exhibition spaces began to provide opportunities for British artists to expand their repertoire, and to offer a range of subjects including landscapes, sporting scenes, 'fancy pictures' on sentimental or anecdotal themes, historical events, and illustrations of the Bible, Shakespeare and other literary sources. This in turn fostered a lively trade in prints reproducing these paintings – 'pictures for the parlour', as they came to be known – which were naturally much more affordable than the originals, as well as being on a scale suitable for display in ordinary domestic interiors. With popular subjects such as the Witch of Endor calling up the Prophet Samuel and the ghost of Hamlet's father being engraved for a relatively large market, ghosts were, for the first time, welcomed into the middle-class home. With a privileged position on the parlour wall, they had even attained a certain respectability.

But not all ghost images at this time had a reassuringly canonical origin, whether Biblical or literary. In his early sixties, Blake invented one of the most bizarre apparitions of all: the ghost of a flea (*fig. 31*). It came about through conversations with a younger friend, John Varley. Now best known as a teacher and a painter of calmly atmospheric landscape watercolours and precise topographical views, Varley was also fascinated

by a less tangible world: in the words of one of his pupils, 'he entirely believes in astrology, palmistry, raising of ghosts and seeing of visions'.[48] Varley regarded Blake as a visionary, and believed that the faces of historical figures appeared to the older artist. He encouraged Blake to record these strange 'visionary heads' on paper during evenings spent together at his house between 1819 and 1825. How seriously Blake himself took it is another matter, although the two men did share an interest in the theories of physiognomy set out by Johann Caspar Lavater, which proposed that an individual's appearance and particular cast of features was expressive of their true character. Blake was, however, happy to play along, and the pencil portraits he created included classical philosophers, Old Testament prophets, various English kings and the leader of the Peasants' Revolt, Wat Tyler.[49]

Varley described witnessing Blake's visitation by the flea's ghost:

> I called upon him one evening and found Blake more than usually excited. He told me he had seen a wonderful thing – the ghost of a flea! 'And did you make a drawing of him?' I enquired. 'No indeed' said he. 'I wish I had, but I shall, if he appears again!' He looked earnestly into a corner of the room, and then said, 'here he is – reach me my things – I shall keep an eye on him. There he comes! his eager tongue whisking out of his mouth, a cup in his hand to hold blood, and covered with a scaly skin of gold and green:' as he described him so he drew him.[50]

Blake was, of course, pulling Varley's leg. But he was also using the flea-ghost as a damning symbol to represent the worst aspects of human nature. Varley recalled that while Blake was making his drawing, 'the Flea told him that all fleas were inhabited by the souls of such men, as were by nature blood-thirsty to excess'.[51]

Blake made carefully observed drawings of the flea-ghost's head, depicting it as though illustrating a natural history specimen, with its mouth both closed and open. From these drawings he then worked up a little tempera painting. In his painting the flea-ghost, in the form of a muscular naked man, strides across what seems to be a stage, with heavy curtains to either side and stars hanging in the background. He grasps a bowl in one grotesquely long-fingered hand and stares avidly into it, his tongue flicking out between his lips. Like his depiction of the Prophet Samuel, Blake's flea – even though the painting is tiny – has a

substantial, even threatening physical presence: veined, scaly and stained red. But unlike Samuel, who glows with light, the flea is a dark, shadowy presence, only, Blake suggests, illuminated for an instant by the fiery light of the shooting star that whizzes past. He is a Gothic figure of nightmares, a terrifying avatar who blurs the distinction between literal sight and inner vision. In Blake's imagination, a 'ghost' expresses the essence of a soul.

It was June 1816, but it felt more like the back end of the year. The chill fogs, mists and rainy days of that summer – unseasonal weather triggered by the catastrophic eruption of Mount Tambora in the Dutch East Indies the previous year – created a wintry atmosphere. Lord Byron was renting the grand Villa Diodati overlooking Lake Geneva at Cologny, where he was accompanied by his young physician, Dr John Polidori, while Percy Bysshe Shelley, Mary Shelley, their four-month-old son William and Mary Shelley's step-sister Claire Clairmont, pregnant with Byron's child, were staying across the lake at Montalègre. As though responding to the weather, the group spent their evenings together in a way more suited to December than June: reading ghost stories to each other. The book from which they read was a collection of German tales translated into French and published in 1812, *Fantasmagoriana, ou Recueil d'histoires d'apparitions de spectres, revanans, fantômes, etc.* It was this that prompted Byron to suggest that they should each write a ghost story of their own.[52]

Byron himself began writing a vampire story, but it remained fragmentary. Polidori later took up the same theme, resulting in his tale *The Vampyre*, which, on publication in 1819, became immensely popular – partly because it was erroneously described by the publishers as 'A Tale by Lord Byron'. Even so, the success of Polidori's vampire subject helped pave the way for the theme's development later in the century, particularly with Sheridan Le Fanu's *Carmilla* (1871–2) and Bram Stoker's *Dracula* (1897). Meanwhile Mary Shelley delved into the darkest corners of her imagination, striving to think of a tale 'which would speak to the mysterious fears of our nature, and awaken thrilling horror – one to make the reader dread to look round, to curdle the blood, and quicken the beatings of the heart'.[53] The result, published two years later as *Frankenstein: or The Modern Prometheus*, was a ghost story of sorts in that it concerned the re-animation of a corpse ('the hideous phantasm of a man stretched out' that begins to 'stir with an uneasy, half-vital motion') – but

it was a ghost story re-thought and given a peculiarly human perspective.[54] The wanderings of the tragic monster in dark and lonely places, and the terrible revenge he eventually takes on Dr Frankenstein, are both activities long associated with ghosts. And no matter what his feelings, intentions or actions, his appearance provokes uncontrollable horror. Like a ghost, Mary Shelley's monster is almost human, very nearly our double, but made strange and separate by a fine but indelible dividing line.

Percy Bysshe Shelley soon abandoned his own ghost story. But he was intensely alive to the psychological power ghosts wielded, and was disconcerted to discover, when Matthew Gregory Lewis (by then known universally as 'Monk' Lewis) visited them in August, that he and Byron were both sceptics:

> We talk of Ghosts; neither Lord Byron nor Monk G. Lewis seem to believe in them; and they both agree, in the very face of reason, that none could believe in ghosts without also believing in God.

He goes on, however, to observe shrewdly that such displays of rationality were sometimes a pose:

> I do not think that all the persons who profess to discredit these visitations really discredit them, or if they do, in daylight, are not admonished by the approach of loneliness and midnight to think more respectfully of the world of shadows.[55]

For Shelley, ghosts were inextricably linked to the ability to experience extreme emotional states; to deny their existence would be to cut oneself off from whole worlds of imagination and feeling. And while the conventional response was to be afraid of ghosts and to shrink from them, he wrote instead of running after them. In 'Hymn to Intellectual Beauty', which he drafted towards the end of June 1816 during an extended boat trip round Lake Geneva with Byron (the weather having improved), he describes how:

> While yet a boy I sought for ghosts, and sped
> Through many a listening chamber, cave and ruin,
> And starlight wood, with fearful steps pursuing
> Hopes of high talk with the departed dead.[56]

It was at first without success: 'I was not heard; I saw them not.' He had, it seemed, been thinking about ghosts in the wrong way; but disappointment was swiftly followed by an epiphany when he realised that all natural phenomena were connected ('Sudden, thy shadow fell on me; / I shriek'd, and clasp'd my hands in ecstasy!'). And in Shelley's later works, he imagines ghosts as forces of nature, not as separate, unnatural phenomena. In another poem a cloud speaks, comparing itself to a ghost as, after dispersing in a rain-storm, it reassembles itself in the atmosphere:

> I silently laugh at my own cenotaph,
> And out of the caverns of rain,
> Like a child from the womb, like a ghost from the tomb,
> I arise and unbuild it again.[57]

The cycles of nature here incorporate the spirits of the dead, to be spoken of in the same breath as cloud formation and childbirth. 'I change, but I cannot die', remarks the cloud: it is as immortal as a human soul.

Shelley also put ghosts in the first stanza of 'Ode to the West Wind':

> O wild West Wind, thou breath of Autumn's being,
> Thou, from whose unseen presence the leaves dead
> Are driven, like ghosts from an enchanter fleeing...[58]

Again he inverts the conventional assumption that ghosts are to be feared: here they themselves are afraid and running away from a more powerful figure. Later the poem's narrator wishes to be a dead leaf, so as to be borne on the wind; and by the end of the poem his 'dead thoughts' are compared to 'withered leaves', but with the capacity 'to quicken a new birth'.[59] For Shelley, even dead leaves contain a spark of life; or, driven by the wind, are animated by a larger, all-encompassing force of nature. By insisting on including ghosts in his conception of an endlessly self-transforming natural universe, Shelley reinvents them as symbols of new life.

In Emily Brontë's novel *Wuthering Heights* (1847), Catherine's ghost is also carried on the wind, a denizen of the stormy air. But her ghost-hood has changed her direction of travel: her passion to be out of doors and on the

moors has been transformed into a desperate wish to return home. 'Let me in – let me in!' she sobs pathetically outside the casement.[60] *Wuthering Heights* is a novel full of windows: windows fastened back to admit the wind, windows that Heathcliff dreams of shattering, windows to be escaped through. They are symbols of the border between the wild and the tame, the opposing forces that drive the novel. Catherine's ghost claws in vain at the window of Wuthering Heights; she is, by nature, a creature of wild, stormy provinces, not of the domestic interior.

But for all her airy nature, the ghost Brontë creates is a child of the Gothic imagination. She is a strong physical force: Catherine's 'little, ice-cold hand' grips Lockwood's when he reaches through the window, with a powerful, tenacious hold that he, a grown man, is unable to loosen. In a shockingly cruel image, Lockwood, terrified rather than moved to pity at the sight of 'a child's face looking through the window', 'pulled its wrist on to the broken pane, and rubbed it to and fro till the blood ran down and soaked the bedclothes'. Catherine's ghost bleeds, like Monk Lewis's nun, but appears to withstand the physical pain, just as she bravely 'did not yell out' when bitten by the Lintons' bulldog after looking in through another window.[61]

At Heathcliff's appearance, Lockwood attempts to pass his super-natural experience off as an impersonal one, resorting to conventional language as he berates his reluctant host for his having been assigned a room 'swarming with ghosts and goblins'. Heathcliff, however, breaks down in tears after Lockwood has left the room and makes a desperate, emotional appeal to the ghost herself: '"Come in! Come in!" he sobbed. "Cathy, do come. Oh do – *once* more! Oh! My heart's darling! hear me *this* time – Catherine, at last!"'[62] He makes no distinction between Catherine and her ghost, recognising that in death her spirit is unchanged. She was, in life, an elemental force, and Heathcliff is another.

When the English artist Barnett Freedman came to illustrate *Wuthering Heights* for the Heritage Press in 1940, for this scene he homed in on the struggle between the two hands, Catherine's and Lockwood's, framing them with the jagged edges of the broken windowpane. In the absence of a broader context of figures or room, the image becomes nearly abstract, two strange creatures in desperate conflict with one another. His image baffles our expectations in another way: most illustrators would have com-posed the picture from an imagined position inside the room and from

the narrator's point of view, capitalising on the horror of his situation. In this one, Freedman gives us the ghost's eye-view as she hovers in the freezing air outside the window and grasps at Lockwood's hand. We, the readers, are invited to see things from the other way around. Catherine's pale hand could be ours.

V

APPEARANCES

and

DISAPPEARANCES

The old life, the old manners,
the old figures seemed present again
HENRY JAMES, *ENGLISH HOURS*

13. A SATIRICAL VIEW

The caricaturist James Gillray was, by most accounts, a lean, taciturn and rather shabbily dressed man. One contemporary described him as a 'gaunt, bespectacled figure', while another recalled his 'slouching gait and careless habits'.[1] A bachelor, he lived an inconspicuous life and lodged quietly in Old Bond Street, later in St James's Street, over the shop belonging to his publisher Mrs Humphrey. Yet Gillray was responsible for creating some of the most spectacular and visually arresting prints of the era. His work reached a wide audience; although individual prints were expensive to buy and produced in relatively small numbers, it was possible to hire a portfolio for a limited period, like a book from a lending library. And you could get to see his latest images for nothing when Mrs Humphrey pinned up her lodger's new prints in her shop window. A French visitor to London in 1802 recounted the scene: 'the enthusiasm is indescribable when the next drawing appears; it is a veritable madness. You have to make your way in through the crowd with your fists.'[2]

Gillray took the rather staid form of caricature – which at the time denoted various sorts of pictorial humour – and taught it a whole new set of tricks. He developed a visual language of distortion and exaggeration, and ruthlessly applied it not only to facial features but to bodies too. In his re-imagining of the world, an obese person might become completely spherical, a thin one impossibly attenuated. His art recognised no boundaries of decorum, and royalty and politicians alike were savagely pilloried. This boundlessly inventive world of wild fantasy and grotesque distortion, which Hieronymus Bosch would have relished, was a natural home to the ghosts that Gillray invented. One might say that they were, in fact, among the least remarkable inhabitants of his imagination.

This was not the first time ghosts had entered the political arena. In the mid-seventeenth century a new genre of 'ghost dialogue' had given pamphleteers licence to imagine posthumous conversations between key political figures; and the death of Oliver Cromwell in 1658 gave rise to

a short-lived slew of pamphlets and broadsides from both republican and royalist sides. Numerous scenarios were imagined in which Cromwell and King Charles I come face-to-face with each other in the afterlife. A pro-Stuart pamphlet, *A Dialogue betwixt the Ghosts of Charls the I, Late King of England: and Oliver, the late Usurping Protector* published in June 1659 imagines the scene. *'Ha!'*, says the late king, *'what doth mine eyes behold, that grand Rebell and Traitor which was the destruction of me and my Family'*. 'O Sir, Pray forgive me,' Cromwell's ghost quails, 'for you cannot imagine the tortures of conscience that I Indure', and he goes on to confess his 'ambitious and damnable Plots, to ruine you and yours, and to set my self in your stead'.[3] This ephemeral new genre, often illustrated with standard-issue woodcut illustrations of ghosts in shrouds bearing lighted tapers, could offer a satisfying form of wish-fulfillment to either side.

Gillray applied his powers of invention to the ghost as he did to everyone else. If the ghost's appearance had become conventionalised in earlier popular prints, Gillray re-imagined it for a new and unprecedentedly undeferential age. His imagination was assisted by the printing technique available to him: etching made it possible for him to draw the design on a waxed copper plate with a needle, enjoying nearly as much freedom as with a pen on paper. Cutting a design into wood (the printing method used for broadsides) requires some force, but in etching lines are incised or 'bitten' into the plate by the action of acid. In comparison to woodcut, therefore, the etching process allows the artist to draw freely – and Gillray, with his supple, bounding line, took full advantage.

In Gillray's hands, ghosts shook off their shrouds and took on a variety of forms. He particularly liked to show them rising up from the ground, in a free interpretation of the old idea that a spirit might emerge from a grave – except that in his interpretation they would pop up wherever convenient for his composition. His ghosts were, moreover, precisely the personalities they were in life, seemingly untransformed by the experience of death. The 1802 print *Blowing up the Pic Nic's* represents contemporary actors including Richard Brinsley Sheridan (his portly figure encased in a skin-tight Harlequin costume) and Charles Kemble (in costume as Hamlet) protesting histrionically about the 'unfair' competition to the acting profession posed by the amateur dramatic 'Pic Nic Society', which had begun to put on plays at a small theatre in Tottenham Street.[4] In the foreground, a smiling David Garrick, who had died in 1779, bursts

PHANTASMAGORIA,

THIS and every EVENING,

AT THE

LYCEUM, STRAND.

M. DE PHILIPSTHAL

Takes the earlieft Opportunity of informing his Patrons, and the Public at large, that in confequence of fome Attempts to impofe upon them a *fpurious Imitation* of his OPTICAL and MECHANICAL INVENTIONS, he has obtained HIS MAJESTY's ROYAL LETTERS PATENT, under the Protection of which he will have the Honour to EXHIBIT his

Optical Illufions and Mechanical Pieces of Art.

SELECT PARTIES may be accommodated with a MORNING EXHIBITION at any appointed Hour, on fending timely Notice.

☞ To prevent Miftakes, the Public are requefted to Notice, that the PHANTASMAGORIA is on the Left-hand, on the Ground Floor:

The OPTICAL PART of the EXHIBITION

Will introduce the PHANTOMS or APPARITIONS of the DEAD or ABSENT, in a way more completely illufive than has ever been offered to the Eye in a public Theatre, as the Objects freely originate in the Air, and unfold themfelves under various Forms and Sizes, fuch as Imagination alone has hitherto painted them, occafionally affuming the Figure and moft perfect Refemblance of the Heroes and other diftin-guifhed Characters of paft and prefent Times.

This SPECTROLOGY, which profeffes to expofe the Practices of artful Impoftors and pretended Exorcifts, and to open the Eyes of thofe who ftill fofter an abfurd Belief in GHOSTS or DISEMBODIED SPIRITS, will, it is prefumed, afford alfo to the Spectator an interefting and pleafing Entertainment; and in order to render thefe Apparitions more interefting, they will be introduced during the Progrefs of a tremendous Thunder Storm, accompanied with vivid Lightning, Hail, Wind, &c.

The MECHANICAL PIECES of ART

Include the following *principal Objects, a more detailed* Account of which will be given during their Exhibition : *viz.*

Two elegant ROPE DANCERS, the one, reprefenting a *Spaniard* nearly Six Feet high, will difplay feveral aftonifhing Feats on the Rope, mark the Time of the Mufic with a fmall Whiftle, fmoke his Pipe, &c.—The other, called *Pajazzo*, being the Figure of a young fprightly Boy, will furpafs the former in Skill and Agility.

The INGENIOUS SELF-DEFENDING CHEST—The fuperior Excellence and Utility of this Piece of Mechanifm is, that the Proprietor has always a Safe-guard againft Depredators; for the concealed Battery of *Four Pieces of Artillery* only appears and difcharges itfelf when a Stranger tries to force open the Cheft.—This has been acknowledged by feveral Profeffional Men to be a *Mafter-piece* of *Mechanifm*, and may with equal Advantage be applied to the Protection of Property in Counting-houfes, Poft Chaifes, &c.

The MECHANICAL PEACOCK, which fo exactly imitates the Actions of that ftately Bird, that it has frequently been thought Alive. It eats, drinks, &c. at command, unfold its Tail in a brilliant Circle, and in every refpect feems endowed with an intuitive Power of attending to the Thoughts of the Company.

The BEAUTIFUL COSSACK, enclofed in a fmall Box, opens it when ordered, and prefents herfelf to the Spectators in a black Habit ; which, as foon as defired, fhe changes with aftonifhing Quicknefs into a moft Elegant Gala Drefs, compliments the Company, and dances after the Manner of the Coffacks; fhe will alfo refolve different Queftions. &c. &c.

The SELF-IMPELLED WINDMILL, which is put in Motion, or ftands ftill by the moft momentary Signal from the Spectators, and in a Manner which apparently does away the Idea of all Mechanical Agency. — *Ph Phill 13024-3 begin at 7* — *Changes*

The whole to conclude with a fuperb OPTICAL and MECHANICAL FIRE-WORK, replete with a Variety of brilliant and fanciful

Frontispiece.

Fig. 26 W.P. after B.O. Esq.
Frontispiece to Anon.,
Tales of Terror, London 1801
British Library, London

Fig. 27 (previous page)
Playbill advertising
Paul de Philipsthal's
'Phantasmagoria' show
at the Lyceum Theatre in
the Strand, London 1801
Woodcut and letterpress
The Lewis Walpole Library,
Yale University, CT

Fig. 28 Edward Francisco
Burney (1760–1848)
*A View of Philippe Jacques
de Loutherbourg's Eidophusikon
with a scene from Milton* 1782
Pen and ink and grey
wash with watercolour
21.2 × 29.2
British Museum, London

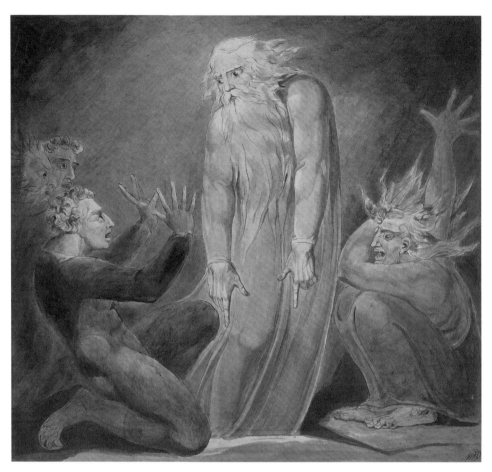

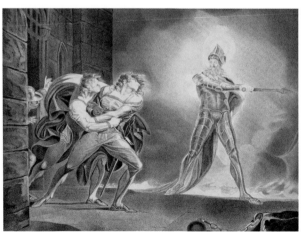

Fig. 29 William Blake
(1757–1827)
*The Ghost of Samuel Appearing
to Saul* c.1800
Pen and ink and
watercolour 32 × 34.4
National Gallery of Art,
Washington

Fig. 30 Robert Thew
(1758–1802), after Henry
Fuseli (1741–1825)
Hamlet, Act I, Scene IV 1793
Stipple engraving
50.2 × 63.7
The Lewis Walpole Library,
Yale University, CT

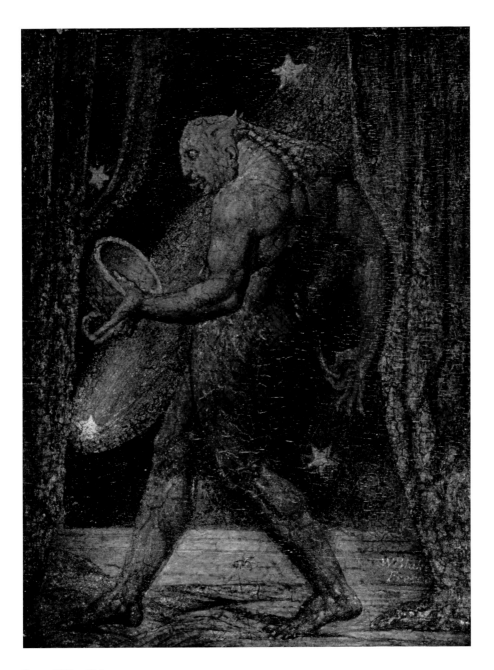

Fig. 31 William Blake
(1757–1827)
*The Ghost of a Flea c.*1819–20
Tempera and gold on
mahogany 21.4 × 16.2
Tate

THE GHOST ~ A CULTURAL HISTORY

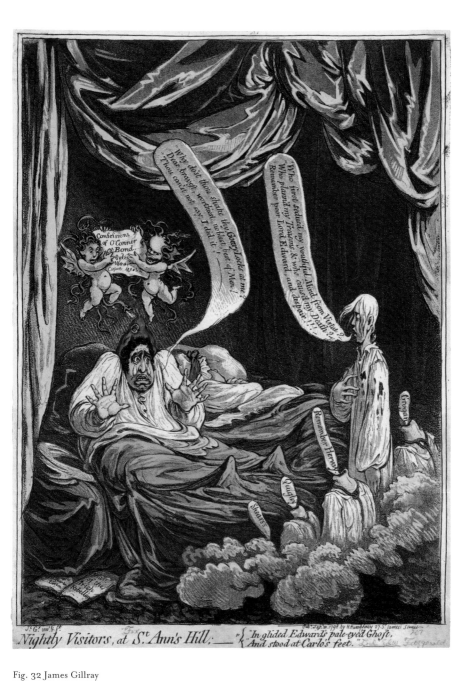

Fig. 32 James Gillray
(1756–1815)
Nightly Visitors, at St Ann's Hill 1798
Hand-coloured etching and
aquatint, 36 × 26
The Lewis Walpole Library,
Yale University, CT

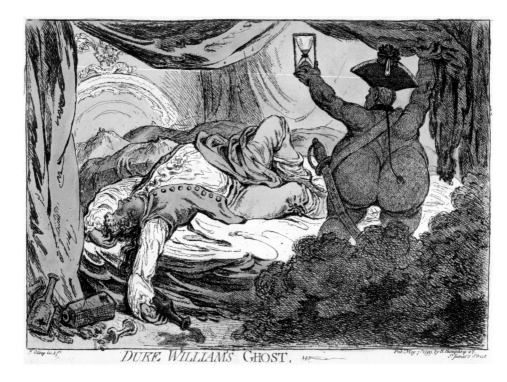

Fig. 33 James Gillray
(1756–1815)
Duke William's Ghost 1799
Hand-coloured etching
26 × 36
The Lewis Walpole Library,
Yale University, CT

Fig. 34 Richard Newton
(1777–98), after G.M.
Woodward (c.1760–1809)
Laying a Ghost!! 1792
Hand-coloured etching
and aquatint 35.7 × 24.8
British Museum, London

Fig. 35 (opposite)
Thomas Rowlandson
(1757–1827), after G.M.
Woodward (c.1760–1809)
Terrour or Fright 1800
Hand-coloured
etching 27.2 × 22.2
The Lewis Walpole Library,
Yale University, CT

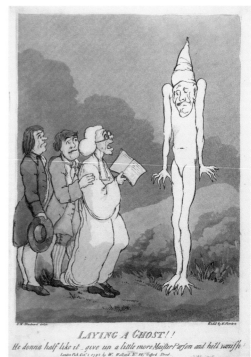

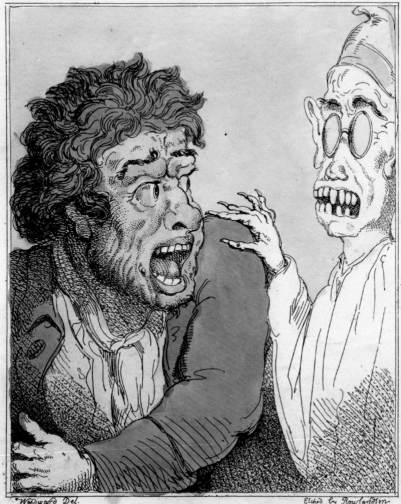

Woodward Del. Etched by Rowlandson

This Passion is frequently excited by dressing up frightful objects to represent Sprites,
Apparitions &c. frequently practiced with success in Country Villages, as delineated
in the above sketch of the Countryman & the Ghost.

London Pub. 1 Jan. 1800. as R. Ackermann's Repository of the Arts. 101 Strand.

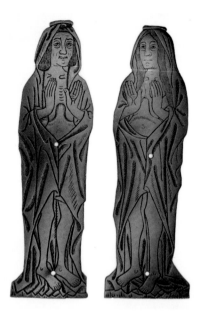

Fig. 36 Memorial brasses for Henry and Agnes Fayrey from Dunstable Priory Church, Bedfordshire, c.1516 Engraved brass 52.2 × 15.4 Victoria and Albert Museum, London

Fig. 37 George Romney (1734–1802) *The Ghost of Darius Appearing to Atossa c.*1778–9 Black chalk 101.5 × 127 Walker Art Gallery, National Museums Liverpool

Fig. 38 (opposite) Anon. *The Hammersmith Ghost* 1804 Etching with stipple 21.3 × 12.5 British Museum, London

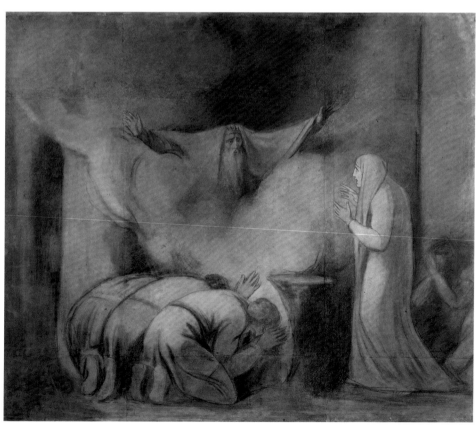

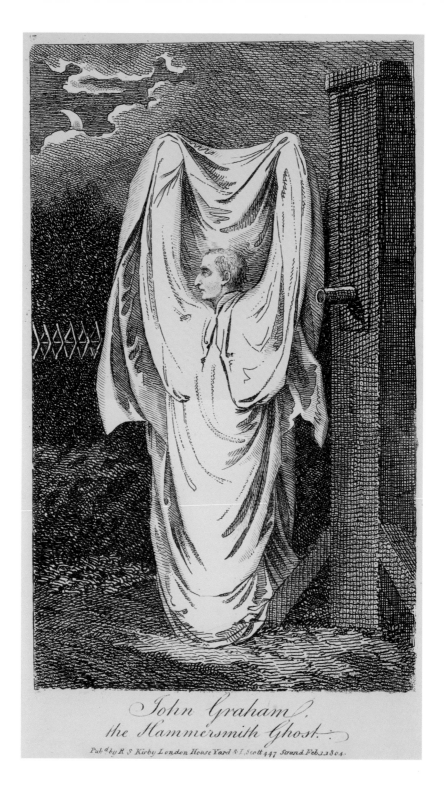

John Graham,
the Hammersmith Ghost.

Pub.d by R.S Kirby London House Yard & I. Scott 447 Strand Feb.1.1804.

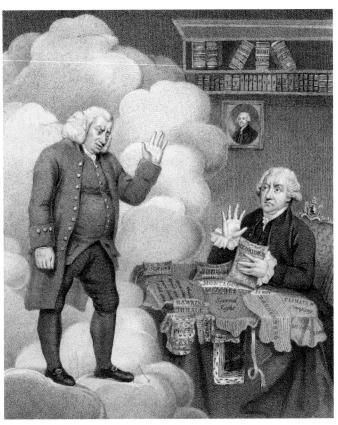

Fig. 39 Anon.
*Boswell and the Ghost
of Samuel Johnson*, 1803
Stipple engraving with
etching 27 × 21
The Lewis Walpole Library,
Yale University, CT

Fig. 40 (opposite)
William Blake (1757–1827)
Richard III and the Ghosts 1806
Pen and ink and grey
wash with watercolour
30.6 × 19
British Museum, London

Fig. 41 Thomas Williams
(1798–after 1863), after
George Cruikshank
(1792–1878)
The Ghosts of Stockings 1863,
from George Cruikshank,
*A Discovery Concerning Ghosts,
with a Rap at the 'Spirit-
Rappers'*, London 1863
Lithograph
British Library, London

GHOSTS OF STOCKINGS.

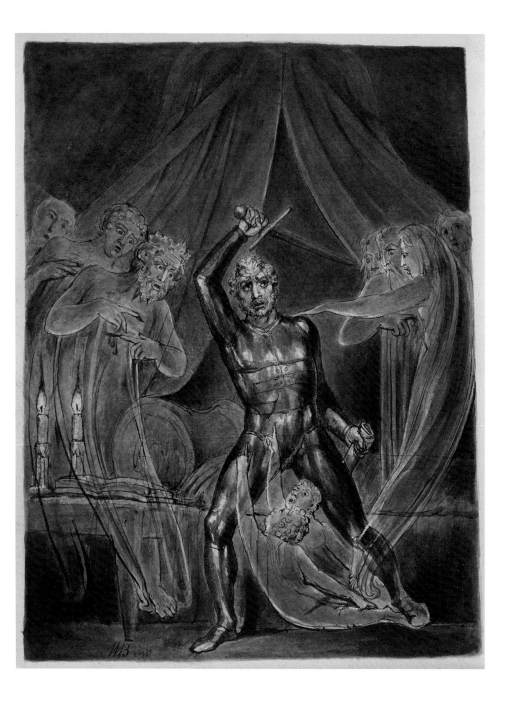

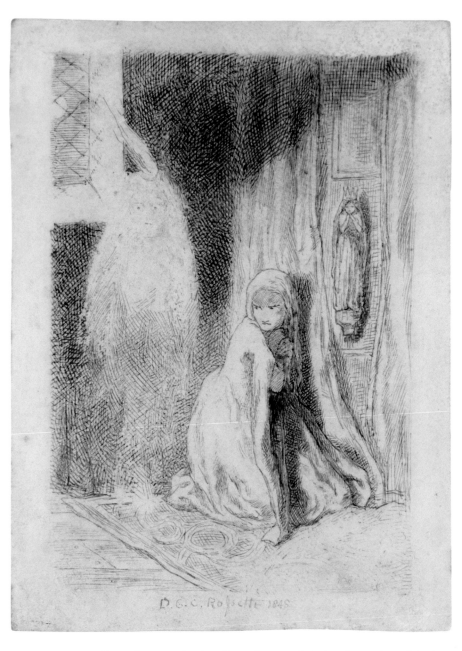

Fig. 42 (opposite, above)
Thomas Rowlandson
(1757–1827)
*Antiquaries in Westminster
Abbey* 1802
Watercolour 24 × 34.5
Private collection c/o
Lowell Libson Ltd

Fig. 43 (opposite, below)
William Frederick Yeames
(1835–1918)
A Visit to the Haunted Chamber
1869
Oil on canvas 59.5 × 84.5
Private collection

Fig. 44 Dante Gabriel
Rossetti (1828–82)
Faust: Margaret in the Church
1848
Pen and ink 17.8 × 12.1
Tate

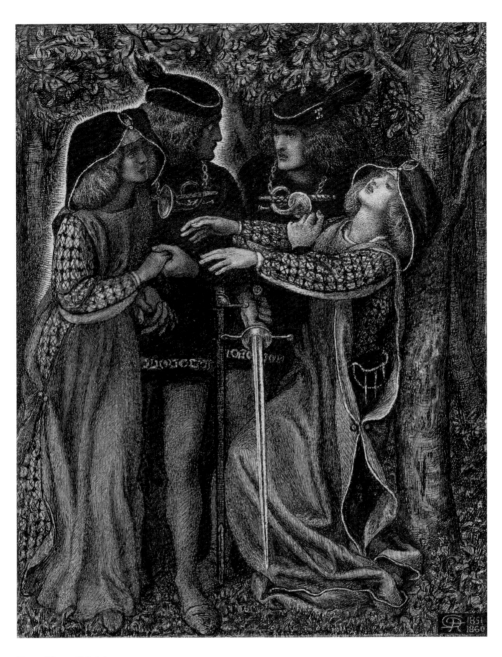

Fig. 45 Dante Gabriel
Rossetti (1828–82)
How They Met Themselves
1860
Pen and ink 27 × 21.3
Fitzwilliam Museum,
Cambridge

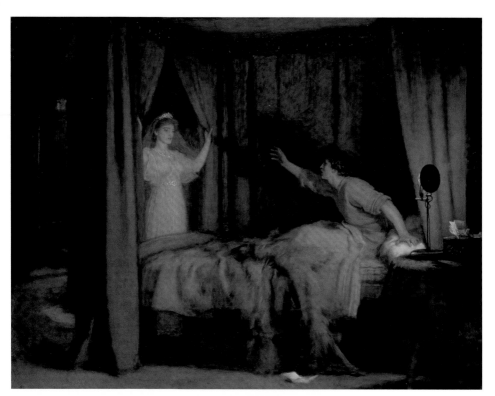

Fig. 46 John Everett
Millais (1829–96)
'Speak! Speak!' 1895
Oil on canvas
167.6 × 210.8
Tate

Fig. 47 (overleaf)
John Leech (1817–64)
Scrooge's Third Visitor 1843
British Library, London

Fig. 48 William Holman
Hunt (1827–1910)
The Haunted Manor 1849–53
Oil on board 23.3 × 33.7
Tate

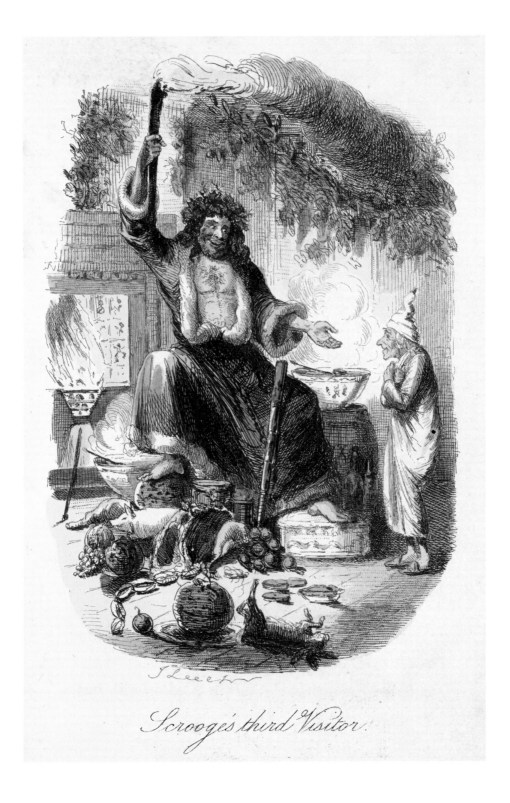

Scrooge's third Visitor.

vigorously up through the floorboards to join the action, casting off his shroud with one hand and clutching a dramatic mask with the other. This is not the admonitory apparition of folk tradition, or a frightening or gruesome one in the new Gothic style – Garrick is simply eager to stand shoulder to shoulder with his colleagues, and is not prepared to let his deceased state stand in his way.

Elsewhere in Gillray's prints, ghosts adopt more traditional roles. *Nightly Visitors, at St Ann's Hill* (1798, *fig. 32*) is an attack on Charles James Fox for his support of the Irish cause.[5] It represents Fox sitting up in bed – tellingly, wearing a revolutionary *bonnet rouge* in place of a night-cap – reacting in terror as he is confronted with a line of white-shirted ghosts who assemble at his feet, emerging from little clouds. Three of them are headless and have nooses around their blood-stained necks; they are identified by captions as the Irish rebels Grogan, Harvey and Quigley (a fourth, hidden by the cloud, is named as Sheares). The tallest is the Irish aristocrat and revolutionary Lord Edward Fitzgerald, who had died of wounds sustained while resisting arrest by the British; he wears a bloodstained shirt and holds his right hand to his chest. He upbraids Fox, his speech-bubble saying: 'Who first seduc'd my youthful Mind from Virtue? – Who plann'd my Treasons, & who caus'd my Death? – Remember poor Lord Edward, and despair!!! –', while the horrified politician, holding his hands defensively in front of him, quotes Macbeth in reply: 'Why do'st thou shake thy Goary Locks at me? Dear, bravest, worthiest, noblest, best of Men! Thou can'st not say, I did it!'. The quotation beneath the image – 'In glided Edward's pale-eye'd Ghosts, / And stood at Carlo's feet' – is adapted from an old English ballad, *Fair Margaret and Sweet William*: 'In glided Margaret's grimly ghost / And stood at William's feet.'[6] In so explicitly evoking a ballad with this prominent inscription, Gillray is nodding to the traditional nature of this scenario: these ghosts represent Fox's conscience. And we, the viewers, are allowed privileged access not only to Fox's bedroom, but also to the feelings that (so Gillray implies) he is at pains to hide from the public.

The ghost wields a subtly different form of authority in a cartoon Gillray devised in the following year, 1799: *Duke William's Ghost* (*fig. 33*). Here William Augustus, Duke of Cumberland (1721–65), returns from the dead in order to admonish his great-nephew the Prince of Wales (later George IV), who sprawls on his bed in a drunken stupor, fully dressed, tell-tale bottles lying

on the floor next to him. The monstrously obese ghost – who, absurdly, is naked except for sword, sword-sash and tricorn hat – emerges from billowing grey clouds, lifting the bed-curtains with one hand and holding aloft an hour-glass with the other. The glass's sands have nearly run out, a reminder to the Duke's (oblivious) great-nephew of the swift passage of time. The Duke, who had indeed been, in life, an exceptionally large man, is in this context a grotesque caricature of the fleshy putti and cherubs that were stock figures of *memento mori* imagery, and a ludicrous inversion of the conventional ghost-figure, which was almost always portrayed as thin or skeletal and either dressed in conventional clothes or a shroud. The composition as a whole, with a supernatural figure intruding into the chamber of one abandoned in sleep, parodies Fuseli's famous painting *The Nightmare* of 1781, still exerting its power eighteen years after it was painted. The Duke's ghost is a terrible warning to the prince of the physical toll of over-indulgence. As things turned out for the Prince, it was a prophetic one.

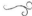

For Gillray, ghosts were a means to an end. A ghost could provide a way of including a deceased individual in a topical story – after the deaths of William Pitt and Fox, for instance, their 'shades' surfaced in *Phaeton alarm'd!* of 1808, a print that shows the earth set on fire by Napoleon. Pointedly, Pitt appears in one corner with a harp, Fox in the other with a pitchfork. Or a ghost could effect the admonishment of a powerful figure, whether a politician or a member of the royal family. At the end of the eighteenth century, a new kind of social satire emerged which simply presented ghosts as funny in themselves – both for their peculiar physiognomy, and in the effect of their appearance on their victims. While demotic broadsides and ballads told ghost stories, more costly and sophisticated satirical prints poked fun at those gullible enough to believe in them. At the beginning of the eighteenth century, Defoe and Addison had both made literary capital out of beliefs commonly attributed to uneducated country folk, and in 1787 the antiquary Francis Grose sarcastically referred to ghosts that haunted churchyards, 'who have no particular business, but seem to appear *pro bono publico*, or to feare drunken rustics from tumbling over their graves'.[7] At the century's close, this was evidently undiminished as a source of amusement – and the culture of terror introduced by Gothic art and literature, which often dramatised encounters with ghosts, only served to fan the flames.

Ghosts are frequently encountered in prints of the 1790s by the Derbyshire-born artist G.M. Woodward (known as Mustard George), where, normally depicted as tall, thin, white figures, they loom over terrified country people at night. In his 1792 design *Laying a Ghost!!* (*fig. 34*), a clergyman reading from a Bible is pushed towards an uncertain-looking ghost by his companions who, in a cowardly manner, take refuge behind him, one of them encouraging him with the words: 'He donna half like it – give un a little more Maister Parson and he'll vanish'.[8] Another print designed by Woodward and etched by his friend and drinking companion Thomas Rowlandson, published in 1800, perfectly illustrates the urban stereotype of the superstitious country bumpkin. *Terrour or Fright* (*fig. 35*) represents an unkempt man, eyes bulging and mouth gaping in terror as he turns to find a pale, ghostly figure tapping him on the shoulder. The ghost's mouth is open to reveal long, widely spaced teeth, and he wears round spectacles, giving the impression of large blank eyes. His Phrygian cap is a convenient shorthand symbol, suggesting terror and bloodthirsty violence.

But the image represents more than just a comic encounter; it is part of a series designed by Woodward, with the title *Le Brun travested* [*sic*], *or Caricatures of the Passions*, which parodies a famous series of expressive heads drawn by the seventeenth-century French artist Charles Le Brun for his *Conférence sur l'expression*, an influential lecture on the effect of emotion on physiognomy that he gave in 1668 to the Académie Royale in Paris. Le Brun explained that: 'Those affected by extreme Terror have the eyebrow raised high in the middle, and the muscles which produce this movement very prominent and swollen, pressing against each other and drawn down over the nose; both the nose and the nostrils must appear drawn up. The eyes must appear wide open, the upper lid hidden below the eyebrow'. The facial expression of Woodward's coarse yokel follows Le Brun's treatise to the letter.

Even more crushingly, the inscription beneath the image explains that this is not a representation of a real ghost, but of a trick played on the unsuspecting man: 'This Passion is frequently exited [*sic*] by dressing up frightful objects to represent Sprites, Apparitions &c: frequently practiced with success in Country Villages, as delineated in the above sketch of the Countryman & the Ghost.'

14. SHEETS AND CLOUDS

Gillray and other caricaturists may have stretched the boundaries, but the late eighteenth century also saw a more general change in the appearance of ghosts: it was a time when a range of new sartorial options became available to them. They had not always had such freedom. Most medieval ghosts had stuck to a soberly monochromatic colour scheme; there were black crows and dogs, and white horses and calves. In the centuries that followed they became even more conservative in their costume. Black-clad ghosts were rarely seen, and ghosts either appeared dressed as they were in life or, according to Francis Grose in 1787, 'clothed all in white'.[9] Grose does identify one apparition that dressed in black, described in the popular ballad *Margaret's Ghost*: 'And clay-cold was her lily hand, / That held her *sable shrowd*', but he prudently goes on to speculate that it 'may be considered as a poetical licence, used in all likelihood for the sake of the opposition of *lily* to *sable*'. In any case, Grose's research had shown that 'chains and black vestments' were 'chiefly the accoutrements of foreign spectres' – to which he added drily, 'dead or alive, English spirits are free'.[10] One of the main reasons for ghosts wearing white was to do with the colour of grave clothes, which were traditionally made from undyed linen or, after 1666, wool – this was when the Burial in Woollens Acts began to come into effect decreeing that English wool must be used for shrouds.[11] Grose noted that white-clad apparitions were 'chiefly the churchyard Ghosts', and Defoe, in *An Essay on the History and Reality of Apparitions*, described the archetypal ghost of the era as 'dress'd up ... in a Shrowd, as if it just came out of the Coffin and the Church-yard'.[12]

Descriptions and images of shroud-wearing ghosts reflect not only the reality of grave-clothes, but also the imagery that was often used for funerary monuments of the sixteenth and seventeenth centuries. Engraved memorial brasses and carved stone effigies usually show the dead dressed in contemporary costume, but it was not uncommon for them to be represented wearing grave-clothes, in anticipation of their resurrection at the Last Judgement. A late medieval alabaster tomb at St Edmund's Church in Fenny Bentley in Derbyshire bears full-scale effigies of Thomas Beresford and his wife parcelled up in shrouds, with even their faces covered, like peas waiting to be podded. Engraved brasses dating from about 1516, originally from Dunstable Priory Church, Bedfordshire, and now in the

Victoria and Albert Museum, depict Henry and Agnes Fayrey, shrouded but alert, hands raised in anticipation of greeting, ready to meet their maker (*fig. 36*); while in King's College Chapel in Cambridge, a modest grisaille panel set into a window represents a quiet detail of the resurrection – an anonymous shrouded corpse standing up in his tomb, his right hand on his heart in a gesture of faith and his mouth open as if about to speak. Images such as these were appropriated by popular culture to the extent that, in terms of visual appearance, there was little to distinguish between ghosts and the resurrected righteous.

As time went on, when corpses were prepared for burial they were dressed in ever-more tailored grave-clothes, less bulky than before and similar to ordinary men's shirts and women's shifts. From around 1700 long-sleeved shirts with drawstrings at wrist and neck replaced the old winding sheet.[13] While seventeenth-century broadsides represent ghosts in shrouds tied up above their heads but loose at the feet to enable them to walk, Gillray and Woodward at the end of the eighteenth century usually show them wearing these simple white shirts instead. This newly conventional form of dress did not cramp caricaturists' style, as by that time a range of other options allowed them to modify the appearance of their ghosts in ways variously gruesome or amusing. But in other arenas of visual art, this reduction of shock-power constituted a significant change: this neat new costume did not remotely correspond to the Romantic idea of the 'magnificent horror' wielded by the ghost. So in the hands of artists such as Henry Fuseli, George Romney and John Flaxman ghosts were provided with a new wardrobe: they began to sport voluminous white sheets.

George Romney was a successful society portraitist who longed to tackle more profound subject matter. He filled sketchbook after sketchbook with ideas for ambitious compositions drawn from history, literature and myth. Few, however, came to fruition. One such preparatory sketch is a large cartoon made around 1778–9 illustrating a scene from *The Persians*, a play by the Greek dramatist Aeschylus (*fig. 37*). Romney draws the ghost of Darius the Great, King of Persia, whose widow Atossa has asked the chorus to summon him up from his tomb when she hears of the Persian defeat by the Greeks at the Battle of Salamis. Atossa hopes that Darius might offer a remedy, but the gloomy ghost only prophesies another loss for the Persians. Romney shows the shade of Darius appearing in the midst of nebulous white vapour, as though he has been swept in on an obliging cloud that has conveyed him back

to earth and is now thinking about dispersing. Cloudy billows completely conceal his lower half, while his upper body is covered by his luxuriant beard and by the large sheet that is draped over his head and arms. The latter is loosely based on the ancient Greek chiton, a long, wide garment made of linen or wool that was normally gathered in at the waist. The apparition lifts and spreads his arms, creating a strange and imposing silhouette as the sheet is lifted from the top of his head, where it appears to rest on his crown, to his wrists. With the more prosaic parts of his figure concealed by the cloud, Darius gives the impression of appearing as a melancholy winged head.

The sculptor and illustrator John Flaxman also recognised the dramatic potential of loose fabric: when he came to depict the ghost of Clytemnestra in his popular outline illustrations to Aeschylus, he dressed her in a white sheet which she lifts high above her head, creating an unnerving silhouette. The voluminous nature of the sheet allowed the ghost to modify its shape and even to exaggerate its height – perhaps this latter trick was an unconscious echo of the shroud's prominent top-knot, which added considerable inches. Clytemnestra's additional height conveys authority, while her gesture suggests heightened emotion and imminent action.

When Romney and Flaxman covered their ghosts up, they were turning decisively away from the Gothic fixation with the rattling skeleton and the ambulant corpse. They wished to suggest mystery and awe by concealment, rather than to shock with exposure, and they looked to the classical world for inspiration. The second half of the eighteenth century saw a huge revival of interest in classical antiquity, which prompted many artists to emulate what the German antiquary and theorist Johann Winckelmann described (in Fuseli's translation) as a 'noble simplicity and sedate grandeur in Gesture and Expression' which he found in Greek art.[14] And just as Romney and Flaxman sought classical texts to illustrate, so they clothed their ghosts in correspondingly classical dress. With a nod to the chiton but with greater versatility, the loose white sheet conveyed unmistakeable authority. So closely associated with sheets did ghosts remain that in 1904 M.R. James could create an appallingly frightening phantom that, at least in its physical form, was nothing but a sheet, with an integral 'intensely horrible, face *of crumpled linen*'.[15]

Ghosts in voluminous garments might have had impeccable classical credentials, but their influence was also felt at the other end of the cultural scale. In 1804 the district of Hammersmith in West London was

terrorized for over a month by the repeated appearance of a figure wearing a white sheet. So terrifying did people find this that a sighting caused one unfortunate woman to die of fright, and local vigilantes made a number of misguided attacks on white-smocked workmen.[16] The 'Hammersmith ghost' was soon exposed as a hoax, but in the meantime a print claiming to represent the spectre was circulated, which helped to reinforce the white-sheeted ghost look (*fig. 38*). It shows the otherwise unremarkable figure raising its arms menacingly within the sheet, in what had become the standard visual shorthand for ghosts – and one that has persisted to the present day.

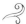

Loose sheets were all very well, but they did not suit every type of ghost. Although they inspired awe, they also tended to obscure an apparition's identity, which was precisely what most illustrators and satirical print-makers wanted to avoid. After the demise of the top-knotted shroud as a convenient shorthand, another strong visual signal was needed to strengthen the impact of simpler burial clothes. It presented itself in the shifting form of the cloud, used by artists from Jan van der Gucht in the early eighteenth century to James Gillray at the end of it. These artists were drawing on an established convention in religious painting, where clouds had long been employed as fleecy ferries that shuttled between earth and the heavens.[17] In the great painting of the Assumption that Titian made between 1516 and 1518 for the church of the Frari in Venice, the Virgin is elevated towards the divine presence of God on a thick woolly cloud-platform, cherubs grappling with its soft bulges as they propel it and its cargo heavenwards. In the theatre, too, early stage machinery had included painted wooden clouds attached to pulleys, fanciful cars ready to winch gods up to their lofty province. Cloudy vapour bubbling around a ghost, like that in the satirical print *Boswell and the Ghost of Samuel Johnson* (*fig. 39*), in which Dr Johnson puts in a post-mortem appearance to berate the hapless Boswell for being 'a retailer of Phrases', suggests a temporary return to earth before being enfolded and spirited away again. To modern eyes, Dr Johnson resembles a rocket about to achieve lift-off.

Clouds have long whetted our visual imagination, inviting conjecture as they endlessly shape-shift, resembling one thing and then another. 'I have', wrote Leonardo da Vinci, 'in the past seen clouds and wall stains

which have inspired me to beautiful inventions in many things."[18] Not only are they useful conveyors of ghosts, but they also have qualities in common with them. Clouds are nebulous and indistinct, inspiring speculation but not satisfying it. We see them in a particular form for only a few moments before they disperse; and they are neither up nor down, but occupy a debatable land in between. Clouds, like ghosts, are ambiguous phenomena. Their latent power is enormous. And just as clouds can announce welcome shade or unwanted rain, so ghosts can bring either comfort or terror: think of the wildly different reactions of Heathcliff and Lockwood to the presence of Catherine's ghost in *Wuthering Heights*.

In visual representations, ghosts could emerge from the rounded contours of their own personal cloudscape, or they could even have extravagant vapour trails for heads, like the one van der Gucht gave Defoe's moralising minister. But as time went on they themselves began to take on a more nebulous form. Back in the 1620s Robert Burton had pondered over what was even then an age-old question of whether or not spirits had physical bodies, and in 1787 Grose noted that in most accounts, ghosts 'are supposed to be mere aërial beings, without substance, and that they can pass through walls and other solid bodies at pleasure'.[19] Passing through solid objects was one thing; but it was partly the element of surprise that accompanied the disappearance of one apparently solid object into, and through, another, that created the effect. It was only in the late eighteenth century that their appearance began to reflect their insubstantial qualities: they became see-through.

Ghosts' acquisition of see-through properties, and the ability to fade in and out, seems to have developed concurrently with developments in optical entertainments and light shows that transformed public entertainment towards the end of the eighteenth century. The old lantern-slide technology of course resulted in a luminous, transparent-looking image. In a phantasmagoria show this impression was made more striking by back-projecting the image onto a gauzy screen.

In visual art, this new quality was also to do with an increasing use of the medium of watercolour. While watercolour had been used more and more in the second half of the eighteenth century for landscape and architectural views, its suitability for literary and historical subjects only began to be fully realised in the early nineteenth century. William Blake exploited its translucent properties in his watercolour of 1806, *Richard III*

and the Ghosts, which shows the king surrounded by the transparent ghostly figures of his victims, his armour and blade no match for their nimble, airy bodies (*fig. 40*). When Dickens made Marley's ghost see-through in *A Christmas Carol*, he was drawing on a convention that had only relatively recently been established:

> His body was transparent: so that Scrooge, observing him, and looking through his waistcoat, could see the two buttons on his coat behind.

> Scrooge had often heard it said that Marley had no bowels, but he had never believed it until now.[20]

In time, purportedly true accounts of cloudy or see-through ghosts began to be recorded. In her popular 1848 compendium of supernatural experiences *The Night Side of Nature; Or, Ghosts and Ghost Seers*, Catherine Crowe described a genre of apparition that was 'vapoury', 'cloudy' and 'transparent'. 'I have met', she writes, 'with several instances of these cloudy figures being seen, as if the spirit had built itself up a form of atmospheric air'. On other occasions, she notes, 'apparitions are represented as being transparent', and she mentions four instances of which she had recently been told.[21] A classic account is included in her 1859 collection, *Ghosts and Family Legends*, which contains the story of Count P. who, having elected to spend the night in a supposedly haunted room, saw 'something like a cloud in the chair' which gradually 'took a form' and resolved itself into a 'tall white figure' which got up and advanced into the room.[22]

The idea that ghosts often appeared to be vaporous or translucent was further reinforced by the invention of photography at the end of the 1830s: it was not long before shadowy figures, produced by the technique of double-exposure, were interpreted as ghosts that had been detected by the camera's mechanical eye. It is paradoxical that it should have been advances in technology, in the shape of back-projection and the science of photography, which provided new ways of 'seeing' such age-old phenomena as ghosts. But the visual revelations of these technologies made sense of common ghost behaviours, reflecting their supposed ability to walk through walls or to appear unexpectedly. They fed back into the ways in which people interpreted their own experiences as much as they influenced images and fictional stories.

Ɋ

Paradoxically it is sometimes a ghost's ordinary clothes that are the give-away. In his reports of ghostly visitations, John Aubrey goes into details of appearance only when an apparition's identity is concerned. He tells, for instance, of a Dr Jacobs in Canterbury, who sees his cousin Henry – who had died at his home a week before. Dr Jacobs was 'in Bed and awake, and the Moon shining bright', when he saw Henry standing by his bed 'in his Shirt, with a white Cap on his Head, and his Beard Moustaches turning up, as when he was alive'.[23] Similarly, in Defoe's *A True Relation of the Apparition of one Mrs. Veal*, the close description that Mrs Bargrave gave to a mutual friend of the striped silk gown that the spectral Mrs Veal was wearing provided proof that it could be no-one but her. Her friend exclaimed: *'You have seen her indeed, for none knew, but Mrs Veal and my self, that the Gown was Scower'd'* (that is, that the fabric had been washed to make it softer).[24]

The seemingly insignificant details of clothes can not only identify a ghost, but can even reinforce its authenticity. In one of the stories collected by Catherine Crowe for *Ghosts and Family Legends*, Miss P. relates how her fiancé was an officer whose regiment was stationed in the West Indies. One day, alone in her room in England, there was a knock at the door. Thinking it was her maid, she told her to enter. But the person who came into the room was her fiancé, Captain S., who fetched a chair, sat down and spoke with her for some time. A month after this inexplicable visit, Miss P. received a telegram informing her that Captain S. had died of fever that very day. What makes her account vividly compelling is her description of his uniform: 'when his back was turned, I remember distinctly seeing the seams of his coat behind.'[25] This is not a generalised sense of a ghostly form, but a tellingly prosaic detail.

Conversely, the very normality and contemporaneity of a ghost's dress can sometimes disguise its true nature. A character in a ghost story published in 1891, *Cecilia* by Lanoe Falconer (the pseudonym of Mary Elizabeth Hawker), put his finger on the problem:

If you study the reports of societies that hunt the supernatural, you will find that the latest thing in ghosts is very quiet and commonplace. Rattling chains and blue lights, and even fancy dress, have quite gone out. And the people who see the ghosts are not even startled at first sight; they think it is a visitor, or a man come to wind the clocks.

In fact, the chic thing for a ghost in these days is to be mistaken for a living person.[26]

The very phenomenon of the clothes-wearing ghost has, however, occasionally given rise to scepticism. In his 1863 pamphlet *A Discovery Concerning Ghosts, With a Rap at the 'Spirit Rappers'*, the Victorian caricaturist and book illustrator George Cruikshank expressed the problem as follows:

> from all I have been able to learn, it does not appear that in the days from Pliny the younger down to the days of Shakespeare, and from thence down to the present time, THAT ANY ONE HAS EVER THOUGHT OF THE GROSS ABSURDITY, AND IMPOSSIBILITY, OF THERE BEING SUCH THINGS AS GHOSTS OF WEARING APPAREL, IRON ARMOUR, WALKING STICKS, AND SHOVELS! NO, NOT ONE, except myself, and this I claim as my DISCOVERY CONCERNING GHOSTS, and that therefore it follows, as a matter of course, that as ghosts *cannot, must not, dare not,* for decency's sake, appear WITHOUT CLOTHES; and as there can be no such things AS GHOSTS OR SPIRITS OF CLOTHES, why, then, it appears that GHOSTS NEVER DID APPEAR, AND NEVER CAN APPEAR, at any rate not in the way in which they have been hitherto supposed to *appear.*[27]

He ended this part of his rant with a sarcastic coda – an illustration of the ghosts of stockings, drooping limply from a clothesline (*fig. 41*).

15. IN THE OLDEN TIME

'Now, pray, shew me anything ancient.'[28] Two tourists, around a century apart, made excursions around England and Wales. They visited many of the same houses – but they viewed them with quite different eyes. The late eighteenth-century diarist John Byng, later Viscount Torrington, made the above request to his guide during a visit to Raby Castle, a fourteenth-century fortress in County Durham. Byng thoroughly disliked modern architecture, abominated any 'ugly, staring red-brick house' and 'new, nasty, tasteless, bridge', and was an enthusiastic connoisseur of 'old castles, old manors and old religious houses', which he wanted to see 'before they

be quite gone'.[29] He was captivated by the medieval past, often taking up his pencil to sketch picturesque views. On one August day in 1788, visiting Ashburnham Place near Battle in East Sussex and waiting for a friend travelling on foot to catch him up, he lay down under a tree 'like a knight in romance' – although perhaps a little more self-consciously.[30] Celia Fiennes, who had made her series of excursions from the late 1680s to the early 1700s, took a rather different view. She surveyed the sites she visited with a pragmatic, matter-of-fact eye that saw more value in mining and manufacturing than in ancient architecture. Visiting the medieval manor house Haddon Hall in Derbyshire, which even Nikolaus Pevsner was moved to describe poetically as 'the large, rambling, safe, grey, loveable house of knights and their ladies, the unreasonable dream-castle of those who think of the Middle Ages as a time of chivalry and valour and noble feelings', Fiennes merely remarked that 'it is a good old house', but added that it was 'nothing very curious'.[31] Her praise was reserved for what was new, convenient and comfortable, and her favourite term of approbation was 'neat'.[32]

Fiennes's interest in the new gradually became old-fashioned – at least among those of a literary sensibility – until by the end of the eighteenth century Byng's interest in 'anything ancient' was all the rage. As advances in technology and manufacturing began to change the face of Britain, people were gripped by a passion for the past. Relics of British history – in particular from its medieval, pre-Reformation past, but also from the Tudor and Stuart periods – came to be invested with a powerful emotional charge, and it was not long before this fascination found its expression in the supernatural. What were ghosts, after all, but the past dramatically realised? It was in an introduction to an edition of Walpole's *Otranto* published in 1811 that Walter Scott, the master of bringing the past to life, described the intense sensations that could be evoked by a medieval interior:

He who, in early youth, has happened to pass a solitary night in one of the few ancient mansions which the fashion of more modern times has left undespoiled of their original furniture, has probably experienced, that the gigantic and preposterous figures dimly visible in the defaced tapestry, the remote clang of the distant doors which divide him from living society, the deep darkness which involves the high and fretted roof of the apartment, the dimly-seen pictures of ancient

knights, renowned for their valour, and perhaps for their crimes, the varied and indistinct sounds which disturb the silent desolation of a half-deserted mansion, and to crown all, the feeling that carries us back to ages of feudal power and papal superstition, join together to excite a corresponding sensation of supernatural awe, if not of terror.[33]

When in 1814, however, he himself was put up for the night in the reputedly 'haunted chamber' at Dunvegan Castle, the robustly sceptical Scott recalled many years later that he had felt 'nothing but that I had had a busy day and eaten a good dinner and drunk a bottle of excellent claret', and had slept soundly without disturbance from 'the ghost of Rorie More or anyone of his long line'.[34] Nonetheless, he went on to observe that 'whether reconcileable to the understanding or not [ghosts] are most interesting to the imagination'; and perhaps recalling this incident suggested its potential as a narrative, because soon afterwards the 1829 issue of the literary annual *The Keepsake* included 'The Tapestried Chamber, or, The Lady in the Sacque', a short story by Scott which dramatises just this situation.[35] A brave officer, General Browne, just returned from the American War of Independence, pays an unexpected visit to an old school-friend, Frank Woodville, at his medieval castle in the West Country. The room in which the general is to sleep is 'old-fashioned', and the furnishings – though barely a hundred years old at the time the story is set – give it an air of 'melancholy':

> The bed was of the massive form used in the end of the seventeenth century, and the curtains of faded silk, heavily trimmed with tarnished gold ... There was an air of gloom in the tapestry hangings, which, with their worn-out graces, curtained the walls of the little chamber ...[36]

Late that night, the ghost of an old woman duly appears which seems to have been fashioned from the soft furnishings of the room itself. What General Browne sees at first is her back-view, dominated by folds of pleated fabric that flow down her dress and 'terminate in a species of train', which he identifies as 'an old-fashioned gown which, I think, ladies call a sacque'. When the ghost turns to reveal a corpse-like face and approaches the general 'with a grin which seemed to intimate the malice and derision of an incarnate fiend', Scott bows to the conventions of Gothic fiction – but it is perhaps

at the expense of the subtle menace he had so skilfully evoked by his descrip-
tion of the stirring of a worn and faded tapestry in an autumnal breeze
from the 'ancient lattice-window' and the strangely sinister presence of
the obsolescent 'hundred strange-shaped boxes' that remain on the toilet
stand.[37] The potential horror and the feeling of the past encroaching into
the present become sharply focused in the figure of the malevolent ghost.
But did Scott's real interest lie in the more subtle atmosphere created by
certain old buildings and the emotional force exerted by history, expressed
in the sensation of supernatural potential that he so vividly describes in his
introduction to *Otranto*? It is hard not to feel disappointed when the ghost
takes over from the creeping ghostliness that the room seems to exhale.

It was, of course, susceptibility to just these sorts of sensations evoked
by ancient architecture and antique furnishings that Jane Austen had so
mercilessly ridiculed in *Northanger Abbey*, her parody of the 'Gothic' novel
largely written in 1798–9 but published posthumously in 1818. During
her first night spent in a comfortably papered and carpeted room at the
abbey, 'by no means unreasonably large', and unromantically containing
'neither tapestry nor velvet', the highly impressionable Catherine Morland
seizes on the one potentially mysterious piece of furniture, an old black
cabinet, and investigates its contents.[38] Finding a roll of paper secreted
deep within, she is gripped with a desire to discover what soul-shaking
mysteries it might contain, and with pale cheek and fluttering heart has
just begun to examine the manuscript when a gust of wind blows out her
candle, leaving her 'motionless with horror' and trembling from head
to foot. Having groped her way into bed in the dark, on waking the next
morning she eagerly collects the papers scattered the night before as she
had hastily taken refuge under the bedclothes, and on perusing them
discovers: 'An inventory of linen, in coarse and modern characters ... she
held a washing-bill in her hand.'[39] Catherine eventually reaches the wise
conclusion that: 'Charming as were all Mrs Radcliffe's works ... it was
not in them perhaps that human nature, at least in the midland counties
of England, was to be looked for.'[40]

While for Austen the humour of the situation lay in the anti-
climax, sometimes the joke was turned on its head, and morbid
curiosity was punished with an unexpected dose of the super-
natural. A cartoon of 1802 by Thomas Rowlandson, *Antiquaries in
Westminster Abbey* (*fig. 42*), satirises contemporary fascination with

medieval history and the archaeological investigations it inspired. It represents three curious historians who have opened a tomb and, by doing so, inadvertently raised the ghost of its occupant. Shambolically tripping over the coffin and each other, they flee in terror at the sight of the spectral armoured knight who strikes an imperious pose. It was Rowlandson's first idea for a joke that he would include in his series *The English Dance of Death*, which explicitly refers to the opening of royal tombs by members of the Society of Antiquaries, and is accompanied by the verse: 'A curious wish their fancies tickled / To know how Royal Folk were pickled'.[41]

This fascination with antiquity was shared by a new kind of sentimental tourist that emerged in the late eighteenth century. While for many years people had, of course, sought out picturesque architecture and enjoyed the sensations of melancholy it engendered, a new enthusiasm for associating sites with particular historic characters shaped late Georgian attitudes: it had become what Samuel Taylor Coleridge disparagingly deemed an 'AGE OF PERSONALITY'.[42] Visitors went to Bemerton to stroll thoughtfully in the footsteps of the seventeenth-century poet and priest George Herbert; they travelled to Woodstock to see the site where Fair Rosamund, the mistress of Henry II, had lived and died; and they visited Hardwick Hall in Derbyshire, where Mary, Queen of Scots had not, in fact, been imprisoned. Her incarceration had actually been at nearby Chatsworth, but after it was remodelled in the late seventeenth century there was little left to connect her with the house. The great Elizabethan 'prodigy house' Hardwick, on the other hand, unquestionably looked the part, although the rooms in which Mary was supposed to have been kept were constructed some time after her execution.[43] Nevertheless, in 1762 Horace Walpole's great friend, the poet Thomas Gray, had been struck by the almost tangible sense of her presence. 'One would think Mary Queen of Scots was but just walked down into the park with her guard for half-an-hour', he rhapsodized.[44] In her travel book published in 1795, Ann Radcliffe described similar sensations during a visit in which she 'followed, not without emotion, the walk, which Mary had so often trodden'. She used her novelist's imagination to dramatise the interior of the great hall:

The scene of Mary's arrival and her feelings upon entering this solemn shade came involuntarily to the mind; the noise of horses' feet and many voices from the court; her proud yet gentle and melancholy look, as, led by my Lord Keeper, she passed slowly up the hall; his somewhat obsequious, yet jealous and vigilant air, while, awed by her dignity and beauty, he remembers the terrors of his own Queen; the silence and anxiety of her maids, and the bustle of the surrounding attendants.[45]

In a way, it hardly mattered. This was an interest in the past that expressed itself through an imaginative, emotional engagement with the stories of previous inhabitants. The house, castle or ruin became a kind of stage set, and a desire arose for it to be peopled with historical figures – a desire that ghosts were in an ideal position to meet.

Walpole had explicitly connected ghosts with buildings in *The Castle of Otranto* (see pp.122–4). Writing to his friend George Montagu a few years later, he described a visit to his niece, who had recently moved to Ham House, near Richmond-upon-Thames. The visit left him with mixed feelings, one of which was peevishness (for all Walpole's love of history, he liked the experience of it to be tempered with modern comforts). Ham House was, he complained:

> so blocked up and barricaded with walls, vast trees and gates that you think yourself an hundred miles off and an hundred years back. The old furniture is so magnificently ancient, dreary and decayed, that at every step one's spirits sink, and all my passion for antiquity could not keep them up. Every minute I expected to see ghosts sweeping by, ghosts I would not give sixpence to see, Lauderdales, Talmachs and Maitlands![46]

In years to come, the aristocratic apparition loomed large in the popular imagination. It is, of course, hard to date tales of ghosts that haunt grand houses – the formidable Duchess of Lauderdale who was indeed thought to sweep down the staircase at Ham, trailing rose-scented perfume; or poor Anne Boleyn, reduced to drifting around in the form of a grey lady at Blickling Hall in Norfolk with only an annual headless outing in a carriage to relieve the monotony – but there is no doubt that these stories became increasingly well known at this time of growing interest in British history.

And no wonder that a strong connection was made between ghosts and the aristocracy: ghosts were walking evidence of a family's antiquity, better than the grandest of portrait galleries. How many of us know anything much about our great-great-grandparents – even our great-grandparents? But ghosts represent unforgotten ancestors; historical characters who refuse to fade into obscurity and who were so important in life that they maintain a presence even in death. They are ideal exemplars of lineage.

Ghosts became associated with the aristocracy to the extent that Mrs Rouncewell, housekeeper to the Dedlocks in Charles Dickens's *Bleak House* (1853), can consider 'that a family of such antiquity and importance has a right to a ghost. She regards a ghost as one of the privileges of the upper classes; a genteel distinction to which the common people have no claim.'[47] The novel's concern with the snakes and ladders of social position gives Dickens the opportunity to invert the conventionally bolstering role of the aristocratic ghost in the tale of the 'Ghost's Walk' at Chesney Wold. Mrs Rouncewell tells her grandson and Lady Dedlock's maid, Rosa, the old story of Sir Morbury Dedlock's proud wife who, during the English Civil War, was on the side of the parliamentarians, and had more than once lamed her husband's horses on nights before he was due to ride out to help the king's cause. On one such night he caught her and they struggled, she falling and injuring her hip. Lamed, she would habitually walk up and down the terrace until one day she fell and died there, vowing to haunt the spot 'until the pride of this house is humbled'.[48] It is on a 'gloomy evening, overcast and sad' that the novel's heroine Esther Summerson goes out alone, and as she draws near Chesney Wold realises that 'there was a dreadful truth in the legend of the Ghost's Walk; that it was I, who was to bring calamity upon the stately house; and that my warning feet were haunting it even then'. Esther's realisation is that, because she is of illegitimate birth, she herself is a ghost of sorts; she haunts her own mother, Lady Dedlock, to whom she has apparently come back from the dead. But although Esther did not die, as her mother had initially believed, neither, given Lady Dedlock's inability to acknowledge her daughter publicly, can she be completely alive to her. And, as a ghostly figure, Esther is granted the ghost's conventional power of revelation. 'Seized with an augmented terror of myself which turned me cold,' she says, horrified by her own ghostly capacity to reveal the deepest of secrets, 'I ran from myself and everything'.[49]

Ghosts could maintain a powerful presence even in their absence. When the illustrator Hablot Knight Browne, better known as 'Phiz', came to depict the Ghost's Walk for the first edition of Bleak House, he chose to show an empty terrace at twilight, faintly illuminated by light from the house. The evening sky is overcast and the only animation is supplied by a couple of bats; the elaborate architecture looks distinctly unwelcoming, and the two stone figures flanking the steps introduce a menacingly Gothic note. It is a comfortless image. The very absence of a figure prompts the eye nervily to search the shadows at the far end of the terrace as it disappears in utter darkness under an archway.

The belief that a house is haunted is enough to create a frisson of dread, dramatising the experience of visiting. William Frederick Yeames caught just this sensation in his 1869 painting A Visit to the Haunted Chamber (fig. 43). Yeames and his friend Philip Hermogenes Calderon, both members of the St John's Wood Clique, a group of painters who specialised in historical subjects of an anecdotal nature, had rented Hever Castle, the former home of the Boleyn family, for the summer months of 1867. Stories that circulated of Anne Boleyn's ghost haunting the castle (as well as Blickling) suggested this scene to Yeames. Two day-tripping young women, smartly dressed in riding clothes, venture into a panelled room dominated by a draped four-poster bed, their postures making their trepidation plain: the bolder of the two peeps round the corner, while her friend places a restraining hand on her arm. There is, of course, nothing to see – except the cause of their alarm, a rat that makes a scratching sound as it tries to mount the threshold on the other side of the room. It is an audacious composition: Yeames leaves the centre of the painting empty of figures, the sunlight that falls on the bed-covers and the chimney piece suggesting the potential for animation. Imagination alone supplies the ghostly atmosphere and suspense. Yeames tactfully offers us, the viewers, a double role: we are licensed to join the wide-eyed young women in scanning the 'haunted room' for evidence of the uncanny, but we are also able to adopt the face-saving role of amused observers, permitted to see what they cannot.

Henry James visited Haddon Hall in 1872, and later described his feelings as he contemplated the scene:

The twilight deepened, the ragged battlements and the low, broad oriels glanced duskily from the foliage, the rooks wheeled and clamoured

in the glowing sky; and if there had been a ghost on the premises I certainly ought to have seen it. In fact I did see it, as we see ghosts nowadays. I felt the incommunicable spirit of the essence of the scene with the last, the right intensity. The old life, the old manners, the old figures seemed present again.[50]

The ghosts were still there – but with a difference. As it seemed to the super-subtle James, a man who was born in the new world but made his life in the old, by this time they had no need to do anything so vulgar and obvious as manifest themselves. To the sensitive observer, the atmosphere of a historic house was pervaded with them, and the bitter-sweet flavour of their absent presence could be savoured, at will, with the view.

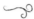

Dante Gabriel Rossetti created some of the most haunting paintings of the nineteenth century. But he was impatient with careful study from nature: instead his works were conceived in his book-lined imagination. His earliest compositions sprang out of the literature he devoured so avidly: when he was eight years old he made drawings illustrating Matthew Gregory Lewis's *The Castle Spectre*, and later he read Walter Scott and was inspired by the ghost scenes in Hamlet.[51] As a young artist coming of age in the middle years of the nineteenth century, over and again he drew scenes from Romantic works: Johann Wolfgang von Goethe's play *Faust* and Edgar Allan Poe's darkly brooding poems 'The Raven' and 'Ulalume'. Rossetti forged his artistic identity by giving visual form to an unseen world of ghosts, doppelgängers, angels and demons.

But for all the inward-looking nature of his art, Rossetti was far from desiring to withdraw from the world at this time. In September of 1848, when he was twenty, he met with a group of young artists in a house on Gower Street with the aim of creating a new sort of art. They despised the ubiquitous sentimental genre paintings that aimed to please an undemanding, middle-brow, picture-buying public, and dismissively referred to the revered first president of the Royal Academy, Sir Joshua Reynolds, as 'Sir Sloshua'. The young men sought instead to create a fresh, sincere kind of art. The name they chose for their group, the Pre-Raphaelite Brotherhood, signalled their desire to reach back in order to find alternative models and indicated their sympathy with what was 'direct and serious

and heartfelt in previous art', as they put it in their manifesto. In order to progress, they believed they needed to delve into the past, enriching their repertoire with European art, literature and legend. The medieval world was, at this early stage in his career, Rossetti's province. Medieval settings were, in part, a signal that he was rejecting the modernity that, in his view, was compromised by the pervasive influence of High Renaissance masters. They also seemed to free him from the constraints of realism and allowed him to create his own imaginary arena in which he could explore intense psychological states with simple candour.

Between 1846 and 1848 Rossetti made numerous drawings based on *Faust*, the poem-play set in sixteenth-century Germany that was begun by Goethe in the 1770s and published in 1808. These drawings reveal that Rossetti was particularly fascinated by the predicament of Margaret (Gretchen), the pure young woman who is tempted from her simple, moral life by the scholar Faust, who has fallen in love with her and who is helped to effect her seduction by the demon Mephistopheles. In the drawing *Faust: Margaret in the Church* (*fig. 44*), Rossetti illustrates an episode in which an evil spirit appears behind Margaret, who now bears Faust's child, when she attends a service. The spirit taunts her:

How changed, Gretchen, you feel
Since full of innocence
You would approach this altar...

'Oh! Oh!' responds Margaret, 'Would I were rid of thoughts / That course my mind along, athwart, / To spite me!'[52] Rossetti's Margaret kneels devoutly beside a small shrine to the Virgin Mary but, although her hands are clasped in prayer, she is distracted and turns to glance fearfully over her shoulder to where the spirit seems to emerge from the gloom, a pale vaporous form against the dark cross-hatching of the pen-work, only the sharp pen-strokes of its eyes distinct. As in the poems by Poe that Rossetti illustrated during the same period, the presence of a supernatural figure gives an additional dimension of psychological horror to the dark but very human forces at work in the play.

In his paintings and drawings Rossetti often employed mirrors and visual echoes to create a strange, dream-like atmosphere, and he uses this to fullest effect in a composition he first made in 1851, *How They Met Themselves*

(*fig. 45*).[53] He had long been fascinated by the old German legend of the doppelgänger, and now he depicted an eerie encounter: a pair of lovers wearing medieval dress walking through a dark wood, where they are confronted by their doubles.[54] The supernatural status of the doppelgängers is signalled by their prickly, glowing auras, and they glare with wide-eyed menace at their counterparts. The living woman collapses with shock, while the man clutches her arm and stares at the supernatural couple, transfixed with disbelief and dismay. Rossetti's technique of building the image with hundreds of short, delicate ink lines, made with the finest of pen nibs, adds to the drawing's claustrophobic ambience. His web of lines is so dense that the composition gives the impression of emerging in ghostly form from a black sheet of paper rather than made, conventionally, in black ink on white. Looking at the drawing, you can sense the close atmosphere in the stillness of the clearing, and almost feel their breath on each other's faces. With *How They Met Themselves* Rossetti re-imagined the ghost theme. His supernatural beings are all the more uncanny because they are so mysterious: do they emanate from within? Or were they lurking, all along, in the darkness of the woods?

Does the historical setting make this supernatural encounter seem more distant, or bring it closer? Stripped of the specifics of modern-day dress, the scene's emotional charge stands revealed. This paradox was one well understood by John Everett Millais, another central member of the Pre-Raphaelite Brotherhood. Millais' early drawings reveal that he shared Rossetti's appreciation of the dramatic potential of the ghost and its ability to add an extra dimension of emotional anguish to an already highly charged scene: in one ethereal pen and ink drawing of 1853 he imagined the ghost of a former lover appearing at the altar to interrupt a couple's vows during their wedding ceremony.[55] Millais' fascination with the supernatural re-emerged at the end of his career. For '*Speak! Speak!*' (1895, *fig. 46*), the last large narrative painting he made, he used the turret chamber of a castle, Murthly in Perthshire, as a model for the room. But it is set in an indeterminate period: the four-poster bed suggests a medieval or seventeenth-century setting – but does the animal pelt on the bed imply a more distant past in classical antiquity?

It is late at night and the only light comes from a single candle, mounted in a lamp by the bed. By its light a young man has been reading old letters: tied together with ribbon, they spill out over the top of a box next to the

lamp. Suddenly the curtains at the foot of the bed part, and he sits up in astonishment and reaches out passionately towards the beautiful woman who stands there, looking at him with a fixed expression and opening her mouth as though about to speak. She wears a simple white dress and a tiara holding a veil, the fabric of her dress and her nacreous necklace and belt appearing to glow in the dark room. Has he conjured her up by reading the letters? Is she the ghost of his dead wife? A living woman? Or a dream? Above all, Millais wanted to maintain the tension of suspense and ambiguity. The artist's early biographer M.H. Spielmann recorded a conversation he had had with the artist:

> When I remarked that I could not tell whether the luminous apparition were a spirit or a woman he was pleased: 'That's just what I want', he said; 'I don't know either, nor', he added, pointing to the picture, 'does he.'[56]

VI

A

HAUNTED

CENTURY

Thus dames the winter night regales
Wi wonders never ceasing tales

JOHN CLARE, 'JANUARY: A COTTAGE EVENING',
THE SHEPHERD'S CALENDAR

16. HAUNTS OLD AND NEW

A Christmas Carol begins in the murk of a December afternoon. 'It was cold, bleak, biting weather: foggy withal', and, on Christmas Eve, London 'had not been light all day'. Charles Dickens describes the fog as a kind of dark magic that cannot be kept out, but comes 'pouring in at every chink and keyhole': it transforms day into night, and solid buildings into wraiths; 'although the court was of the narrowest,' Dickens tells us, 'the houses opposite were mere phantoms'. It hides the ancient church tower opposite Ebenezer Scrooge's counting-house and, when the bell strikes the hours and the quarters up in the clouds, the 'tremulous vibrations' that follow give the odd impression that 'its teeth were chattering in its frozen head up there'.[1]

'Foggier yet, and colder!' But the fog that obscures London's streets, thickening the air and making it so dark that the buildings themselves become ghosts, is Scrooge's native element. He generates a chilly micro-climate, carrying 'his own low temperature always about with him', and he lives in the dark – 'darkness is cheap, and Scrooge liked it'.[2] However, the chilly dimness in which he exists is also moral. He treats his loyal clerk with heartless cruelty, paying starvation wages, and even then grudgingly. He feels no pity for the poor and destitute, demanding, when asked to make a charitable donation, 'Are there no prisons? ... And the Union workhouses? ... Are they still in operation?'[3] And he despises the idea of love even more than the idea of Christmas.

The foggy atmosphere, under cover of which strange transformations occur, pervades *A Christmas Carol*, a story Dickens wrote fast, beginning in October of 1843 and mentally composing as, night after night, he walked the city's dark, autumnal streets.[4] The book was published on 19 December that year, just two days before the solstice, when the nights were stretching out to their longest.

With *A Christmas Carol* Dickens turns the traditional ghost story inside out. When we first meet him, Scrooge has more in common with

a traditional ghost than some of the apparitions he is to encounter later that evening. He is shunned and feared, and is considered such an anti-social figure that no one ever stops to ask him the way or the time.[5] He haunts a particular spot, seldom venturing far beyond his counting-house. When he engages with people in business it is to call them to account, in the way that, in popular ballads and stories, ghosts often do. And for all the story's dark atmosphere, Dickens dispenses with the horrifying Gothic phantom. Although Scrooge is frightened by the ghosts – he 'feared the silent shape so much that his legs trembled beneath him' – the reader is invited to respond more subtly; Dickens employs few of the scare tactics common to Gothic fiction.[6] And there is another difference: rather than an ordinary situation suddenly being disrupted by the horrifying appearance of a ghost, the London of *A Christmas Carol* is already teeming with them. Jacob Marley's ghost opens Scrooge's eyes to reveal to him that, outside his window, the air is 'filled with phantoms, wandering hither and thither in restless haste, and moaning as they went'.[7] These are not malevolent, fearsome ghosts – quite the opposite. Their moans result from their sad awareness of their inability to help people in need. Having not given any assistance to the needy in life, in death they find they have lost the power, and are tormented by its lack, destined perpetually to try and fail.

When the 'Three Spirits' promised by Marley's ghost appear, the ghost story is twisted into an even stranger shape. Only one, the Ghost of Christmas Yet to Come, conforms to convention in that it is shrouded in fabric 'which concealed its head, its face, its form, and left nothing of it visible save one outstretched hand'. The only unusual element is the colour of its garment – 'deep black', rather than the traditional white – which adds to its mysterious and funereal air.[8] The Ghost of Christmas Past and the Ghost of Christmas Present, however, are extravagantly unlike any traditional ghost-type; Dickens re-invents them as allegorical figures with their attributes symbolically expressed by their dress and strange physical forms. They are like figures from a Jacobean masque. The Ghost of Christmas Present, the subject of one of the illustrations supplied by John Leech for the first edition of the book, is a one-man party, a colossal figure loosely draped in a long, fur-trimmed, green robe, sitting on top of a great throne consisting of 'turkeys, geese, game, poultry, brawn, great joints of meat, sucking-pigs, long wreaths of sausages, mince-pies, plum-puddings, barrels of oysters, red-hot chestnuts, cherry-cheeked apples, juicy oranges,

luscious pears, immense twelfth-cakes, and seething bowls of punch' (*fig. 47*).[9] Holding a burning torch in the air, this genial ghost beams benevolently down from his mound of festive comestibles at the comparatively diminutive Scrooge, touchingly vulnerable in his night-shirt.

But for all Dickens's limber inventiveness in describing the appearance and behaviour of these spirits, in essence they were not new. In *A Christmas Carol* he resurrects two distinct, pre-Gothic ghost-types. Firstly, Dickens implies that the ghost of Jacob Marley is, in common with Old Hamlet, a resident of purgatory ('My hour is almost come / When I to sulph'rous and tormenting flames / Must render up myself', says Hamlet's father). Like Scrooge, Marley carries his own microclimate with him – but his, ominously, is hot rather than cold, and his hair and clothes are constantly in motion, 'agitated as by the hot vapour from an oven'.[10] Secondly, the role played by the spirits of Christmases past, present and future is closely related to that defined in late seventeenth-century stories by Richard Baxter (see pp.64–81) and early eighteenth-century ones by Daniel Defoe (see pp.94–7): these ghosts have a distinct moral purpose, which they implement through striking up a relationship with the person haunted. The question pondered by Baxter, of 'what kind of spirit this is, that hath such a care of this man's soul', is as relevant to *A Christmas Carol* in the 1840s as it was back in 1691.[11] Each of the ghosts to appear to Scrooge has the same aim – to attempt to divert him from his habitually cruel behaviour and to kindle in him a sense of pity and a desire to change.

In the end, the spirits succeed in transforming Scrooge until he is the opposite of what he once was – as genial as he had been bad-tempered, as generous as he had been stingy, as eager to participate as he had been to withdraw. Scrooge is changed from a ghost back into a man. Running to the window on Christmas morning, he finds that the fog has lifted.

The 1840s was an apt time to re-shape the ghost as a moral teacher. Dickens wrote *A Christmas Carol* as a protest against the poor living conditions produced by increasing industrialisation and fast urban expansion, and in particular against the exploitation of children as a source of cheap labour. The 'hungry forties', so-called because of high food prices exacerbated by a series of failed harvests, made the problem acute. Dickens very nearly expressed his outrage not in a story at all, but in a political pamphlet with the provisional title 'An appeal to the people of England,

on behalf of the Poor Man's Child'. One of the catalysts for this was a tour Dickens had made earlier that year of Cornwall's tin mines, where he had been horrified by the conditions in which he found children working. Remembering, too, his own childhood experience of working in a boot-blacking factory, he had also been 'stricken' by a parliamentary report, published in February 1843, that described how children were forced to labour for long hours in factories or mines.[12] Dickens only decided against writing a pamphlet when he reflected that a work of fiction would reach a wider audience and therefore have a greater impact; writing to one of the commissioners of the parliamentary report, he promised he would 'feel that a Sledge hammer has come down with twenty times the force – twenty thousand times the force – I could exert by following out my first idea'.[13] With A Christmas Carol Dickens re-introduced a moral dimension to the ghost story. And the ghosts' message was meant not only for Scrooge, but for readers too. In a review in the February 1844 issue of Fraser's Magazine, William Makepeace Thackeray called A Christmas Carol 'a national benefit and to every man or woman who reads it a personal kindness'.[14]

On publication A Christmas Carol was a huge popular success, although not as remunerative as Dickens had hoped – the book's high production costs, partly a result of Leech's hand-coloured illustrations, ate into the profits. If the author himself was not profiting, however, others were. Particularly galling was the huge number of stage performances closely based on the story, about which, given the weakness of copyright laws at the time, Dickens could do very little. Within a matter of weeks around five Christmas Carol-themed plays were running in London theatres.[15] But it was no doubt through these performances that the story reached the vast audience it did, as the book itself was, at five shillings, relatively expensive. Dramatic entertainments based on A Christmas Carol continued to be staged over the following decades, and these often included an element of illusionistic novelty in the representation of the ghosts. A poster produced for the Royal Assembly Rooms at Weston-Super-Mare in 1877 advertises a performance of the story featuring 'Strange & Wilson's newly invented and wondrous ÆTHERSCOPE', an optical illusion created with mirrors and sheets of glass that reflected real actors performing on a stage hidden from the audience, making their figures on stage appear three-dimensional but transparent. The Ætherscope, or Ætheroscope, was a version of 'Pepper's Ghost', named after the chemist and director of the Royal Polytechnic,

John Henry Pepper, which was first used on Christmas Eve of 1862 for a performance of Dickens's final Christmas book, *The Haunted Man* (1848).[16] The poster for the Royal Assembly Rooms features, in holly-framed roundels, colourful copies of Leech's illustrations, images that were lodged in people's minds quite as firmly as the story itself. The popularity of *A Christmas Carol* was so great that the Assembly Rooms' managers evidently did not care that the play's six-day run was not, seasonably, in December, but in July.

With *A Christmas Carol*, Dickens re-fashioned the ghost story for the Victorian era, combining novelty with tradition. But it was not only as a writer of supernatural tales that Dickens put ghosts back on the agenda – it was also as an editor. In 1850 he launched the weekly journal *Household Words*, which, alongside serialised novels and articles, carried many supernatural tales, as would its successor *All The Year Round* (1859–95). These journals, especially their special Christmas numbers, encouraged reading aloud, continuing the age-old tradition of story-telling round the fire in what was, for many, a new urban environment. In itself, this was a way of harnessing ghosts to morality. Tales of the mid-nineteenth century might be printed in periodicals, rather than being part of an oral tradition, but they were still capable of engendering a sense of continuity and of reinforcing family ties.

The sheer quantity of printed matter available to the Victorians would have astounded earlier generations. Various factors combined to stimulate both supply and demand. Advances in technology made printing much cheaper, and the cost of materials was reduced by the use of wood-pulp paper instead of higher-quality rag paper. Greatly improved transport links – by road and, eventually, by rail – made distribution faster and more reliable. These factors went hand in hand with huge social changes: a more organised system of education resulted in a higher general rate of literacy that extended to the poorest, while new industrial places of work created a vast urban working and middle class. Many journals and magazines were launched to meet the demands of a new reading public: in addition to *Household Words* and older journals such as *Blackwood's*, *Fraser's* and *Ainsworth's*, there were, among others, *Once a Week*, *Temple Bar*, *Good Words*, *The Cornhill*, *Argosy* and *Tinsley's*. The readers of these periodicals wanted a regular supply of news, stories and articles on anything and everything, from ferns to foreign policy, railways to religion.

They also wanted ghosts. The advent of gas lighting and the railways did nothing to quash the keen appetite for ghost stories, and supernatural tales proliferated, the great majority of which appeared in periodicals. Victorian ghosts were shaped by the demands of the magazine format: stories had to be brief, gripping and sensational. While a ghost might add a frisson and an element of mystery to the plot of a long novel such as *Bleak House*, its dramatic potential was most fully realised within the tighter constraints imposed by short fiction. A new generation of writers was given a mandate by a large and enthusiastic audience, and they approached the subject with an unprecedented inventiveness.

In the earlier of the stories published in the second half of the nineteenth century, the Gothic tradition of the large, decaying, solitary house as a haunt for ghosts is strongly maintained. Among Dickens's early commissions for *Household Words* was a supernatural tale by Elizabeth Gaskell, 'The Old Nurse's Story', which was published in the special Christmas number for 1852. The nurse relates events that had occurred when, as a young woman, she was sent to a large manor house to look after a little orphaned girl, Miss Rosamund. For Gaskell, who wrote with such precision about homes and interiors, the house itself takes on a central role in the story. Reaching back to the conventions of Gothic fiction, Gaskell presents the Manor House, a lonely place at the foot of the Cumberland Fells, as 'great and stately' but neglected, its carriageway mossy, and trees allowed to grow so close that in the wind their branches drag against the walls.[17] The house is ambiguous: on the one hand, it is a 'famous place for little Miss Rosamund', the nurse's innocent young charge. Rosamund 'made expeditions all over it, with me at her heels'.[18] And when the ghost of a little girl appears, she is not inside but looking in through a window; she lures Rosamund outdoors, away from the comfort and protection offered by the house, and into the snow, where she nearly dies. On the other hand, the nurse soon discovers that the house is haunted by the sound of wild, rolling music that seems to emanate from an old organ in the hall – which no living person plays.

And Miss Rosamund does not go quite all over the house in her expeditions – she does not, for instance, venture into the east wing, 'which was never opened'. When eventually the ghosts show themselves, the east wing is, of course, where they come from:

All at once the east door gave way with a thundering crash, as if torn open in a violent passion, and there came into that broad and mysterious light, the figure of a tall old man, with grey hair and gleaming eyes. He drove before him, with many a relentless gesture of abhorrence, a stern and beautiful woman, with a little child clinging to her dress.[19]

The house has been harbouring the dead as well as the living, and when the two sides dramatically meet in the central hall – the space that connects their quarters – a terrible act of cruelty that had taken place many years before, involving a child's murder, is replayed. Boundaries blur as the perpetrator, Rosamund's elderly relative Miss Furnivall, is present both as herself and as the ghost of her younger self. Punished for her crime by being forced to witness it, yet powerless to prevent it, she dies repeating the words 'what is done in youth can never be undone in age!'[20] During the intervening years the house itself had reflected her state of mind, with the haunted east wing acting as her conscience.

When Henry James described Sheridan Le Fanu's stories as 'the ideal reading in a country house for the hours after midnight', he was referring ironically to the oppressive fear that this prolific supernatural-story writer could evoke with his descriptions of haunted rooms.[21] In Le Fanu's story 'An Account of Some Strange Disturbances in Aungier Street', first published in the *Dublin University Magazine* in December 1853, the haunting is so severe that the narrator's house-mate admits to preferring to walk the streets all night rather than spend a night in the house. 'Squire Toby's Will', published in the periodical *Temple Bar* in 1868, is also set in a ghostly old house, Gylingden Hall. At the time of the tale's telling, about seventy years after the events described, the ramshackle, timber-framed house shows 'many signs of desertion and decay, – the tufted grass sprouting in the chinks of the steps and window-stones, the smokeless chimneys over which the jackdaws are wheeling'.[22] There are broken windows and missing roof tiles – all often enough seen – but even so, there is something uncanny about the way on stormy nights 'you can hear the doors clapping in the old house, as far away as old Gryston bridge, and the howl and sobbing of the wind through its empty galleries'.[23] A long-disused chamber, called 'King Herod's room' because of the subject of an old tapestry that used to hang there, long since rotted away, holds a secret that will not rest quietly. The scene is thus set for the story – one of retribution dealt by the dead to

the living – to unfold in this haunted space, with its shadowy corridors, long-shut-up chamber and 'dark recesses'.[24]

Both Gaskell and Le Fanu use a house's antiquity and large scale – which allows for the existence of long, dark passages, disused rooms and locked-up wings – to create atmospheric spaces in which we would expect to encounter ghostly presences. By this time the idea of the haunted house was thoroughly fixed in people's imaginations: it was a place where old passions might not have died with their owners, and where there was enough room for shadows to gather among the antique furniture. Dickens understood this, describing the inns of London's Borough as 'great, rambling, queer old places ... with galleries, and passages, and staircases, wide enough and antiquated enough, to furnish materials for a hundred ghost stories'.[25] A picture that William Holman Hunt called *The Haunted Manor* (*fig. 48*), mostly painted out of doors in Wimbledon Park in 1849, meets our expectations in depicting a solitary, many-gabled house. The late-afternoon sun turns west-facing windows to gold, while others are thrown into deepest shadow; either way, the house seems to repel attempts to look into it. In fact Hunt's title is rather odd, given that the manor itself is hardly the focal point of the composition; the picture's true subjects are the stream, stones and water-plants, all meticulously painted in this shady spot with Pre-Raphaelite fidelity. But the house, bathed in warm sunlight, keeps claiming our attention. From our low view-point down by the bank of the stream, it feels as though we are keeping watch over it, waiting for something to happen – or, perhaps, lingering in the garden, putting off the moment when we have to go back inside.

But how many readers of *Household Words* or the *Cornhill* or any other popular periodical actually lived in such houses? How many contributors did? The contrast between old houses and those in which most people lived became more marked with each passing year. The sheer pace and velocity of Victorian building campaigns was staggering, utterly changing the nature of towns and cities across Britain. A high number of periodical readers would have lived in, or aspired to live in, brand-new houses, with the result that the Victorian fascination with the past was conducted from the standpoint of self-conscious modernity. As time went on, a younger generation of story-writers wrested ghosts from their time-honoured haunts and made them more immediate and topical by placing them in modern, urban settings. The ghost in Rhoda Broughton's 'The Truth,

the Whole Truth and Nothing But the Truth' (published in *Temple Bar* in 1868) occupies a fashionably furnished house in smart Mayfair that the sophisticated young narrator, Mrs Montresor, has rented for an unaccountably low sum. Her new home was described to her by the friend who discovered it, Mrs De Wynt, as 'a small compartment of Heaven', seemingly perfect, and furnished with 'a thousand of the important little trivialities that make up the sum of a woman's life: ormolu garden gates, handleless cups, naked boys and décolleté shepherdesses'. It is only later that Mrs Montresor is informed that the house is haunted ('Good Heavens! No! Is it?'), and that the ghost begins to make its presence felt. Mrs De Wynt remains hard to convince, attempting to reassure Mrs Montresor that 'most of them, if run to earth, would turn out about as genuine as the famed Cock Lane one'.[26] In the end, though, after the shock caused by a sight of the ghost consigns her maid to a lunatic asylum and kills her friend Ralph Gordon, a handsome young Hussar, she finds that moving out (to a large house in nearby Piccadilly) is her only option.

Violet Hunt's 'The Story of a Ghost', first published in the Christmas number of *Chapman's Magazine of Fiction* in 1895, gains power from its drab modern setting. It is the sombre tale of Edward Arne, a man who dies but whose body, brought back from death by the passionate prayers of his young wife, lives on in their Chelsea home (a house probably built in the mid-nineteenth century), spiritless and cold (he is, in a way, the opposite of a ghost).[27] Horrified by what her husband has become, Mrs Arne begins to imagine that her house is a tomb. Her friend remonstrates with her for withdrawing from the world, saying: 'You choose to bury yourself alive'. She responds: 'Sometimes I do feel as if I lived in a grave. I look up at the ceiling and fancy it is my coffin-lid.'[28] Mr Arne moves down to the basement, where he feels more at home. Hunt's story, like so many others by female writers of the late nineteenth century, can also be read as a sharp protest against the constraints of middle-class women's lives at this time. The ghost could be employed as a potent symbol for anger and frustration that could not be openly expressed.

The Pre-Raphaelite artist Edward Burne-Jones is best known for his dreamy, melancholy paintings of stories from myth and legend. Less familiar are the brilliant caricatures and comic sketches he made to amuse his friends. A particular group that they called his 'bogey drawings' picture ghosts hiding in unexpected places within the home (*fig. 50*). According to

Georgiana Burne-Jones, writing in her biography of her husband, these drawings 'dealt fearlessly with the fearful subject', reminding the drawings' recipients of long-forgotten childhood terrors. In one, the door of a long-case clock is swung slowly open by a ghost lurking within, just as a little girl goes upstairs to bed with her candle, while another frames a 'new and terrible idea of "a Bogey come home from the wash"', and depicts a ghost that lies 'neatly folded up in a drawer' – to the horror of its discoverer.[29] Not even the most prosaic places within the home were safe.

Ghosts could and did wander; but if they did, they often retained a peculiar sense of place. The ghost of poor murdered Miss Jéromette in a story of 1875 by Wilkie Collins has no home left to haunt: the 'shabby little house' near the Thames where she had rented modest lodgings, and where the narrator visited her over the course of a hopeless love affair, was pulled down to make way for 'improvements'. Undaunted, Miss Jéromette's ghost travels to the west of England to visit her old suitor, appearing at first as 'a pillar of white mist' – apparently made of the same substance as the 'vaporous shroud' that he had noticed hovering over the nearby river just before his sad parting from her.[30] The ghost can leave London, but it would seem that London cannot leave the ghost: the Thames fog is this urban apparition's atmospheric means of transport; it lets her out for a few moments in her friend's study before re-engulfing her and spiriting her away.

In the hands of these short-story writers, readers' expectations were continually thwarted and suspense was kept alive. Conventions were upended until it was no longer possible to think complacently of ghosts as habitués of the obvious old places. The demand for more and more stories liberated them, allowing them to make their presence felt in different ways and spaces. For an audience used to the old Gothic conventions, how disconcerting it must have been to find this new generation of particularly protean ghosts lurking amid the furniture and fashions of everyday life. These tales of intrusion reached their terrifying apogee with Bram Stoker's *Dracula* (1897), a novel that pits Count Dracula's 'vast, ruined castle' in Transylvania against the well-heeled comfort of Lucy Westenra's family home in the Crescent, a smart address in Whitby.[31] It is a book about trespass and penetration. The middle-class home, Stoker tells us, is as vulnerable to corruption by the ancient, unspeakable horror represented by the vampire as Lucy's body proves to be. As a family group gathered around the fire to read aloud from a novel or the Christmas number of a journal, 'with a cold

wind rising and wailing outside, and all snug and cosy within', there must have been more than one anxious glance cast over the shoulder (*fig. 49*).[32]

When the fin-de-siècle writer Ella D'Arcy published an elegant ghost story in the artistic and literary quarterly the *Yellow Book* in 1896, she called it 'The Villa Lucienne'. It was an apt title because it was the house itself that stimulated fear in those who approached and entered it, rather than the figure of a ghost. D'Arcy's story sits calmly apart from the inventive acrobatics of most tales of the period, content with its own simplicity. In fact, in the very opening paragraph the narrator freely admits that 'there is in reality no story at all'.[33] What there is consists of a tale told by a Madame Koetlegon of how, one winter on the Riviera, she went with two friends to look at a furnished villa that one of them considered renting. But, the story begins, she 'told it so well that her audience seemed to know the sombre alley, the neglected garden, the shuttered house, as intimately as though they had visited it themselves', and, perhaps most importantly, 'seemed to feel a faint reverberation of the incommunicable thrill which she had felt'. When the group in her story draw closer to the house, they are gripped with a powerful if inexplicable sense of fear, which, when they get inside, mounts to terror and finally panic, although there is apparently nothing but 'ancient furniture ... everything dust-covered and time-decayed'.[34] They leave hastily, and discuss later what they had felt. Although the young daughter of one of the party explains that she saw an old woman looking at her and advancing towards her, the revelation is almost incidental. For the narrator, it was 'the Villa itself which inspired fear':

> Fear seemed to exude from the walls, to dim the mirrors with its clammy breath, to stir shudderingly among the tattered draperies, to impregnate the whole atmosphere as with an essence, a gas, a contagious disease.[35]

The curious atmosphere that D'Arcy evokes and describes becomes the story's main subject: the ghostly takes precedence over the ghost. We, the readers, are not invited to solve the mystery so much as to feel it, to experience D'Arcy's 'faint reverberation' of emotion as we imagine ourselves

in the villa's dusty rooms, glancing uneasily at the tarnished mirrors as we step gingerly across the parquet floor with its thick drugget of dust.

Atmosphere was also taking over from subject matter in paintings. Earlier in the century nobody would have considered a nearly empty moonlit lane worth painting, but it was a theme that the Leeds-born, self-taught painter John Atkinson Grimshaw made his speciality. His urban and suburban street scenes, usually depicted in the dusk of an autumnal evening or lit by the first glimmers of a wintry dawn, are rarely entirely devoid of people – but the figures they include are not central to the composition; they are small and shadowy, usually with their backs turned to us. By their reticence, Grimshaw's paintings create a space for our imaginations to fill. *Silver Moonlight* of 1880 (*fig. 51*) invites us in, and we picture ourselves walking down the walled lane by the light of a moon that casts the dim shadows of bare branches over the paving stones. It has recently rained, and the sky is still speckled with dispersing storm clouds. The suburban lane is broad and well maintained, with the glow from the downstairs windows of a large house providing a cheerfully domestic note. Even so, the single slim figure we seem to follow is cut off from this haven by the garden wall which stretches ahead until it disappears in shadows around the corner. It is a lonely path, and we do not know where it leads. Will anyone come round the corner towards us? Is the moon about to be obscured by the scudding clouds that threaten to drift over its face? There are no obvious ghosts at large in *Silver Moonlight*, and this well-to-do Yorkshire suburb is hardly an image likely to stir up sensations of 'delightful Horror' – forbidding ruins, blasted trees and fearsome mountains have no place in late nineteenth-century British art – but Grimshaw's rich autumnal atmosphere, redolent of the supernatural, works on the imagination until we cannot be sure that they are entirely absent.

The truly ancient house remained, of course, full of potential for ghost-story writers. But how to update an old formula to fit a new era? A social phenomenon that began to emerge towards the end of the nineteenth century offered a solution: that of extravagantly wealthy Americans either marrying British aristocrats or simply buying their houses. The house itself could be old as long as the people were refreshingly new. Oscar Wilde's *The Canterville Ghost* (1887) revels in the resulting clash of cultures. 'I come from a modern country', declares Hiram B. Otis, the purchaser of Canterville Chase near Ascot, with its fine Tudor hall and oak-panelled

library, 'where we have everything that money can buy ... and I reckon that if there were such a thing as a ghost in Europe, we'd have it at home in a very short time in one of our public museums, or on the road as a show'.[36] The poor resident ghost, Sir Simon de Canterville, is subjected to Mr Otis's brisk practicality, and suffers the indignity of being given 'Tammany Rising Sun Lubricator' to oil his rusty chains, while 'Pinkerton's Champion Stain Remover and Paragon Detergent' is employed daily to remove the ancient blood-stain he assiduously tries to maintain.[37]

As a child, the American writer Edith Wharton was subject to such a visceral horror of ghosts that she could not bear to sleep in a room that contained a book of ghost stories. Her aversion continued into her twenties, and even books kept in other rooms would have to be put on the fire to ensure her peace of mind.[38] This hyper-sensitivity to an apparently inanimate object that almost vibrates with the power of its contents pervades the ghost stories that Wharton herself wrote later in life. In 'Afterward' (1910), this object is the house itself. Lyng, an ancient Dorsetshire house that has been 'for centuries a deep, dim reservoir of life' is bought by a newly wealthy American couple, Mary and Ned Boyne. In an upending of tradition, they are informed at the outset that there is indeed a ghost at Lyng, 'but you'll never know it', their friend tells them. 'Well – not till afterward, at any rate.'[39] The questions that resonate through the story are: what type of ghost will it turn out to be? And how will the haunting manifest itself? 'Can it be the house?' Mary wonders. 'The room itself might have been full of secrets,' she muses. 'They seemed to be piling themselves up, as evening fell, like the layers and layers of velvet shadow dropping from the low ceiling'.[40] But the house is not haunted in a conventional way. It is, as Mary has begun to suspect, an intelligent house, and it eventually generates a ghost tailor-made for its current custodians. The ghost it produces – which, as predicted, is only recognised as such afterwards – turns out to be a prosaic American one, the vengeful victim of Ned Boyne's dubious business dealings over the Atlantic. When her husband disappears, Mary reflects that 'she would never know what had become of him – no one would ever know. But the house knew; the library in which she spent her long, lonely evenings knew ... there were moments when the intense consciousness of the old, dusky walls seemed about to break out into some audible revelation of their secret.' The house, however, although reverberating with all it has witnessed, will never reveal it:

'it had always been the mute accomplice, the incorruptible custodian of the mysteries it had surprised'. We leave Mary Boyne 'sitting face to face with its portentous silence'.[41]

Traditional expectations are set on a collision course with modern science in a wry story by Mary Elizabeth Braddon, 'The Ghost's Name', published in *Mistletoe Bough* in December 1891. A room on the ground floor of the solitary Yorkshire house Halverdene, in its oldest wing, has acquired a reputation for being haunted. A series of young children who slept in the room have died. Curiously, though, no-one can ever agree on the nature of the haunting. 'The ghost was a very Proteus of ghosts; now man now woman; now old now young; but mostly horrible'.[42] It is only when the seventh Lord Halverdene, 'a dry-as-dust county magistrate and scientific farmer' inherits title and house that the 'ghost' is pinned down. On being told by the housekeeper that the 'room was a haunted room, and had on more than one occasion proved fatal to the race of Halverdene', Lord Halverdene responds:

> Ghost – bosh! Fatal – yes, no doubt. The room would be pernicious to infant health, and possibly fatal to infant life. I know what country houses are – cesspools under drawing rooms, rotten brick drains … abominable!

'Shall I tell you the ghost's name?' asks Lord Halverdene at the end of the story, having pulled up the floor of the 'haunted' room and been rewarded by finding both an 'ancient cesspool' and a 'comparatively modern brick drain', in 'loathsome condition' alike. 'The ghost's name was Typhoid Fever.'[43]

Ever since the advent of the Gothic novel, ghosts had been increasingly strong presences in fiction. But where did that leave 'real' ghosts? For the novelist Catherine Crowe, writing in the late 1840s, they had been too long neglected. Crowe took a long view. In the seventeenth century, she noted – presumably thinking of Glanvill, Baxter and their ilk – 'credulity outran reason and discretion'. But then, 'by a natural reaction', things went to the 'opposite extreme' in the eighteenth century. It was about time the pendulum swung back to the centre. 'Whoever', she continues:

closely observes the signs of the times, will be aware that another change is approaching. The contemptuous scepticism of the last age is yielding to a more humble spirit of inquiry.[44]

Crowe saw herself as a species of scientist, a patient cataloguer of supernatural phenomena. Observation, experience and investigation were at the heart of her method. 'And by *investigation*', she explained, what she meant was 'the slow, modest, pains-taking examination, that is content to wait upon nature, and humbly follow out her disclosures, however opposed to pre-conceived theories or mortifying to human pride.'[45] The challenge she set herself was to look again, and to look harder. She believed she was pushing at a door that was just about to swing open; that rapid advances in science were likely at any moment to throw new light on these phenomena and to expose their mechanisms.

Crowe published these observations in 1848, in her introduction to *The Night Side of Nature; Or, Ghosts and Ghost Seers*, a lengthy compendium of purportedly true stories of unexplained phenomena. She organised her material by type: presentiments, warnings, wraiths, doppelgängers, apparitions, haunted houses, spectral lights, 'the Poltergeist of the Germans' and so on. She approached her subject in precisely the same way as countless of her contemporaries, amateur naturalists engaged in collecting botanical or entomological specimens and organising them in typological sequences, carefully labelling them and pasting them into albums or arranging them in glass-topped display cases.

Science did not, in the end, fulfil Crowe's expectations by shedding light on the dark mysteries that would explain ghostly appearances. However, her application of rigorous taxonomy to the supernatural had struck a distinct and unmistakeably contemporary note. Her brief stories proved to be immensely popular, no doubt because of the frisson aroused by their being allegedly true accounts. Throughout the second half of the nineteenth century *The Night Side of Nature* was published in numerous editions, and Crowe capitalised on its success in 1859 by publishing *Ghosts and Family Legends*, to which she appended the enticing subtitle: *A Volume for Christmas*. The genesis of this book, as she explains in her preface, was a long stay in a 'large country mansion in the north of England'. She sketches the enviable social setting: 'we had a succession of visitors, and all manner of amusements – dancing, music, cards, billiards, and other games'.

A misfortune that befell one of their company, however, interrupted these cheerful activities, and caused them to assemble gravely by the fire – where they began, perhaps inevitably, to tell ghost stories. 'The substance of these conversations fills the following pages,' writes Crowe, 'and I have told the stories as nearly as possible in the words of the original narrators.'[46] The first part of the book is arranged not by ghost type, like *The Night Side of Nature*, but by the order of the tales told over the course of eight winter evenings. The reader is thus offered a seat by the fireside amongst a charmed social circle, invited to listen to their personal tales more or less verbatim as they tell them. But were the stories fact or fiction? And, thus richly entertained, did the reader truly care?

The huge popularity of these purportedly true tales coincided not only with that of fictional ghost stories, but also with another kind of investigation into the supernatural realm, one that would profoundly shape the way in which people thought about ghosts: spiritualism.

17. 'IS THERE ANYBODY THERE?'

In the middle of the Victorian era, when Britain's imperial power and industrial might were unparalleled, the kingdom was seized with an unlikely passion. The British stopped being afraid of ghosts, drew the curtains and tried to usher them in.

It all began in 1848, when Margaret and Kate Fox, two young sisters living in the hamlet of Hydesville in Wayne County, New York, claimed to be able to communicate through knocking sounds with the ghost of a murdered pedlar which was thought to haunt their house. Managed by their elder sister, they exploited their apparent gift (which, forty years later, they admitted was a hoax), and began to perform as mediums, sparking a craze that would last for several decades. Within four years, the movement was brought to England by an American, Maria Hayden, who in October 1852 advertised her services as a spiritualist medium with the power to contact the ghosts of dead relatives dwelling in the spirit world. It was her success at evening parties and private sittings, for which she charged a minimum of the considerable sum of half a guinea, that helped pave the way for the widespread adoption of spiritualism in Britain.[47]

Up and down the land, tables were rapped and tilted, and planchettes poised expectantly over paper. Spiritualism's success was due to its apparently universal appeal: it was adopted by members of all social classes and religious affiliations. Crucially, in most quarters (if not all), spiritualism was not regarded as a challenge to Christianity, but as complementary, even affirmative. Many writers and artists were drawn in: Elizabeth Barrett Browning was powerfully attracted (her enthusiasm was not, however, shared by her husband Robert Browning, whose dramatic poem 'Mr Sludge, The Medium' paints a ruthless portrait of a charlatan). In the mid-1860s Dante Gabriel Rossetti took up spiritualism, with, according to his studio assistant, 'a feverish interest for some considerable time, going to all the private séances to which he might be invited' and organising events for a close circle of friends at his home on Cheyne Walk in Chelsea.[48] Rossetti's obsession was connected with the tragic death in 1862 of his wife Lizzie Siddal caused by an overdose of laudanum; his brother William Michael Rossetti records one evening a full decade after her death of 'table-turning' at Chelsea, during which 'the table moved very considerably but not violently, and some messages came, purporting to be from Lizzie. Nothing very marked in these,' he continues drily, 'unless one can so consider the answers that she is happy, and still loves Gabriel'.[49] Rossetti's American friend and fellow artist, James McNeill Whistler, who attended his séances, was himself highly susceptible to the idea of ghosts, and 'pottered with table-turning and spirit-rapping' for years.[50] Séances even take place in that acute barometer of the just-behind-the-times, George and Weedon Grossmith's *The Diary of a Nobody*, first serialised in *Punch* in 1888–9:

More table-turning in the evening. Carrie said last night was in a measure successful, and they ought to sit again. Cummings came in, and seemed interested. I had the gas lighted in the drawing-room, got the steps, and repaired the cornice, which has been a bit of an eyesore to me. In a fit of unthinkingness – if I may use such an expression, – I gave the floor over the parlour, where the séance was taking place, two loud raps with the hammer. I felt sorry afterwards, for it was the sort of ridiculous, foolhardy thing that Gowing or Lupin would have done.[51]

In the movement's heyday from the 1860s to the 1880s, membership of local spiritualist societies flourished. Many more people, who would

have hesitated to identify themselves as spiritualists, nonetheless enjoyed attending séances, regarding them as an entertaining species of parlour-game. It had 'taken hold of Society', in the words of one contemporary commentator, and was 'the trifle of the day'.[52] For the more committed, a large and active spiritualist press, beginning with The Spirit World in 1853, provided a loose collective identity as well as circulating accounts of phenomena. But why did spiritualism capture the mid-Victorian imagination so decisively, and spread with such rapidity? Did its overwhelming success signal a reaction against the pace of change which had seen the age-old balance between town and country change forever – a collective recoil from the sheer might and scale of Victorian progress?

It could be seen in another way. Scientific discoveries and technological innovations had a remarkably powerful effect on the Victorian imagination. This was perhaps nowhere more apparent than in the field of communications, one of the nineteenth century's great spheres of advancement. From the very beginning of the Victorian era technology had begun to transform communication with extraordinary rapidity, making possible what had previously been unimaginable. In the year of Queen Victoria's accession, 1837, Charles Wheatstone and William Fothergill Cooke patented an 'electrical telegraph', allowing two devices placed several miles apart to communicate with each other via an electrical current. The charge would move one of five needles at the receiving end, and this would point to a letter inscribed on the instrument's diamond-shaped dial, allowing a message to be sent without even resorting to code. Its first use was on the railway system, and within a short time it was being used to send telegrams. From the 1840s onwards, the electric telegraph transformed world communications, collapsing distances and allowing messages to be transmitted instantaneously. As Prince Albert declared in 1849:

we are living at a period of most wonderful transition ... The distances which separated the different nations and parts of the globe are gradually vanishing before the achievements of modern invention ... thought is communicated with the rapidity and even by the power of lightning.[53]

Science thus introduced a new idea: that with extraordinary rapidity a message could be sent a long distance by an invisible force. From the novel vantage point provided by that conceptual platform, it was a relatively small

imaginative step to put one of those two points in the 'spirit world' rather than in the real physical world. In the highly codified environment of the séance, the electric telegraph's inscribed dial was, essentially, re-cast as a table-top alphabet through which ghosts could communicate; and it is possible, too, that Morse code, the simple and efficient system invented by Samuel Morse in 1837, provided the template for the way in which the spirit would answer questions put to it – with one rap generally meaning 'yes', three raps 'no', and two implying uncertainty. Rather than being a reaction against the onrush of brash modernity and its new technologies, spiritualism seems rather to have been a product of contemporary innovations.[54] Ghosts moved, as ever, with the times.

This interface between science and spiritualism cut both ways. While spiritualists explored the enticing vistas that new technology had disclosed, scientists wondered whether their own discoveries pointed to the existence of an invisible world of spiritual phenomena. Oliver Lodge and William Crookes, eminent scientists and pioneers of electromagnetism, were both drawn to spiritualism. New discoveries of invisible electrical forces, including cathode rays and electromagnetic waves, revealed a whole range of phenomena that changed perceptions about how the world was constructed. Could ghosts and electrical phenomena be formed from the same kind of invisible energy? And was science poised to reveal the hidden spirit world, in which the dead still lived?

One instrument that promised to reveal all was the camera. Photography offered a prism through which the world could be seen afresh. However, from its earliest days it was an ambiguous medium. In the first place, was it an art or a science – poetry or prose? The camera appeared to offer unbiased objectivity, to hold a mirror up to the world. It was used to survey landscapes, buildings, foreign countries and peoples, and of course it was used for portraiture. This use as a tool of general record affected the way it was thought about: it appeared to offer views more dispassionate and perhaps more truthful than any artist. In 1857, Lady Eastlake, wife of Sir Charles Eastlake, the Director of the National Gallery, wrote an article in which she remarked on photography's ubiquity, describing how it had become 'a household word and a household want; is used alike by art and science, by love, business and justice; is found in the most sumptuous saloon and in the dingiest attic'.[55] Photography had become intrinsic to how people dealt with the world. But it also

defamiliarised it; think of how we can, even now, be beguiled by photographs of ourselves, because they show us versions of ourselves as others see us. This sensation must have been even more powerful in the 1840s and 1850s, when photography was still relatively new. It was, above all, an experimental medium, and in the early days numerous new techniques were devised, offering ever greater degrees of clarity and repeatability.

In time, it was demonstrated that this extraordinary invention's talent for capturing truth extended to the revelation of things not visible to the human eye. In 1872 Eadweard Muybridge made his initial experiments with a high-speed shutter that was able to freeze-frame the legs of a galloping horse, disclosing their precise movements for the first time. Within the contemporary atmosphere of scientific discovery, what else might photography reveal? Could it be capable of seeing 'behind the veil, behind the veil', as Tennyson put it in *In Memoriam* (1850); exposing those forces that, as science was beginning to demonstrate, were present in the world, but that the human eye was not able to perceive?

Early photography was almost uncannily predisposed to the creation of ghostly images. Lengthy exposure times inevitably led to accidents as a person moved, a light was struck or a door suddenly opened. Someone stepping into the frame for a short period of time would appear in the resulting picture as a see-through figure because their image had not had sufficient time to register. Sometimes plates were cleaned and re-used; an insufficiently wiped plate could still bear traces from its previous exposure, which, when printed, produced a faint, ghostly image, with the later stronger picture superimposed. The state of transparency had been a key attribute of ghostliness since the late eighteenth century, and the quirks and accidents of early photography just happened to produce images that chimed precisely with entrenched expectations of a spirit's appearance.

In 1861, the amateur photographer William Mumler, an engraver from Boston, chanced upon 'spirit photography' when he made a self-portrait which, when printed, also bore the faint and ghostly image of a girl. He realised that this phenomenon was due to his having used a previously exposed plate which had not been properly cleaned, and which still bore the traces of an earlier portrait session, but was soon persuaded to exploit the commercial potential of his 'discovery'.[56] Mumler was, in fact, not the first to have created such images, although he was the most successful at their promotion. In the early years of the following decade,

spirit photography found popularity in France, where it was pioneered by Édouard Isidore Buguet, and in England, where its principal exponents were Frederick Hudson and John Beattie.

In spite of the fundamental aim of spiritualism to make contact with the dead, spirit photographs did not often depict attempted communication, but rather sought to demonstrate that the dead are with us, even though they cannot, under normal circumstances, be perceived. Mumler's photographs are based on the *carte-de-visite* format, a posed portrait of the sitter, usually full-length, but with the inclusion of a see-through 'ghost' stationed behind him or her. *Cartes-de-visite*, portrait photographs pasted onto mounts the size of a visiting card, became hugely popular in the 1860s, coinciding with the first spirit photographs. Perhaps there was not so much difference between the two. Portrait photography in itself had a ghostly air, with its ability to commit a person's appearance to paper. The dead were recorded and commemorated in image, more prosaically present than in any painted portrait.

Mumler's spirit photographs seem to propose that the dead are our mute companions, willing to pose with us, even if we are not aware of their presence. His 'spirits' do not usually interact with the sitter beyond occasionally placing their hands affectionately on their shoulders, and they pose in conventional ways, though normally standing rather than sitting, another way of underlining their separateness. In any case, why would a ghost need to sit down? Hudson, on the other hand, often staged more interactive tableaux. Among his earliest photographs is one taken on 31 October 1872 that shows the medium Georgiana Houghton and Tommy Guppy, the small son of another well-known medium, in the presence of a heavily draped figure that was later identified as the spirit of the child's grandmother (*fig. 52*). Houghton left an account of sitting for this particular photograph with 'dear little Tommy Guppy':

> I seated him on a small hassock upon the table, and stood behind, so that he might rest against me, and on the plate appears a tall female figure in a bonnet, with flowing embroidered drapery, which I at first thought was extended towards us by her right hand, but I now see that the face of another spirit is just visible within the drapery which falls so as to touch Tommy's face.

When the photograph was developed, the close encounter it revealed might, to the uninitiated, have been thoroughly alarming, but Houghton remained unperturbed, captivated above all by the ghost's aesthetic qualities and remarking that it was 'altogether a very pretty, graceful figure'.[57]

Spirit photography offered a fertile arena for visual experimentation. While Mumler's transparent spirits dress in normal clothes, Hudson's more solid ones tend to be heavily draped in pale fabric, reviving an older convention of the white-sheeted ghost. This gave the added advantage of allowing the face to be veiled – often a contentious issue in cases where spirits were supposed to be close family members. Beattie introduced another idea: his photographs represent spirits as bright, shifting forms, with no distinct shape, as though in the process of materialising, echoing descriptions given by some mediums.

The careers of specialist spirit photographers were punctuated by frequent investigations that on occasion led to court cases, so their activities were by no means widely accepted as above board; one of the reasons they were able to practise at all was the professional status of the photographer. This changed after 1888, when a great increase in amateur photography followed the release of the Kodak camera, designed for use by amateurs and carrying the slogan 'You Press the Button, We Do the Rest'. Until that time, photography was undertaken by professionals who had been initiated into its technical complexities. Indeed, Houghton remarked on the 'peculiar difficulties' that attended the taking of spirit photographs, noting that it 'has to be carried on by standing about, perhaps for hours, in a cold, damp glass-house, with all sorts of atmospheric impediments to contend against, as well as fatigue of body and nervous anxiety'.[58] So it is understandable that an air of mystery hovered over it, which made its putative ability to capture another world all the more plausible.

This mystery was thoroughly exploited by one of the principal spirit photographers, Édouard Isidore Buguet, who practised between 1873 and 1875, mostly in Paris but with a brief spell in London. According to a journalist writing in Le Temps in 1875, Buguet 'gave a sort of religious character to the evocation, in order to make people believe in supernatural effects'.[59] Sittings were ritualistic, marked by an ostentatious display of occult power. A sense of expectation was created by keeping clients waiting; indeed they were sometimes asked to return another time because the previous session had exhausted Buguet's powers. In preparing to take the photograph,

he would affect to be in a trance, speak in incantations and make theatrical gestures around the camera.[60] Buguet was tried and convicted for fraud in 1875, but the move he made at this point is revealing about the fluidity between the purportedly sincere and the openly fake. He continued to take 'spirit' photographs, but, this time, he made them expressly as entertainment, fully admitting the tricks he employed. He even had a new business card printed advertising his new trade, which he called 'anti-spirit photography': '*Photographie Anti Spirite / Manipulation Invisible Le Spectre Choisi Est Garanti / Illusion Complète*'.

It is remarkable that spirit photography was taken as seriously as it was, given that it co-existed with similar images produced as popular entertainment. There was a thriving market for these. Just as many participants regarded the séance more as a thrilling form of parlour-game than as a way of gaining real access to another world, so the potential of spirit photography as a source of amusement was recognised from its very earliest days. Photography's propensity to produce figures resembling ghosts had been discussed in print as early as 1856 by the Scottish physicist and polymath Sir David Brewster. Brewster was particularly fascinated by optics, and called the eye 'the most fertile source of mental illusions'.[61] In his monograph on the stereoscope – a hand-held optical device through which two slightly different images mounted side-by-side on a card are viewed, creating the illusion of three dimensions – Brewster described how '[f]or the purpose of amusement, the photographer might carry us even into the regions of the supernatural'. He explains:

> His art, as I have elsewhere shewn, enables him to give a spiritual appearance to one or more of his figures, and to exhibit them as 'thin air' amid the solid realities of the stereoscopic picture. While a party is engaged with their whist or their gossip, a female figure appears in the midst of them with all the attributes of the supernatural. Her form is transparent, every object or person beyond her being seen in shadowy but distinct outline.[62]

Brewster describes in detail how this can be achieved:

When the party have nearly sat the proper length of time, the female figure, suitably attired, walks quickly into the place assigned her, and after standing a few seconds in the proper attitude, retires quickly [...]. If this operation has been well performed, all the objects immediately behind the female figure, having been, previous to her introduction, impressed upon the negative surface, will be seen through her, and she will have the appearance of an aerial personage, unlike the other figures in the picture.[63]

But despite the cat having well and truly been turned out of the bag – or even partly because of the cheerfully informative nature of Brewster's 'how to' guide – countless purportedly genuine 'spirit photographs' were produced over the following decades. Perhaps it was because there was so much at stake that many were willing to suspend disbelief.

The stereoscope, which had been invented in 1832 by Wheatstone to explore binocular vision, became an exceptionally popular novelty item. From the 1850s well into the twentieth century, stereoscopes were ubiquitous in British households, and stereoscopic cards were produced in vast numbers. The 1858 catalogue of a leading firm, the London Stereoscopic Company, advertised over one hundred thousand photographic views. The majority of these scenes were of landscapes and architecture, but they also offered many light-hearted theatrical or sentimental tableaux. Among this category was a series entitled 'The Ghost in the Stereoscope' (fig. 53) – a name suggesting the unscheduled appearance of a spirit during the process of taking a normal photograph. Combining the technique of double-exposure with the illusion of three-dimensionality, the ghost was a particularly entertaining subject. If the convention of the carte-de-visite style of spirit photography was that the sitter was unaware of the ghostly presence behind them, or by their side, things were very different in the world of the stereoscope. A typical example has a transparent 'ghost' draped in a white sheet, looming menacingly over an evidently terrified person, who claws the air as though to fend it off. That this person is, more often than not, a rustic character in a smock suggests that the stereotype of the credulous country bumpkin continued to thrive.

Not everyone, of course, accepted spiritualism, however casually, or even embraced its potential for amusement. Among the reactions against it is a children's book of 1864 concerning optical tricks, with the alluring

title *Spectropia; or, Surprising Spectral Illusions. Showing Ghosts Everywhere, and of any Colour (fig. 54)*. The author, J.H. Brown, disparages the 'contemptible forms of spirit-rapping and table-turning', and remarks incredulously on how 'in this age of scientific research, the absurd follies of spiritualism should find an increase of supporters'.[64] Brown's stated aim was to effect:

> the extinction of the superstitious belief that apparitions are actual spirits, by showing some of the many ways in which our senses may be deceived, and that, in fact, no so-called ghost has ever appeared, without its being referable either to mental or physiological deception...

Sixteen lithographed plates, most in vivid colour, follow. These depict spectres, skeletons and witches that the reader is asked to look at steadily for around fifteen seconds, before transferring his or her gaze to a wall, sheet or other blank surface. Sure enough, as a result of the eye's retention of residual images, the picture from the book appears, gains in intensity, and gradually fades away *(fig. 55)*. The didactic, no-nonsense tone of the introductory text, however, and the author's pointed apology for the 'apparent disregard of taste and fine art in the plates' are somewhat at odds with the evident fun of the grinning, stalking skeletons and cloaked, gesturing apparitions that follow.[65] The image of the ghost, whether produced to deceive, entertain or educate, appeared to exert a universal fascination.

In spite of the sceptics, spiritualism thrived. This was in part, no doubt, because it offered the living access to a vast telephone directory of the dead. Through the agency of a medium (a sort of switchboard operator) a believer could be connected to just about anybody dwelling in the spirit world and entice them into the comfort of their darkened drawing room. The only limits appeared to be imagination and ambition. One medium who realised spiritualism's staggering potential was Georgiana Houghton. As a young woman Houghton had trained as an artist, and she lived an unremarkable life until, in her mid-forties, she attended a séance which immediately convinced her of her own 'gift'. Combining her talents, she put drawing at the centre of her practice, allowing her hand to be led, as she claimed, by a range of spirit-guides; her first, Henry Lenny, she described as a 'deaf and dumb artist'. She soon became more ambitious, and illustrious painters popped

up by her side in Victorian London: ghosts of the Renaissance artists Titian and Correggio, and, perhaps most impressively of all, St Luke himself, their patron saint. From 1862 probably until her death in 1884, Houghton set aside every Sunday evening for the purpose of making drawings in pen, ink and watercolour (fig. 56) under the guidance of these eminent spirits.

Houghton habitually wrote on the backs of her drawings, her tiny, neat words skittering over the page, sometimes obscured by apparently uncontrollable doodles and flourishes. Some of these inscriptions convey messages from her ghostly guides. 'I, Antonio Allegri, known as Correggio,' one begins, considerately using the English language, 'have endeavoured through Georgiana's hand to represent the Eye of God, in the Three Persons of the Trinity'. After a pious observation on the difference between man's trifling and important acts (not as great as you might suppose), he goes on to explain the drawing's iconography: the Father is 'in vivid yellow, with The Eye clearly looking upon all'.[66] Another drawing, purporting to be by a renowned English artist, bears the explanation: 'Through the hand of Georgiana, I, Thomas Lawrence, have endeavoured to symbolise The Marvellous Love of God.' 'I wish to explain our drawing in as few words as I can', he continues thoughtfully, 'because Georgiana's written accounts are already so numerous that long explanations would be tedious, and would hinder the real object of these manifestations, which is to impress the minds of the beholders with The Power and Loving Mercy of The Lord'; and in any case 'the many previous descriptions must have made all familiar with the emblematic meanings', he adds, confidently.[67]

The drawings themselves are extraordinary: bright bursts of yellows, reds, greens and blues forming sinuous whorls and waves, pen and ink lines spiralling dizzyingly over the top, with often a fine web of white ink lines and dots applied over that. They are hard to look at for any length of time – the eye has no clear direction to follow and nowhere to rest, and is forced to rove uneasily over the surface. In Houghton's day, they must have looked like nothing on earth. When she staged an exhibition of her work in 1871 at the New British Gallery in Old Bond Street, a reviewer from the *Daily News* was at a loss to know how to describe them. He could only suggest that his readers tried to imagine 'an accurate copy of coloured and white Berlin wools, all tangled together in a flattened mass, framed and hung round a gallery'; that was, he thought, the only way an 'idea could be formed of the appearance of this most strange exhibition'.[68] The *News*

of the World offered cautious praise, drawing attention to 'the brilliancy and harmony of the tints', before somewhat fancifully comparing the drawings to 'a canvas of Turner's, over which troops of fairies have been meandering, dropping jewels as they went'.[69]

Extraordinary as they are, why, we might impertinently ask, did drawings guided by the ghostly hands of Lawrence, Titian and Correggio all look like works by Georgiana Houghton, and not like drawings by Lawrence, Titian or Correggio? But such 'scoffs of the ignorant' would have been regarded as unimportant by Houghton herself. Her drawings, she believed, 'could not be criticised according to any of the known and accepted canons of art'.[70]

VII

RE~INVENTING
GHOSTS

I am all for putting new wine in old bottles

ANGELA CARTER, 'NOTES FROM THE FRONT LINE'

18. 'THE DEAR OLD SACRED TERROR'

If spiritualists had carefully drawn the curtains to create a sympathetic habitat for ghosts, members of the Society for Psychical Research vigorously flung them open again. Founded in 1882, the Society's stated aim was 'to investigate that large body of debatable phenomena designated by such terms as mesmeric, psychical and spiritualistic', and to approach it 'in the same spirit of exact and unimpassioned enquiry which has enabled Science to solve so many problems'.[1] While spiritualism carefully maintained its mysteries in darkness and under drapes in the formalised rituals of the séance, the Society was determined for light to flood in. Under the distinguished presidency of Henry Sidgwick, Professor of Moral Philosophy at Cambridge University, this band of respected scholars set about investigating these 'debatable phenomena' with Victorian energy and thoroughness, applying a standardised methodology to their project with the assumption that ghosts and other apparently supernatural occurrences were essentially no different from flora and fauna and that, like them, they could be sifted, identified, catalogued and labelled. Significantly, the Society tended to avoid using the word 'ghost', preferring terms with less cultural baggage: the word 'apparition', that hinted instead at the science of optics, or 'phantasm', because it did not suggest purely visual phenomena.[2] The many apparitions they recorded and described seemed, by and large, to be purposeless – a far cry from the vengeful old ballad-ghosts.

The Society might – at long last – have brought a degree of intellectual respectability to ghosts and other supernatural phenomena, but at what cost? Some felt it was at the expense of the fascination they had previously exerted. When the writer and essayist Vernon Lee (the pseudonym of Violet Paget) attended a meeting of the Society in 1885, she confessed to finding it 'a very dull business'.[3] Five years later, in the preface to her collection of four tales, *Hauntings: Fantastic Stories*, she observed that:

Altogether one quite agrees, having duly perused the collection of evidence on the subject, with the wisdom of these modern ghost-experts,

when they affirm that you can always tell a genuine ghost-story by the circumstance of its being about a nobody, its having no point or picturesqueness, and being, generally speaking, flat, stale, and unprofitable.[4]

Lee faced a curious paradox. Attentive research into hitherto unexplained phenomena that should have resulted in the most compelling stories of all seemed only to have succeeded in extracting the romance, even the intrinsic interest, from the subject. What Lee found lacking was the ghost's effect on the imagination, which she characterised by evoking the most ineffable of the senses, smell: 'that odour (we all know it), musty and damp, but penetratingly sweet and intoxicatingly heady, which hangs in the air when the ghost has swept through the unopened door'.[5] In an era of ghost-mania, when even the academic establishment was open-minded about their existence, the story-writer's task seemed, oddly, to have become more exacting than ever.

Lee worried about the effect of writing ghost stories at all – 'to write is to exorcise, to dispel the charm', she wrote; 'printers' ink chases away the ghosts that may pleasantly haunt us, as efficaciously as gallons of holy water'.[6] To define a ghost with too much clarity was to strip it of all its suggestive power. She began her preface to *Hauntings* by describing how, 'last evening',

> we were talking of a certain castle whose heir is initiated (as folk tell) on his twenty-first birthday to the knowledge of a secret so terrible as to overshadow his subsequent life. It struck us, discussing idly the various mysteries and terrors that may lie behind this fact or this fable, that no doom or horror conceivable and to be defined in words could ever adequately solve this riddle; that no reality of dreadfulness could seem aught but paltry, bearable, and easy to face in comparison with this vague we know not what.[7]

For Lee, the art of the effective ghost story was a balancing act: the combination of a richly suggestive atmosphere with a narrative that was sufficiently compelling but not too definite.

How can a ghost be evoked enough but not too much? This question lies at the heart of 'Oke of Okehurst', which Lee wrote around the time of her experience with the Society for Psychical Research, and indeed the idea

of the sketch as opposed to the finished work is woven through the story.[8] It is narrated by a portrait painter, a suave figure based on John Singer Sargent, who painted a bravura oil sketch of Lee herself in 1881 (*fig. 57*). He is commissioned by William Oke to paint his wife, which takes him to their Kentish home, Okehurst. It is the artist's inability to complete her portrait that keeps him there for a period of weeks, during which the events of the story take place. The many sketches he makes of her both give him a reason for frequent conversations and serve as a leitmotif for the indefinite, suggestive qualities that Lee sought to create. During his sittings with Alice Oke the artist remarks on the extraordinary resemblance she bears to an early seventeenth-century ancestress of hers, also called Alice Oke (she and her husband being cousins), whose portrait hangs at Okehurst. It becomes apparent that she identifies with her namesake to a morbid and unnatural degree, wearing her clothes and becoming obsessed with the earlier Alice's lover, a poet called Christopher Lovelock. Does Lovelock's ghost appear to the modern Alice? Does her husband, whom she torments with hints of her affair until he becomes unwell and deranged, begin to see him too? Or is it only their minds that are haunted? Lee maintains the ambiguity, and adds a new psychological dimension to the supernatural mystery.

On its publication early in 1890, Lee sent *Hauntings*, which included 'Oke of Okehurst', to her friend Henry James. He replied with scrupulous candour, thanking her for the book which he characterised as 'eminently psychical' but voicing his reservations about the genre, explaining that: 'The supernatural story, the subject wrought in fantasy, is not the *class* of fiction I myself most cherish (prejudiced as you may have perceived me in favour of a close connotation, or close observation, of the real – or whatever one may call it – the familiar, the inevitable).'[9]

But James was to change his mind. In January of 1895 he went to stay with his friend E.W. Benson, the Archbishop of Canterbury, at Addington Palace, his official residence near Croydon. At some point during his stay, as they sat by the drawing-room fire together in the evening, Benson related a half-remembered, fragmentary story that James recorded in his notebook shortly afterwards. It was, James recalled,

the story of the young children (indefinite number and age) left to the care of servants in an old country-house, through the death, presumably, of parents. The servants, wicked and depraved, corrupt

and deprave the children; the children are bad, full of evil, to a sinister degree. The servants *die* (the story vague about the way of it) and their apparitions, figures, return to haunt the house *and* children, to whom they seem to beckon, whom they invite and solicit, from across dangerous places, the deep ditch of a sunk fence, etc. – so that the children may destroy themselves, lose themselves by responding, by getting into their power.[10]

It was the quality of indefiniteness that particularly appealed to James, just as it had to Lee. The fragment prompted him to write a supernatural novella, *The Turn of the Screw*, described by Oscar Wilde shortly after its publication in 1898 as 'a most wonderful, lurid, poisonous little tale'.[11]

Some years later, when James wrote prefaces for his novels and stories in the course of preparing a collected edition of his works, he turned once more to his reservations about ghost stories, observing that:

The good, the really effective and heart-shaking ghost stories (roughly so to term them) appeared all to have been told, and neither new crop nor new type in any quarter awaited us. The new type indeed, the mere modern "psychical" case, washed clean of all queerness as by exposure to a flowing laboratory tap, and equipped with credentials vouching for this – the new type clearly promised little, for the more it was respectably certified the less it seemed of a nature to rouse the dear old sacred terror.[12]

James faced the same problem as Lee, but he found a different solution. He thought that, to be frightening, ghosts had to be 'real', not mere hallucinations, mental projections or even the apparently purposeless phantoms recorded by the Society for Psychical Research. They needed to have it in their power to do terrible – if unspecified – harm. The ghosts in *The Turn of the Screw*, of the former governess Miss Jessel and the master's manservant Peter Quint, are characters motivated by evil, menacingly present to the governess who desperately tries to protect the children from their influence. But they must remain out of reach – on the other side of a window, or across a lake, or at the top of a tower. And the evil must stay unspecific, to conjure up horrors in the reader's own mind. 'Make him *think* the evil,

make him think it for himself, and you are released from weak specifications', James noted some years later.[13] He even felt the force of 'the dear old sacred terror' in his own tale, jokingly admitting to his friend Edmund Gosse that, having corrected proofs late in the evening, 'when I had finished them I was so frightened that I was afraid to go upstairs to bed!'[14]

James was guarded about discussing the nature of the ghosts in *The Turn of the Screw* to those who wrote to him after its publication. After a few lines on the subject in a letter replying to one from H.G. Wells, he firmly shut down discussion, concluding: 'But the thing is essentially a pot-boiler and a *jeu d'esprit*.'[15] When Frederic Myers, one of the founders of the Society for Psychical Research, contacted him, James replied to say that he did not 'quite *understand*' his questions – presumably concerning the precise type of supernatural beings he had put in his tale – and pointedly described his ghosts as fictional: 'the fruit, at best, of a very imperfect ingenuity'. 'The *T. of the S.* is a very mechanical matter, I honestly think', he demurred, adding that, as a subject, it was 'merely *pictorial*'.[16] 'Good ghosts', he wrote in 1909, in his preface to a second edition of the tale, '... make poor subjects', and went on to re-define Peter Quint and Miss Jessel as 'not "ghosts" at all, as we now know the ghost, but goblins, elves, imps, demons'.[17] Because ghosts were, by that time, the focus of such concerted scientific attention, they had, James implies, to be reclaimed by fiction-writers and re-invented as malevolent forces if they were to be at all effective. But despite James's protestations about the unfitness of his ghosts to stand up to psychological analysis, *The Turn of the Screw* grips the imagination. Virginia Woolf felt that the particular horror of the story

> comes from the force with which it makes us realize the power that our minds possess for such excursions into the darkness; when certain lights sink, or certain barriers are lowered, the ghosts of the mind, untracked desires, indistinct intimations, are seen to be a large company.[18]

'We must admit that Henry James has conquered,' she writes elsewhere. 'That courtly, worldly, sentimental old gentleman can still make us afraid of the dark.'[19]

It was *Phantasms of the Living*, a work of 1886 written by Edmund Gurney, another of the Society for Psychical Research's early luminaries and

a friend of James's brother William, along with co-authors Frank Podmore and Frederic Myers, that seems to have prompted James to re-visit the 'mere modern "psychical" case' and to expand what ghosts could be and what they could do. Rather than using psychology to explain ghosts away, as he complained writers of the 'new type' of story did, James began to use ghosts to explore aspects of psychology. He bought the two 'big volumes' of *Phantasms of the Living*, a vast compendium of over seven hundred supernatural experiences, soon after its publication, reporting the purchase to William from the villa in Bellosguardo where he was staying over Christmas that year, but admitting 'they were too big to bring along and I haven't read a word of them'.[20] However, it seems likely that James eventually read at least some of the words of *Phantasms*, if only to be in a position to discuss them with his brother, an eminent psychologist who had been involved with the Society from its inception. The authors' principal focus, as their title suggests, was not so much on conventional ghosts as on the phenomenon of a person seemingly appearing to a distant loved one at the moment of their death – a hardy perennial of ghost-sighting that crops up in accounts from John Aubrey to Catherine Crowe, but here discussed and analysed at exhaustive length. The idea of the self divided in two lay at the heart of one of James's most haunting tales.

'The Jolly Corner', first published in 1908, concerns the American Spencer Brydon, who, having left New York for Europe as a young man of twenty-three, returns to the city thirty-three years later to oversee the conversion into apartments of a property he owns. He has another, his old family house on a 'jolly corner', which he keeps empty and will not turn over to the developers. Wondering at the enormous changes that have happened to the city in his absence, Spencer begins to wonder too about what he himself would have become had he stayed in New York. He has led a privileged life in Europe on the proceeds of his New York rents but, as he oversees the conversion and reconstruction of his property, he becomes aware of a 'lively stir, in a compartment of his mind never yet penetrated, of a capacity for business and a sense for construction. These virtues, so common all round him now, had been dormant in his own organism'. His friend Alice Staverton remarks ironically that 'he had clearly for too many years neglected a real gift... If he had but stayed at home he would have discovered his genius in time really to start some new variety of awful architectural hare and run it till it burrowed in a goldmine.'[21] Alice's words

find an answering echo in Spencer's mind as his fascination with this active alter ego grows.

Increasingly possessed by the idea that his putative other self has some kind of actual existence, late every evening Spencer lets himself into his empty family home and prowls quietly through the rooms with the growing conviction that his alter ego is present in the house. His sense that he is pursuing a quarry is, however, reversed one night when he finds a door on an upper storey closed that he knew he had opened earlier that evening. He shrinks in horror from coming face to face with himself and determines to leave, but just as he reaches the front door he is confronted by his other self, and feels the same horror and incomprehension that Rossetti's lovers express when faced with their doppelgängers (see pp.180–1):

> It gloomed, it loomed, it was something, it was somebody, the prodigy of a personal presence.

> Rigid and conscious, spectral yet human, a man of his own substance and stature waited there...

The ghost at first covers his face with his hands – hands that have lost two fingers, 'which were reduced to stumps, as if accidentally shot away'. But when he allows his hands to fall, Spencer finds it impossible to recognise the man as himself: 'The face, *that* face, Spencer Brydon's? – he searched it still, but looking away from it in dismay and denial ... It was unknown, inconceivable, awful, disconnected from any possibility – !' But Alice, to whom Spencer's alter ego has also appeared, gently asks him: 'Isn't the whole point that you'd have been different?'[22]

James's phantasm of the living dramatises the path not taken, and the discomforting sense of what might have been. In a notebook entry that seems to record his first idea for 'The Jolly Corner', he wrote of 'the Dead Self' – the compelling idea of an alternative, divergent identity that is neither alive nor can altogether be said to be wholly absent.[23] It is an idea which led James to invent a ghost fit for an age of pioneering enquiry into the workings of the mind. Ghosts have always been our doubles: James presents us with the psychological implications of this while, at the same time, administering a strong dose of 'the dear old sacred terror'.

19. THE HAUNTED LAND

On a darkening afternoon at the end of December 1899, Thomas Hardy leant on a coppice gate and surveyed the bleak landscape in front of him. Experiencing a terrible cosmic vision, it suddenly seemed to him that he was looking at the century's corpse, laid out under the 'cloudy canopy' of the sky. The whole world had become a crypt, and the earth, it appeared, was every bit as dead as the century itself. Could there be any hope of new life, whether through the cycle of nature or Christian faith? A little thrush sang cheerfully; but Hardy was not optimistic. 'The ancient pulse of germ and birth / Was shrunken hard and dry,' he wrote in his poem 'The Darkling Thrush', and any remaining colour in the landscape was masked by the 'spectre-gray' frost.[24] Hardy's image suggests that the only animate being in the landscape is a ghostly one, distributing a clinging freeze as it passes.

Scanning the desolate winter landscape in our mind's eye, we are invited to share Hardy's mood; but we can hardly follow him to the bleak conclusion of 'The Darkling Thrush'. The end of the year is a hinge, not a dead end. Of course the new year will dawn. Of course spring will come, and of course there is hope. But in imagining the landscape as a body, in however pessimistic a context, Hardy evokes the concept of a land haunted by a ghostly spirit of place, or *genius loci*. It was an idea that had an intimate connection to national identity. Pondering the subject in 1907 in his work *The Spirit of the People: An Analysis of the English Mind*, Ford Madox Hueffer (later Ford Madox Ford) wrote: 'It is not – the whole of Anglo-Saxondom – a matter of race but one, quite simply, of place – of place and of spirit, the spirit being born of the environment.'[25] An acute consciousness of these layers of cultural significance that had been laid down in the land for time out of mind had grown towards the end of the nineteenth century, and would be of huge importance in the twentieth.

Hardy's pessimism, however, was not unfounded. Underneath the apparent confidence of the times was a sense of unease and a mood of introspection. People worried about what this new century would hold. The sheer scale and momentum of house-building and industrialisation that in the late Georgian and Victorian eras had so rapidly and irreversibly changed the character of Britain had created an ever-widening gulf between city and country and upset the old balance between manufacturing,

trade and agriculture. From an urban vantage point, the hardships of rural life were often overlooked and the country – in particular the non-industrial south of England – began to be perceived as a site of unchanged national identity. People began to value the landscape, not only for pragmatic reasons but for emotional ones too. When the National Trust was founded in 1895, it was as much to protect unspoiled green spaces from the seemingly unstoppable building boom as to preserve historic structures. The country was re-imagined as a repository of ancient history and legend, of mysterious long barrows and standing stones, where Hardy's 'ancient pulse' continued to beat its age-old rhythm.

Some began to feel that the nation's folklore needed to be saved just as much as its green spaces. From the mid-1860s onwards a few books on the traditions, legends and superstitions of particular counties had been published, but they were not enough for Charlotte Sophia Burne, the first female president of the Folklore Society (founded in London in 1878).[26] In 1890 she issued a call to action: 'we must have a great deal more collecting', she declared in the journal *Folklore*. Acknowledging that 'a good deal of matter has been recorded', she nonetheless lamented that much of it was 'unsystematic, patchy, incomplete'. A concerted effort had to be made, and made soon, before modernity swept the old oral traditions away. This had, after all, happened before.

> How a struggle, which was at once, political, social, and religious, could and did affect old customs, we may learn from Aubrey, who notes over and over again, that things, laid aside when he wrote, had been in use 'before the warres'.[27]

'If the folk-lore of England is not recorded soon', she concludes, 'it will never be recorded at all, for these "foot-prints in the sands of time" are fast being trampled by the hurrying feet of the busy multitudes of the Present.'[28] First and foremost, what was needed was 'a careful geographical examination of the habitats and boundaries of the various items of English folk-lore'.[29] Burne's insistence on the importance of unique local detail underlay her own monumental *Shropshire Folk-Lore: A Sheaf of Gleanings* (1883), in which she recorded the precise places in which she had heard every story.[30] When it came to ghosts, she applied her systematic mind to the nuances with which Shropshire people referred to different

varieties of haunting – whether there was 'summat to be sid', or there was a 'frittening', or somebody 'came again'.[31]

This new emphasis on the geographies of haunting (which has persisted to this day, with many collections being grouped by county) coincided with the new emotional value that people began to place on the countryside; and both had a decisive effect on the ways British artists and writers thought about ghosts. Ever since the Reformation, they had mostly described ghosts visiting people in their urban environments. In the late nineteenth century, however, with this change in mood and the publication of numerous regional folkloric tales, they began instead to find them deep in the country. The poems of A.E. Housman's *A Shropshire Lad* (1896) are haunted by the ghosts of young men who cannot lie quietly in the Shropshire loam. It was not even absolutely necessary to be dead: the poet's soul behaves like a ghost, 'sighing / About the glimmering weirs' of his beloved county while he is in bed in London.[32]

This new breed of ghosts represented the national past – not quite as they had done a hundred years before, when they often served to dramatise a historical figure or important event; their new role was to personify a deeper, more primitive idea of history that was intimately connected with particular locations. They were drafted in to re-enchant the land.

The Canadian-born writer Grant Allen, in his story 'Pallinghurst Barrow', published in the 1892 Christmas number of the *Illustrated London News*, imagined his ghosts deep inside an ancient feature of the landscape. As the story begins, our hero, Rudolph Reeve, is sitting on the terraced slope of a prehistoric long barrow near the fictional Pallinghurst Manor in Hampshire, towards sunset on 28 September, Michaelmas Eve, at around the time of the autumnal equinox. He becomes aware, 'through no external sense, but by pure internal consciousness, of something living and moving within the barrow'. Although he feels afraid, at the same time he is powerfully drawn to 'the mysterious and the marvellous in the dark depths of the barrow'.[33] Late that night, his willpower weakened by the intoxicating soma-juice he has taken to relieve a headache, he looks out of his window and sees a strange light hanging over the barrow which he feels impelled to go towards. He has just been reading a volume of English fairy tales and remembers the story of Childe Roland, who gains entry to the dark tower to rescue his sister Burd Ellen by walking around it three times widdershins while speaking the words 'Open door! Open door! /

And let me come in'.[34] Rudolph does the same, and the barrow opens to admit him. At once he is surrounded by 'a ghostly throng of naked and hideous savages', the spirits of Neolithic men and women (*fig. 58*). This was doubly dreadful, worse than ordinary hauntings, because: 'They were savages, yet they were ghosts. The two most terrible and dreaded foes of civilized experience seemed combined at once in them.' Although they are spirits, their 'intangible hands' and 'incorporeal fingers' are strong, and it is only when the 'dim and uncertain' ghost of an Englishman wearing sixteenth-century costume – a previous victim, we infer – helpfully appears in order to advise him to 'Show them iron!' that Rudolph manages to fight his way free with the aid of his pocket-knife, which the ghost-savages avoid 'with superstitious terror'.[35] At the end of the story his hostess's young daughter recalls a 'terrible old rhyme' about the barrow:

Pallinghust Barrow – Pallinghurst Barrow!
Every year one heart thou'lt harrow!
Pallinghurst Ring – Pallinghurst Ring!
A bloody man is thy ghostly king.
Men's bones he breaks, and sucks their marrow,
In Pallinghurst Ring on Pallinghurst Barrow.[36]

She had been taught the rhyme by a Romany woman, someone with a deeper understanding of folklore, ritual and the strange forces alive in the landscape than the educated folk at the manor. These people might own the land, but, having lost touch with old country traditions and legends that are passed on orally like the Romany woman's rhyme, they are, Allen suggests, fundamentally estranged from it. Dismissing such lore as superstition makes them vulnerable to its ghosts.

Ghosts, the landscape of southern England and a ring of prehistoric standing stones all converge to set the scene for a highly charged episode at the mid-point of E.M. Forster's novel *The Longest Journey* (1907). 'Here is the heart of our island', says the narrator from the site of the fictional Cadbury Rings, near Salisbury: 'the Chilterns, the North Downs, the South Downs radiate hence. The fibres of England unite in Wiltshire, and did we condescend to worship her, here we should erect our national shrine.' Forster makes the Cadbury Rings an arena for bleak emotional drama, in which a host of imaginary ghosts act as a silent chorus.

'This place is full of ghosties,' remarks one of the characters, just before revealing a shocking secret; 'have you seen any yet?'[37]

Gentler ghosts populate Rudyard Kipling's story 'They', first published in *Scribner's Magazine* in 1904. It relates another encounter with the past, also lodged deep in the English countryside. If, from the top of Pallinghurst Barrow, Rudolph could see 'far into the shadowy heart of Hampshire' (a hint that the land holds further dark secrets), in 'They' the narrator motors along the narrow, leafy lanes of the Sussex Downs, plunging 'first into a green cutting brim-full of liquid sunshine, next into a gloomy tunnel', as though being sucked into a different element within which he has little control. He loses his way and, at the end of an unexpectedly steep downhill slope, suddenly reaches 'an ancient house of lichened and weather-worn stone, with mullioned windows and roofs of rose-red tile', its front door 'a miracle of old oak'.[38] The eruption of a motor-car into this peaceful picture of old England produces a number of curious but shy children, who appear at a distance, and can be glimpsed only for a moment. They are, of course, the ghosts of dead children, forever playing in this deep pocket of the country where the past can slowly accumulate, and – excepting the narrator's motor-car, which is presented by the author, a keen motorist, as a benign object – where they are sheltered from encroaching modernity. The death in 1899 of Kipling's young daughter Josephine of pneumonia suggests the presence of a touchingly autobiographical dimension to 'They', especially in the light of the similarity the house bears to Bateman's, the Jacobean mansion in Sussex that Kipling made his home from 1902 until his death in 1936. Now owned by the National Trust, Bateman's is approached from a distinctly precipitous lane.

The country also hides the past in its pockets in stories by the Cambridge scholar and director of the Fitzwilliam Museum, Montague Rhodes James. When in 1904 he published his first collection, *Ghost Stories of an Antiquary*, James was making public stories that he had been inventing for years to amuse his circle of friends, reading them as entertainments at Christmas-time. For these stories James used the central preoccupation of his professional life – research into medieval manuscripts and artefacts – as a framework; the tales in this and his three subsequent collections (1911, 1919 and 1925) often turn on the consequences of unearthing something buried or concealed in the land. There is an old whistle in '"Oh, Whistle, and I'll Come to You, My Lad"' (1904), interred on the ancient coastal

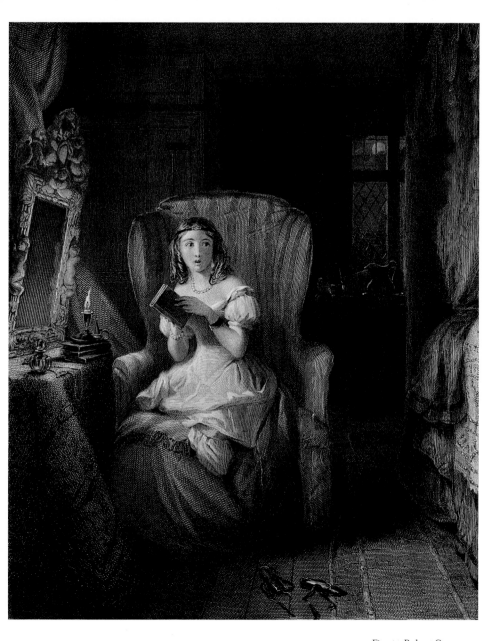

Fig. 49 Robert Graves
(1798–1873), after Robert
William Buss (1804–75)
The Ghost Story c.1840–5
Engraving 25.9 × 21
Wellcome Library, London

Fig. 50 Edward Burne-Jones (1833–98) 'Bogey drawings' c.1864, reproduced in Georgiana Burne-Jones, *Memorials of Edward Burne-Jones*, 1904, Tate Library and Archive

Fig. 51 John Atkinson Grimshaw (1836–93) *Silver Moonlight* 1880 Oil on canvas 83.2 × 121.9 The Mercer Art Gallery, Harrogate

Fig. 52 (opposite) Frederick Hudson *Georgiana Houghton, Tommy Guppy and a Spirit* 1872 Albumen silver print 9 × 6 (approx.) The College of Psychic Studies, London

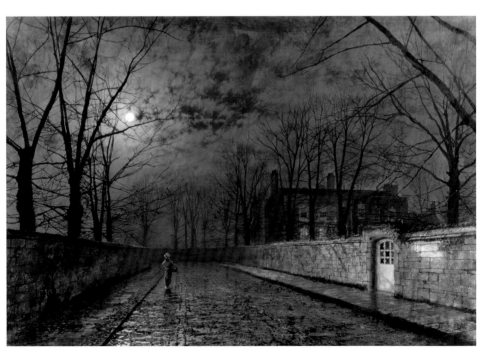

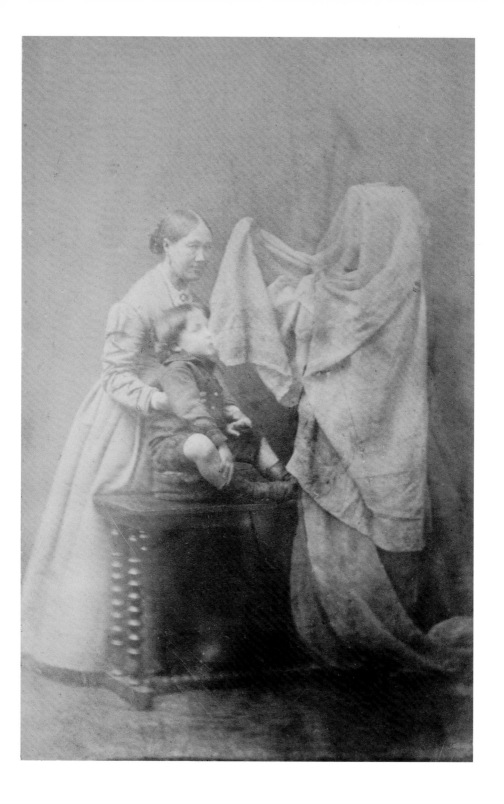

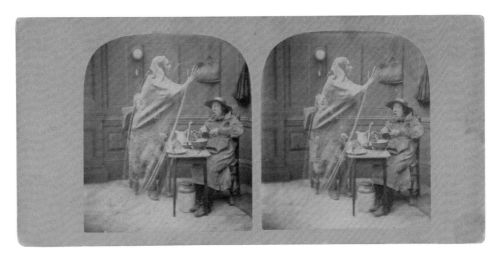

Fig. 53 Anon.
The Ghost in the Stereoscope
*c.*1856
Two albumen silver prints
with hand-colouring,
each 7.8 × 6.5
Metropolitan Museum
of Art, New York

Fig. 54 Cover design,
J.H. Brown, *Spectropia; or,*
Surprising Spectral Illusions.
Showing Ghosts Everywhere, and
of any Colour, London 1864
British Library, London

Fig. 55 Plate VI, 'This
orange figure will give
a blue spectre', J.H.
Brown, *Spectropia; or,*
Surprising Spectral Illusions.
Showing Ghosts Everywhere, and
of any Colour, London 1864
British Library, London

Fig. 56 (opposite)
Georgiana Houghton
(1814–84)
The Eye of the Lord 1866
Watercolour and gouache
32.7 × 23.8
Victorian Spiritualists'
Union, Australia

Fig. 57 John Singer
Sargent (1856–1925)
Vernon Lee 1881
Oil on canvas 53.7 × 43.2
Tate

Fig. 58 Anon.
Illustration to Grant
Allen, 'Pallinghurst
Barrow', *Illustrated London
News*, Christmas number,
1892
Private collection

Fig. 59 James McBryde
(1874–1904)
Illustration to '"Oh,
Whistle, and I'll Come to
You, My Lad"' in M.R.
James, *Ghost Stories of an
Antiquary*, London 1904
Archive Centre, King's
College, Cambridge

Fig. 60 Paul Nash
(1889–1946)
Ghosts c.1932
Lithograph with hand-
colouring 22.5 × 15.3
Tate

Fig. 61 (opposite) Paul
Nash (1889–1946)
Mansions of the Dead 1932
Graphite and watercolour
57.8 × 39.4
Tate

Fig. 62 Paul Nash
(1889–1946)
Ghost in the Shale 1942
Pen and ink and
watercolour 39 × 57
The John Creasey
Museum, Salisbury

Fig. 63 Still from
The Innocents, dir. Jack
Clayton, England 1961

Fig. 64 Still from
Whistle and I'll Come to You,
dir. Jonathan Miller,
BBC, England 1968

Fig. 65 (opposite) John
Farleigh (1900–65)
Dust jacket design for
Christina Hole, *Haunted
England*, London 1940

Fig. 66 John Farleigh
(1900–65)
Illustration to Christina
Hole, *Haunted England*,
London 1940
Private collection

Fig. 67 Felix Kelly
(1914–94)
Dust-jacket design
for Joseph Braddock,
Haunted Houses,
London 1956

Fig. 68 Susan Hiller
(b.1940)
*Belshazzar's Feast, the Writing
on Your Wall* 1983-4
Sofa, armchairs, tables,
pillows, lamps, artificial
plants, rug, 12 works
on paper, wallpaper
and video, 21 min 52 sec
Tate

Fig. 69 (opposite)
Adam Fuss (b.1961)
From the series
My Ghost, 2001
Unique gelatin silver
print photogram
mounted on muslin
197.5 x 136.5

Fig. 70 Jeremy Deller
(b.1966) and Rufus
Norris (b.1965)
We're here because we're here,
1 July 2016
Performance, approx.
1,400 men
Part of '14–18 Now',
photograph by Eoin
Carey, Glasgow

site of a church that had been built by the Knights Templar. When the holidaying Professor Parkins digs the whistle up, cleans the earth from it and deciphers its inscription 'QUIS EST ISTE QUI VENIT' as 'Who is this who is coming?', he concludes that 'the best way to find out is evidently to whistle for him'; but in blowing through it he conjures up the terrible phantom of a lonely figure in a bleak landscape that relentlessly pursues him (*fig. 59*).[39] The gold Anglo-Saxon crown of 'A Warning to the Curious' (published in 1925) had long been hidden deep inside a hillock near the East Anglian coast to ward off invaders. When the amateur archaeologist Paxton ignores local folklore and digs it up, he is haunted and eventually done away with by the crown's ghostly protector, William Ager, whose family had for generations claimed to be its dedicated guardians. The last of his line, even in death Ager honours his obligation.

'I have tried to make my ghosts act in ways not incongruous with the rules of folklore', wrote M.R. James in 1931 in the preface to a collected edition of his stories.[40] One of these rules concerns a respect – or lack of it – for the spirit of place, so potent a concept in traditional tales. Over and again James writes of powerful historical forces buried or otherwise present in the land that continue to simmer away, or are guarded by local ghosts or other supernatural beings. As in 'Pallinghurst Barrow', the academic knowledge of the protagonists – seldom lightly worn – is always revealed to be no match for the deeper, more rooted knowledge of the country folk who accommodate the history they know to be buried in the land by leaving it, and its attendant ghosts, undisturbed.

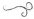

The First World War swept the old world away. It was, in the words of Henry James, 'all too close and too horrific and too unspeakable and too immeasurable'.[41] Writing seemed impossible. 'I dip my nose, or try to, into the inkpot as often as I can', he admitted to a friend, 'but it's as if there were no ink there, and I take it out smelling gunpowder, smelling blood'.[42] In an interview published in the *New York Times* in the spring of 1915, the year before his death, James gave a bleak evaluation of the power of writing:

> The war has used up words; they have weakened, they have deteriorated like motor car tires;... and we are now confronted with a depreciation of all our terms, or, otherwise speaking, with a loss of expression

through increase of limpness, that may well make us wonder what ghosts will be left to walk.[43]

What ghosts indeed. James conjures up a depressingly flat world in which words themselves lose their buoyancy. Ghosts – in the sense of *genii loci*, historical atmosphere, and of meaning that extends above and beyond the merely literal – might also, perhaps, have been extinguished. Could they survive into the modern era? Or were they, like so many others, casualties of the Great War?

Perhaps they were more necessary than ever. Arthur Machen's story 'The Bowmen' was a fantasy about a company of ghostly archers who had fought at the battle of Agincourt in 1415, coming to the aid of British troops at the Battle of Mons – 'on the most awful day of that awful time, on the day when ruin and disaster came so near that their shadow fell over London far away'. The ghosts were summoned by a soldier who, at a moment of apparent hopelessness, voiced an appeal to St George: '*Adsit Anglis Sanctus Georgius*'. In response, medieval longbowmen immediately appeared as 'a long line of shapes, with a shining about them'.[44] When on 29 September 1914 'The Bowmen' was published in the *London Evening News*, it was not clearly designated as fiction, and as a result it was seized upon and widely taken to report an actual supernatural event. Within months, the legend of the 'Angels of Mons' had become part of the British story. Accounts circulated that dead Prussians had been found on the battlefield with arrow wounds. The 'snowball of rumour that was then set rolling has been rolling ever since,' groaned Machen the following year, 'growing bigger and bigger, till it is now swollen to a monstrous size.'[45] It has not been entirely extinguished even today.

At the outbreak of the First World War, the landscape painter Paul Nash enlisted in the Artists' Rifles, and was later made an Official War Artist in the new scheme run by the Department of Information. He was at the front for several weeks following the battle of Passchendaele, and the drawings he made there are bleak dispatches, told in black ink on brown paper, of the chaos that was left behind: jagged, broken trees and disfigured land. After the war, the rich spirit of Romanticism that had pervaded Nash's work before the conflict returned, but with a difference. The war had stretched his imagination and made it more capacious, allowing it to recognise and incorporate the monstrous and the threatening in

the landscape as much as the beautiful and the harmonious. The *genii loci* he found were ambiguous ones.

It was a book about objects buried in the land that first inspired Nash to depict ghosts. In 1930 he was commissioned to illustrate a tract originally published in 1658, *Hydriotaphia, Urne-buriall* by the physician and antiquarian Sir Thomas Browne. Browne's book hinges on the discovery in a Norfolk field of buried vessels that he and others took to be Roman funerary urns (they were later revealed to be Saxon, and are now in the British Museum); but his text soon wanders as his mind turns to funerary customs, immortality and ghosts. Nash takes Browne's associative meanderings as a guiding principle, responding freely to his ideas. In his illustration *Ghosts* (*fig. 60*), he shows us a surreal, watery world populated by strange beings – a cloud drifts nonchalantly past, propelled by two slender hands; a green-haired head stares as if in a trance; and a pale humanoid figure drifts down a staircase beneath the canopy of a goggle-eyed jellyfish.[46] Another, *Mansions of the Dead* (*fig. 61*), is a response to Browne's line 'Before Plato could speak, the soul had wings in Homer, which fell not, but flew out of the body into the mansions of the dead'. It depicts, in Nash's words, 'aerial habitations where the soul like a bird or some such aerial creature roamed at will'.[47] Nash's souls – bird-like forms riding on discs – elegantly navigate their way upwards through an air-borne geometric structure of shelves and wires. *Urne Buriall* was the ideal commission for Nash: a book that was as much about delving into odd corners of the mind as it was about archaeological research. The very British version of Surrealism that he applied to it liberated the ghosts of his imagination, allowing them to roam happily around in whatever shape or form they chose.

As an artist of the landscape Nash thought of himself not as studio-bound but as an explorer, prowling the land in search of material and 'hunting far afield over the wild country, to get my living out of the land as much as my ancestors ever had done'.[48] In these expeditions he was drawn to unusual natural forms or standing stones that seemed to him to have a presence and a character, and he photographed and painted his found objects with a Surrealist's relish for their charisma and strangeness. The name he found to describe them – whether they were stones, bones or fallen trees – was 'personage'. It was not that Nash projected anthropomorphic or even zoomorphic qualities onto these forms – 'The word *personage* by the way,' he explained, '... is applicable equally to animate and inanimate

forms. A tree or a stone may amount to a personage in its personality without necessarily having human or even animal resemblance.' It was rather that he recognised some innate, essential force that they possessed; a concentrated form of *genius loci*.[49] It was in the early 1940s, during the Second World War, that Nash described how the idea of ghosts came to him through thinking about 'personages' in relation to the deep past:

> now I was looking round for a new form and character of object-personage. This came to me eventually in a roundabout way through studying a book of paleontology. Looking at the engraved plates of fossil impressions, it seemed to me these delicate, evocative forms could be re-vitalised in a particular way. I made a series of drawings of ghost personages, which showed them in the environment they naturally occupied in pre history.[50]

Among Nash's numerous 'ghost personage' drawings is a 'ghost of the shale in the Black Cliff of Kimmeridge clay' of 1942 (*fig. 62*).[51] It is another story of something being unearthed. Constructed with delicate blocks of pale watercolour wash, this picture presents its unexpected subject, the fossil-bird, like a vision, perhaps a momentary after-image on the retina resulting from that low sun. The nervous, tremulous lines that describe its shape suggest movement, as though, exposed to the light for the first time in millions of years, it might just flex its wings. In one way this is a punning drawing; Nash is comparing the fossilized bones with the skeletal ghost of Gothic stereotype. But this 'ghost personage', which lived, died and impressed its form into the rock where it maintained a presence over unimaginable stretches of time before suddenly coming to light, is a delicate but enduring symbol of a profoundly haunted land.

Nash's discovery of 'ghost personages' haunting the ancient land suggested a highly localised way of thinking about the spirit of place, but the idea could also be seen to relate to the country more widely – and to throw its relationship with other nations into sharp relief. In René Clair's 1935 film *The Ghost Goes West*, when a Scottish castle is bought by an immensely wealthy American businessman and shipped to Florida, its resident ghost, Murdoch Glourie, is inadvertently imported too, apparently inseparably connected to the stones of his ancestral home. The United States Congress reacts angrily to what it sees as a clear violation of immigration laws, and complains of

the inappropriateness of a 'relic of medieval superstition' being imported into its 'progressive country'. While, they speculate, ghosts might well be tolerated 'in the effete atmosphere of the British House of Lords', they are not acceptable 'in the free air of the United States'. The House of Lords counters with a lament that not only are 'the fairest flowers of Scottish architecture ... being uprooted from their native soil to be replanted in an alien land' but our ancestors too 'are being shipped over to please the fancy of a millionaire who, apparently, has no ancestor of his own'. In the end, the conflict between new-world money and old-world history is happily resolved when the ghost is finally released from his haunting duties and given permission to proceed to the afterlife, while his descendant, Donald Glourie, looks set to marry the businessman's daughter.

The protective role of ghosts continued to be expressed during the Second World War. Made during war-time, Nash's 'Ghost in the Shale' suggests that the ghost personage may be a form of tutelary spirit of the land. Powell and Pressburger's 1944 film *A Canterbury Tale* also offers the idea that there is a rich ghost-strata in the landscape. When the ghostly group of medieval pilgrims on horseback are heard making their way along the old pilgrim's route just outside Canterbury by the 'land girl' Alison Smith, it is as though a fossil layer has suddenly been exposed, a part of British history thrust up to the surface by the trauma of war. It is a deeply reassuring event: far from being frightening, these ghosts are galvanising reminders both of the country's Christian history and of its rich literary heritage. This idea of the earth as a treasury of shared culture acquired a fittingly literal dimension during war-time, when the land swallowed some of the nation's greatest paintings for temporary safe-keeping. 'Bury them in the bowels of the earth,' scrawled Winston Churchill on a memorandum sent to him by Kenneth Clark, then Director of the National Gallery, in June 1940, 'but not a picture shall leave this island.' Clark stashed away Titians, Claudes and Van Dycks in subterranean store-rooms provided by the Manod Caves, an abandoned slate quarry near Blaenau Ffestiniog in north Wales.[52]

Other films released either during or shortly after the Second World War offered a subtly different form of reassurance, treating death with tact and humour, and presenting it as an incident that simply brings about a change of circumstances that has no effect on one's intrinsic existence. David Lean's *Blithe Spirit* (1945), adapted by Noël Coward from his

own 1941 West End play, uses the séance to frame a sophisticated social comedy in which the vampish Elvira, the dead first wife of novelist Charles Condomine, is conjured up and refuses to leave, disrupting her husband's second marriage to Ruth. Elvira's plot to sabotage Charles's car so that he may join her goes wrong, leading instead to Ruth's death; she, in turn, torments Elvira. The film ends with Charles's death, and all three characters being reunited as ghosts in the spirit world. Even so, Coward was keenly aware that his original play was something of a gamble in war-time; as he later recalled, when it opened in London the audience 'had to walk across planks laid over the rubble caused by a recent air raid to see a light comedy about death'.[53] Indeed, although the play broke box-office records, it was not universally well received: Graham Greene, for instance, described it as 'a weary exhibition of bad taste'.[54] But as his biographer Philip Hoare has observed, Coward had a genuine interest in the supernatural, albeit one tempered by scepticism. In 1960 he attended a séance with Philip Astley, the former lover of the late Gertrude Lawrence who had starred in his 1930 play *Private Lives*, at which the medium announced that the actress was present and wearing the white Molyneux gown she had worn for the performance. 'Christ! It must be tatty by now' was Coward's response.[55]

Released in 1947, the comic film *The Ghosts of Berkeley Square*, directed by Vernon Sewell, also posits an essentially unchanged posthumous existence for the spirits, in this case General Burlap and Colonel Kelsoe (played by Robert Morley and Felix Aylmer), but goes further than Coward and Lean in using a war-time bombing raid as a means of resolving their predicament.[56] In 1709, Burlap and Kelsoe learn of the Duke of Marlborough's military strategy for what would become known as the Battle of Malplaquet, and decide it is flawed. Anticipating defeat, they plan to capture the duke and keep him hostage until the battle is safely over. However, in testing their snare (a trap-door in the floor) they inadvertently kill themselves, the all-important mattress below having been removed. They had been expecting Queen Anne for tea later that day, and when on alighting from her carriage at Berkeley Square the queen is informed that the two men are dead she returns to St James's Palace, greatly displeased. Being ghosts does not exempt General Burlap and Colonel Kelsoe from being subject to military justice, and the pair are court-marshalled and found 'guilty of offending against the crown' by 'dereliction of duty' and being absent without leave. Their sentence is to haunt No. 7 Berkeley Square until 'said premises aforesaid shall

be visited *in person* by reigning Royalty'. After two centuries of mishaps in which the housebound ghosts attempt unsuccessfully to bring about a royal visit, it is when the house is bombed in a First World War Zeppelin raid that, finally, Queen Mary makes an appearance and Burlap and Kelsoe can at last ascend to heaven. In *The Ghosts of Berkeley Square*, bombing paradoxically leads to life, not death: it is the means through which order is re-imposed and the ghosts are allowed to leave their earthly prison and enter the state of eternal life. But, although their costumes change with the times, the ghosts are also symbols of British history and of the phlegmatic British character; when the bombs come, they bring disenchantment. As Henry James had predicted, after the war there are no ghosts left to walk.

For the Wiltshire writer Edith Olivier, the land's enchantment was unaffected by war – or even, perhaps, more deeply entrenched by it. Back in 1930 she had gathered local superstitions and accounts of particular ghost-sightings from members of the Women's Institute and published them in the collection *Moonrakings: A Little Book of Wiltshire Stories*. In her 1938 book of 'personal memories', *Without Knowing Mr. Walkley*, she describes an experience she had had one October evening in 1916 when she was driving home in the rain from her war-work supervising the Wiltshire Women's Land Army. Near Avebury she left the main road and found herself in an impressive avenue, 'passing through a succession of huge grey megaliths, which stood on either hand, looming like vast immovable shadows'. She realised she was approaching Avebury's great prehistoric stone circles, and felt herself 'dominated, even at some distance away, by the sense that I was nearing an ancient and very wonderful place'.[57] When she reached the bank that surrounds the standing stones, she got out of her car and climbed to the top, from where she looked down over a village fair taking place among the megaliths, the scene 'partly obscured by the failing light and the falling rain, but ... fitfully lit by flares and torches from booths and shows'. Much later, she discovered that the fair had been abolished in 1850, and the avenue of stones destroyed before 1800.[58] Olivier had seen the land apparently re-enacting its own past. Was it significant that it had happened in the middle of the First World War and was recounted in the run-up to the second? Nearby Salisbury Plain had always seemed 'profoundly haunted' to Olivier.[59] And yet, she wrote in 1938, it 'possesses few, if any actual ghost stories'. The plain harboured a different kind of presence, an impersonal spirit of place:

The hauntings of the Plain are not personal, they are universal. The word 'Revenant' fits them better than 'Ghost'. Abstract presences seem to come and go upon the Plain, and they pass like the cloud shadows which move eternally over its still, impassible face.[60]

There was more than a hint that the antiquity of this particular landscape put all conflict into a different and far vaster perspective.

20. 'HALLO, GEORGE!'

'He looked as if he would murder me and he did', recalls Needle, the narrator of Muriel Spark's story 'The Portobello Road'. Spark re-invented ghosts for 1950s Britain. Hers are not showy or macabre; neither are they deep elemental forces, nor comforting historical presences. They are everyday apparitions: modern, urban and articulate. They accommodate themselves to their straitened circumstances. In fact it can be hard to tell that they are ghosts at all. In two early stories Spark collapses the distinction between the living and the dead to the point where there is little to choose between them. 'The Girl I Left Behind Me' (1957) is mostly narrated from the crowded discomfort of a London bus by a tired young woman making her way back to her lodgings after a tedious day in an office, haunted by the idea of something important left undone. She is depressed when no-one seems to notice her. It is only when she returns to the office and is joyfully reunited with her own strangled body, left lying on the floor, that the clues scattered through the tale can be pieced together; our realisation coincides with hers.

In the longer story that Spark published the following year, 'The Portobello Road', the narrator puts her cards on the table at an early stage:

I must explain that I departed this life nearly five years ago. But I did not altogether depart this world. There were those odd things still to be done which one's executors can never do properly.[61]

Needle's administrative duties keep her occupied, except on Sundays, holidays of obligation when she attends Mass and Saturday mornings when she takes her recreation. On fine days she likes to visit the street market

on Portobello Road, which is where, one day, she spots her murderer, an old friend, whom she cheerfully hails from her position beside a fruit barrow with the words 'Hallo, George!' Although she terrifies George, Needle explains that she was merely motivated by a 'sudden inspiration' to greet him – although she acknowledges that her unexpected appearance causes him to look 'unwell'. His conscience duly pricked (for all her brisk modernity, Needle is a ghost of the old school), George repeatedly tries to confess to the murder but without success: he is taken to be mentally unbalanced. He is eventually persuaded to emigrate to prevent him from obsessively visiting Portobello Road to see if Needle's ghost will appear again. A measure of revenge has been dished out. 'George has recovered somewhat in Canada', notes Needle slyly at the end of the story, 'but of course he will never be the old George again'.[62]

On the whole, though, the post-war years and 1950s turned out to be relatively lean ones for ghosts. A.N.L. Munby was among a small number of writers who continued to engage with ghostly phenomena, with stories such as 'The Alabaster Hand' (1949) that were closely based on the model established earlier in the century by M.R. James. The ghost story was firmly associated in the public mind with the Victorian and Edwardian eras, at a time when the art and culture of those periods was almost universally considered to be overblown, fusty and irrelevant. Ghosts were also blocked by other preoccupations. The telescope was turned through 180 degrees, and the focus on and into the land that had been so marked in the first half of the twentieth century was replaced by a speculative gaze out into space, towards far distant worlds. As people's imaginations were captured by space exploration, and literature responded with varieties of science fiction, the traditional place of ghosts was quickly usurped by aliens. These new beings, who offered such scope to the imagination into the bargain, were excellently qualified to fulfil the ghost's age-old task of reminding us that we are not alone.

But if ghosts had been thin on the ground in the 1950s, the revival of interest in Victorian and Edwardian culture that marked the following two decades swept them back again. *The Innocents*, a film directed by Jack Clayton based on Henry James's *The Turn of the Screw*, was released in 1961 (*fig. 63*), and later in the decade the BBC began to commission a series of influential adaptations of ghost stories by M.R. James. The first of these was Jonathan Miller's 1968 adaptation of James's 1904 story '"Oh, Whistle, and I'll Come

to You, My Lad"' as 'Whistle and I'll Come to You'.[63] In Miller's hands the atmosphere is oppressive, and communication minimal. The psychological effect of the haunting on the arch-rationalist Professor Parkins – much older and more awkward in Miller's story than in James's, and consequently more touchingly vulnerable – becomes the film's insistent focus. The ghost that he has conjured up is a thing of grey tattered rags, making strange, unnerving shapes as it blows in the wind (*fig. 64*). 'Oh no, oh no', Parkins mumbles in terror at the end of the story, just as he has been saved by his friend from the 'intensely horrible, face *of crumpled linen*' that has reared up from the spare bed in his room.[64] 'Oh no', he repeats finally, but in a different tone, his rationalism reasserting itself to deny the dreadful phenomenon he has just experienced. Miller's haunting adaptation, made as part of the arts documentary series *Omnibus*, cast a long shadow: it inspired the BBC to commission an annual *Ghost Story for Christmas*. Shown on BBC1 from 1971 to 1978, the first five were based on stories by M.R. James. The idea that ghosts were particularly suitable Christmas fare was in itself a revival of a Victorian custom.

The eruption of the ancient into the here-and-now, a theme so deftly handled by James, struck a chord in the turbulent, shifting 1970s. Among the new supernatural dramas that were commissioned for television was *The Stone Tape*, written by Nigel Kneale and broadcast on BBC2 at Christmas 1972. It brought recent technology to bear on an old subject. A team researching recording media, working for an electrical company that has recently moved its operations to a Victorian house, discover that one room in the much older core of the building appears to be haunted by the sound of a woman's running footsteps followed by a terrible scream and the sound of a fall. The company's director guesses that the ancient stone of this part of the building has captured the sound, which is apparently connected to the death of a maid in the room in the nineteenth century. The team investigate and discover that, like a modern tape recorder, the stone has recorded the most recent sound produced in a moment of extreme emotional crisis over the top of countless such older recordings. It is another story about layers of the past remaining unextinguished – time out of mind, perhaps, but still dangerously fizzing away in our ancient building-blocks. Like Nash's bird-fossil, these recorded ghosts, sinister *genii loci*, are embedded deep within Britain's stones; in Kneale's hands the idea is ingeniously rejuvenated with a modern metaphor.

The Stone Tape was originally intended to have been the final episode in a series of unconnected short films broadcast by the BBC in the autumn of 1972 with the collective title *Dead of Night*, although in the event it was shown separately. Those that were part of the series and that survive in the BBC's archives bring a political dimension to the supernatural tale that reflects the cultural and social upheavals of the decade, dealing with pressing contemporary issues such as poverty and sexual inequality. One of only three extant episodes, 'A Woman Sobbing' by John Bowen, is a dark, intense drama about Jane (played by Anna Massey), a middle-aged housewife who, after hearing the sound of a woman crying coming from an empty attic room, is patronised, humiliated and brushed off by a succession of men to whom she turns for help. Most ghost stories hinge on the clash of a capable, commonsensical person coming face to face with the sort of supernatural phenomenon they would ordinarily dismiss as nonsense; this one has a more subtle agenda. In 'A Woman Sobbing', the ghost – whatever its precise nature – is on one level an expression of Jane's own unhappiness and of the tension generated by her stifling confinement within her marriage and home, and Bowen shifts the conventional focus so that it is trained insistently on the psychological effects of the haunting rather than on the supernatural itself.

The 1970s was also an era in which a new generation of horror films flourished, changing the cultural landscape with their burden of violence, bloodshed and shock. How could ghosts compete in this revival of the Gothic? While many writers in this period ranged over wider supernatural territory, some continued to tap the rich potential of the ghost-figure, incorporating it into this new context. Robert Aickman's ghosts may have a repulsive physicality that links them to the gruesome terrors of the late eighteenth century, but the Gothic horror of his 'strange stories' (his own preferred description) is pointed up by their context of drab, mid-twentieth-century mundanity. Aickman's stories are about the horror that lies just below the ordinary surface, waiting to erupt. He anticipated the Gothic mood that was to characterise the 1970s in 'Ringing the Changes', first published in 1964, in which a honeymooning couple, Gerald and Phrynne, arrive at a small seaside town in Suffolk. 'Tonight?' asks the station-master, ominously, when they tell him they have booked a hotel room. A church bell begins to ring as they enter the town, and it is soon followed by another, and another, until the air resounds with cacophonous

noise. 'They can hardly go on practising all night,' remarks Gerald in the shabby hotel lounge. 'Practising!' replies the only other guest scornfully. 'They're ringing to wake the dead.' Late that night the bells cease, one by one, then from the street the shout goes up: 'The dead are awake!' Dozens of corpses rise up from the sea and from their graves, and rampage through the town, singing:

The living and the dead dance together.
Now's the time. Now's the place. Now's the weather.[65]

They shoulder their way into Gerald and Phrynne's room, 'more and more of them, until the room must have been packed tight with them'. 'The smell. Oh God, the smell', screams Phrynne. She is caught up in the dance – only for a few moments, but long enough for her to be touched by the ferocious sexual energy of the ritual. When the couple leave the town the next day, they pass the cemetery, and see men digging fresh graves, 'as thick as flies on a wound, and as black'. Gerald glances at his wife, who is absorbed by what she sees:

In the mild light of an autumn morning the sight of the black and silent toilers was horrible; but Phrynne did not seem to find it so. On the contrary, her cheeks reddened and her soft mouth became fleetingly more voluptuous still.[66]

Even Matthew Gregory Lewis might have thought twice about casting the gruesome, stinking living dead as mass sexual predators. But it is Phrynne's unconscious response, indicating some nameless change that has taken place in her, that introduces a more subtle, lingering horror.

An even bleaker flavour of Gothic horror pervades Aickman's story 'The Swords' of 1975. The hapless narrator, a young and inexperienced travelling salesman, recounts how, when in bed with an enigmatic fairground performer with whom he has become obsessed, he did what he supposed was 'rather a wretched thing': he caught hold of her wrist and pulled hard to 'lug her up' towards him. 'I shouldn't have done it', he reflects, but still, 'no one could have said it was very terrible. It was quite a usual sort of thing to do, I should say. But what actually happened', he continues, 'was very terrible indeed':

I gave this great, bad-tempered, disappointed pull at Madonna. She came up towards me and then fell back again with a sort of wail. I was still holding on to her hand and wrist with my two hands, and it took me quite some time to realise what had happened. What had happened was that I had pulled her left hand and wrist right off.[67]

In Aickman's stories, the gruesome nature of these zombie-like ghosts – which would in the late eighteenth century have been revealed in the context of the graveyard or the castle vaults – is laid bare in the dim greyish light of down-at-heel hotel bedrooms.

In her 1983 novella *The Woman in Black* Susan Hill brought together all the ingredients for a classic Gothic tale. At the funeral of Alice Drablow, whose affairs he is required to settle, the young solicitor Arthur Kipps sees a woman

dressed in deepest black, in the style of full mourning... A bonnet-type hat covered her head and shaded her face ... not only was she extremely pale, even more than a contrast with the blackness of her garments could account for, but the skin and, it seemed, only the thinnest layer of flesh was tautly stretched and strained across her bones, so that it gleamed with a curious, blue-white sheen, and her eyes seemed sunken back into her head.[68]

The concealing cowl might have been replaced by a poke bonnet, but in other respects this malevolent walking corpse might have stepped straight from the cloisters of Otranto. As a back-drop, Mrs Drablow's old home, Eel Marsh House, where Kipps unwisely chooses to stay, is from the same stable as Gaskell's and Le Fanu's haunted houses: it is a 'tall, gaunt house of grey stone', accessible only by a causeway at certain times of day, with a lonely, disused burial ground that has a 'decayed and abandoned air'.[69] The scene is set for a rattlingly good tale of strange noises, ghostly presences and lights that suddenly go out. The appetite for this full-throttle expression of the Gothic by a master story-teller remains keen today: Stephen Mallatratt's 1987 stage adaptation of *The Woman in Black* is the second longest-running play in the West End.

Angela Carter invented her own version of the Gothic, defying expectations with her startlingly extravagant and sensual stories. In 'Travelling Clothes', the final section of *Ashputtle* or *The Mother's Ghost: three*

versions of one story (published posthumously in 1993), Carter takes Gothic conventions and, with a knowing wink at the reader, turns them inside out and marries them to a fairy-tale structure. When the poor orphan's mother climbs out of her grave at night in order to visit the living, it is, perhaps uniquely, with benign intent. She finds her daughter sleeping on the hearth among the ashes and gives her a red dress with the words 'I had it when I was your age'. She plucks worms from her eye sockets that turn into jewels, then into a diamond ring, which she gives her daughter, repeating 'I had it when I was your age'. Finally, the ghostly mother gives her daughter the macabre instruction: 'Step into my coffin', adding, coaxingly, 'I stepped into *my* mother's coffin when I was your age.' Her daughter reluctantly obeys, thinking gloomily that 'it would be the death of her'. But instead the coffin 'turned into a coach and horses. The horses stamped, eager to be gone.' 'Go and seek your fortune, darling', says the generous ghost.[70] Carter cuts her ghost from the same cloth the old balladeers used for their justice-dealing spirits, but this most resourceful of writers shows us the other side of the pattern. Where ballad-ghosts punish wrong-doers, Carter's motherly spirit, an unusually practical ghost, offers a helping hand to the oppressed.

How, meanwhile, were people disposed to think about the 'actual' ghosts that appeared in towns, villages and great houses up and down the land? 'The English have been haunted too long for their own good', declares the cover blurb of *The Stately Ghosts of England* by Diana Norman (1963):

> Far too many printless toes have stepped down the lovely corridors of our stately homes with impunity. We have become blasé. We shoulder our way through this perpetual *danse macabre* with hardly a thought.

Publishers in the second half of the twentieth century certainly saw to that. Norman's book is one of an enormous number of works published from the middle of the century onwards that discuss and list British ghosts in such detail that readers really had no excuse for not being as familiar with them as they were with kings and queens.

At the more scholarly end of the spectrum is a work by the folklorist Christina Hole, *Haunted England*, first published in 1940 with illustrations

by the wood-engraver John Farleigh (*figs 65 & 66*). In her preface Hole makes no rash claims for the reality of all the supernatural phenomena to be found in the 'richly diversified ghost-lore of England', acknowledging that if some stories are 'well authenticated and supported by the evidence of trustworthy percipients', others are 'mere country tales handed down from generation to generation, or confused memories of fairy tradition or pagan belief'. But whether they could be countenanced or sounded distinctly dubious, all, she remarks astutely, 'reveal something of the English mind'.[71] *Haunted England* was brought out by Batsford, a publisher who, from the 1930s, produced a series of attractive, hardback books devoted to the country's architectural and rural heritage, among the earliest of which are *Homes and Gardens of England* (1932), *The Villages of England* (1932), *The Landscape of England* (1933), *The Cathedrals of England* (1934), *The Old Inns of England* (1934), *The Parish Churches of England* (1935) and *The Beauty of Britain* (1935). In commissioning Hole to write about England's ghosts, Batsford repackaged supernatural stories: ghosts were, they appear to suggest, an intrinsic and significant part of the nation's character and cultural heritage – to be spoken of in the same breath as cricket or coaching inns. Clad in Farleigh's smart dust-wrapper, the various ghosts Hole assembled in *Haunted England* now rubbed respectable shoulders with England's pubs and parish churches.

Farleigh's linear illustrations, however, are somewhat at odds with Hole's sober text in that they daringly translate ghosts into the visual language of British modernism. His amorphous forms zig-zag jazzily across the pages, not illustrating individual stories so much as inhabiting their own surreal and uncanny landscapes over which they loom and billow. But the modernist ghost was a short-lived phenomenon. After the war Batsford, which had previously clad its books in dust-jackets with bold and colourful contemporary graphics, rebranded them, issuing many of its titles with covers based on softer, more traditional images of England.[72] When in 1956 they published *Haunted Houses* by Joseph Braddock, it was with romantic illustrations by Felix Kelly that looked back to the Victorian vision of Dickens's illustrator 'Phiz' rather than across the channel to contemporary avant-garde art (*fig. 67*). Kelly's drawings drench each scene in deep, inky pools of shadow, creating an atmosphere of the cosily familiar through which draped apparitions could safely glide. After a brief flirtation with modernism, British ghosts had reverted to type and been restored to their natural habitat.

As people began to make more frequent excursions by car, a demand grew for practical information about particular places and houses that were reputedly haunted: the ghost-gazetteer was born. A book of 1973 by Antony D. Hippisley Coxe, *Haunted Britain: A Guide to Supernatural Sites frequented by Ghosts, Witches, Poltergeists and other Mysterious Beings*, describes itself as 'the ideal vade-mecum for the visitor in search of the offbeat and the eerie'. The book, the blurb continues,

> is arranged by counties as a series of tours, but the maps and index allow the sites to be visited on other itineraries which the tourist may have already planned and the book therefore complements guides with more down-to-earth objectives like *The Shell Guide to Britain* or *Historic Houses, Castles and Gardens*.[73]

It was a bold, even hubristic comparison; even so, there was no doubt that the new ghost-gazetteers offered a fresh, snappy and surprisingly business-like approach to the subject. Under *Haunted Britain*'s entry on Honington and Tredington in Warwickshire, for example, we are briskly informed that 'Halfway between these places you may see the ghost of a witch, sitting on a wall', while at Laugharne in Carmarthenshire we note that 'Pant-y-Madog is haunted by a spectral mastiff with baleful breath and blazing red eyes'.[74] Every brief entry is thoughtfully assigned a symbol to allow the hurried traveller to identify at a glance the category into which each phenomenon falls, be it a ghost (a skull) or a legend or odd story (a unicorn).

Hand-in-hand with the taste for geographical ghost-surveys went a demand for the illusion of immediacy: our itineraries might not permit us to visit some of the places we read about, so instead we would like the experience by proxy of having been in a particular place. The author's personal account of each visit began to assume a new importance. We are assured, for instance, not only that Hippisley Coxe had 'travelled widely in Britain and visited most of the places described' but also that uncanny things happened when he got there (although not, apparently, to him): 'while checking sites in Bristol the author's wife saw the ghost of a man in broad daylight; and the photographer was overcome by such a sense of evil at Saddell Abbey that he could not bear to stay longer than a few minutes'.[75] As time went on, books of this kind began to be illustrated with

large, atmospheric photographs to enhance the readers' sense that they themselves were present in a lonely graveyard at dusk, standing in front of the forbidding façade of a building, or hesitating at the shadowy turn of a stair.

Haunted Britain and numerous other guides, from Peter Underwood's 1971 *Gazetteer of British Ghosts* (reissued in 1992 with the suitably updated title *The A-Z of British Ghosts*) to Jennifer Westwood and Jacqueline Simpson's magisterial survey of 2005, *The Lore of the Land: A Guide to England's Legends*, became Pevsners for the United Kingdom's ghosts. Siân Evans's *Ghosts: Mysterious Tales from the National Trust* (2006) brings together tales of hauntings both historical and recent to add a thrilling extra dimension to our countryhouse visits, while coming with the Trust's *imprimatur* of solid, middle-class respectability. The photographs with which it is illustrated are reproduced in black and white, creating the illusion of an alternative reality, familiar yet strange; this is just the sort of twilit, in-between state – after the staff have shut the house and cashed up in the café – in which the lingering visitor might expect to see a ghost. Meanwhile, the television programme *Most Haunted* (first broadcast by Living TV in 2002) continues to offer a vicarious entrée into the purportedly haunted corners of castles, forts, houses, theatres, pubs, museums, town halls and even prisons. Ghosts themselves may be as elusive as ever, but present-day television producers, and publishers and writers of the innumerable books, blogs and websites devoted to 'true hauntings' and 'real life encounters', make sure that there is never the slightest difficulty in identifying their reputed haunts. Thanks to decades of publishing and broadcasting, which have met an unfailing demand for news of the supernatural, ghosts have become more entrenched than ever in our heritage.

21. GHOSTS AT LARGE

Ghosts have maintained an unbroken presence in British culture since the late sixteenth century, but in visual art they have generally flourished at the margins. With the exception of the Romantic era, when a particularly favourable cultural climate allowed them to take centre stage in oil paintings and watercolours, their natural habitat has lain outside the gallery, in street stalls, print shops and amusement halls. They thrived in the

poorer soil of popular visual art, appearing in illustrations, caricatures, light-shows and entertainments. The problem was one of too much definition: it was all very well for the medieval living dead to lumber around on their mouldy bones on church walls or in psalters, but such antics were hardly likely to appeal to the refined tastes of a later picture-buying public. Furthermore, depictions of more decorous ghosts would render them too definite, would be guaranteed to dispel the mystery. Preserving what in 1890 Vernon Lee had called 'this vague we know not what' became even more important as images proliferated and we responded by becoming more visually sophisticated.[76]

In the late twentieth century, however, fresh means of representing ghosts arrived with new forms of artistic expression: installations, projections and video art. Alternative conceptions that re-thought the viewer's relationship to a work of art often proposed a more immersive experience, making it possible for artists to explore the idea of the ghost in new ways. Susan Hiller, an American-born artist who has spent much of her working life in Britain, is interested in messages: messages that bubble up from the unconscious mind in dreams and visions, or – who knows? – that might even have supernatural sources. She organises and manipulates light and sound to create environments in which these messages can be intercepted, tested and felt. 'There is something elusive, uncanny, fascinating, beneath the surface of what at first seems easy to understand, or ordinary, or banal', she says.[77] Her work invites us to look beneath that surface.

Her installation of 1983–4, Belshazzar's Feast, the Writing on Your Wall (fig. 68), is Hiller's reflection on the fact that the humble television, so ubiquitous as to be barely registered but simply accepted as a window onto the world, has been interpreted as a medium for receiving supernatural messages. Prompted by newspaper reports of 'people seeing ghostly images on their television screens after closedown', she re-imagines the screen, placed in an ordinary domestic interior, as though it might be a frontier between the living and the dead, or at the very least a transmitter of apparitions.[78] A recording of Hiller's voice reading the newspaper articles in a whisper is played, then a voice singing, then remembered accounts of Rembrandt's painting Belshazzar's Feast and of the Old Testament story, spoken by Hiller's son. The flickering bonfire displayed on the television screen suggests something uncontrollable and elemental that exists just out of reach. We can see the fire but we cannot touch it – which is how

ghosts are often described. Does the framing of the bonfire with modern technology open a window into another dimension? Does it show us the place where ghosts are? The piece explores the human imagination, and its propensity to find faces in the flames. As Hiller observes, 'the television is like the fireplace or hearth, and the hearth with its moving flames is a vehicle for reverie, and reverie creates visions'. 'I called the video *Belshazzar's Feast*', she says, 'because I wanted to find a context, a traditional context for a modern communal hallucination, or vision if you like.'[79] The title, though, leaves a door ajar to admit the discomforting hint of supernatural agency. The words written by a divine hand on the wall at the feast, as referred to in the Book of Daniel, could not be described as an illusion; they had all too real consequences for King Belshazzar himself.

Hiller's 1987 work *Magic Lantern* also explores what we see and hear, and invites us to reflect on how the mind interprets and distorts these perceptions. The experience *Magic Lantern* offers is an absorbing one. The room is darkened, and three large circles of coloured light are projected onto a wall in front of us. These perfect red, yellow and blue discs change in scale and overlap. When all three coincide, the colour in that section appears to drain away, turning white. The mind has no control over the after-images these pure colours leave on the retina. Is what we see the same as what is objectively there? Or are we involuntarily concocting our own visual reality? Complicating the experience of watching the coloured discs is the sound of a recording made by the Latvian scientist Konstantin Raudive, who from the mid-1960s until his death in 1974 investigated 'electronic voice phenomena', or sounds purportedly made by spirits of the dead. Raudive made numerous audiotape recordings in empty, silent rooms and when he played the tapes back he came to believe that he had captured names, words and phrases spoken there. In *Magic Lantern*, words can be discerned, garbled and barely audible over the interference of the tape.

Again, Hiller's title is a teasing one, referring to an archaic form of entertaining light-show that was often used to project images of ghosts. In its combination of visual spectacle and sound it is reminiscent of Philippe Jacques de Loutherbourg's Eidophusikoṅ, with its strange demon voices (see p.130), or the phantasmagoria show with its striking images and dramatic aural accompaniment (see p.127). The title places the work in this long tradition of illusionism, and shows us how our minds react to sensory stimuli and strive to find order in chaos. But at the same time,

those snatches of recorded voices continue to nag and haunt us, long after the after-images on the retina have faded.

Hiller's use of visual technology is ambiguous. On the one hand, her installations and large-scale projections fit into the context of contemporary art. On the other hand, projection is an age-old form of visual entertainment, as her title *Magic Lantern* reminds us. The light might be electric, but the technology is essentially unchanged. The photographer Adam Fuss has a similarly equivocal approach to media, looking backwards as well as at the contemporary. For his series *My Ghost* (fig. 69), begun in 1995, he used a long-obsolete photographic method that had first been introduced in 1839, the daguerreotype. A daguerreotype is made on a copper plate that has been coated with a thin layer of silver, made light-sensitive. This is exposed to capture an image, then the plate is fumed with mercury vapour to make the image visible. Its sensitivity to light is then removed by chemical treatment. A daguerreotype image has a distinctly ghostly quality – tilt the plate one way and the image is positive; tilt it the other and it switches to negative. This is compounded by the uncanny impression the image gives of hovering slightly above the plate.

Fuss makes photograms – photographs created without a camera – using the daguerreotype process. Those that he has made for the series *My Ghost* are haunting images, each one focusing intently on a single object. In one, a lone butterfly is captured, small and fragile against a glowing blue background. In another, an extravagantly billowy plume of smoke rises, inviting us to discern human forms in its intricate patterns. Here is a nineteenth-century child's christening robe, made of such fine cotton lawn that it is transparent: carefully laid out, its embroidery showing white against a black background, it looks like a diagram of itself. And there is the body of a swan, wings outstretched and head bowed as though in melancholy acknowledgement of its mortality. These photograms have an underwater quality; they seem to offer a window into a different dimension. The rich blue of the butterfly image is like a glimpse into endless space. If some images – the butterfly, the smoke – are symbols representing the human spirit, then the christening gown and the swan are *memento mori*, physical traces left behind. The title *My Ghost* seems to propose that these haunting photograms are self-portraits – of a sort.[80]

A title can change the way we see a picture or a sculpture. Both Rachel Whiteread and Mark Wallinger have named works *Ghost* – works that, on the face of it, have little in common, yet in each case the title invites us to look

beneath the surface for meanings not immediately obvious. Whiteread's title initially seems almost to be a joke, in that it leads us to expect something ethereal while in fact denoting a massive structure, the plaster cast of an entire Victorian parlour that the artist made in 1990: anything with a less ghostly form is hard to imagine. And yet the work gives form to negative space, it makes visible what is normally invisible – the space in which, decade by quiet decade, numerous lives have been lived. The title alerts us to the subtle ghostliness of Whiteread's project. Wallinger's *Ghost* (2001) is also about exposing something that lies beneath the surface. Like Whiteread's, it presents a negative, in this case a negative photographic image of George Stubbs's celebrated painting *Whistlejacket* (c.1762), reproduced on the same scale as the original, but with a difference: Wallinger has transformed the thoroughbred into a mythical beast by adding a unicorn's horn to its forehead. The title seems to propose that his method of representation has exposed a deeper, stranger identity underlying the oil painting. But it also carries the sly suggestion that Stubbs's depiction of Whistlejacket, rearing up against his background of blank canvas, was in itself coloured by a strong dose of fantasy, despite its claim to be a realistic portrait.[81] With his title, Wallinger deftly puts his finger on the equivocal nature of the ghost: that it is simultaneously truth-telling and fantastic.

Recently, artists have taken ghosts out of the gallery and released them into the cities. If in the spring of 2010 you had been walking beside the Clyde in central Glasgow you would have heard the haunting sound of an old Scottish song, 'Lowlands', played from speakers placed underneath three neighbouring bridges. This sixteenth-century ballad is a woman's lament. It relates a dream she had one night in which her sailor-sweetheart appeared to her:

I dreamt I saw my own true love,
Lowlands, lowlands, away my John
He stood so still, he did not move,
My lowlands, away

I knew my love was drowned and dead,
Lowlands, lowlands, away my John

He stood so still, no word he said
My lowlands, away

All dank his hair, all dim his eye,
Lowlands, lowlands, away my John
I knew that he had said goodbye,
My lowlands, away

The chilly, seaweedy ghost has come back to tell her that he has been 'drowned in the Lowland Seas', and that therefore they could 'ne'er be wed'. For the Glasgow International Festival of Visual Arts in 2010, the sound artist Susan Philipsz recorded herself singing three variant versions of the song, unaccompanied; a different recording was then played simultaneously from speakers under three bridges in the city centre.[82] As you walked along, you would have caught snippets of the songs, with their insistent refrain 'Lowlands, lowlands, away my John', apparently welling up from the shadowy, watery space underneath the bridge. Philipsz was attracted to the contrast these places offered to the busy streets above. Though central, they are little used; they are sites of desperation and drug abuse, homelessness and suicide. Their dark atmosphere contrasts poignantly with the frail sweetness of Philipsz's singing voice. We are so used to hearing music played in public spaces that we often hardly register it. But by singing without an accompaniment, and with a voice that is untrained, Philipsz disarmed us with a song that sounded private – almost as though she was singing to herself. You could not help but absorb it. 'Sound is very visceral; you have to respond to it … you're being affected by it', she has said.[83] Her song about the sailor-ghost insistently haunted the centre of Glasgow that spring.

The conceptual artist Jeremy Deller and Rufus Norris, Director of the National Theatre, collaborated to organise a different sort of haunting for 1 July 2016, the anniversary of the first day of the Battle of the Somme. For their work 'We're here because we're here', part of 14-18 NOW, the UK's arts programme for the First World War centenary (*fig. 70*), around one thousand four hundred men, all wearing First World War army uniform, mixed with commuters all over Britain, in the street and at railway stations, in town squares and markets. They gathered without ceremony, waiting around, expressionless, maintaining an eerie, ghostly presence. They did not speak, either to the public or to each other, but each carried cards

printed with the name, rank and regiment of one of the 19,240 men who
were killed on that first day, followed by the words 'Died at the Somme on
1 July 1916'. When approached by a member of the public, the uniformed
men silently handed over a card. Occasionally a group would break into a
song from the trenches: the words 'we're here because we're here' repeated
over and again, a jaded anthem of reluctant acquiescence sung to the tune
of 'Auld Lang Syne'. The National Theatre has said that the work was partly
inspired by accounts of people seeing their dead loved ones' ghosts both
during and after the war.

Deller and Norris wanted to create something that felt different from
the familiar sight of costumed actors playing a historical role. 'If they
speak they become re-enactors, living history,' said Deller. 'They'd have to
assume a character for a day. We didn't want that – we wanted them to have
a detached quality to them. There is no narrative. They are not playing
or acting the men who fought. They are a presence.'[84] For a few hours that
day, the Great War's ghosts were made visible.

What place do ghosts have in recent and contemporary literature? Can
an age-old subject be framed in new ways? Just as in visual art, here too
ghosts have been liberated from the confines of their habitual haunts and
let loose in a larger arena. No longer confined to the short story, they are
beginning to be woven into the larger, more complex and expansive plots
of novels where they express emotions, fears and secrets, and offer subtle
ways of imagining the past and of thinking about life and death. Ghosts'
capacity to be about things other than themselves is being recognised more
fully now than ever before.

Back in the late sixteenth century Robert Greene and his fellow pam-
phleteers (see pp.42–6) imagined the topography of the afterlife, through
which the dead made their picaresque journeys. They pictured it as an
overgrown path leading up a steep hill towards heaven's gates, or as a house
with interconnecting rooms. Otherwise, the dim holding-pen where
ghosts are supposed to dwell when they are not making appearances back
on earth has not been much considered; ghosts' significance lies in their
presence, rather than in their absence. In 1991 Will Self turned his atten-
tion to this peculiar blind-spot in his short story 'The North London Book
of the Dead', in which the narrator bumps into his dead mother in the

street in Crouch End. 'When you die you move to another part of London,' she explains: 'that's all there is to it.' But not quite all, because the parts of London where the dead are billeted are further from the centre than those in which they had lived before, and, to their minds, less desirable. Still, she remarks philosophically, 'It could have been worse, some dead people live in Wanstead.'[85] Self developed this peculiarly urban eschatology for his novel *How The Dead Live* (2000), which maps an alternative, necropolitan London to which Londoners go when they die, and superimposes it – slightly crookedly – on familiar locations: Dulston replaces Dalston, Clapham becomes Dulburb. Ghosts are, at last, granted a fully independent and complex existence, albeit one dogged by boredom and irritation and ruled by petty bureaucracy – or, in this case, 'deatheaucracy'.

Like Self's, the ghosts of Hilary Mantel's novel *Beyond Black* (2005) are only too like the people they had been in life, and Alison Hart, a clairvoyant, is harried by their presence. Mantel's ghosts are relentless: repetitive, dreary, demanding. They fret endlessly about buttons missing off their cardigans. They slip into Alison's car and bounce around on the back seat, demanding to stop at the next service station. At home they lurk behind the tea-cups in her kitchen, and even pop up in the bath. Worst of all is Alison's spirit guide, Morris:

It was only when she got older and moved among a different set of psychics that she realised how vulgar and stupid Morris really was. Other mediums have spirit guides with a bit more about them – dignified impassive medicine men, or ancient Persian sages – but she has this grizzled grinning apparition in a bookmaker's check jacket, and suede shoes with bald toecaps. A typical communication from Sett or Oz or Running Deer would be: 'The way to open the heart is to release yourself from expectation.' But a typical communication from Morris would be: 'Oh, pickled beetroot, I like a nice bit of pickled beetroot. Make a nice sandwich out of pickled beetroot!'[86]

Morris is an extreme case, boorish and vindictive. But as Alison realistically points out to her assistant, Colette, 'You say they [the dead] give trivial messages, but that's because they're trivial people. You don't get a personality transplant when you're dead. You don't suddenly get a degree in philosophy.'[87]

Beyond Black is a story about a woman haunted by her past. Although they are dead, the men who raped and abused Alison as a child, leaving her with scars both mental and physical, are abiding presences in her adult life. To take the story literally, these 'fiends' are not frightening because they are ghosts; they are frightening because their personalities are unchanged by death. Or to look at it another way, Alison is a woman oppressed and controlled by the terrible things that happened to her as a child but that her mind blocks out, not allowing her to remember distinctly; and instead the memories seep through as tormenting ghosts.

Sarah Waters' 2009 book *The Little Stranger*, though mostly set in 1948 and concerned with post-war social change, is charged with the heavy atmosphere of a Victorian ghost story. The novel's power derives, like Henry James's *The Turn of the Screw* (one of its godparents, along with Edgar Allan Poe's 'The Fall of the House of Usher'), from the ambiguity at its heart. Is there a malevolent ghost at Hundreds, the big house, as the housemaid believes – one that seems instinctively to home in on each of its victim's particular weakness? Or is Hundreds, as one character proposes, 'consumed by some dark germ, some ravenous shadow-creature, some "little stranger", spawned from the troubled unconscious of someone connected with the house itself'?[88] Over the length of the novel, accretions of apparently supernatural occurrences build up to create a more complex and layered narrative than could be achieved in the more pared-down format of a short story.

Ghosts have long haunted Julie Myerson's imagination. In her 2016 novel *The Stopped Heart* she harnesses their emotional resonance. The novel interleaves stories about families living in the same cottage in a small Suffolk village around a hundred years apart; and in that cottage the present comes to haunt the past as much as the past haunts the present. For modern-day Mary, the bereaved mother of two murdered girls, grief – expressed by her endless mental re-playing of their disappearance – is like being haunted by a ghost that insists on acting out the same dramatic event over and again. As she tells a friend, 'It's not seventeen months ... It's not even yesterday. It's now. It's happening now. It's always just about to happen. Don't you see? That's what I live with. It will never be over, never.'[89] The ghosts in *The Stopped Heart* are both real and symbolic, and the haunted cottage Myerson evokes is a disorientating hall of mirrors as one crisis refuses to diminish while another rushes inexorably closer.

Black humour, psychological drama, emotional trauma, or simply the sense of the past inhabiting the present: today's writers and artists are re-imagining what ghosts are, what they do, what they mean to us – even where they 'live' – more creatively and more broadly than ever before. Now liberated from the margins of visual culture and from ghost-story ghettoes, ghosts' rich emotional potential, whether as metaphor, Gothic reality or something indefinably in-between, is decisively shaping art and literature. These are lively days for ghosts. And what seems certain is that artists and writers will keep on re-inventing them. What uses will be fashioned for them in the future, as the world continues to change? What new content found to pour into an age-old form? 'I am all for putting new wine in old bottles', declared Angela Carter, adding: 'especially if the pressure of the new wine makes the old bottles explode.'[90]

POSTSCRIPT

On the evening of 25 November 2016 I found myself in the company of M.R. James – or the next best thing, the actor Robert Lloyd Parry. Around thirty of us were gathered at Otley Hall in Suffolk, sitting in a panelled room lit by a single candle. It was the kind of dim light in which our great-great-grandparents would happily have spent a good portion of the evening, but that today we find oddly disconcerting. After a while, when our eyes had adjusted to the light and our minds to the atmosphere, the door opened and M.R. James strolled in, sat down in a capacious armchair, lit two further candles and poured himself a drink. He began to relate 'The Ash Tree', a story concerning witchcraft, set not far from where we were, followed by '"Oh, Whistle, and I'll Come to You, My Lad"', the awful events of which take place on a bleak stretch of East Anglian coast.[1] They were settings most of us knew well, and on that dark November evening it was not hard to believe that supernatural undercurrents could be at work in our peculiarly haunted stretch of the country. Lloyd Parry, who bears a marked physical resemblance to James, held the audience silent and spellbound by the tales he unfolded, sometimes leaning back in his chair and speaking with dry academic precision, sometimes on the edge of it and gesturing for emphasis, his hands, as he described the dramatic events, creating flickering shadows that seemed to crawl over the great beams above. We willingly suspended our disbelief until we could imagine being among a little band of undergraduates listening raptly to James himself.

A few days later, a newly published book arrived in the post: *Ghost Stories of an Antiquary: A Graphic Collection of Short Stories by M.R. James*, with four tales re-imagined in cartoon-strip form by the artists Aneke, Kit Buss, Fouad Mezher and Alisdair Wood. 'The Ash Tree' and '"Oh, Whistle, and I'll Come to You, My Lad"' were among them, but here the stories were packaged in a very different form, each key dramatic moment given punchy, and distinctly twenty-first-century, graphic expression. I thought I had found M.R. James, with his tweeds and pipe, in a cosily cloistered past – and yet here he was again, bursting noisily into the present.

If the ghosts James conjured up continue to resonate powerfully with us today, perhaps this is because the information revolution has, to a degree, put us all in the position of his sceptical academics. The internet

has enabled us to find data more or less instantly on just about anything under the sun – but, as James consistently reminds us, perhaps not quite everything – and his dark mysteries perhaps appeal to an obscure yearning in ourselves for the unknown. What if, we find ourselves wondering along with him, there is a more ancient kind of knowledge that we cannot access in the ordinary ways, that concerns terrible, uncontrollable things lurking out there in the dark, whether in the wild, lonely places or – even worse – just around the next turn of the lane? After all, in our brightly lit, connected age, ghosts continue to give ghost-hunters the slip, maintaining their thrilling elusiveness. It is by dramatising this uneasy coexistence of the known and the unknown that James, and other writers who deal with the same theme, speak so directly to us today.

I am fascinated by this phenomenon – by how and why each successive age responds to a particular type of ghost. In this book I wanted to focus principally on ghosts' appearances in imaginative works, because it is through the prism of art and literature that we can catch the clearest sight of them. Through pictures, poems, ballads and stories we are able to watch the British ghost as it changes from violent revenant to suffering soul, from admonitory corpse to demonic illusion, from moral teacher to visual spectacle, from historical ambassador to translucent spectre, from fearsome presence to reassuring historical spirit. In whatever ways ghosts choose to manifest themselves in reality, it is in the imagination that they have the most varied and revealing existence. It is here that ghosts hold up a mirror to us, one that reveals our desires and fears.

So what else can we see today when we look into this mirror? What do our ghosts tell us about ourselves? Certainly that we heartily value the thrill of the unknown and the unexplained. Many of us would readily admit, along with the narrator of E.F. Benson's story 'The Bus-Conductor', 'Why, of course, I like being frightened … Fear is the most absorbing and luxurious of emotions. One forgets all else if one is afraid.'[2] Many would also admit that on some level we have a sneaking admiration for ghosts' anarchic, disruptive and unbiddable aspects: they can never be made to behave, and can only be relied upon to be unreliable. As frightening and subversive figures, ghosts have something in common with other characters from folk tradition. Today, perhaps what we appreciate most of all is the value ghosts add to our heritage, whether they are re-enacting parts of our rich and turbulent history or haunting our country houses.

Ghosts' likeness to us, coupled with their utter strangeness, has encouraged us to search their nebulous forms for ways of questioning or coming to terms with what it means to be human. They offer a new perspective on life – and on death. And if they have acted as our moral guardians by giving us timely reminders that we, like them, shall die, then they have also provided solace by demonstrating that existence continues after death. Whatever forms they have taken, for centuries British ghosts have added another dimension to our lives and re-enchanted each age. We cannot predict the future, but as long as there are people to tell the tale, in however highly developed an environment, there can be little doubt that ghosts will be there too – having adapted, as they always do, to their new circumstances.

NOTES

INTRODUCTION

1. Dickens 2003, p.45.
2. Thomas More, *The Supplication of Souls*, quoted in Marshall 2002, p.15.
3. Quoted in James Boswell, *The Life of Samuel Johnson, LL.D., including A Journal of a Tour to the Hebrides*, ed. by John Wilson Croker, 5 vols, London 1831, IV, p.85.
4. *Donne: Poetical Works*, ed. Herbert J.C. Grierson, Oxford and New York 1971, p.43.
5. *The Diary of Samuel Pepys*, ed. Robert Latham and William Matthews, 11 vols, London 1970–83, IX (1976), p.495.
6. Bourne 1725, p.76.
7. John Clare, *The Shepherd's Calendar*, ed. Eric Robinson, Oxford 2014, p.17.
8. Defoe 1727, p.390.
9. 'The Stately Homes of England' is from Noël Coward's musical *Operette*, 1938.
10. *The Miscellaneous Works, in Verse and Prose, of the Right Honourable Joseph Addison, Esq.*, 4 vols, London 1765, II, p.167.
11. See Schmitt 1998, pp.206 and 213–14.

I THE LIVING AND THE THE DEAD

1. *The Chronicle of John of Worcester*, ed. R.R. Darlington and P. McGurk, trans. Jennifer Bray and P. McGurk, Oxford 1995, vol.2: Annals from 450 to 1066, p.477.
2. For more on the cult of St Edmund, see Pinner 2010 and Pinner 2015.
3. Hermann, *De Miraculis Sancti Eadmundi*, quoted in Pinner 2010, p.88.
4. William of Malmesbury, *The Deeds of the Bishops of England (Gesta Pontificum Anglorum)*, trans. David Preest, Woodbridge 2002, p.127. I have also drawn on

material published online by 'A Clerk of Oxford': see http://aclerkofoxford.blogspot.co.uk/2012/09/st-edith-of-wilton-nun-fashionista.html
5. Alan Thacker, 'Æthelthryth (d. 679)', *Oxford Dictionary of National Biography*, Oxford University Press, Oct. 2009; http://www.oxforddnb.com.ezproxy2.londonlibrary.co.uk/view/article/8906
6. From the twelfth-century *Liber Eliensis*, II.132, translated by Janet Fairweather in *Liber Eliensis: A History of the Isle of Ely from the Seventh Century to the Twelfth*, Woodbridge 2005, pp.252–3. See also http://aclerkofoxford.blogspot.co.uk/2012/06/lady-etheldreda-nun-and-valkyrie.html
7. Translation of Old English in Swanton 1978, p.39.
8. Ibid.
9. See also Harris 2015, pp.35–6.
10. From *Historium rerum Anglicarum* in *Chronicles of the Reigns of Stephen, Henry II and Richard I*, ed. R. Howlett, London 1885, II, here quoted from Joynes 2001, p.137.
11. Quoted in Joynes 2001, pp.137–8.
12. Ibid., p.135.
13. Ibid., p.136.
14. Ibid., p.137.
15. *Grettis Saga*, 1.35, chapter XXXV, University of Oxford Text Archive: http://ota.ox.ac.uk/text/3221.html. Although the Sagas of Icelanders were mostly recorded in the thirteenth and fourteenth centuries, they are based on much earlier stories.
16. See Caciola 1996, pp.15–16.
17. Joynes 2001, pp.136 and 139.
18. British Library MS Royal 15 A XX, ff.140v–143 and ff.163v–164v.
19. James 1922, p.413.
20. Ibid., p.414.
21. Ibid.
22. Quoted in Joynes 2001, p.167.
23. Ibid., p.171.

24. Ibid., p.168.
25. Ibid., p.169.
26. Bourne 1725, p.77.
27. Some thirty examples of this date survive in England, of which a third are in Norfolk. Nichols 2002, p.259. See also Tristram 1976, pp.162–7, and Caciola 2016, pp.227–9.
28. James 1929, p.125.
29. British Library, Arundel 83 II (the 'De Lisle Psalter'), folio 127r.
30. 'Ich am afert. Lo whet ich se. Me pinkes hit bey develes pre[.] Ich wes wel fair. Such schel tou be. For godes love bewer by me.'
31. Tristram 1955, pp.4 and 112.
32. Gregory to Serenus, Bishop of Marseilles, July 599; *The Letters of Gregory the Great*, ed. John R.C. Martyn, 3 vols, Toronto 2004, II, p.674.
33. Thomas Hoccleve, *The Regiment of Princes*, ed. Charles R. Blyth, Kalamazoo, MI 1999, p.186 (lines 4999–5005).
34. See translation by Julian Luxford in Luxford 2010, p.315. Their words paraphrase Job 14:1–2.
35. Luxford 2010, p.308.
36. Ibid., p.302.
37. www.bl.uk/manuscripts/FullDisplay.aspx?ref=Add_MS_37049
38. British Library, MS Additional 37049, f.32v. Here quoted, with some minor adaptations, from 'A Disputation between the Body and the Worms', in *Middle English Debate Poetry: A Critical Anthology*, ed. John W. Conlee, Woodbridge 1991, pp.50–62.

II QUESTIONABLE SHAPES

1. British Library, MS Harleian 425, ff.4–7; here quoted from Marshall 2002, p.245.
2. Ibid.
3. *The Sermons of Edwin Sandys*, ed. John Ayre, Cambridge 1841, p.60.

4. Lavater 1572, pp.183 and 71.
5. Ibid. [p.v of preface].
6. Ibid. [p.vi of preface].
7. Taillepied 1933, p.xvi.
8. See Bennett 1986, *passim*.
9. Scott 1886, pp.412-3. This usage of the word 'bug' (or 'bugge') is now virtually obsolete, the OED defines it as: 'An object of terror, usually an imaginary one'. 'bug, n.1.' *OED Online*. Oxford University Press, Sept. 2016. Scott was presumably thinking of a line from Coverdale's translation of Psalm 91 (5): 'Thou shalt not nede to be afrayed for eny bugges by night'.
10. Rowse 1971, p.262.
11. Scott 1886, p.389.
12. Ibid., p.390.
13. 1 Samuel 28:14.
14. Scott 1886, p.118.
15. Cotta 1616, pp.39-40; and see Davies 2007, pp.109-10.
16. Anthony Wood, *Athenae Oxonienses*, 3rd edn; here quoted from J.B. Bamborough, 'Burton, Robert (1577-1640)', *Oxford Dictionary of National Biography*, Oxford University Press, 2004; online edn, Oct. 2009; http://www.oxforddnb.com.ezproxy2.londonlibrary.co.uk/view/article/4137
17. Burton 1989-2000, I (1989), p.174, and IV (1998; commentary), p.207. Gulielmus Postellus was a French theologian of the sixteenth century.
18. Ibid., I (1989), p.174.
19. Ibid., p.175.
20. Ibid., p.176.
21. Ibid., p.187.
22. Ibid., p.194.
23. See Raymond 2003, p.61.
24. Belfield 1978, p.282.
25. Ibid., p.283.
26. Ibid., p.284.
27. Ibid., p.285.
28. Ibid., p.345.
29. Ibid., p.346.
30. Gabriel Harvey, *Foure Letters* (1592), here quoted from Raymond 2003, p.61.
31. Thomas Nashe, *Strange News* (1592), here quoted from L.H. Newcomb, 'Greene,

Robert (*bap.* 1558, *d.* 1592)', *Oxford Dictionary of National Biography*, Oxford University Press, 2004; http://www.oxforddnb.com.ezproxy2.londonlibrary.co.uk/view/article/11418
32. Nina Green, modern spelling transcript of *Greene's Vision*, 2003, at http://www.oxford-shakespeare.com/Greene/Greenes_Vision.pdf, p.3
33. Nina Green, modern spelling transcript of *Greene's News Both from Heaven and Hell*, 2003, at http://www.oxford-shakespeare.com/Greene/Greenes_News.pdf, p.4
34. Ibid., p.2.
35. Ibid., p.10.
36. Ibid., p.35.
37. Ibid., p.36.
38. Ibid., p.1.
39. Thomas Kyd, *The Spanish Tragedy*, I.v, 1-2.
40. Ibid., I.i, 82-3; 85.
41. Ibid., IV.v, 29-30.
42. Ibid., IV.v, 47-8.
43. Thomas Lodge, *Wits Miserie and the Worlds Madnesse: Discovering the Devils Incarnat of this Age*, London 1596, p.56.
44. Anon., *A Warning for Fair Women*, ed. A.F. Hopkinson, London 1904, pp.xix and 3.
45. Christopher Marlowe, *Plays*, London and New York 1909, p.123.
46. Ibid., p.133.
47. Ibid., p.147.
48. Ibid., p.142.
49. Ibid., p.155.
50. *Hamlet*, I.i, 21.
51. Ibid., I.i, 54-6.
52. Ibid., I.i, 108; I.i, 139 and 142; and I.i, 146.
53. Ibid., I.iv, 21-3.
54. Ibid., I.iv, 24-5.
55. Ibid., I.iv, 25-6.
56. Ibid., I.iv, 32-5.
57. Ibid., I.v, 9-13.
58. *Donne: Poetical Works*, ed. Herbert J.C. Grierson, Oxford and New York 1971, p.48.
59. Ibid., p.52.
60. Ibid., p.43.
61. Walton 1927, pp.39-40.
62. Ibid., pp.40-2.
63. Ibid., p.78.
64. Burton uses this description in the first edition of the

Anatomy (1621); quoted in Burton 1989-2000, I (1989), p.xiv.
65. Quoted by Oliver Lawson Dick in his biographical introduction to *Brief Lives*, Aubrey 1949/2016, p.lxxxv.
66. *The Works of Francis Bacon: Volume 4, Translations of the Philosophical Works I*, ed. James Spedding, Robert Leslie Ellis and Douglas Denon Heath, Cambridge 1858, p.303.
67. Ibid.
68. Aubrey 1972, p.290.
69. Ibid. Quoted in Aubrey 1949/2016, pp.cxiv-cxv.
70. Aubrey 1972, p.57.
71. Ibid., pp.53 and 55.
72. Ibid., p.50.
73. Ibid., p.53.
74. Ibid., p.50.
75. Quoted ibid., p.xxx.
76. See Olivia Horsfall Turner, '"The Windows of this Church are of several Fashions": Architectural Form and Historical Method in John Aubrey's "Chronologia Architectonica"', in *Architectural History*, vol.54, 2011, pp.171-93 (p.171 and *passim*). Aubrey thought that Stonehenge was neither Danish nor Roman, as his contemporaries believed; he advanced a theory that it was much older, and probably built by the Druids.
77. Thomas Hobbes, *Leviathan*, London 1651, part 3, chapter 34, p.208.
78. Ibid., p.210.
79. Ibid., pp.210-11.
80. Ibid., p.211.
81. Glanvill 1700, II, p.2.
82. Ibid., I [preface, p.iii].
83. 'A Letter Concerning Enthusiasm', in Anthony Ashley Cooper, third Earl of Shaftesbury, *Characteristics of Men, Manners, Opinions, Times*, ed. Lawrence E. Klein, Cambridge 1999, p.5.
84. Glanvill, I [preface, p.v].
85. Glanvill 1700, II, pp.49-50.
86. Ibid., p.50.
87. Ibid., p.51.
88. Ibid., p.55.
89. Ibid., p.58.
90. Ibid., pp.58-9.
91. Ibid., p.61.

92. John Aubrey, *The Natural History of Wiltshire*, ed. John Britton, London 1947, p.121.
93. *The Diary of Samuel Pepys*, ed. Robert Latham and William Matthews, 11 vols, London 1970–83, IV (1971), p.186.
94. Glanvill 1700, II, p.59.
95. Ibid., p.60.
96. Richard Baxter, *A Treatise of Conversion*, London 1657, epistle to the reader.
97. Baxter 1691, p.1.
98. Ibid., p.2.
99. See Handley 2005, p.60.
100. Baxter 1691, p.59.
101. Ibid., pp.60–1.
102. Ibid., p.61.
103. Ibid., pp.61–2.
104. Ibid., p.11.

III GHOSTS FOR A NEW AGE

1. *The Diary of Samuel Pepys*, ed. Robert Latham and William Matthews, 11 vols, London 1970–83, II (1970), p.68.
2. Ibid., IV (1971), pp.185-6.
3. Ibid., p.312.
4. Ibid., IX (1976), p.495.
5. Hughes 2015, p.32.
6. O'Connell 1999, p.19.
7. See Watt 1991, pp.11–12.
8. Anon., *Tears of the Press*, London 1681, p.7; cited in Mark Knights, *Politics and Opinion in Crisis, 1678–81*, Cambridge 1994, p.184.
9. Holcroft 1925, I, p.89.
10. *Catalogue of the Pepys Library at Magdalene College, Cambridge*, vol. II: Ballads, part i: Catalogue, compiled by Helen Weinstein, Cambridge 1992, p.3.
11. Pepys Library, Magdalene College Cambridge (Pepys 3.328). English Broadside Ballad Archive, University of California, Santa Barbara, 21343.
12. Pepys Library, Magdalene College Cambridge (Pepys 1.504-505). English Broadside Ballad Archive, University of California, Santa Barbara, 20238.
13. Pepys Library, Magdalene College Cambridge (Pepys 2.145). English Broadside Ballad Archive, University

of California, Santa Barbara, 20763.
14. Early English Books Online, http://quod.lib.umich.edu/e/eebo/A93987.0001.001?rgn=main;view=fulltext
15. Davies 2007, p.5.
16. Ibid.
17. O'Connell 1999, p.117. See also Watt 1991, pp.148–9.
18. Pepys Library, Magdalene College Cambridge (Pepys 2.145). English Broadside Ballad Archive, University of California, Santa Barbara, 20763.
19. Defoe 1706, p.1.
20. Ibid., p.2.
21. Ibid., p.4.
22. Ibid., p.3.
23. Ibid., p.4.
24. Ibid., p.5.
25. Ibid., p.9.
26. See Handley 2007, pp.80–5.
27. Backscheider 1989, pp.200–1.
28. Defoe 1706, p.3.
29. The previous year, 1726, had seen the publication of two other works by Defoe on the supernatural, *The Political History of the Devil* and *A System of Magick*. See Backscheider 1989, pp.520–6 and Baine 1968, *passim*.
30. Defoe 1727 [preface, p.iii].
31. Ibid., pp.5–6.
32. Ibid., p.21.
33. Ibid., p.394.
34. Ibid., pp.109–10.
35. Ibid., pp.94–5.
36. Ibid., p.100.
37. Ibid., pp.101–4.
38. Ibid., pp.132–50.
39. Ibid., p.395.
40. Ibid., pp.7–8.
41. Ibid., p.150.
42. Backscheider 1989, p.526.
43. The physician and chemist Peter Shaw, in *The Reflector: Representing Human Affairs, As They Are*, London 1750, p.142; quoted in Davies 2007, p.119.
44. Hilliar 1730, pp.9–10.
45. Joseph Addison, *Spectator*, 6 July 1711.
46. Ibid.
47. Joseph Addison, *Spectator*, 20 April 1711.
48. *The Drummer* was put on by Addison's friend Richard Steele at Drury Lane, where he was then manager, on 10

March 1716.
49. *The Miscellaneous Works, in Verse and Prose, of the Right Honourable Joseph Addison, Esq.*, 4 vols, London 1765, II, p.165.
50. Ibid.
51. Ibid., pp.169–70.
52. Ibid., p.190.
53. *Gentleman's Magazine*, vol.2, October 1732, p.1001.
54. Ibid., p.1002.
55. Ibid.
56. 'Report given to Robert Withers, Vicar of Gateley, of the Appearance of a Ghost 1706', Parish Records of Gateley, Norfolk Record Office, MS Norfolk, MS PD 9/1. See also Davies 2007, pp.6–7, and Handley 2007, p.164.
57. Horace Walpole to George Montagu, 2 February 1762, *Horace Walpole's Correspondence with George Montagu*, ed. W. S. Lewis and Ralph S. Brown Jr., New Haven and London 1941, II, p.6.
58. Quoted in James Boswell, *The Life of Samuel Johnson, LL.D., including A Journal of a Tour to the Hebrides*, ed. John Wilson Croker, 5 vols, London 1831, IV, p.85.
59. *Gentleman's Magazine*, vol.32, February 1762, p.81.
60. Charles Churchill, *The Ghost*, London 1763 (3rd edn), p.55.
61. John Wesley, *An Extract from the Rev. Mr. John Wesley's Journal, from May 14, 1768, to September 1, 1770*, London 1790, p.6.
62. *Credulity, Superstition and Fanaticism* is a heavily re-worked version of an earlier plate. The original composition, *Enthusiasm Delineated*, was a satire combining two of Hogarth's favourite targets: Methodism and blind reverence for Old Master paintings.
63. *Pope's Literary Legacy: The Book Trade Correspondence of William Warburton and John Knapton*, ed. Donald W. Nicholl, Oxford 1992, in P, III, p.366.
64. Horace Walpole, *Memoirs of the Reign of King George the Third*, ed. Sir Denis Le Marchant, 2 vols, Philadelphia 1845, I, p.97. See also Uglow 1997, pp.652–4.

65. *The Letters of John Keats, 1814–1821*, ed. Hyder Rollins, 2 vols, Cambridge, MA 1958, II, pp.260 and 271.

IV TERROR AND WONDER

1. *Collected Poems of Thomas Parnell*, ed. Claude Rawson and F.P. Lock, Newark, NJ 1989, pp.169–70.
2. Gerard Carruthers, 'Blair, Robert (1699–1746)', *Oxford Dictionary of National Biography*, Oxford University Press, 2004; http://www.oxforddnb.com.ezproxy2.londonlibrary.co.uk/view/article/2570
3. *The Poetical Works of Beattie, Blair, and Falconer*, ed. Rev. George Gilfillan, Edinburgh 1854, pp.133–4.
4. Butlin 2002, pp.68–73, and Sotheby's, *William Blake: Designs for Blair's Grave*, auction catalogue, New York 2006, pp.7–16 and p.50, no.12.
5. Beattie, Blair and Falconer 1854, p.134. This watercolour was among the group of Blake's original designs for Blair's *The Grave* that was rediscovered in 2001.
6. Hervey 1748, I, p.2.
7. Ibid., p.68.
8. Ibid., pp.69 and 74.
9. Ibid., p.74.
10. Ibid., pp.76 and 81.
11. See Altick 1978, pp.64–5.
12. Isabel Rivers, 'Hervey, James (1714–1758)', *Oxford Dictionary of National Biography*, Oxford University Press, 2004; http://www.oxforddnb.com.ezproxy2.londonlibrary.co.uk/view/article/13113
13. *The Duchess of Malfi*, V.iii, 1–12.
14. Aubrey 1949/2016, p.lx.
15. Burke 1990, p.55.
16. Ibid., p.58.
17. Pott 1782, pp.58–9.
18. Horace Walpole to the Rev. William Cole, 9 March 1765, *The Yale Edition of Horace Walpole's Correspondence*, 48 vols, ed. W.S. Lewis, New Haven 1937–83, I (1937), p.88.
19. See Angela Wright, 'Gothic, 1764–1820', in Townshend 2014, pp.68–91 (pp.70–1).
20. Horace Walpole, *The Castle of Otranto: A Gothic Story*, ed. W.S.

Lewis, London 1964, pp.23–4, 102 and 25.
21. See Angela Wright in Townshend 2014, p.75.
22. Walpole 1964, p.108.
23. Jane Austen, *Northanger Abbey and Persuasion*, ed. John Davie, London 1971, p.34.
24. Joseph Addison, 'On the Pleasures of the Imagination', *Spectator*, 1 July 1712.
25. Ann Radcliffe, *The Mysteries of Udolpho, a Romance*, 4 vols, London 1794, II, p.209.
26. Samuel Taylor Coleridge, 'Lewis's Romance of the Monk', *Critical Review*, no.19, February 1797, pp.194–8 (p.197).
27. Matthew Gregory Lewis, *Tales of Wonder*, London 1801, p.25.
28. Anon., *Tales of Terror, with an Introductory Dialogue*, London 1801, p.77. See also Dale Townshend, 'Terror and Wonder: The Gothic Imagination' in Townshend 2014, pp.17–24.
29. Philipsthal playbill, British Museum, no. C,2.729. See also Heard 2006, p.131.
30. 'phantasmagoria, n.' *OED Online*. Oxford University Press, September 2016.
31. See Altick 1978, pp.128–220 and *passim*.
32. Heard 2006, pp.57–84.
33. *The Diary of Samuel Pepys*, ed. Robert Latham and William Matthews, 11 vols, London 1970–1983, VII (1972), p.254.
34. William Nicholson, 'Narrative and Explanation of the Appearance of Phantoms and Other Figures in the Exhibition of the Phantasmagoria. With remarks on the philosophical use of common occurrences', in *A Journal of Natural Philosophy, Chemistry and the Arts*, vol.I, Feb. 1802, p.148; cited in Heard 2006, pp.135–6.
35. Philipsthal playbill, British Museum, no. C,2.729. See also Heard 2006, p.131.
36. Quoted in Witley 1928, II, p.352.
37. See Altick 1978, pp.123–4.
38. Ibid.
39. Ibid.

40. Quoted in Guy Chapman, *Beckford*, London 1937, p.99.
41. William Beckford to Louisa Beckford, 1838, quoted in John Walter Oliver, *The Life of William Beckford*, London 1932, pp.89–91.
42. E. Phillips, *New World of Words*, London 1696, at 'Lanthorn', and Anon., *Glossographia Anglicana Nova*, London 1707, at 'Magick-Lanthern'.
43. John Constable to John Fisher, 4 July 1829, quoted in C.R. Leslie, *Memoirs of the Life of John Constable*, London 1951, 3rd edn, 1995, p.152.
44. Quoted in James Kennedy, *Conversations on Religion, with Lord Byron and others*, London 1830, p.154.
45. 1 Samuel 28:14.
46. *The Prose Works of Charles Lamb*, 10 vols, London 1836, II, pp.152–3.
47. Victoria and Albert Museum, no. Dyce 777.
48. C. M. Kauffmann, 'Varley, John (1778–1842)', *Oxford Dictionary of National Biography*, Oxford University Press, 2004; online edn, May 2007; http://www.oxforddnb.com.ezproxy2.londonlibrary.co.uk/view/article/28115
49. Butlin 1978, pp.133–5.
50. Quoted ibid., p.135, no.283.
51. Ibid, p.135, no.282.
52. Shelley 1993, p.194, and MacCarthy 2002, pp.291–4.
53. Mary Shelley, introduction to the Standard Novels edition of *Frankenstein*, 1831; Shelley 1993, p.195.
54. Ibid., p.196.
55. Holmes 1974, p.344.
56. *The Complete Poetical Works of Percy Bysshe Shelley*, ed. Thomas Hutchinson, London 1935, p.527.
57. Ibid., p.596.
58. Ibid., p.573.
59. Ibid., p.574.
60. Emily Brontë, *Wuthering Heights*, London 1985, p.67.
61. Ibid., pp.67 and 90.
62. Ibid., p.70.

V APPEARANCES AND DISAPPEARANCES

1. Anita McConnell, Simon Heneage, 'Gillray, James (1756–1815)', *Oxford Dictionary of National Biography*, Oxford University Press, 2004; online edn, Sept. 2014; http://www.oxforddnb.com.ezproxy2.londonlibrary.co.uk/view/article/10754
2. Ibid.
3. See Raymond 2003, pp.253–4.
4. See Godfrey 2001, p.205, no.188 (see also no.187).
5. Ibid., p.154, no.126. See also Myrone 2006, p.144, no.96.
6. Child 1905, p.158, no.74B.
7. Grose 1787, p.10.
8. British Museum, no. 2001,0520.37.
9. Grose 1787, p.9.
10. Ibid, p.10.
11. Litten 1991, pp.73–4.
12. Grose 1787, p.10, and Defoe 1727, p.380.
13. Litten 1991, p.76.
14. Winckelmann 1765, p.30.
15. James 1931, p.148.
16. Davies 2007, pp.21–2.
17. See also Warner 2006, p.83.
18. Martin Kemp, *Leonardo*, Oxford 2004, p.172.
19. Grose 1787, p.8.
20. Dickens 2003, p.44.
21. Crowe 1848, I, pp.309–10.
22. Crowe 1859, p.131.
23. Aubrey 1972, p.51.
24. Defoe 1706, p.6.
25. Crowe 1859, p.4.
26. Lanoe Falconer, 'Cecilia de Noël', in Dalby 1988, p.234.
27. George Cruikshank, *A Discovery Concerning Ghosts, With a Rap at the 'Spirit Rappers'*, London 1863, p.25.
28. Byng 1954, p.414.
29. Ibid., pp.437, 411 and 177.
30. Ibid., p.122.
31. Nikolaus Pevsner, *The Buildings of England: Derbyshire*, ed. Nikolaus Pevsner and Judy Nairn, rev. Elizabeth Williamson, 2nd edn, Harmondsworth 1978, p.221; Fiennes 1947, p.102.
32. Christopher Morris, introduction to Fiennes 1947, p.xxxvii.
33. Introduction by Walter Scott to Walpole's *Castle of Otranto*, first published in 1811. Quoted here from *Horace Walpole: The Critical Heritage*, ed. Peter Sabor, London and New York 1987, pp.91–2.
34. Letter of 1 February 1828 to Miss Wagner, quoted in Parsons 1932, p.104.
35. Ibid., p.103.
36. Cox and Gilbert 2008, p.4.
37. Ibid, pp.8 and 4.
38. Jane Austen, *Northanger Abbey and Persuasion*, ed. John Davie, London 1971, p.144.
39. Ibid., pp.151–3.
40. Ibid., p.177.
41. See *Lowell Libson Ltd: British Art*, London 2016, pp.32–3.
42. Samuel Taylor Coleridge, *The Friend*, ed. Barbara E. Rooke, 2 vols, Routledge & Kegan Paul, London 1969, II, p.138.
43. Mark Girouard, *Hardwick Hall, Derbyshire: A History and a Guide*, London 1976, pp.43–5.
44. *The Works of Thomas Gray*, 5 vols, ed. Rev. John Mitford, London 1835–1843, III (1835), p.300.
45. Radcliffe 1795, p.372.
46. Horace Walpole to George Montagu, 11 June 1770, in *The Yale Edition of Horace Walpole's Correspondence*, 48 vols, ed. W.S. Lewis, New Haven 1937–83, X (1941), p.306.
47. Charles Dickens, *Bleak House*, London 2003, p.112.
48. Ibid., p.113.
49. Ibid., p.586.
50. Henry James, *English Hours*, London 1905, p.76.
51. Marsh 1999, p.5.
52. Johann Wolfgang von Goethe, *Faust: A Tragedy; An Authoritative Translation, Interpretative Notes, Contexts, Modern Criticism*, 2nd edn, trans. Walter Arndt and ed. Cyrus Hamlin, New York and London 2001, p.108.
53. Julian Treuherz, 'The most startlingly original living', in Treuherz, Prettejohn and Becker 2003–4, pp.11–49 (pp.37–8).
54. Rossetti's first version of *How They Met Themselves*, made in 1851, is lost, possibly destroyed; he made another version, in pen and ink, in 1860, followed by two watercolour replicas.
55. Victoria and Albert Museum, no. E.244–1947.
56. Spielmann 1898, p.119.

VI A HAUNTED CENTURY

1. Dickens 2003, pp.35 and 39.
2. Ibid., pp.40, 34 and 43.
3. Ibid., p.38.
4. Described in a letter from Dickens to Cornelius Felton, quoted in the introduction by Michael Slater, ibid., p.xviii.
5. Ibid., p.34.
6. Ibid., p.95.
7. Ibid., p.52.
8. Ibid. p.95.
9. Ibid., p.72.
10. Dickens 2003, p.47.
11. Baxter 1691, p.25.
12. See Michael Slater in Dickens 2003, p.xviii.
13. Letter to Dr Southwood Smith, 10 March 1843, quoted in Donald Hawes, *Charles Dickens*, London and New York 2007, p.115.
14. William Makepeace Thackeray, 'A Box of Novels', *Fraser's Magazine*, vol.29, February 1844, pp.153–69.
15. See Michael Slater, 'The Origins of A Christmas Carol', https://www.bl.uk/romantics-and-victorians/videos/dickens-a-christmas-carol
16. Altick 1978, pp.504–5.
17. Cox and Gilbert 2003, p.3.
18. Ibid., p.5.
19. Ibid., p.17.
20. Ibid., p.18.
21. 'The Liar', in James 1962–4, VI (1963), p.383.
22. Cox and Gilbert 2008, p.25.
23. Ibid., p.26.
24. Ibid., p.42.
25. Charles Dickens, *The Posthumous Papers of the Pickwick Club*, London 1837, p.90.
26. Cox and Gilbert 2003, pp.74–5, 77 and 80. See pp.109–111 for the Cock Lane Ghost.
27. The story was later published with the title 'The Prayer'.
28. Dalby 1988, p.267.
29. Georgiana Burne-Jones, *Memorials of Edward Burne-Jones*, 2 vols, London 1904, I, pp.272–3.
30. Wilkie Collins, 'Miss Jéromette and the Clergyman', first published (as 'The Clergyman's

Confession') in the *Canadian Monthly*, 1875. Here quoted from Cox and Gilbert 2003, pp.201, 214, 204 and 215.

31. Bram Stoker, *Dracula*, ed. Roger Luckhurst, Oxford 2011, p.17.
32. Sheridan Le Fanu, 'An Account of Some Strange Disturbances in Aungier Street', in Cox and Gilbert 2003, p.19.
33. Dalby 1988, p.301.
34. Ibid., p.306.
35. Ibid., p.307.
36. Wilde 1966, p.193.
37. Ibid., pp.197 and 195.
38. In Wharton's 'Life and I', quoted in Lee 2007, p.40.
39. Wharton 2009, pp.40–1.
40. Ibid., p.43.
41. Ibid., pp.61–2.
42. Mary Elizabeth Braddon, *The Face in the Glass and Other Gothic Tales*, London 2014, p.168.
43. Ibid., pp.197–8.
44. Crowe 1848, I, p.4.
45. Ibid., p.5.
46. Crowe 1859, pp.v–vi.
47. Owen 1989, p.19.
48. Treffry Dunn 1984, p.48.
49. William Michael Rossetti, diary entry for 3 June 1872, in *The Diary of W.M. Rossetti 1870–1873*, ed. Odette Bornand, Oxford 1977, p.206.
50. Menpes 1904, p.64.
51. George and Weedon Grossmith, *The Diary of a Nobody*, ed. Peter Morton, London 2009, p.177. *The Diary of a Nobody* was first published in book form in 1892.
52. Treffry Dunn 1984, pp.46–8.
53. Speech given by the Prince Consort on 21 March 1849 at a banquet at Mansion House, and printed in the *Illustrated London News*, 11 October 1849. Here quoted from *The Broadview Anthology of British Literature: Volume 5, The Victorian Era*, 2nd edn, ed. Joseph Black et al., Peterborough, Ont., and Plymouth 2006, p.859.
54. See Glendinning 1995, *passim*; and Warner 2006, p.222.
55. Lady [Elizabeth] Eastlake, 'Photography', *London Quarterly Review*, April 1857, pp.442–68 (p.442).
56. Chéroux 2005, pp.20–1.

57. Houghton 1882, pp.86–7.
58. Ibid., p.191.
59. Quoted Chéroux 2005, p.49.
60. Ibid.
61. David Brewster, *Letters on Natural Magic*, 1832, here quoted from Burwick 1990, p.168.
62. Brewster 1856, p.205.
63. Ibid., pp.205–6.
64. Brown 1864, [p.7].
65. Ibid., [p.3].
66. Grant et al. 2016, p.50, no.7.
67. Ibid., p.52, no.8.
68. Ibid., p.19.
69. Ibid., p.20.
70. Ibid., p.19.

VII RE-INVENTING GHOSTS

1. Quoted in Gauld 1968, p.138.
2. See Davies 2007, p.131.
3. Quoted in Lee 2006, p.40.
4. Ibid., p.38.
5. Ibid., p.39.
6. Ibid., p.105.
7. Ibid., p.37.
8. 'Oke of Okehurst', published in *Hauntings* in 1890, was first published in 1886 as a novella with the more sensational title *A Phantom Lover: A Fantastic Story* (Lee 2006, p.105 n.1).
9. Henry James to Vernon Lee, 27 April 1890; James 1974–84, III (1980), pp.276 and 277.
10. James 1987, p.109.
11. Oscar Wilde to Robert Ross, ?12 January 1899, *The Complete Letters of Oscar Wilde*, ed. Merlin Holland and Rupert Hart-Davis, London 2000, p.1118.
12. James 1909, p.xv.
13. James 1909, pp.xxi–xxii.
14. Quoted in Kaplan 1992, p.413.
15. James to H.G. Wells, 9 December 1898, James 1974–84, IV (1984), p.86.
16. James to Frederic Myers, 19 December 1898, ibid., p.88. See also Kaplan 1992, p.413.
17. James 1909, p.xx.
18. Virginia Woolf, 'Across the Border', *Times Literary Supplement*, 31 January 1918, p.55.
19. Virginia Woolf, 'Henry James's Ghost Stories', *Granite and Rainbow*, New York 1921; here quoted from *Henry James: A Collection of Critical Essays*, ed. Leon Edel, Englewood Cliffs,

NJ, 1963. p.54.
20. Letter to William James, 23 December 1886; James 1974–84, III (1980), p.152.
21. 'The Jolly Corner', in James 1962–64, XII (1964), pp.195 and 197.
22. Ibid., pp.224, 225–6 and 231.
23. Notebook entry for 5 February 1895, James 1987, pp.112–13.
24. Thomas Hardy, 'The Darkling Thrush', in *The Collected Poems of Thomas Hardy*, ed. Michael Irwin, Ware 2002, p.137. The poem was first published in the *Graphic* on 29 December 1900, with the title 'The Century's End, 1900'; however, the manuscript bears the deleted date '1899', suggesting that Hardy had written it at the end of the previous year. When preparing the poem for publication in 1901, he renamed it 'The Darkling Thrush'. Claire Tomalin, *Thomas Hardy: The Time-Torn Man*, London 2006 (reissued 2012), pp.277–8.
25. Ford Madox Hueffer, *The Spirit of the People: An Analysis of the English Mind*, London 1907, p.43.
26. Dorson 1968, pp.319–20.
27. Burne 1890, p.320.
28. Ibid., p.330.
29. Ibid., p.314.
30. See Dorson 1968, p.322. *Shropshire Folk-Lore* was built on material gathered by Georgina Jackson, edited and substantially added to by Burne.
31. See Ashman and Bennett 2000, p.6.
32. A.E. Housman, *A Shropshire Lad*, London 1896, LII.
33. Dalby 1997, p.292.
34. Ibid., p.300.
35. Ibid., pp.302–3 and 306.
36. Ibid., p.307.
37. E.M. Forster, *The Longest Journey*, London 1992, pp.126 and 128.
38. Dalby 1997, p.292, and Rudyard Kipling, *Mrs Bathurst and Other Stories*, ed. Lisa Lewis, Oxford 1991, pp.43, 44 and 48.
39. James 1931, pp.131–2.
40. James 1931, p.viii.
41. Henry James to Thomas Sergeant Perry, 25 October

NOTES

1914, *The Letters of Henry James*, 2 vols, ed. Percy Lubbock, London 1920, II, p.433.

42. Henry James to Mrs Alfred Sutro, 8 August 1914, ibid., p.402.

43. Here quoted from Hazel Hutchison, *The War That Used Up Words: American Writers in a European Conflict, 1914–1918*, New Haven and London 2015, pp.15–16.

44. Arthur Machen, *The Angels of Mons: The Bowmen and other Legends of the War*, New York and London 1915, pp.23, 27 and 28–9.

45. Machen's introduction, ibid., pp.10–12.

46. See Causey 2013, pp.93–5.

47. Browne 2010, p.68; letter from Paul Nash to Hartley Ramsden, 4 June 1941, quoted in Causey 1980, p.224.

48. Paul Nash, *Outline: An Autobiography and Other Writings*, London 1949, p.123.

49. Paul Nash, letter to Dudley Tooth, November 1943. Tate Archive, 769.1.31 (a).

50. Ibid., (d).

51. Ibid.

52. Kenneth Clark, *The Other Half: A Self-Portrait*, London 1977, p.5. The Prime Minister's actual words may have been the slightly less picturesque 'Hide them in caves and cellars, but not one picture shall leave this island.' See James Stourton, *Kenneth Clark: Life, Art and Civilisation*, London 2016, p.158.

53. Noël Coward, *Future Indefinite*, London 1954, p.205.

54. Philip Hoare, *Noël Coward: A Biography*, London 1995, pp.320–1.

55. Ibid., p.322.

56. The film was adapted from the novel *No Nightingales* (1944) by Caryl Brahms and S.J. Simon.

57. Edith Olivier, *Without Knowing Mr. Walkley: Personal Memories*, London 1938, p.227.

58. Ibid., pp.228–30.

59. Ibid., p.224.

60. Ibid., p.226.

61. Spark 2003, pp.129 and 101.

62. Ibid., pp.102, 100 and 103.

63. 'Whistle and I'll Come to You', adapted and directed by Jonathan Miller, was broadcast as part of the BBC's arts strand *Omnibus* in 1968.

64. James 1931, p.148.

65. Robert Aickman, 'Ringing the Changes', in *Dark Entries*, London 2014, pp.41, 60, 72 and 76.

66. Ibid., pp.76 and 80.

67. Robert Aickman, 'The Swords', in *Cold Hand in Mine*, London 2014, pp.36–7.

68. Susan Hill, *The Woman in Black*, London 1998, pp.48–9.

69. Ibid., pp.60 and 64.

70. Angela Carter, *American Ghosts and Old World Wonders*, ed. Susannah Clapp, London 1993, pp.119–20. A shorter version of *Ashputtle or The Mother's Ghost* was published in 1991.

71. Hole 1950, p.vii.

72. See Stephen Calloway, 'Recording Britain: Patriotism, Polemic and Romantic Psychogeography', in *Recording Britain*, ed. Gill Saunders, London 2011, pp.53-75 (p.64).

73. Antony D. Hippisley Coxe, *Haunted Britain: A Guide to Supernatural Sites frequented by Ghosts, Witches, Poltergeists and Other Mysterious Beings*, London 1973, cover blurb.

74. Ibid., pp.95 and 147.

75. Ibid., cover blurb.

76. Lee 2006, p.37.

77. Susan Hiller, 'The Provisional Texture of Reality: On Andrei Tarkovsky', quoted in Gallagher 2011, p.11.

78. Quoted in Gallagher 2011, p.25.

79. Ibid.

80. See also Barnes 2010, pp.151–4.

81. See Ralph Rugoff, 'Jesus is an Oxymoron' in *Mark Wallinger: British Pavilion: the 49th Venice Biennale*, ed. Ann Gallagher and Hannah Hunt, London 2001, pp.5–17 (pp.10–11).

82. Susan Philipsz, 'Lowlands', 16 April to 3 May 2010, commissioned by Glasgow International. Later that year Philipsz won the Turner Prize with 'Lowlands'.

83. http://www.tate.org.uk/context-comment/video/turner-prize-2010-susan-philipsz

84. Quoted in Charlotte Higgins, '#Wearehere: Somme tribute revealed as Jeremy Deller work', *The Guardian*, 1 July 2016.

85. Will Self, 'The North London Book of the Dead', in *The Quantity Theory of Insanity*, London 1991, pp.6, 8 and 11.

86. Hilary Mantel, *Beyond Black*, London 2005, pp.138–9.

87. Ibid., p.98.

88. Sarah Waters, *The Little Stranger*, 2nd edn, London 2010, p.498.

89. Julie Myerson, *The Stopped Heart: A Novel*, London 2016, p.398.

90. From 'Notes from the Front Line', 1983, in Angela Carter, *Shaking a Leg: Collected Journalism and Writings*, ed. Jenny Uglow, London 2013, p.46.

POSTSCRIPT

1. Nunkie Theatre, https://robert-lloydparry.squarespace.com

2. Benson 2016, p.114.

SELECT BIBLIOGRAPHY

Peter Ackroyd, *The English Ghost: Spectres through Time*, London 2011.

Richard D. Altick, *The Shows of London*, Cambridge, MA, and London 1978.

Gordon Ashman and Gillian Bennett, 'Charlotte Sophia Burne: Shropshire Folklorist, First Woman President of the Folklore Society, and First Woman Editor of Folklore. Part 1: A Life and Appreciation', *Folklore*, vol.111, no.1, April 2000, pp.1–21.

John Aubrey, *Aubrey's Brief Lives*, ed. Oliver Lawson Dick, London 1949, reissued 2016.

–––––, *Three Prose Works: Miscellanies; Remaines of Gentilisme and Judaisme; Observations*, ed. John Buchanan-Brown, Sussex 1972.

Paula R. Backscheider, *Daniel Defoe: His Life*, Baltimore, MD, and London 1989.

Rodney M. Baine, 'Daniel Defoe and The History and Reality of Apparitions', *Proceedings of the American Philosophical Society*, vol.106, no.4, Aug. 1962, pp.335–47.

–––––, *Daniel Defoe and the Supernatural*, Athens, GA, 1968.

Chris Baldick (ed.), *The Oxford Book of Gothic Tales*, Oxford 1992.

Martin Barnes, *Shadow Catchers: Camera-Less Photography*, exh. cat., Victoria and Albert Museum, London 2010.

Jo Bath and John Newton, '"Sensible Proof of Spirits": Ghost Belief During the Later Seventeenth Century', *Folklore*, vol.117, no.1, April 2006, pp.1–14.

Richard Baxter, *The Certainty of the Worlds of Spirits, Fully Evinced by Unquestionable Histories of Apparitions and Witchcrafts, Operations, Voices, &c., Proving the Immortality of Souls, the Malice and Miseries of the Devils and the Damned, and the Blessedness of the Justified*, London 1691.

Jane Belfield, 'Tarlton's News out of Purgatory (1590): A Modern-Spelling Edition with Introduction and Commentary', PhD thesis, University of Birmingham 1978.

Catherine Belsey, 'Shakespeare's Sad Tale for Winter: Hamlet and the Tradition of Fireside Ghost Stories', *Shakespeare Quarterly*, vol.61, no.1, 2010, pp.1–27.

Gillian Bennett, 'Ghost and Witch in the Sixteenth and Seventeenth Centuries', *Folklore*, vol.97, no.1, 1986, pp.3–14.

–––––, *The 100 Best British Ghost Stories: Ghosts, Poltergeists, Boggarts & Black Dogs from the Oral Tradition*, Stroud 2012.

E.F. Benson, *Ghost Stories*, ed. Mark Gatiss, London 2016.

Anthony Bertram, *Paul Nash: The Portrait of an Artist*, London 1955.

David Bindman, *Blake as an Artist*, Oxford and New York 1977.

María del Pilar Blanco and Esther Peeren (eds), *Popular Ghosts: The Haunted Spaces of Everyday Culture*, London 2010.

Henry Bourne, *Antiquitates Vulgares; or, the Antiquities of the Common People*, Newcastle 1725.

Nicola Bown, Carolyn Burdett and Pamela Thurschwell (eds.), *The Victorian Supernatural*, Cambridge 2004.

Joseph Braddock, *Haunted Houses*, London 1956.

David Brewster, *Letters on Natural Magic, addressed to Sir Walter Scott, Bart.* Edinburgh 1832.

–––––, *The Stereoscope: its history, theory and construction, with its application to the fine and useful arts and to education*, London 1856.

Julia Briggs, *Night Visitors: The Rise and Fall of the English Ghost Story*, London 1977.

J.H. Brown, *Spectropia; or Surprising Spectral Illusions. Showing Ghosts Everywhere, and of any Colour*, London 1864.

Thomas Browne, *Hydriotaphia: Urne-Buriall, or, A Brief Discourse of the Sepulchrall Urnes Lately Found in Norfolk*, New York 2010.

Edmund Burke, *A Philosophical Enquiry into the Origin of Our Ideas of the Sublime and Beautiful*, ed. Adam Phillips, Oxford 1990.

Charlotte S. Burne, 'The Collection of English Folk-Lore', *Folklore*, vol.1, no.3, Sept. 1890, pp.313–30.

Robert Burton, *The Anatomy of Melancholy*, ed. Thomas C. Faulkner, Nicolas K. Kiessling and Rhonda L. Blair, 6 vols, Oxford 1989–2000.

Frederick Burwick, 'Romantic Drama: from Optics to Illusion', in *Literature and Science: Theory & Practice*, ed. Stuart Peterfreund, Boston, MA, 1990.

Peter Buse and Andrew Stott (eds), *Ghosts: Deconstruction, Psychoanalysis, History*, London and New York 1999.

Martin Butlin, *William Blake*, exh. cat., Tate Gallery, London 1978.

–––––, 'New Risen from the Grave: nineteen unknown watercolours by William Blake', *Blake: An Illustrated Quarterly*, vol.35, no.3, 2002, pp.68–73.

John Byng, *The Torrington Diaries: A Selection from the Tours of the Hon. John Byng (later Fifth Viscount Torrington) between the years 1781 and 1794*, ed. C. Bruyn Andrews and Fanny Andrews, London 1954.

Nancy Caciola, 'Wraiths, Revenants and Ritual in Medieval Culture', *Past & Present*, no.152, 1996, pp.3–45.

–––––, *Afterlives: The Return of the Dead in the Middle Ages*, Ithaca, NY, 2016.

Andrew Causey, *Paul Nash*, Oxford 1980.

–––––, *Paul Nash: Landscape and the Life of Objects*, Farnham 2013.

Clément Chéroux, Andreas Fischer et al., *The Perfect Medium: Photography and the Occult*, New Haven and London 2005.

Francis James Child, *English and Scottish Popular Ballads*, ed. Helen Child Sargent and George Lyman Kittredge, London 1905.

Roger Clarke, *A Natural History of Ghosts: 500 years of Hunting for Proof*, London 2012.

Anthony Clayton, 'Credulity, Superstition and Fanaticism: who believed in ghosts in Hogarth's England?', http://www.antonyclayton.co.uk/hogarth.html

E.J. Clery, *The Rise of Supernatural Fiction, 1762–1800*, Cambridge 1995.

John Cotta, *The Triall of Witch-Craft, Shewing the True and Right Methode of the Discovery*, London 1616.

Michael Cox and R.A. Gilbert (eds), *The Oxford Book of English Ghost Stories*, Oxford 1986, reissued 2008.

—————, *The Oxford Book of Victorian Ghost Stories*, Oxford 1991, reissued 2003.

Catherine Crowe, *The Night Side of Nature; Or, Ghosts and Ghost Seers*, 2 vols, London 1848.

—————, *Ghosts and Family Legends: A Volume for Christmas*, London 1859.

Richard Dalby (ed.), *The Virago Book of Victorian Ghost Stories*, London 1988.

—————, *The Giant Book of Classic Ghost Stories*, London 1997.

Owen Davies, *The Haunted: A Social History of Ghosts*, London 2007.

Owen Davies (ed.), *Ghosts: A Social History*, 5 vols, London 2010.

A.J. Day (ed.), *Fantasmagoriana: Tales of the Dead*, St Ives 2005.

Daniel Defoe (as anon.), *A True Relation of the Apparition of one Mrs. Veal, the next Day after Her Death: to one Mrs. Bargrave at Canterbury, the 8th of September 1705*, London 1706.

Daniel Defoe (under the pseudonym Andrew Moreton), *An Essay on the History and Reality of Apparitions*, London 1727.

Charles Dickens, *A Christmas Carol and Other Christmas Writings*, ed. Michael Slater, London 2003.

Richard M. Dorson, *The British Folklorists: A History*, Chicago 1968.

Caley Ehnes, '"Winter Stories Ghost Stories... Round the

Christmas Fire": Victorian Ghost Stories and the Christmas Market', *Illumine*, vol.11, no.1, 2012, pp.6–25.

Hilda R. Ellis Davidson and W.S. Russell (eds.), *The Folklore of Ghosts*, Cambridge 1981.

Robert N. Essick and Morton D. Paley, *Robert Blair's The Grave Illustrated by William Blake: A Study with Facsimile*, London 1982.

Hilary Evans, *Seeing Ghosts: Experiences of the Paranormal*, London 2002.

Siân Evans, *Ghosts: Mysterious Tales from the National Trust*, London 2006.

Alison Ferris, 'Disembodied Spirits: Spirit Photography and Rachel Whiteread's "Ghost"', *Art Journal*, vol.62, no.3, 2003, pp.33–55.

The Journeys of Celia Fiennes, ed. Christopher Morris, London 1947.

Mia Fineman, *Faking It: Manipulated Photography before Photoshop*, New Haven and London 2012.

Ronald C. Finucane, *Ghosts: Appearances of the Dead and Cultural Transformations*, 2nd edn, New York 1986.

Christopher Frayling, *Vampires: Lord Byron to Count Dracula*, London 1991.

Ann Gallagher (ed.), *Susan Hiller*, exh. cat., Tate Britain, London 2011.

Alan Gauld, *The Founders of Psychical Research*, London 1968.

Joseph Glanvill, *Saducismus Triumphatus: or, Full and Plain Evidence Concerning Witches and Apparitions*, 2 vols, 3rd edn, revised, London 1700.

Victoria Glendinning, *Electricity*, London 1995.

Richard Godfrey, *James Gillray: The Art of Caricature*, exh. cat., Tate Britain, London 2001.

Avery F. Gordon, *Ghostly Matters: Haunting and the Sociological Imagination*, Minneapolis and London 1997.

Simon Grant, Lars Bang Larsen and Marco Pasi, *Georgiana Houghton: Spirit Drawings*, ed. Ernst Vegelin van Claerbergen and Barnaby Wright, exh. cat., Courtauld Gallery, London 2016.

Francis Grose, *A Provincial Glossary, with a Collection of Local Proverbs, and Popular Superstitions*, London 1787.

Sasha Handley, '"Visions of an Unseen World": The Production and Consumption of English Ghost Stories, c.1660–1800', PhD thesis, University of Warwick 2005.

—————, *Visions of an Unseen World: Ghost Beliefs and Ghost Stories in 18th-Century England*, London 2007.

Alexandra Harris, *Romantic Moderns: English Writers, Artists and the Imagination from Virginia Woolf to John Piper*, London 2010.

—————, *Weatherland: Writers & Artists under English Skies*, London 2015.

Simon Hay, *A History of the Modern British Ghost Story*, London 2011.

Seamus Heaney (trans.), *Beowulf*, London 1999.

Mervyn Heard, *Phantasmagoria: The Secret Life of the Magic Lantern*, Hastings 2006.

James Hervey, 'Meditations among the tombs', in *Meditations and Contemplations*, 4th edn, 2 vols, London 1748.

Anthony Hilliar, *A Brief and Merry History of Great Britain: Containing An Account of the Religions, Customs, Manners, Humours, Characters, Caprice, Contrasts, Foibles, Factions, &c. of the People. Written Originally in Arabick, By Ali Mohammed Hagdi, Physician to his Excellency Cossem Hojah, late Envoy from the Government of Tripoli, in South-Barbary, to this Court. Faithfully rendered into English by Mr. Anthony Hilliar, Translator of Oriental Languages*, London 1730.

Thomas Holcroft, *The Life of Thomas Holcroft Written by Himself Continued to the Time of his Death from his Diary Notes & Other Papers by William Hazlitt*, ed. Elbridge Colby, 2 vols, London 1925.

Christina Hole, *Haunted England: A Survey of English Ghost-Lore*, 2nd edn, London 1950.

Richard Holmes, *Shelley: The Pursuit*, London 1974.

Georgiana Houghton, *Chronicles of the Photographs of Spiritual Beings and Phenomena Invisible to the Material Eye, Interblended with Personal Narrative*, London 1882.

M.E.J. Hughes, *The Pepys Library and the Historic Collections of Magdalene College Cambridge*, London 2015.

Ronald Hutton, 'The English Reformation and the Evidence of Folklore', *Past & Present*, no.148, 1995, pp.89–116.

John Ireland, *Hogarth Illustrated*, London 1791, reprinted 1884.

Mason Jackson, *The Pictorial Press: Its Origin and Progress*, London 1885.

Henry James, *The Aspern Papers, The Turn of the Screw, The Liar, The Two Faces*, London 1909.

—, *The Complete Tales of Henry James*, 12 vols, ed. Leon Edel, London 1962–4.

—, *Letters*, 4 vols, ed. Leon Edel, Cambridge, MA, 1974–84.

—, *The Complete Notebooks of Henry James*, ed. Leon Edel and Lyall H. Powers, New York and Oxford 1987.

M.R. James, 'Twelve Medieval Ghost-Stories', *The English Historical Review*, vol.37, no.147, 1922, pp.413–22.

—, 'The Wall Paintings in Wickhampton Church', in *A Supplement to Blomefield's Norfolk: being a series of articles on the antiquities of the County contributed by many distinguished antiquarians, and profusely illustrated by numerous plates selected and reproduced from the extensive collection of water-colour drawings made last century by the Reverend S. C. E. Neville-Rolfe, now in the possession of the Editor*, ed. Clement Ingleby, London 1929, pp.123–42.

The Collected Ghost Stories of M.R. James, London 1931.

Ghost Stories of an Antiquary: A Graphic Collection of Short Stories by M.R. James, adapted by Leah Moore and John Reppion, London 2016.

Andrew Joynes (ed. and trans.), *Medieval Ghost Stories: An Anthology of Miracles, Marvels and Prodigies*, Woodbridge 2001.

Fred Kaplan, *Henry James: The Imagination of Genius: A Biography*, London 1992.

Ludwig Lavater, *Of Ghostes and Spirites Walking by Nyght*, trans. Robert Harrison, London 1572.

Hermione Lee, *Edith Wharton*, London 2007.

Vernon Lee, *Hauntings and Other Fantastic Tales*, ed. Catherine Maxwell and Patricia Pulham, Peterborough, Ontario 2006.

C.R. Leslie, *Memoirs of the Life of John Constable*, ed. Jonathan Mayne, London 1995.

Julian Litten, *The English Way of Death: The Common Funeral Since 1450*, London 1991.

Nigel Llewellyn, *The Art of Death: Visual Culture in the English Death Ritual c.1500–c.1800*, London 1991.

Roger Luckhurst (ed.), *Late Victorian Gothic Tales*, Oxford 2005.

Julian Luxford, 'The Sparham Corpse Panels: Unique Revelations of Death from Late Fifteenth-Century England', *Antiquaries Journal*, vol.90, Sept. 2010, pp. 299–340.

Fiona MacCarthy, *Byron: Life and Legend*, London 2002.

Jan Marsh, *Dante Gabriel Rossetti: Painter and Poet*, London 1999.

Peter Marshall, *Beliefs and the Dead in Reformation England*, Oxford 2002.

Andrew Martin, *Ghoul Britannia: Notes from a Haunted Isle*, London 2009.

P.G. Maxwell-Stuart, *Ghosts: A History of Phantoms, Ghouls & Other Spirits of the Dead*, Stroud 2006.

Shane McCorristine, *Spectres of the Self: Thinking about Ghosts and Ghost-Seeing in England, 1750–1920*, Cambridge 2010.

David Alan Mellor, 'A Spectral Modernity', in Emma Chambers (ed.), *Paul Nash*, exh. cat., Tate Britain, London 2016.

Mortimer Menpes, *Whistler As I Knew Him*, London 1904.

Bruce Mitchell and Fred C. Robinson, *A Guide to Old English*, revised 4th edn, Oxford 1986.

R. Laurence Moore, 'Spiritualism and Science: Reflections on the First Decade of the Spirit Rappings', *American Quarterly*, vol.24, no.4, Oct. 1972, pp.474–500.

Henry More, *The Immortality of the Soul*, London 1659.

Andrew Moreton: see under Daniel Defoe

Lisa Morton, *Ghosts: A Haunted History*, London 2015.

Martin Myrone, *Gothic Nightmares: Fuseli, Blake and the Romantic Imagination*, exh. cat., Tate Britain, London 2006.

Simone Natale, 'A Short History of Superimposition: from Spirit Photography to Early Cinema', *Early Popular Visual Culture*, vol.10, no.2, May 2012, pp.125–45.

—, *Supernatural Entertainments: Victorian Spiritualism and the Rise of Modern Media Culture*, Pennsylvania 2016.

Lynda Nead, *The Haunted Gallery: Painting, Photography, Film c.1900*, New Haven and London 2007.

John Newton (ed.), *Early Modern Ghosts: Proceedings of the 'Early Modern Ghosts' conference held at St John's College, Durham University on 24 March 2001*, Durham 2003.

Ann Eljenholm Nichols, *The Early Art of Norfolk: A Subject List of Extant and Lost Art Including Items Relevant to Early Drama*, Kalamazoo 2002.

Diana Norman, *The Stately Ghosts of England*, London 1963.

Rachel Oberter, 'Esoteric Art Confronting the Public Eye: The Abstract Spirit Drawings of Georgiana Houghton', *Victorian Studies*, vol.48, no.2, Winter 2006, pp.221–32.

Sheila O'Connell, *The Popular Print in England, 1550–1850*, London 1999.

Janet Oppenheim, *The Other World: Spiritualism and Psychical Research in England, 1850–1914*, Cambridge 1985.

Alex Owen, *The Darkened Room: Women, Power and Spiritualism in Late Nineteenth Century England*, London 1989.

Simon Palfrey and Emma Smith, *Shakespeare's Dead*, Oxford 2016.

Coleman O. Parsons, 'Scott's Experiences in Haunted Chambers', *Modern Philology*, vol.30, no.1, Aug. 1932, pp.103–5.

Ronald Pearsall, *The Table-Rappers*, London 1972.

Rebecca Pinner, 'St Edmund, King and Martyr: Constructing his Cult in Medieval East Anglia', PhD thesis, University of East Anglia 2010.

–––––, The Cult of St Edmund in Medieval East Anglia, Woodbridge 2015.

Joseph Holden Pott, An Essay on Landscape Painting. With remarks general and critical, on the different schools and masters, ancient or modern, London 1782.

Anthony Powell, John Aubrey and his Friends, London 1948.

Diane Purkiss, 'Shakespeare, Ghosts and Popular Folklore', in Shakespeare and Elizabethan Popular Culture, ed. Stuart Gillespie and Neil Rhodes, London 2006, pp.136–54.

Ann Radcliffe, A Journey made in the Summer of 1794, through Holland and the Western Frontier of Germany, with a Return down the Rhine: to which are added, Observations During a Tour to the Lakes of Lancashire, Westmoreland, and Cumberland, Dublin 1795.

Joad Raymond, Pamphlets and Pamphleteering in Early Modern Britain, Cambridge 2003.

Michael Reed, The Landscape of Britain from the Beginnings to 1914, London 1990.

A.L. Rowse, The Elizabethan Renaissance: The Life of the Society, London 1971.

Tom Ruffles, Ghost Images: Cinema of the Afterlife, Jefferson, NC, 2004.

Jean-Claude Schmitt, Ghosts in the Middle Ages: The Living and the Dead in Medieval Society, trans. Teresa Lavender Fagan, Chicago 1998.

Reginald Scott, The Discoverie of Witchcraft, ed. Brinsley Nicholson, London 1886.

Ruth Scurr, John Aubrey: My Own Life, London 2015.

Mary Shelley, Frankenstein, or The Modern Prometheus, the 1818 Text, ed. Marilyn Butler, Oxford 1993.

Jacqueline Simpson, '"The Rules of Folklore" in the Ghost Stories of M. R. James', Folklore, vol.108, 1997, pp.9–18.

–––––, 'Repentant Soul or Walking Corpse? Debatable Apparitions in Medieval Europe', Folklore, vol.114, no.3, 2003, pp.389–402.

Andrew Smith, The Ghost Story 1840–1920: A Cultural History, Manchester 2010.

Susan Sontag, On Photography, New York 1977.

The Ghost Stories of Muriel Spark, New York 2003.

M.H. Spielmann, Millais and his Works: with special reference to the exhibition at the Royal Academy, 1898, Edinburgh and London 1898.

Margaret Spufford, Small Books and Pleasant Histories: Popular Fiction and its Readership in Seventeenth-Century England, London 1981.

Jack Sullivan, Elegant Nightmares: The English Ghost Story from Le Fanu to Blackwood, Athens, OH, 1978.

Michael Swanton (ed. and trans.), Beowulf, Manchester 1978.

Noël Taillepied, A Treatise of Ghosts, originally published 1588, trans. Montague Summers, London 1933.

Keith Thomas, Religion and the Decline of Magic: Studies in Popular Beliefs in Sixteenth- and Seventeenth-Century England, London 1971.

Adrian Tinniswood, The Polite Tourist: A History of Country House Visiting, London 1998.

Dale Townshend (ed.), Terror and Wonder: The Gothic Imagination, London 2014.

Henry Treffry Dunn, Recollections of Dante Gabriel Rossetti & His Circle, or, Cheyne Walk Life, ed. Rosalie Mander, Westerham 1984.

Julian Treuherz, Elizabeth Prettejohn and Edwin Becker, Dante Gabriel Rossetti, exh. cat., Walker, Liverpool and Van Gogh Museum, Amsterdam, 2003–4.

E.W. Tristram, English Wall Painting of the Fourteenth Century, London 1955.

Philippa Tristram, Figures of Life and Death in Medieval English Literature, London 1976.

John A. Twyning, 'The Literature of the Metropolis' in A New Companion to English Renaissance Literature and Culture, ed. Michael Hattaway, Chichester 2010.

Jennifer Uglow, introduction to Richard Dalby (ed.), The Virago Book of Victorian Ghost Stories, London 1988, pp.ix–xvii.

–––––, The Chatto Book of Ghosts, London 1994.

–––––, Hogarth: A Life and a World, London 1997.

Peter Underwood, A Gazetteer of British Ghosts, London 1971.

–––––, Peter Underwood's Guide to Ghosts and Haunted Places, London 1996.

Izaak Walton, The Lives of John Donne, Sir Henry Wotton, Richard Hooker, George Herbert and Robert Sanderson, London and New York 1927.

Marina Warner, Phantasmagoria: Spirit Visions, Metaphors, and Media into the Twenty-first Century, Oxford 2006.

C.S. Watkins, History and the Supernatural in Medieval England, Cambridge 2007.

Tessa Watt, Cheap Print and Popular Piety 1550–1640, Cambridge 1991.

Jennifer Westwood and Jacqueline Simpson, The Lore of the Land: A Guide to England's Legends, from Spring-Heeled Jack to the Witches of Warboys, London 2005.

–––––, The Penguin Book of Ghosts, ed. Sophia Kingshill, London 2008.

Ghost Stories of Edith Wharton, Ware 2009.

Complete Works of Oscar Wilde, London and Glasgow 1966.

Dover Wilson, What Happens in Hamlet, Cambridge 1935.

Johann Winckelmann, Reflections on the Painting and Sculpture of the Greeks, trans. Henry Fuseli, London 1765.

William T. Witley, Artists and their Friends in England 1700–1799, 2 vols, New York and London 1928, reissued 1968.

William Butler Yeats, The Celtic Twilight: Men and Women, Dhouls and Faeries, London 1893.

Francis Young, English Catholics and the Supernatural, 1553–1829, Farnham 2013.

SOURCES OF EPIGRAPHS

But whether reconcileable to the understanding or not they are most

interesting to the imagination

Walter Scott, letter of 1 February 1828 to Miss Wagner,

quoted in Parsons 1932, p.104.

In maner of a dyaloge it wente

Anon., 'A Disputation between the Body and the

Worms', in *Middle English Debate Poetry: A Critical Anthology*,

ed. John W. Conlee, Woodbridge 1991, p.53.

This put me in mind of a Story

John Aubrey, *Three Prose Works: Miscellanies;*

Remaines of Gentilisme and Judaisme; Observations,

ed. John Buchanan-Brown, Sussex 1972, p.53.

All argument is against it; but all belief is for it

Samuel Johnson, quoted in James Boswell,

The Life of Samuel Johnson, LL.D., including A Journal of a

Tour to the Hebrides, ed. John Wilson Croker, 5 vols,

London 1831, IV, p.85.

Come in! Come in!

Heathcliff to Catherine's ghost in Emily Brontë,

Wuthering Heights, London 1985, p.70.

The old life, the old manners, the old figures seemed present again

Henry James on Haddon Hall, Derbyshire, in *English*

Hours, London 1905, p.76.

The chapter heading 'In the Olden Time' refers to a

lavishly illustrated four-volume work by Joseph Nash,

The Mansions of England in the Olden Time (1839–49).

Thus dames the winter night regales

Wi wonders never ceasing tales

John Clare, 'January: A Cottage Evening',

in *The Shepherd's Calendar*, ed. Eric Robinson,

Oxford 2014, p.17.

I am all for putting new wine in old bottles

Angela Carter, 'Notes from the Front Line', 1983,

in *Shaking a Leg: Collected Journalism and Writings*,

ed. Jenny Uglow, London 2013, p.46.

SOURCES OF ILLUSTRATIONS

ACKNOWLEDGEMENTS

Ghosts fire the imagination and inspire conversation, and for that I am most grateful to them. As I have been writing this book, the following friends have told me ghost stories, kindly sent me books, images and information, and helped in many and various ways: Caroline Ball, Joanna Banham, David Beevers, Edward Bigden, Horatio Blood, Bronwen Burgess, Ilinca Cantacuzino, George Carter, Stephen Clarke, Tim Clayton, Jezzar Giray, Sarah Grant, Jane Greenwood, Christopher Hartop, Sandy Heslop, Olivia Horsfall Turner, Richard Humphreys, Kevin Jackson, Thomas Jayne, Ian Keable, the late J. Leader, Alex Martin, Julie Myerson, Lawrence Mynott, Juliet Nusser, Nicholas Pickwoad, Hadrien Rambach, Tristram Riley-Smith, Marcus Rowell, Veronica Sekules, Kim Sloan, Miles Thistlethwaite, the Marquess Townshend, Nigel Vardy, Ernst Vegelin van Claerbergen, Veronica Watts, Martin Williams and David Wurtzel. I extend warm thanks to them all, as I do to the many others along the way who have generously shared tales of their own supernatural experiences.

At Tate, warmest thanks go to Jacky Klein for her enthusiasm for the project, and I am most grateful to John Stachiewicz and everyone at Tate Publishing who has worked on the book. I should particularly like to thank managing editor Jane Ace, copy-editor Jenny Wilson, picture-researcher Emma O'Neill, production controller Jonas Vanbuel and Avni Patel, who has created an elegant design. On the curatorial side, Emma Chambers and Ann Gallagher have been generous with their expert help and advice.

I should also like to thank Vivienne Roberts and Leslie Price at the College of Psychic Studies, the staff of the Department of Prints and Drawings at the British Museum and those of the British Library.

Finally, special thanks, as ever, are due to my husband, Stephen Calloway.

INDEX